Contemporary Public Sculpture

CONTEMPORARY PUBLIC SCULPTURE

Tradition, Transformation, and Controversy

HARRIET F. SENIE

New York Oxford
OXFORD UNIVERSITY PRESS
1992

Oxford University Press

Oxford New York Toronto
Delhi Bombay Calcutta Madras Karachi
Kuala Lumpur Singapore Hong Kong Tokyo
Nairobi Dar es Salaam Cape Town
Melbourne Auckland

and associated companies in
Berlin Ibadan

Published by Oxford University Press, Inc.,
200 Madison Avenue, New York, New York 10016

Library of Congress Cataloging-in-Publication Data
Senie, Harriet F.
Contemporary public sculpture :
tradition, transformation, and controversy /
by Harriet F. Senie.
p. cm. Includes bibliographical references and index.
ISBN 0-19-507318-5
1. Public sculpture. 2. Sculpture, Modern—20th century.
I. Title. NB198.S355 1992 735′.235—dc20 91-33760

9 8 7 6 5 4 3 2 1

Printed in the United States of America
on acid-free paper

For Laura, like always!

Preface

My interest in contemporary public sculpture was sparked some twenty years ago by Noguchi's red "cube" at 140 Broadway in lower Manhattan. Quite simply, I wanted to know why it was there. That question eventually led to a Ph.D. dissertation, numerous articles and exhibitions, an issue of the *Art Journal,* and finally, this book.

The wave of public sculpture that began in the late 1960s must be understood in the context of two traditions that determined its existence, its placement, and public expectations of it. Historically, sculpture entered the public domain either for commemorative or decorative purposes or for both. Chapter 1, Monuments and Memorials Reconsidered, looks at ways in which the commemorative tradition of public sculpture has been transformed in subject and form in recent years. Chapter 2, Sculpture and Architecture: A Changing Relationship, discusses the changing relationship of sculpture and architecture in the evolution from modern to postmodern styles. It was, essentially, modern architects' insistence that integration of the arts was possible (later translated in public art parlance to collaboration) that largely prompted the public sculpture revival of the late 1960s.

Chapter 3, The Public Sculpture Revival of the 1960s: Famous Artists, Modern Styles, examines the precedent-setting commissions of works by Picasso, Calder, Moore, and, somewhat later, Nevelson. These single works by famous artists were placed in front of modern buildings both as ornaments and signs of culture. Once a system of government and corporate support was established, the proliferation of public sculpture expanded to include artists whose names alone did not immediately confer status to the patron. The implications of works in figurative, Constructivist, and Minimal styles are analyzed in terms of their implicit art and public content.

As artists gained experience with public art, they developed new solutions that addressed public needs as well as the environment itself. Chapter 4, Landscape into Public Sculpture: Transplanting and Transforming Nature, discusses the recent uses of nature in public sculpture, from the inclusion of natural elements of stone and water to the creation of parks or gardens, and even land reclamation projects.

Chapter 5, Sculpture with a Function: Crossing the High Art–Low Art Barrier, addresses public sculpture that incorporates elements of use. These works include sculptures that also function as street furniture, gates, bridges, bus shelters, or lighting, as well as urban sculptures that create their own built environment. They bring to public sculpture something in addition to an esthetic and intellectual solution. They serve both an art and a non-art function.

Regardless of form or approach, however, the one persistent element in the recent history of public sculpture has been controversy. Chapter 6, The Persistence of Controversy: Patronage and Politics, discusses the political factors, the role of the press, the psychodynamics of seeing art in public spaces (as opposed to the museum), and the lamentable lack of an education component in the public art process.

This book is not intended as an inclusive history of recent public sculpture. Rather, it offers a conceptual overview and develops a typology that may serve as a basis for further study and critical discussion. Within this context, selected works of special historical and/or artistic significance have been singled out.

My research in contemporary public sculpture was initially encouraged by the late H. W. Janson, Kathleen Weil-Garris Brandt, and the late Gert Schiff at the Institute of Fine Arts, New York University. Since then I have had the benefit of discussions with many artists, architects, and public art administrators. I particularly want to thank the late Gordon Bunshaft, Scott Burton, and Isamu Noguchi; Andrea Blum, Nancy Holt, Pat Johanson, Richard Serra, George Sugarman, Athena Tacha, and Elyn Zimmerman. In serving on selection panels and/or in lengthy discussions I have learned much from Penny Balkin Bach, Jennifer McGregor Cutting, Lake Douglas, Mary Kilroy, Tom Moran, and Cesar Trasobares.

Release time was provided by an Eisner Scholars Award at The City College of New York, and my research was in part supported by a grant from the PSC–CUNY Research Foundation. Elaine Koss's reading of the manuscript was crucial. Professional and personal support and advice from Annie Shaver-Crandell, Judith Chiti, Sylvia Netzer, Elke Solomon, and, above all and most often, Sally Webster, were invaluable. My parents' enthusiasm and support for this project were a source of much pleasure. Burt Roberts's constant support and critical judgment stand behind this book in more ways than I can say.

New York H. F. S.
October, 1991

Contents

Contemporary Public Sculpture

Introduction

The problems endemic to public art in a democracy begin with its definition. How can something be both public (democratic) and art (elitist)? Who is the public? What defines art or sculpture today, for that matter? What makes it public—its essence, its patron, or its location? If instead of "public art" we say "art in public places," we acknowledge site as the determining, and perhaps the only, public factor. But what makes a site public—access or amenities? Do we discuss public sculpture in the context of art or urban design or both? How can we approach a subject that makes news as an object of controversy more often than it makes sense to its primary audience?

Nowhere has this country's ambivalent attitude toward art been more apparent than in the history of its public sculpture. Ignored or approached with suspicion by many, art becomes the focus of public attention when it involves huge sums of money (at auction or in theft) or it becomes an object of controversy, usually for a variety of reasons having little to do with the art itself. For the most part, however, art and its surrounding activities are apparently not perceived as essential by the society at large. Art institutions and funding programs are the first and most drastically cut during a budget crisis, and even more damaging, the first to be eliminated from public school curricula. As a result, although museum construction and attendance are at an all-time high, art (making or understanding) remains peripheral to most lives. Although art, as part of culture, may in general be perceived as a good thing, a specific and unfamiliar example of it in our immediate environment may generate a panoply of hostile responses.

The real success or failure of public art is difficult to judge for a number of reasons, first and foremost because the true success of art

3

cannot be measured in quantifiable terms. At issue are not tourist dollars but the creative life of the imagination. How can we know, let alone measure, the effect of a work of art in a public space on all those who encounter it? Sometimes it is so subliminal that spectators may not even be aware of it. But take it away and they know they are missing something, something all the more vital because it is intangible— intangible because it addresses the spirit, or what would in centuries past have been called the soul.

As a culture we have difficulty in admitting that art has a use, because that use is primarily spiritual. Its greatest contribution lies in the realm that we are least able to quantify and therefore value. It is not easy to justify spending tax dollars on intangibles, especially in a society with many tangible and overwhelming problems. But the imaginative life addressed by art is a benefit that should be accessible to all; it is a significant factor in physical and mental health. This is not to say that recent public art has successfully fulfilled its potential. Although sited in the public realm, it has often appeared mute to the very public it had hoped to address.

The lamentable split between an artist's intentions and public perception is a continuous theme in this book. It is largely the result of the absence of art education and the nurturing of visual thinking throughout our public school systems. And it is the result of the isolationist stance of the art community, which has refused to recognize that visual perception in the public sphere does not occur within art-world parameters. It occurs in the context of the "real world," in the context of popular culture. Thus Richard Serra's *Tilted Arc* is compared to the Berlin Wall; a figurative sculpture by Joel Shapiro is seen as Gumby; and radically different sculptures by Isamu Noguchi and Michael Heizer are both related to the "pet rock" craze because they utilize natural stone.

These comparisons stick because they refer to a shared visual vocabulary and because they reduce art to a controllable commodity—one that can be understood and even, in the case of Gumby and the "pet rock," bought and owned. The jokes made at the expense of art cost the art public dearly, because they inhibit (if not prohibit) any other reading of the work. It is easy to blame the popular press for their catchy quips. But artists and public art administrators are also at fault for ignoring the total context within which public art exists and therefore the possibility of just such responses. A museum or gallery sets the

stage for the reading of a work of art as art; a public place does not unless it is a sculpture garden, designated and designed as such.

Nevertheless, judging from the various uses to which recent public art has been put, the need for it in the form of art object or urban amenity persists. Neighborhoods of all kinds need a sense of identity and of place, and art is well suited to fulfill those needs. Indeed, the recent history of public sculpture has shown the public art community's increasing awareness of its responsibility to address local cirumstances and understand both the using public's practical requirements and spiritual goals.

Most problematic has been the reappearance since the late 1960s of contemporary public sculpture in the open spaces traditionally occupied by monuments and memorials, raising a spectrum of public expectations that the art could not possibly fulfill. These works and their evolution from freestanding sculptures in a variety of styles, to site specific works, to entire sites, are the subject of this book. Public sculpture, almost as divergent in appearance as gallery sculpture, is still considered a single category, making meaningful distinctions difficult. With a significant body of contemporary public sculpture now in place, a broader and more critical evaluation is possible. Public sculpture, as it appears in photographic reproductions, is often seen from the sky—an omnipotent view not available to mortals. A more grounded approach is necessary, one that is rooted in the historical context to which public art belongs.

In this country public art, based largely on European precedent and instigated by members of the monied (ruling) class, has been valued as important for a variety of esthetic and socioeconomic reasons, but considerable ambivalence about it was apparent right at the start.[1] In 1781 Congress approved plans for a column to commemorate the Franco-American victory at Yorktown. Two years later plans were approved to build a bronze equestrian monument to George Washington to celebrate the end of the American Revolution. Apparently funds for these projects never existed, and congressional approval signified little more than a monumental gesture. Art was closely associated with luxury, and as such it was antithetical to the philosophy of the new republic. Indeed the role and responsibility of federal art patronage in a democratic society continue to be subjects of often bitter debate.

With the construction of the United States Capitol, issues surrounding the appropriate form and content of art within a public

building had to be addressed.[2] Debates again raised the question of whether the government should be involved in purchasing art at all, for there was still a widespread perception that linked public art to European precedents that were regarded as propaganda tools of monarchies and the Catholic church. A consensus was reached largely through the leadership of President John Quincy Adams, never known as an art connoisseur, who sincerely believed that the government's sponsorship of art was an index of our progress as a new country and a mark of our place in the history of civilized nations. It was the almost universal disappointment with various Capitol decorations that prompted leading critics, artists, and architects in the 1870s to look to European precedents for inspiration and guidance. Writers such as Henry Van Brunt and Montgomery Schuyler, the architect H. H. Richardson, and the painters John La Farge and William Morris Hunt felt that a major problem of American art and architecture was the technical and conceptual inexperience of American artists and architects. Indeed, early commissions for public sculpture went to Europeans.[3]

European precedents and artists were sought as late as the 1960s, when the most recent revival of public sculpture began, although by then the United States enjoyed the status of world power, economically, militarily, and culturally. In previous periods, when public art had flourished, this country suffered from an artistic inferiority complex and acted accordingly, attempting to emulate and update European paradigms of the past. During the American Renaissance of the later nineteenth and early twentieth centuries, mostly under private patronage, art and architecture followed Italian High Renaissance precedents of styles and practices established under very different political, economic, and artistic conditions.

The American Renaissance spanned the years roughly from 1876 to 1917, although projects based on its esthetic continued to be built well into the 1930s.[4] The purest statement of this vision of public art and public life was seen at the World's Columbian Exposition of 1893 held in Chicago[5] (fig. 1). Here buildings by George B. Post, McKim, Mead & White, Richard Morris Hunt, and others were decorated by teams of professionally trained painters and sculptors. Known as the White City, the architecturally harmonious buildings in an Italian Renaissance style formed a Court of Honor around a huge basin that extended from Frederick Mac Monnies's wildly eclectic multifigured *Columbian Fountain* to Daniel Chester French's sixty-five-foot-high gilt standing female statue of the *Republic*. This exposition, visited by millions,

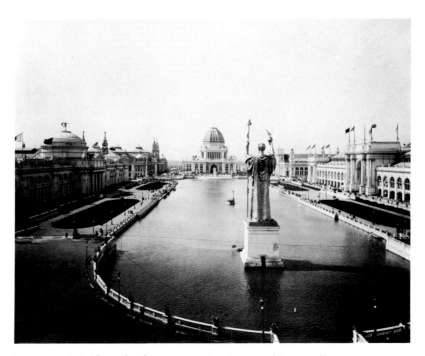

Figure 1. *World's Columbian Exposition*, 1893, Chicago, Ill.
(Chicago Historical Society).

served as a model for many other ambitious architectural projects, including the Library of Congress and numerous state capitols and courthouses, and was the inspiration behind the City Beautiful movement.

Architecture, painting, and sculpture were conceived as a harmonious whole, with the architect, often the social equivalent of his patrons, allocating appropriate spaces for art. Artists, trained specifically in the French Beaux-Arts tradition and beginning to form influential professional societies, evolved modes of expression that complemented the styles and spaces of this European-based American neoclassical architecture. The totality thus created envisioned an equally harmonious and elevated public life, often at odds with the immediate urban reality surrounding these projects. In this context, freestanding sculpture depicted civic heroes or civic virtues while architectural sculpture took the form of ornament.

As the American Renaissance spread into the early decades of the twentieth century, the esthetic and moral values that determined its form and content were increasingly being called into question.[6] The failure of Thomas Hastings's *World War I Victory Arch* (fig. 2) to achieve

7

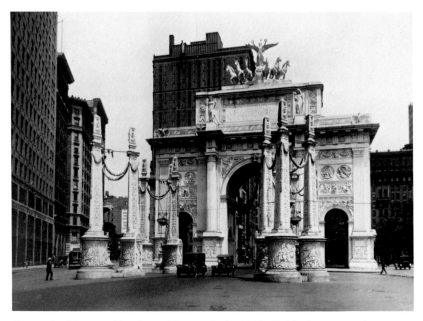

Figure 2. Thomas Hastings, *Victory Arch*, 1919, Fifth Avenue and
24th St., New York City (destroyed) (Museum of the City of New York).

a permanent form in New York City signalled an end of the viability of
the Beaux-Arts tradition and both a literal and figurative change in the
position of public sculpture in the cityscape.[7] At issue in the transfor-
mation of the temporary structure celebrating the victorious end of the
Great War were changing attitudes about the appropriate content and
form of war memorials. Should they be celebratory, emphasizing victo-
ry and triumph, or conciliatory, focusing on the human cost of war and
future peaceful coexistence? Should they take the traditional form of
art (usually a combination of architecture and sculpture) or should
they be living, useful structures such as parks, playgrounds, or swim-
ming pools? These debates not only prefigured similar discussions
concerning appropriate memorials for World War II, but the actual
evolution of public sculpture itself after the late 1960s from art objects
to useful art.

The controversy surrounding Hastings's arch challenged the posi-
tion of the National Sculpture Society, whose members were recipients
of most public sculpture commissions during and after the American
Renaissance. The role of the sculptor, compared with that of the
architect and various politicians, diminished to such a degree that this
professional organization was among those that eventually took a

stance against the erection of the *Victory Arch* in permanent form. By this time (1924), the issue had become the intended site as well as the form of the memorial. The use of Central Park for public art, then as now, was problematic for many and gave rise to a debate that had little to do with the memorial itself. The issue of site, which has its own significance for a community or a nation, is always critical for public art. Indeed, many controversies that appear to be about public art are actually about the use and meaning of the site.

The politics surrounding the *Victory Arch* controversy extended well beyond art-world struggles for turf or neighborhood concern with park land use. They involved anti-German sentiment surrounding World War I and the nationalist concern that this country have an American art expressed by American artists. In various guises this concern was expressed by artists and the general public and worked against the National Sculpture Society, some of whose members had German names.

The split of sculpture from architecture heralded by the *Victory Arch* controversy became a problematic reality for public sculpture later in the century when the predominant style of building was glass-box modern, which allowed no place for it. While a Beaux-Arts style of art and architecture continued to be used for government buildings and museums, International Style modern, as widely seen in the exhibition of 1932 at the Museum of Modern Art, proliferated. Abstract styles of art, introduced by the famous Armory Show of 1913, and exhibited in the growing numbers of museums and galleries devoted to modern art, gradually began to take hold among artists.[8] Abstract sculpture, apparently inconsistent with a public function, found a new home in the museum, while figurative public art continued to be commissioned, most notably in the Federal Triangle in Washington, D.C. (1926–47), some of the works sponsored by the Works Progress Administration (1931–40) in response to the Great Depression, and more grandly, in the private enterprise of Rockefeller Center.

The Federal Triangle in Washington, D.C., was built to accommodate the increased size of the government itself.[9] Initiated by the Public Buildings Act of 1926, it was based on L'Enfant's 1791 plan for the city and the subsequent recommendations of the McMillan Commission of 1902. The architects, many trained in Paris at the Ecole des Beaux-Arts, continued the neoclassical style of the American Renaissance with sculpture, both in the form of applied relief and freestanding figures, conceived with either an ornamental or an allegorical

function. As such, it was, according to its primary historian, George Gurney, "the largest and last grand statement in the United States of traditional Beaux-Arts principles, combining architecture and sculpture."[10] Following traditional practice, architects chose the sculptors.

After 1934, with various programs of government support for the arts in effect, the selection of art for the Federal Trade Commission building, the last construction in the Triangle, fell under the jurisdiction of the Treasury Department's Section of Painting and Sculpture (later the Section of Fine Arts), directed by Edward Bruce. This agency, a precursor of the later Art-in-Architecture program of the General Services Administration, commissioned art directly for government buildings, often through anonymous competitions, at a rate of 1 percent of construction costs. In contrast, the WPA Federal Art Project (WPA/FAP), supervised by Holger Cahill, was a wide-ranging relief program for artists, and it became a precedent for many of the programs of the National Endowment for the Arts.

Many sculptors welcomed the opportunity to create a public and monumental art once again joined to architecture.[11] However, they were severely hindered by economic constraints and technical problems. Relief sculpture and freestanding statues in the form of heroic figures, singularly or in groups, were portrayed in a stylized or streamlined mode (following the predominant 1930s design in architecture and industry).[12] These stylistic choices were much maligned or ignored by subsequent generations of modernist critics and historians.

Michael Lantz's pair of sculptures, *Man Controlling Trade* (1937–41), outside the Federal Trade Commission at the apex of the Federal Triangle in Washington, D.C., is typical and probably the best-known example of this style in monumental form (fig. 3). Lantz was the winner of a national competition, and his pair of muscular men taming their horses was received enthusiastically in the popular press.[13] These over-lifesize limestone sculptures (measuring 15′ × 17′½″ × 6′6″ each) conceived symbolically to relate to the function of the building, represent the more simplified geometric style that characterized the decade before World War II. Chaim Gross's relief, *Industry* (1937–38), depicts a more contemporary vision of construction workers (fig. 4).

The impetus behind the various WPA art programs was quintessentially democratic, perhaps uniquely so in American history, although to what degree these sculptures were understood by the general public is debatable. Under the Treasury Department's Section, art was spe-

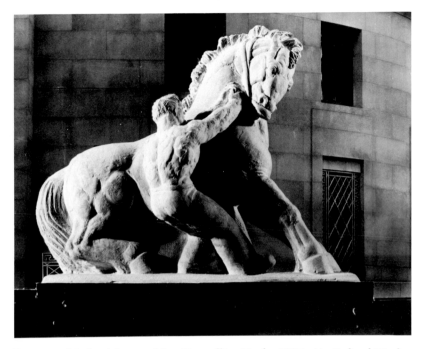

Figure 3. Michael Lantz, *Man Controlling Trade*, 1937–41, Federal Trade Commission, Washington, D.C. (National Archives).

cifically created for a broad public audience (many of whom had no prior access to original works of art), and segments of the general public were involved in the choice of subject and location.[14] WPA programs that supported artists directly, rather than commission specific works, assumed that artists had a right to work (just like other unemployed persons) and tolerated abstract art to an unusual degree. Without question, the WPA programs extended the opportunity for the general public to become involved with art and for artists to work. Considering the numerous constraints, the results were impressive and are still being re-evaluated today in a postmodern context when abstract art is no longer considered the only acceptable style of art.

Concurrently, but under private patronage, and in a stylistic language shared by contemporary WPA projects, Rockefeller Center (1931–40) provided public art in the center of Manhattan.[15] Often cited as a paradigm of enlightened urban design, it included an extensive art program. This, according to a Center brochure,

was recognized as a necessary component in the original concept of Rockefeller Center as a modern community, and in each new expan-

11

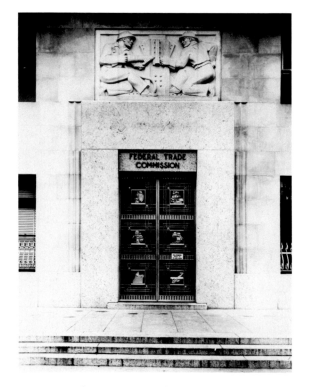

Figure 4. Chaim Gross, *Industry*, 1937–38, Federal Trade Commission, Washington, D.C. (National Archives).

sion, leading artists were called in to maintain the tradition set by the founder. Using the subject "New Frontiers" as a central theme, more than thirty outstanding artists contributed well over one hundred works for the Center's art program, which pioneered one of the most interesting collections of contemporary art to be found in America outside of museums and government buildings.[16]

Following the architect's recommendation, Lee Lawrie got the most important commissions. Of the freestanding sculptures, his *Atlas* (cast in 1936), reflecting the contemporary moderne update of a classical figure style, has become the best known, if not best loved, of the group, with its prominent Fifth Avenue site (fig. 5). Although the artworks as a whole have not been much admired, John D. Rockefeller, Jr., set a precedent for urban design and art inclusion that was followed, with varying degrees of success, by his sons: John D. Rockefeller III at Lincoln Center, David at the Chase Manhattan Bank, and Nelson at the Empire State Plaza in Albany.[17]

12

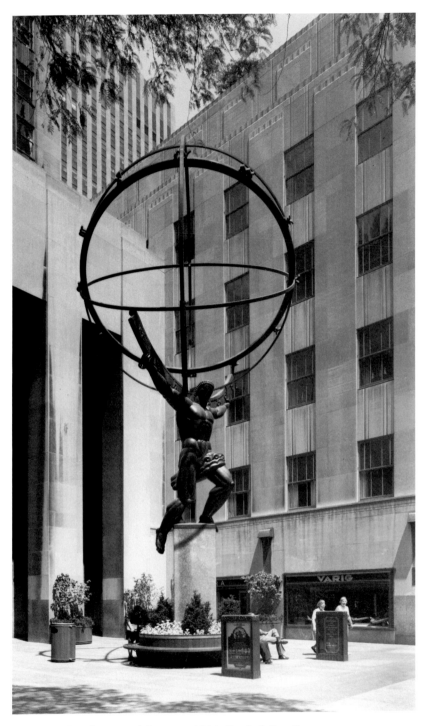

Figure 5. Lee Lawrie, *Atlas,* cast 1936, Rockefeller Center,
New York City (courtesy Rockefeller Center).

13

Elements of both the American Renaissance and WPA traditions of public art merged in the public art revival of the late 1960s. Initiated by blue-chip architects working for corporate and government clients, it became an integral part of federally funded programs that eventually had offshoots at the state and local levels. Architects initially, once again, looked to Europe for precedents. In their vision of public space, the European piazza served as paradigm. Thus Lincoln Center (1962–68), with buildings by Wallace K. Harrison, Philip Johnson, and Eero Saarinen, looked like a modern update of Michelangelo's Capitoline Hill (1538–64). Like the Capitoline Hill, it was part of an urban renewal project, and as such sought to revive the potential of public life. However, the emblematic statue of the Roman emperor Marcus Aurelius was replaced by an innocuous fountain, and sculpture was relegated to the rear court. Works by the most famous sculptors of the day, Henry Moore and Alexander Calder, were chosen, a sign of their creators' international reputations rather than an expression of shared values or any specific meaning of the site.

The public sculpture revival of the late 1960s began in earnest with the Chicago Picasso (1967) and the Grand Rapids Calder (1969). Both were part of publicly funded urban renewal projects, intending to revitalize downtown areas with open spaces and art. The moving forces behind the inclusion of art, however, were art collectors, art professionals, and architects (who were also collectors). The Chicago Picasso came about largely through the efforts of William Hartmann of Skidmore, Owings & Merrill, part of the team of architects who built the Chicago Civic Center, which formed the backdrop for the sculpture. The Grand Rapids Calder was commissioned as a result of a suggestion made by Henry Geldzahler (then Director of the National Endowment for the Arts' Visual Arts Program) to Nancy Mulnix (then Vice President of the Friends of the Grand Rapids Art Museum), and largely due to her efforts, the project was realized. As the brainchildren of art collectors, the new public sculptures reflected the attitudes of their patrons, who (following the tradition of the American Renaissance) valued art as, among other things, a sign of culture.

But conditions had changed significantly since the late nineteenth century. By the 1960s critically recognized art was largely abstract; modern architecture had rejected its traditional relationship with art in favor of an unadorned glass and steel facade with no place for art; and cities were more often organized around real estate values rather than public life. Although it was placed in comparable urban spaces,

art without recognizable content could not easily fulfill the traditional commemorative role of public sculpture, and modern cities defined by modern skyscrapers provided few hospitable spaces for public art.

Even though the historical precedent of the European piazza had little relevance to contemporary urban life, federal urban renewal programs and local zoning ordinances in the 1960s attempted to create comparable open spaces in cities, in the hope of encouraging an economic and cultural revitalization. Unfortunately these spaces, usually in the form of forecourts (called plazas) in front of high-rise office buildings, were built without basic urban amenities such as plantings and street furniture. Public sculpture could not be a substitute for urban renewal. Neither could it redeem the barren modern architecture that predominated in most city building. Introduced into the urbanscape in the late 1960s initially as an ornament after the fact for modern architecture or city spaces, public sculpture could hardly make up for all that was missing in the urban environment or significantly improve city dwellers' quality of life.

The decade of the sixties ended with major social and political upheavals at home and abroad. The civil rights and women's movements called for radical changes in the structure of society. Students took to the streets to protest American involvement in Vietnam. And the condition of the environment became a focus of international concern. At a time when the power structure was seriously challenged from within, this country embarked on a public art revival, instituting government programs of support that led to a widespread proliferation of public sculpture.

Whatever its form, this sculpture in barren urban spaces understandably raised public expectations based on a memorial tradition that had by this time been seriously challenged. Traditional memorial sculpture, whether it was funerary in nature or dedicated to ideas, events, or individuals, took a figurative form and was built with the assumption that the community that commissioned it existed as a historical continuity and that the values it expressed were shared. This presupposed a fairly homogeneous population at least ideologically, with a body of artists who could and would interpret its ethos in visually compelling and comprehensible forms. In the later twentieth century these premises no longer hold. History is no longer seen as a continuous, rationally explicable progression.[18] Past or present values or events aren't necessarily seen as important for the future; indeed, they are often perceived as egregious or irrelevant. The public is in-

creasingly diverse, composed of multicultural ethnic groups whose right to recognition is now acknowledged by a society that long excluded them. The very definition of "the public" as a meaningful entity is in question, as well as the possibility of an integrated public life.[19]

Nevertheless, once a public art patronage system was established and precedents were set, the proliferation of public art, at least for a time, was assured. The initial selection of famous artists with immediate name recognition expanded to include other sculptors whose names alone did not immediately confer credibility to the patron. More important, a group of artists, as they gained experience with public sculpture, began to consider and address the actual needs of the public realm.

During the 1970s nature became a significant element in both the history of contemporary sculpture and the syntax of public art. Coinciding with a national focus on environmental issues at home and abroad, artists started to incorporate elements of nature directly into public sculpture, eventually designing entire parks and even land reclamation projects. A decade later public use became part of the formal solution and political rhetoric of public art. Taking the form of seating, lighting, bridges, gates, fences, or any combination of elements that function as urban amenities, useful sculpture became one way to make public art accessible and acceptable.

The evolution of recent public sculpture has been a largely democratizing process, reflecting changing attitudes toward the public realm. Individual object sculpture presumes that art is a positive sign of culture and will be experienced as such wherever it is placed. The primacy of the art object is emphasized. Public sculpture incorporating landscape elements addresses a traditional and widespread longing for pastoral relief in the urban environment, accessible to more than an art audience. Public sculpture with a use places pragmatic public needs, available to all, alongside spiritual and intellectual ones. These various approaches are not mutually exclusive; their suitability depends on the nature of their physical site and immediate community. However, given the deplorable state of so many urban centers, those projects that create their own hospitable space, combining art with use, appear to be the most appropriate.

In spite of—and perhaps because of—the democratization process at work, controversy over public sculpture persists, largely because the process has not been complete. There has been a serious failure of communication. Contemporary art is not immediately comprehensible

to the general public, and artists and critics have largely failed to explain their work in understandable language. Since art is not part of a public school education, mutual education is critical throughout the public art process. Public needs must be articulated, and contemporary art still has to be explained. Public sculpture has the potential to function as a powerful connector, a meaningful and integral part of contemporary public life, defining and expanding our common ground.

Toward that end, this book is an invitation to begin a more productive public art dialogue—one that is based on a shared understanding of the recent evolution of public sculpture and the range of options available today. It is for the general public who live with public art and have a real stake in its success. It is also for a professional audience: artists, art historians, critics, and art educators; architects, landscape architects, and city planners; public art administrators and policy makers; government and corporate commissioners of public art and their art advisors. If public art is to make a significant contribution to contemporary life we all have to communicate—in a language we can all understand.

1

Memorials and Monuments Reconsidered

Historically, the monument—as distinguished from all other things that are present—was supposed to endure for all time.

Dan Graham

It is a sad fact, but most monuments lie. They say that war is wonderful, bravery always worthwhile, that liberty is for everyone; that Napoleon was a great guy; that Lincoln was not a conniving politician; that the nation is noble, no Greek irrational, the Prince was a prince, Saint Joan a saint, and that there once was, in Palestine, a deity.

William H. Gass

We don't need another hero.

Tina Turner

When the public sculpture revival of the late 1960s began, public sculpture in the form of monuments and memorials seemed to be an art form of the past. Commemorative sculpture that celebrated heroic men, deeds (usually of war), or virtues appeared to have no function in a country embroiled in an unpopular foreign war that would radically alter its national image, and enmeshed in domestic struggles that challenged the power structure from within. The very premises of monuments and memorials had eroded, as well as the traditional form of allegorical figure sculpture that had once represented them. Gradually, an alternative to traditional memorials evolved, one that focused on victims rather than heroes or adopted an ironic or humorous stance,

18

and often, in one form or another, engaged the public physically by providing a walk-through experience.

The tradition of the American Renaissance, epitomized by the Ecole des Beaux Arts–inspired style of the World's Columbian Exposition of 1893, was already challenged by the growing distrust for public sculpture that emerged toward the end of World War I.[1] Thus the *Victory Arch* designed by architect Thomas Hastings in 1919 failed to achieve permanent form in Madison Square in New York City.[2] As a celebration of the return of American soldiers, it was already in marked contrast to the memorials to the Great War that took the form of useful buildings or parks, setting a precedent for the debate over appropriate memorials to World War II.

One significant link to the tradition of glorifying memorials is *Gateway Arch* in St. Louis (fig. 6). Part of an urban renewal project begun in the late 1940s as the Jefferson National Expansion Memorial in St. Louis, in memory of the president's Louisiana Purchase,[3] the arch, finally dedicated in 1966, was the chief monument of the entire complex, which included a park and several buildings intended to provide a range of public amenities from the educational to the purely entertaining. By concentrating on the single symbolic element of the design, and indeed, making that its focus, Eero Saarinen hoped to create a memorial that would compete with the Washington Monument, the Statue of Liberty, and the Eiffel Tower.[4] His choice of the parabolic arch form evolved from thinking about the design of Jefferson's buildings at the University of Virginia and the Virginia State Capitol and the more general history of the arch as a monumental and architectural form.[5] The colossal size of Saarinen's 630-foot arch was also implicitly a monument to modern technology and engineering.

The arch was built with a combination of federal and local funds and seen as a symbol of St. Louis's claim to national fame and local pride. The aspirations and funding of the Jefferson National Expansion Memorial are precursors of much of the public sculpture built in the following decades under the National Endowment of the Arts' Art in Public Places Program (begun in 1967). Arising from local demand, seen in the context of urban renewal, the project and the arch in particular were meant to create a sense of civic identity and impress outsiders, and in the process, generate funds through tourist revenues.

In contrast to its actual appearance, however, *Gateway Arch* has retained a low profile in terms of widespread public awareness. Saarinen lacked a world-famous reputation, and the arch, although

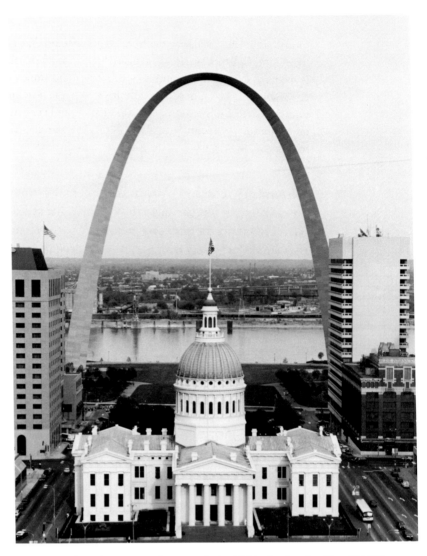

Figure 6. Eero Saarinen, *Gateway Arch,* 1966, St. Louis, Mo. (Al Bilger, courtesy National Park Service, Jefferson National Expansion Memorial Archives).

visited by over two million annually, is far away from the East Coast art press. Nevertheless, it remains the period's major effort at creating a modern large-scale civic memorial germane to both its site and the country as a whole. As William Gass observed,

Saarinen's Arch is a perfect expression of our position. It aspires. It opens out. It looks west, but it has no face. Like the Golden Gate Bridge

20

(and those other bridges which we have memorialized) it soars and
spans. We look through it at the Courthouse, perhaps, but its meaning
is modern; it is built of stainless steel, not of old stones. . . . Beneath
the Arch lies history, dead as we desire it to be; so dead indeed that the
museum buried there has nothing to display, and concentrates instead
on exhibiting the techniques of exhibition: on layouts, labels, lighting,
models and montages. . . everything absolutely up-to-date.[6]

Saarinen's modernized version of a traditional architectural form
was a triumph of technology. Esthetically beautiful, its scale and im-
plicit celebration of territorial expansion were at odds with the memo-
rials conceived in later decades that commemorated the plight of vic-
tims in earthbound forms and invited personal participation rather
than awe.

Museums as Memorials

Architecture in another form eventually emerged as a favored model
for American monuments to the Holocaust and its six million victims.
The debate over appropriate memorials for this awesome event began
even before World War II was over. Initially, many favored useful
structures like hospitals, libraries, swimming pools, or parks,[7] while
others preferred art. Discussions took place both in Europe and the
United States, primarily among architects and city officials in charge
of approving the memorials built in their locale.[8] Although it was
generally agreed that Civil War–style monuments could not address
the complexities of World War II, there was no consensus about what
type of memorial would best reflect the recent war. Many public com-
missions went to members of the National Sculpture Society, devoted
to a Beaux-Arts esthetic based on figural sculpture seen as an orna-
mental addition to architecture. The Fine Arts Commission created by
Congress in 1910, with the power to approve all government art and
architecture, as well as suggest consultants to commissioning agen-
cies, was responsible for many of these choices.[9]

But the debate of art (or beauty) versus use, already an issue regard-
ing World War I monuments, continued. Some argued that art and
use were not incompatible and that perhaps art had a use too. Philip
Johnson thought that the question of form might best be addressed by
looking at those traditional shapes that were still meaningful, es-
pecially "the megalith and the mound."[10] (Johnson's suggestion now

seems strangely prophetic, prefiguring both Maya Lin's design for the *Vietnam Veterans Memorial* and the whole movement of earthworks to which it is related.)

An equally prophetic suggestion was reported in 1945 by Albert T. Reid, then National Vice President of the American Artists Professional League. An American soldier returning to his hometown envisioned the ideal war memorial as "a place where friends and townspeople could meet with perhaps a place where they could dump their medals and souvenirs—a museum of momentos." He felt there should be "a place for statuary and paintings—above all, a place where they would like to come."[11] Eight years later, such a complex was actually built in Jerusalem at Yad Vashem, established in 1953 "to enshrine and preserve the memory of the six million Jews annihilated and thousands of flourishing communities destroyed by Nazi Germany."[12] Yad Vashem contains a history and an art museum, a Hall of Names (a constantly updated record of all those who died in World War II), a Hall of Remembrance (dedicated to the concentration camps of World War II), a Children's Memorial, a synagogue, a Memorial Cave, and a library with archives. Each part has a specific function. Together with the memorial paths and independent sculptures placed throughout the complex, they attempt to encompass the horror of the Holocaust. Yad Vashem is a place for introspection and mourning. It documents a gruesome history with the insistence that we all remember.

Holocaust memorials in the United States, removed from the actual site of battle (as the country had been in World War I), necessarily took a different form and expressed a different ideology.[13] Nevertheless, the composite nature of Yad Vashem may be seen as a precursor, on an appropriately vaster scale, of the Holocaust museums that were later built in the United States in Washington, D.C., Los Angeles, New York, and other cities. James E. Young identifies liberty and pluralism as "the central motifs in both current and proposed Holocaust museums in America . . . enshrining not just the history of the Holocaust, but American ideals as they counterpoint the Holocaust. By remembering the crimes of another people in another land, Americans would recall their nation's own, idealized reason for being."[14]

In their attempt to grasp the totality of the Holocaust, all these memorials are multimedia in content and include libraries or learning centers. The concept of museums serving as memorials reflects the changing role of museums in the later twentieth century. Not only have museums multiplied, their attendance has grown and their func-

tions have expanded to include shopping, eating, and socializing. Beyond this, they have taken on an increasingly active role as educational institutions, engaging the public through guided tours, lectures, organized trips, and extensive outreach programs. More and more museums are functioning like community centers, especially in small towns. In this context, it is not surprising that they also function as keepers of communal memory.[15]

Individual memorial sculptures proved more problematic, as developments in New York City showed.[16] Between the end of the war and 1965, six separate Holocaust memorials were planned in the city with the largest number of Holocaust survivors outside Israel. They included proposals by Jo Davidson, Percival Goodman, Ivan Mestrovic, Nathan Rapoport, Neil Estern, and Louis Kahn. Widely different in form, all were plagued by controversy, and their sponsors ultimately failed to raise the necessary funds for their construction.[17]

Monuments to Victims

The Unknown Political Prisoner

The problems of building a memorial were not confined to the subject of the Holocaust or the United States. The international competition of 1953 to build a memorial dedicated to "the unknown political prisoner" resulted in a similar stalemate. Honoring the suffering and anonymity of most of those captured in war, the subject was deemed necessary to provide a focal point, although any style was considered acceptable, including abstraction. Sponsored by the Institute of Contemporary Art in London, an art institution rather than a government body, this competition acknowledged and even embraced modernist styles to an unusual degree.[18]

Competition guidelines instructed entrants to conceive their work "as standing free and independent of any architectural setting." A site, to be chosen later, was thus deemed of secondary importance. The 3500 entries from fifty-three countries were judged by a nine-member international jury.[19] To emphasize the importance of the competition, many of the participating countries awarded national prizes as well. In the United States the competition was conducted by the Museum of Modern Art, with its own five-member jury.[20]

The British artist Reg Butler won, with a proposal for a semi-abstract welded metal sculpture in the open linear style pioneered by Juan Gonzalez and Picasso. The Russian Constructivist Naum Gabo,

then living in the United States, won one of four second-place prizes, and the Americans Alexander Calder and Richard Lippold won two of the seven third-place prizes. The choices elicited considerable controversy centered on the issue of abstract versus representational art, and several critics questioned whether the competition marked the end of an era in monumental sculpture,[21] a lament that was often heard in other contexts in the years to follow. Butler's proposal for a 140-foot-high open cage containing isolated figures was interpreted by many as a statement of hopelessness. One critic saw it as "the conception of a world in which the insignificant individual is caught in a cruel and inescapable tangle" and questioned "whether we should erect a monument to despair."[22] Controversy persisted, and the memorial, by then intended for a significant site in London or on the cliffs of Dover, was never built.

The subject itself was problematic. Although anonymous memorials were hardly a new phenomenon,[23] the theme of the unknown political prisoner seemed to suggest a confusion between heroes and victims that has permeated our culture in the later twentieth century. The need for heroes persists in spite of the difficulty in finding them. Victims are frequently designated as heroes, and the distinction between the two has gradually eroded. Examples of this confusion in recent history abound. When hostages held in Iran for 444 days were finally released early in 1981, they were hailed as national heroes, leading to considerable resentment among Vietnam War veterans who had, at that point, been largely ignored. When thirty-nine Americans who had been held hostage on an airplane in June 1985 were released, they too were hailed as heroes. A memorial wall called *The Place of Remembrance* was built at Syracuse University in 1990, dedicated to the thirty-five students killed by terrorist bombs placed on a Pan American flight that was to have brought them home after a semester overseas.

The Berlin Wall

Walls are tangible barriers, exclusionary structures of separation, evocative monuments to victims. The Berlin Wall, built in 1961 to stem the steady exodus from East Berlin, was until its destruction in 1989 a symbol of the Cold War, following in the wake of World War II. The Berlin Wall was a symbol of defeat—a solid barrier to movement, sight, and the human spirit. It divided an entire city, leaving spectators on both sides with a sense of permanent exclusion. Originally a blank

slate, it offered the opportunity to record a new history of witnesses through layers of graffiti, a manifestation of the ongoing need to protest, be heard, and, perhaps above all, leave a mark.

Throughout history certain structures built for decidedly non-art purposes, like the Eiffel Tower, often filled the traditional functions of monuments more effectively than any public sculpture.[24] The Berlin Wall, some 100 miles long and guarded by 40,000 troops, was discussed in a symbolic context almost immediately after its construction in a wide range of publications from the *Reader's Digest* to *Architectural Review*, the latter referring to it as "the most consequential building of 1961."[25] As the Wall became a fact of life, it also became a widely used symbol of frustration, of individual lives being governed by factors beyond their control.[26] As an artifact of history, its appearance changed with time. In an ad hoc method of construction, concrete blocks made from rubble were stacked four and five high, topped with barbed wire or broken glass, alternating with sections of barbed wire alone, and sometimes incorporating actual buildings (abandoned houses and even churches) that bordered on the line separating East from West Berlin.

This bizarre structure replaced the Brandenburg Gate as the visual symbol of Berlin.[27] Situated in the East, along with other architectural treasures of a shared cultural heritage, the Gate, taking its form from the Roman triumphal arch, was linked to a western heroic tradition. The Wall, on the other hand, was linked almost immediately to the Great Wall of China.[28] That wall served as a barrier against the barbarian invaders of the steppes, while the Berlin Wall was intended to make a city's inhabitants its prisoners. The Great Wall was thought to symbolize a sleeping dragon and reflect the path of the Milky Way, while the Berlin Wall had no such benign associations. In this it has had more in common with the Wailing Wall of Jerusalem, to which it was also compared.[29]

In West Berlin the Wall almost immediately was seen as an ideal painting surface, inviting graffiti, as a blank wall in an urban environment frequently does. The Berlin Wall was a magnet for amateur and professional artists alike. In 1982 the American artist Jonathan Borofsky, as part of his contribution to the international exhibition *Zeitgeist* (at Martin-Gropius-Bau in West Berlin), painted one of his typical images of a frightened running man directly on the Wall[30] (fig. 7). In 1987 a photograph of this *Running Man* opened the exhibition *Berlinart* at the Museum of Modern Art in New York. When Keith

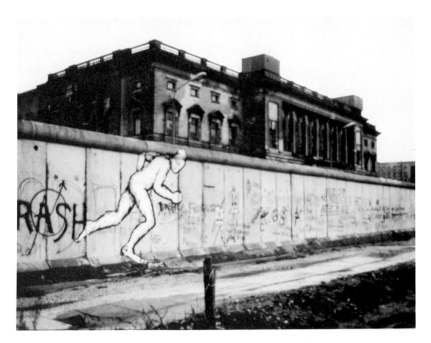

Figure 7. Jonathan Borofsky, *Running Man*, 1982, Berlin Wall, Germany (courtesy Paula Cooper Gallery).

Haring was invited in 1986 to paint a mural on the Wall by the Arbeitsgemeinschaft (a West Berlin group that monitored human rights violations in East Germany), he thought of his work as "a political and subversive act—an attempt to psychologically destroy the Wall by painting it."[31]

The Berlin Wall not only functioned as a political monument, providing a surface for personal expression (artistic and otherwise), it even gave rise to its own museum (albeit an ad hoc one), the Haus at Checkpoint Charlie. A shabby building, the last on the street leading to the border crossing, it included a disorderly display of works by artists as well as photographs and stories that documented the human consequences of the Wall.

The pervasive presence of the Wall was recorded in German fiction and in films such as Wim Wenders's *Wings of Desire* (1988), which used the Wall as a recurrent visual theme. Perversely, the Wall became a tourist attraction, mimicking the fate of museums and public art in a capitalist society. Stranger yet, it incorporated the form and essence of much controversial twentieth-century sculpture. A Duchampian ready-made-assisted, of minimal form and with no identifiable esthet-

26

ic, a giant earthwork in an urban setting, the longest-standing, most audacious "Christo," wrapping and isolating an entire city, the Wall became a basis of comparison with Richard Serra's *Tilted Arc* in New York City (also dismantled in 1989) and Maya Lin's *Vietnam Veterans Memorial* in Washington, D.C.

For the present, the destruction of the Berlin Wall in 1989 has not erased the economic and social boundaries that exist between East and West Germany.[32] Just as art once adhered to the surface of the wall, it is now finding a home in the space that the wall once occupied. It remains to be seen to what extent the physical absence of the Wall and the reunification of Germany will eradicate from public memory the Cold War that the Wall both enforced and symbolized.

Judith Baca: Great Wall of Los Angeles

Some fifteen years after the Berlin Wall was built, in 1976, Judith Baca began work on a wall with the mission to preserve a largely unwritten history. Known as the *Great Wall of Los Angeles* (its actual title is *The History of California*), it depicts local history from the point of view of groups and events that have been traditionally ignored by the mainstream (fig. 8). An ongoing project of the Social and Public Resource Center (SPARC) founded by Baca, the wall to date spans 2435 feet and a historical period from the dinosaurs to the start of the civil rights

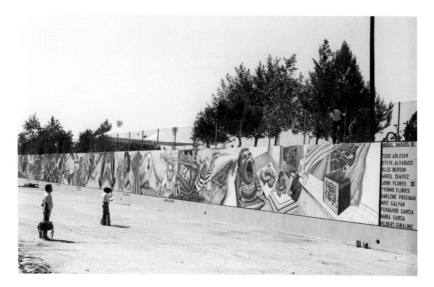

Figure 8. Judith F. Baca, *Great Wall of Los Angeles,* begun 1976, Los Angeles, Calif. (Linda Eber, courtesy SPARC).

movements of the 1960s.[33] The impetus for the project came from the Army Corps of Engineers, who asked Baca to consider the possibility of creating a mural in the flood control channel at Coldwater Canyon Avenue and Burbank Boulevard, between the Hollywood and San Diego Freeways, "as part of a beautification project that included a mini-park and bicycle path."[34]

The *Great Wall of Los Angeles* depicts images of prehistoric California, the Spanish arrival in 1769, the Gold Rush of 1848, successive waves of Chinese and Mexican immigrants in the later nineteenth century, World War I (emphasizing the role of women), Thomas Alva Edison (as a native of Mexico), social conditions in Hollywood in the 1920s, the 1929 crash and subsequent depression, the Dust Bowl refugees (comparing the fates of Mexican and Japanese Americans), World War II (including examples of local discrimination), Jewish refugees, the 1950s (the development of suburbia, the "Red Scare" and McCarthyism, Chavez Ravine and the division of the Chicano community, the birth of rock 'n' roll, the origins of the gay rights movement, the Beats), Jewish achievements in arts and science, Indian and Asian assimilation, and Olympic champions from 1948 to 1964.

This longest mural in the world evolved through research and labor sponsored by a variety of organizations and individuals. Each section of the wall (about 100 feet) takes a year to research, organize, and execute. Under Baca's general supervision, different artists are responsible for specific sections. Painted by teams of locally recruited teenagers, the wall reflects Baca's community-based conception of public art. According to the SPARC mission statement,

Public art is a vital part of everyone's culture because it exists where people work and live—in schools, on public transportation, and in our neighborhoods. SPARC is particularly committed to heightening the visibility of work which reflects the lives and concerns of America's diverse ethnic populations, women, working people, youth, and the elderly.[35]

The *Great Wall* is populist art from the point of view of content and style. Its size and scope, however, set it apart from the contemporary mural movement of the last few decades,[36] while its style placed it outside the mainstream of art criticism, which until recently concentrated primarily on formalist issues and gallery art.

The wall is full of figurative images, although the specific content is no more accessible than any other iconography that has not become part of a general cultural vocabulary. Baca is attempting to "put back into public consciousness information that has been lost,"[37] but it is difficult to measure to what extent the wall does this. What the wall surely communicates is a sense of history, energy, and the evidence of many hands at work. Indeed, the message of the wall may be more ably expressed through the voices of its young painters and their shared experience than from a passing reading of the monument itself. Sixteen-year-old Sergio Moreno, after his first summer on the project, hoped "that when people see this mural they forget all their prejudices and try to live with all people, no matter what race, in peace."[38] Baca's goal was "to dissolve cultural boundaries."[39] Toward this end, the method of making the mural was as important as the style. As she put it,

The elements of my designing are not just line, form and color but all the environmental and social factors that are inherent in the space and that cannot be separated from it. That's changing everything and not just the facade.[40]

Maya Lin: Vietnam Veterans Memorial and Civil Rights Memorial

The *Vietnam Veterans Memorial* (1981) also began with a mission: to "heal a nation," and it, too, took the form of a wall (fig. 9). Among other things, it also sparked a revival of thinking about memorials as a viable contemporary art form. Frequently referred to as "America's wailing wall" or just "the Wall," embroiled in controversy almost every step of the way, its commission is both a testament to the contemporary democratic process in art and politics and a manifestation of its liabilities. The impetus for the memorial came from a private citizen, a Vietnam veteran. Returning from the war to study psychology, Jan Scruggs became interested in Jung's idea of the importance of symbols in the collective psychology of a culture and the issue of survivor guilt.[41]

Scruggs first proposed the idea for a Vietnam veterans' memorial to Congress in 1977. Two years later, after seeing Martin Scorsese's film *The Deer Hunter,* he decided to take action: he hired an attorney, formed the Vietnam Veterans Memorial Fund, and held a press conference.[42] The saga of Scruggs's tenacity in seeing the memorial through to completion is a heartrending tale with twists and complications reminiscent of the Vietnam War itself. Embedded in the story of

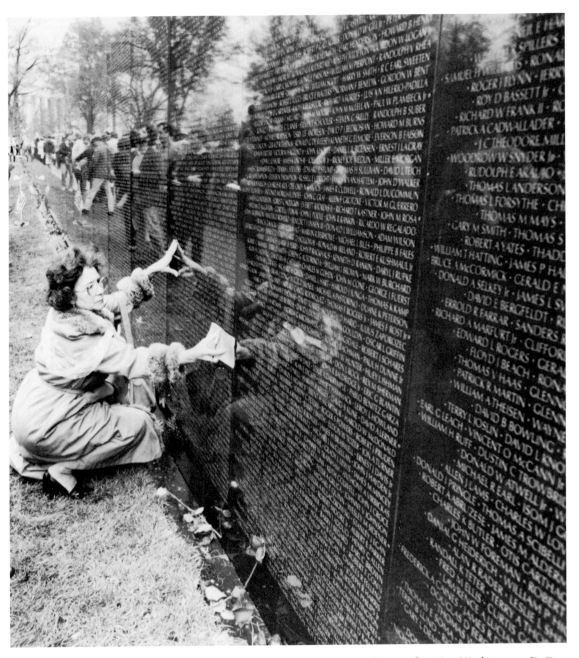

Figure 9. Maya Lin, *Vietnam Veterans Memorial*, 1981, Washington, D.C. (Department of Defense, Still Media Records Center).

this memorial are the complexities and contradictions inherent in the nature of memorials. Intended to be commemorative, they are inexorably linked to their subject (usually an individual, event, or value) and the emotions associated with it. In 1979 the Vietnam War was still a valent issue, the country having succumbed to a kind of collective amnesia, unable to process the experience of having "lost" a war and unwilling to cope with the problems that veterans were confronting daily.[43] Although the Vietnam Veterans Memorial Fund (VVMF) tried to keep the controversy surrounding the war separate from its aim of honoring the sacrifice of those who fought it, the two were always in danger of being conflated.

Before selecting an artist, the VVMF wanted to secure an appropriate site, an indication of the importance of site in conveying the content of a memorial. Their first choice was Constitution Gardens on the Washington Mall, in close proximity to the Lincoln Memorial. At one point Scruggs observed that "site location was *the* issue, more important even than design."[44] The site between the Washington Monument and the Lincoln Memorial on the Washington Mall was both symbolic and important.

In 1980, after a year of campaigning, Scruggs obtained approval for the chosen site. To be as democratic as possible, he set up an open design competition to select the memorial. Members of the jury were recommended by the fund's official, Paul Spreiregen (author of a book on architectural competitions), and approved after being interviewed by Scruggs and two other members of the fund, both lawyers and veterans. The jury consisted of architects Pietro Belluschi and Harry Weese, landscape architects Hideo Sasaki and Garrett Eckbo, critic Grady Clay (editor of *Landscape Architecture*), and sculptors Richard Hunt, Constantino Nivola, and James Rosati.

Competition guidelines specified that the memorial be "reflective and contemplative in character, harmonious with its site, and that it honor the service and memory of the war's dead, its missing, and its veterans—not the war itself." Above all it should be "conciliatory, transcending the tragedy of war."[45] The staggering response of 1421 anonymous entries made this possibly the largest competition in American history. The jury deliberated for four days before announcing their unanimous choice. Maya Lin, the surprise winner, was than a twenty-one-year-old architecture student in her last year at Yale. Originally designed for a class in funerary architecture, Lin's project was influenced by World War I memorials, especially the Thiepval Memo-

rial Arch by the British architect Sir Edwin Lutyens. Dedicated to the missing of the Somme (France), that memorial required visitors to walk past a list of 100,000 names in order to get to the cemetery. Lin described it as "a journey from violence to serenity," which closely paralleled the intended experience of the *Vietnam Veterans Memorial*.[46]

Her design, subsequently built in all its essentials, consisted of two 250-foot-long walls meeting at an angle of 125 degrees, one pointing to the Lincoln Memorial, the other to the Washington Monument. Beginning at ground level, the walls reach a height of ten feet at the center where they meet. Built into a rise in the land, they appear to be sheltered by the earth, forming a kind of natural structure that merges landscape and architecture. Panel by panel, the walls were inscribed with a list of names arranged in the chronological order of their deaths or the dates they were reported missing in action. Made of black granite with a highly polished surface, the walls reflected both the visitors and the surrounding landscape with its constantly changing appearance.

Almost every element of Maya Lin's design, at one time or another, became a subject of controversy. Art and non-art issues quickly became intertwined, and the work itself all too frequently became secondary to personal politics and/or the focus of larger political issues. The most easily countered objections were those about the listing of the names. The argument against listing them in alphabetical order quickly became apparent; the memorial would look like a large telephone book, with groupings of common names like Smith and Jones lessening the impact of individual identity, sacrifice, and loss. Lin's decision to list the names according to a chronology of death was singularly important to the conception and experience of the memorial. It incorporated the factor of time—historical time and present time—the time to look up a name in the directory and time to find it on the discreetly numbered wall panels. By following the history of the casualties it also created the experience of an inexorable buildup of fatalities, 57,939 in all. "I wanted to return the veterans to the time-frame of the war," Lin said, "and in the process, I wanted them to see their own reflection in the names."[47]

Initially the memorial was to include only the names of the war dead and still missing. In order to satisfy the demand that all those who served in Vietnam be honored, a compromise was reached to include an inscription before the first name and after the last. The prologue reads:

In honor of the men and women of the armed forces of the United States who served in the Vietnam War. The names of those who gave their lives and those who remain missing are inscribed in the order that they were taken from us.

The epilogue reads:

Our nation honors the courage, sacrifice and devotion to duty and country of its Vietnam veterans. This memorial was built with private contributions from the American people. November 11, 1982.

While the order of the names and the decision to honor all who served were easily resolved, the issue of color was more complex. Black was interpreted by many as a statement of shame and dishonor, especially in contrast to the many white memorials in Washington. But Lin found black "a lot more peaceful and gentle than white," and more important, able to reflect its surroundings when polished. "The point is," she stated, "to see yourself reflected in the names. Also the mirror image doubles and triples the space. I thought black was a beautiful color and appropriate to the design."[48] Black is also, of course, the traditional color of mourning, but this association implied a negative interpretation of the war. In the minds of many, the color black made it difficult to separate honoring the veterans from damning the war.

Black had other negative connotations as well. A disproportionately large number of those who fought in the war were black, leading to a criticism of the war as a form of genocide. According to Scruggs, objections to the color were finally put to rest by General George Price, a black officer who liked the memorial. At a particularly crucial meeting when Lin's design was under considerable fire, he stated:

I remind all of you of Martin Luther King, who fought for justice for all Americans. Black is not a color of shame. I am tired of hearing it called such by you. Color meant nothing on the battlefields of Korea and Vietnam. Color should mean nothing now.[49]

If the color of the memorial elicited conscious and unconscious racist responses, its shape and placement were also associated with

decidedly non-art issues. Some saw in the **V** shape of the memorial the **V** sign made by protesters of the war, while others perceived it as an open book, a different visual interpretation.[50] Critic Elizabeth Hess suggested a feminist reading of the sculpture, "placing at the base of Washington's giant phallus a wide **V**-shape surrounded by a grassy mound."[51]

A combination of many factors led to a serious and pervasive criticism of the memorial as unheroic. This was a problem in spite of the fact that the original design competition rules stated clearly that the work was to take no political position on the war and its function was "to heal a nation" by honoring those who had lost their lives. From its inception it was intended to be a memorial dedicated to individual sacrifice, not heroism. According to Scruggs, those who opposed the memorial for its lack of heroic rhetoric "wanted the Memorial to make Vietnam what it had never been in reality: a good, clean, glorious war seen as necessary and supported by a united country."[52]

Nevertheless, the desire for an obviously heroic monument persisted. Tom Carhart, a volunteer at the Vietnam Veterans Memorial Fund, succinctly stated this view: "There have been a lot of us who've been looking for a memorial to celebrate and glorify the Vietnam veteran." Carhart's idea of an appropriate memorial was seen in his submission to the design competition: a representational sculpture of an officer standing in a purple heart lifting the dead body of a G.I. in a sacrificial gesture.[53] Here the argument of abstract versus representational art began to emerge as a significant issue, one that was frequently interpreted as elitist versus popular opinion. Although the commissioners had at one time considered specifying that a representational component be included in the memorial design, they decided against this limitation because they felt that the American people had already seen the war on television. They concluded not only that more realistic images were not needed but that no single representational image could stand for the diverse population that had served in the Vietnam War.[54]

Punctuating and sometimes overriding the barrage of criticism leveled at the proposed memorial was the clash of politics and personalities. Secretary of the Interior James Watt and Scruggs locked horns on more than one occasion. Since Watt's approval was necessary in order to obtain a construction permit, his objections to the memorial were always potentially serious. Whether these were based on his

conservative politics or esthetic taste or both was difficult to determine.

The original sponsor of the memorial competition, the Texas millionaire, H. Ross Perot, also played a critical role.[55] Disappointed with Lin's winning design, he tried to organize a large opposition. It is now widely believed that his behind-the-scenes activities eventually culminated in the decision to include a representational sculpture, effectively making acceptance and approval of Lin's design a package deal. Watt and Perot were powerful men. As Scruggs put it, "Some 58,000 G.I.'s were in death, what they had been in life: pawns of Washington politics."[56]

Although members and supporters of the Vietnam Veterans Memorial Fund tried to keep public focus on their goals, they were seriously hampered by the press. Television and the popular press thrive on controversy. A good story (one of conflict) often takes precedence over correct reporting of facts. Art in any form and public art, in particular, makes a better story as an object of controversy than as a subject of serious discussion or criticism. Opposing camps were portrayed: Maya Lin and the art community versus Perot, Watt, and the Washington establishment; antiwar versus prowar factions; elitist elements favoring abstract art versus a popular constituency that preferred more traditional representational art.[57] There were many ways the public could take sides on the *Vietnam Veterans Memorial*. Arguments were frequently reported without comment on their accuracy, and the existence of controversy, not the specific issues, became the primary message communicated to the public. Although privately funded, the Vietnam Veterans Memorial Fund required the support of politicians, and public opinion was therefore a very serious issue.

The final compromise, suggested by General Mike Davison, leader of the Cambodian invasion in 1971, was reached at a closed-door meeting called by Senator John Warner (a Republican from Virginia and a supporter of the fund). Motivated by the desire to keep the memorial on schedule and the belief that their opposition had the power to block it completely, the Vietnam Veterans Memorial Fund agreed to include a flag and a representational sculpture at the site, thus negating the open democratic selection process they had originally established with such care.[58]

An ad hoc panel was created to select the representational work. It consisted of four Vietnam veterans, two of whom had supported Lin's

design (Art Mosley and Bill Jayne) and two who had opposed it (James Webb and Milt Copulas). They recommended Frederick Hart, a sculptor who had been part of the design team that placed third in the original competition. More important, Hart had by this time established good personal relationships with key board members of the Vietnam Veterans Memorial Fund, as well as others still opposed to Lin's design.[59] Hart's bronze sculpture of three larger-than-life combat soldiers, one black, one white, and one Hispanic, were depicted at a moment of apprehension, apparently for what lies ahead (in this case, the Wall). *Three Fightingmen*, at best inoffensive, is both too generalized in its conception and too literal in its detail to be good art[60] (fig. 10). Its literalness, in fact, prompted other groups active in the war but not specifically represented to petition for a statue of their own on the Mall, a problem originally anticipated by the fund.[61] The most immediate problem, however, was its placement. Supporters of Hart's sculp-

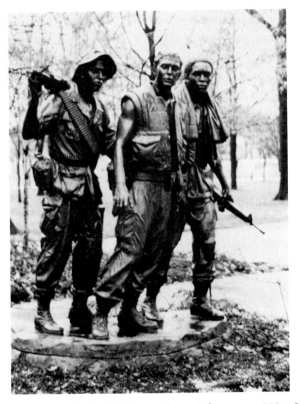

Figure 10. Frederick Hart, *Three Fightingmen*, 1984, Washington, D.C. (Annie Shaver-Crandell).

ture wanted to see it in or near the center of Lin's memorial. Through the efforts of J. Carter Brown, Director of the National Gallery in Washington and Chairman of the National Fine Arts Commission, Hart's statue was finally located 120 feet away, near a flagpole at the western entrance to the memorial site.

The controversy and compromise apparently endemic to the public art process eventually fade from memory. What remains ultimately is the work. Lin's *Vietnam Veterans Memorial* is an incredibly moving war memorial and the most visited sculpture in Washington. A crucial factor in its success is its emphasis on the individual and its respect for individual experience and interpretation. Each name on the wall represents an individual and the point in time when he or she disappeared or died. There are no distinctions of military rank; all are made equal by death. As Scruggs observed, "This is a memorial to human beings, not a military symbol."[62]

Lin's original entry statement emphasized that "it is up to each individual to resolve or come to terms with this loss. For death is in the end a personal and private matter and the area contained within this memorial is a quiet place, meant for personal reflection and private reckoning." Lin's approach was much in tune with her time. While the public realm is generally viewed with distrust,[63] private life and personal interpretation are generally valued, an attitude fostered by a psychological orientation. Descriptions of responses to the *Vietnam Veterans Memorial* often focus on its therapeutic and cathartic effect.[64] Scruggs, with his training in psychology, was especially sensitive to the need for just such an experience. The Vietnam War had not been resolved in the public mind or in the personal psyches of those involved. Ignoring or repressing the problem had not made it disappear. The psychological premises underlying the concept of the memorial largely account for its success.

The memorial offers a rite of passage. Just as the listing of the names acknowledges the passage of time, so the form of the memorial imposes on the viewer an experience in time. Whether you begin in the center (where the first names are listed) or at the western end (where the wall appears to begin), it takes time to walk the distance of the piece. As people walk slowly, they stop and touch the wall and the names; some make rubbings to take home. Others leave things—medals, flowers, flags, notes, articles of clothing—a range of memorabilia. Few who visit the memorial are not profoundly affected; many are unexpectedly moved to tears.

The *Vietnam Veterans Memorial* is a living memorial in a ritual-poor age, a testimony to the continuing power of memorials that truly help us remember. Public response to the memorial is an indication of the need to participate. The objects people leave are collected daily by Park Service rangers and stored in a warehouse in Maryland for some as yet undefined purpose. As the veterans built their own memorial, so people are creating their own museum.[65] Beyond acting as a catalyst for personal experience, the sculpture sparked interpretations and reinterpretations of the Vietnam War in art and other media—books, theater, film, and television.[66]

In 1988, almost a decade after Maya Lin designed the *Vietnam Veterans Memorial,* she was commissioned by the Southern Law Center in Montgomery, Alabama, to create a national civil rights memorial, and once again she offered the public a participatory experience[67] (fig. 11). After reviewing films and literature of the civil rights era, Lin decided to frame the memorial with a quotation from Martin Luther King: "We will not be satisfied until justice rolls down like water and righteousness like a mighty stream." Inscribed in a curved asym-

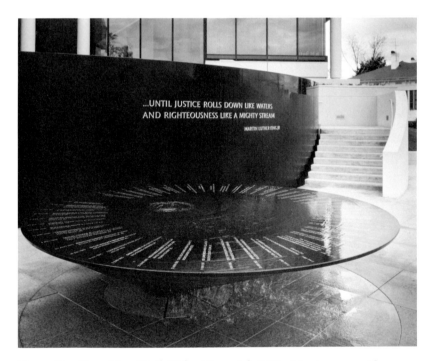

Figure 11. Maya Lin, *Civil Rights Memorial,* 1989, Montgomery, Ala. (John O'Hagen, Courtesy Maya Lin).

metrical black granite wall measuring nine feet by forty feet, it forms the backdrop of an asymmetrical water table of the same material. Inscribed on its circular surface is a time line of the movement from 1954 (the date of *Brown* v. *Board of Education*) to 1968 (King's assassination). Events are interspersed with the names of individuals who died for the cause but did not become famous. The dedication in November 1989 was attended by crowds estimated at between 10 and 15,000. Participants touched the names as their tears merged with the flowing water. Maya Lin's *Civil Rights Memorial* is a composite structure—part architecture, part sculpture, part text. It reflects the expanded definition of sculpture in the later twentieth century from individual object to a complex that creates and defines a site.

George Segal: Kent State, Gay Liberation, the Holocaust

George Segal almost alone among contemporary artists continues the tradition of figural memorial sculpture, often in tableau form and specifically focused, as were Lin's memorials, on a variety of victims. In 1978 he was commissioned by a private foundation, the Mildred Andrews Fund in Cleveland, to make a memorial to a group of students killed and wounded by National Guardsmen at Kent State University during a demonstration protesting the Vietnam War (fig. 12).

Segal saw in the biblical theme of Abraham and Isaac an analogy to the events at Kent State, emblematic of larger issues of generational conflict as well as the conflict between loyalty to state and personal responsibility, issues repeatedly raised by the Vietnam War itself. The depiction of Isaac as a young man instead of a boy related the biblical story directly to the Kent State victims. Clad only in shorts, almost as tall as his father, Isaac nevertheless kneels before him, his wrists bound with rope, gazing up intently, in a silent plea for mercy. The placement of his hands, as well as the loose rope that binds them, suggest that Isaac's dependency is at least partly psychological.

Abraham, in casual contemporary dress, stands determinedly over Isaac, a pointed knife in his right hand. The knife, a startling suggestion of sexual potency, is visible only from certain views. The gaze between the two figures establishes an invisible diagonal, underlined by the thrust of the knife. The tension is riveting. There is no angel of mercy and the outcome of the conflict remains unclear.

The administration at Kent State University interpreted the sculpture as a depiction of impending murder. The ensuing controversy raised questions of artistic freedom as well as the use of art as propa-

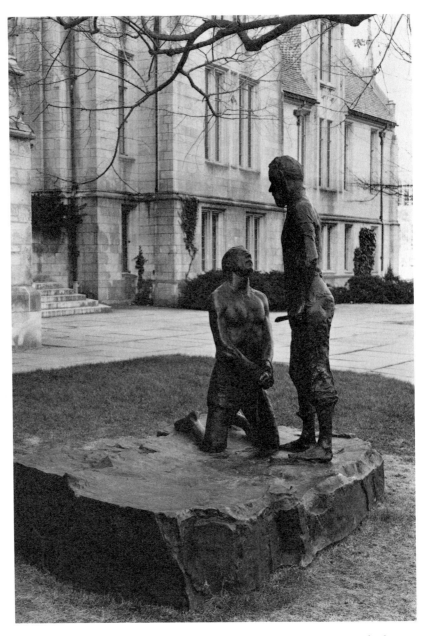

Figure 12. George Segal, *In Memory of May 4, 1970, Kent State: Abraham and Isaac*, 1978, Princeton University, Princeton, N.J.
(courtesy The Art Museum, Princeton University, The John B. Putnam Jr. Memorial Collection).

ganda.[68] Segal rejected proposals that he depict students or National Guardsmen literally or that he portray a nude young girl putting a flower in the barrel of a young soldier's rifle.[69] Even though Segal agreed to add an inscription from Genesis indicating that Isaac was spared, the sculpture was rejected. Kent State officials explained their position as follows:

The inescapable first impression is that an older person is threatening to kill a younger person who is pleading for his life. . . . It was thought inappropriate to commemorate the deaths of four and the wounding of nine others . . . by a statue which appears to represent an act of violence about to be committed.[70]

Segal's sculpture was thus condemned for being too effective. It prodded a collective guilty conscience, rather than providing a distraction or a balm. Instead of distancing viewers from the subject, it forced them to think about the event and the victims being commemorated. While Segal saw his sculpture as "a call for compassion and restraint," university officials perceived it as a potential incitement to further violence. No resolution was possible.

As a result, the original patron of the piece, Peter Putnam, through his foundation, the Mildred Andrews Fund, donated it to Princeton University, where it was placed next to the University Chapel, a site chosen by Segal and the director of the university's museum. However, this location, by emphasizing the religious source of the subject, neutralized its political content. A memorial stripped in part of its subject, it nevertheless remains a strong and moving sculpture.

In 1979 Segal was once again asked to commemorate and honor a controversial subject—this time the gay rights movement, representing a much-victimized segment of the population.[71] The commission stipulated that the work "had to be loving and caring, and show the affection that is the hallmark of gay people—it couldn't be ambiguous about that. . . . And it had to have equal representation of men and women."[72] The intended site was in Greenwich Village, a community with a large homosexual population, and the site of riots in June 1969 protesting police harassment of gays. Segal accepted the commission, also funded by Peter Putnam's foundation, after a gay artist had turned it down, based on the advice of her gallery.

In Segal's sculpture of 1980, two men stand in front of a bench on

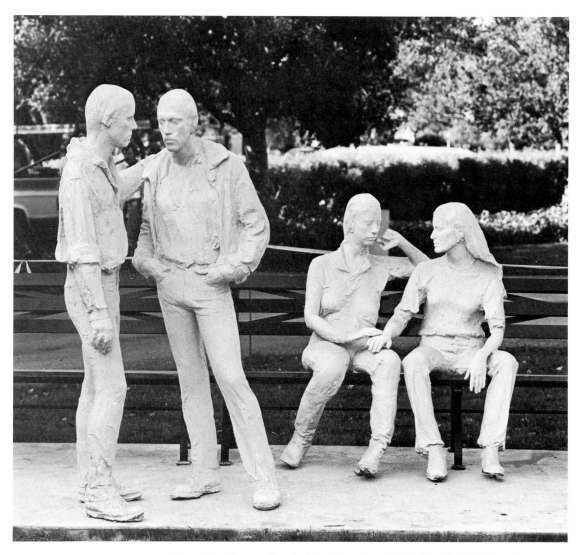

Figure 13. George Segal, *Gay Liberation*, 1980, Stanford University, Palo Alto, Calif. (courtesy News Service, Stanford University).

which two women are seated (fig. 13). One man has his arm around the shoulder of the other; one woman touches the other's hand on her thigh. The gestures are gentle and restrained, indicating close friendship as well as sexual intimacy. According to Segal, "the sculpture concentrates on tenderness, gentleness and sensitivity, as expressed in gesture. It makes the point that gay people are as feeling as anyone else."[73] Although not overtly erotic, Segal's sculpture could not escape the negative views associated with its subject matter, and it was attacked by several community factions. Some feared that the sculpture

42

would identify the entire community as a homosexual ghetto. Others anticipated the advent of tour buses or worried that the bench would attract vagrants. Gay leaders objected to the youth and homogeneity of the couples; they felt that the inclusion of older people as well as a representative racial diversity would be more appropriate.

Once again controversy prevailed. Although the sculpture was approved by the New York City Fine Arts Commission, the Landmarks Commission, and the local community board, the city never approved funds for its installation, no doubt due to political pressure, the exact nature of which has yet to be revealed.[74] Subsequent attempts to place the sculpture in Cambridge, Massachusetts, and Los Angeles also met with strong public resistance. Eventually *Gay Liberation,* like the Kent State memorial, found refuge on a university campus. At Stanford University since 1985, it is sited on Lomita Mall, a heavily trafficked area between the physics and math buildings that has no particular relationship to its subject.[75]

Segal commemorates more obvious victims in *The Holocaust,* commissioned in 1982 by San Francisco's mayor Dianne Feinstein's Committee for a Memorial to the Six Million Victims of the Holocaust for a site in Lincoln Park overlooking the Golden Gate Bridge (fig. 14). Initially Segal resisted becoming involved with the project because he didn't like "the idea of dwelling with all that death."[76] Segal's response paralleled that of many Holocaust survivors who tried at first to bury the past in order to lead normal lives. As many of these people aged, however, they assumed the burden of remembering and bearing witness.

Segal's decision to take on the commission was sparked by an anti-Semitic report of Israel's invasion of Lebanon. He began by reviewing photographs of the death camps, relating his most vivid memories of the Holocaust to *Life* magazine pictures of the subject. Needing a "visual hook" to translate these gruesome images into a single work, he decided "to make a heap of bodies that was expressive of this arrogance and disorder" of the German death industry and its obscene murder of millions of Jews. Following his customary way of working, he made plaster models of a group of friends, who were asked to pose for this particular subject.

The arrangement of the ten bodies lying on the ground suggests an image of death defined by personal gesture, the last signs of human individuality. The bodies can also be seen as spokes in a wheel or radii in a circle. They are joined physically by touch and compositionally by

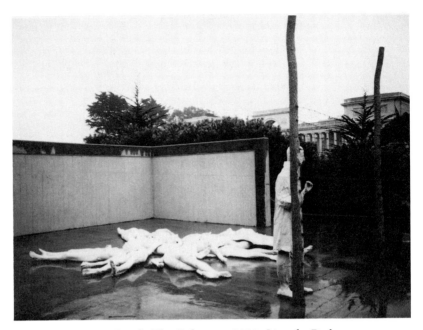

Figure 14. George Segal, *The Holocaust,* 1982, Lincoln Park,
San Francisco, Calif. (Harriet Senie).

their projection from a single point. Segal described the piece as "a
summation of gestures and movements, of piling and heaping. It be-
comes a collection of each individual's ideas about death . . . a series of
movements that are all ruminations on death."[77]

A biblical context is established by the woman holding a partially
eaten apple and lying across the rib of a man, suggesting Adam and
Eve. A man shielding a young boy evokes the story of Abraham and
Isaac. The pose of another man recalls the Crucifixion. Thus the
figures become more than individuals, and the Holocaust is related to
biblical history. The viewer identifies with the single standing figure,
gazing through the barbed wire. The model for this figure was Martin
Weyl, then director of the Israel Museum in Jerusalem and himself a
Holocaust survivor. By viewing the bodies we too become witnesses to
the tragedy of the slaughter and share the burden of survival.

A full-scale model in plaster, wood, and wire was put on display in
the Jewish Museum in New York in 1983.[78] Displayed alone in a dark
room, it provided an overwhelmingly moving experience. The same
sculpture, cast in whitened bronze and installed in 1984 in San Fran-
cisco, is far less powerful. Situated on a lower level than the Museum
of the Legion of Honor, Segal's sculpture is actually difficult to find.

Visible and accessible only on foot in an area where nearly all visitors drive, it is silently absorbed by the vast natural environment surrounding it.

Monuments to Workers: George Segal, Andrew Leicester

Segal's sculptures dedicated to the theme of work represent society's economic victims. *The Steelmakers* (1980) in Youngstown, Ohio, was a civic commission sponsored by the Youngstown Area Arts Council with support from the National Endowment for the Arts, the Ohio Arts Council, and public subscription (fig. 15). The sculpture celebrating the town's chief industry was seen as a means for revitalizing a declining neighborhood. Segal used local steelworkers chosen by the union as his models. Union support for the project increased when economic circumstances forced the steel industry to close down while the sculpture was being built. Thus *The Steelmakers* became both a memorial

Figure 15. George Segal, *The Steelmakers,* 1980, Youngstown, Ohio (courtesy The Youngstown Area Arts Council).

through circumstance and a rallying point, a sign of the human worth of the worker amid a scenario of economic despair.

While Segal used an actual open-hearth furnace from an idle mill in his sculpture, Andrew Leicester created symbolic structures in his two memorials dedicated to the lives of miners. *TOTH (Tower on the Hill)* (1983) is located just east of downtown Rapid City, South Dakota (fig. 16). Dedicated to the gold-mining industry that was important to the economic development of the region, the fifty-five-foot-high wooden structure evokes the structural support system commonly used by miners to extract gold from the earth. Sponsored by the Rapid City Fine Arts Council and local businesses, the piece is intended to evoke the history of the Black Hills site as the sacred province of the Plains Indians and its conversion to a white commercial enterprise. Each of

Figure 16. Andrew Leicester, *TOTH*, 1983, Rapid City, South Dakota (courtesy Andrew Leicester).

the four facades is painted a different color and refers to a different aspect of the site's history. Thus,

The western facade of *TOTH*, showing a tepee studded with fool's gold, is painted black to connote the annihilation of Native Americans and their culture in the nineteenth century. The east, with its gable-roofed shape in bright gold, symbolizes the white man and where he came from. The northern facade, showing the headframe of the northern Homestake mine, is white, signifying the cold snows of winter. *TOTH's* southern side is open and reveals the sculpture's red interior walls . . . the sacred color of the Sioux.[79]

Although *TOTH* is a participatory structure inviting climbing, its meaning and symbolism are not as immediately clear as *Prospect V— III* (1982), located on the campus of Frostburg State College in Maryland (fig. 17). This 120-foot-long, 27-foot-high walk-through structure commemorates the coal-mining history of the region. It overlooks the site where coal was first discovered in this country and where one of the earliest mining unions first went on strike. Although the mines have largely been abandoned, a community of miners still lives in the area. They provided Leicester with much of the content as well as the artifacts embodied in the sculpture.

The various cabins symbolize different periods in a miner's life. The first relates to the miner's infancy and includes a blue cradle in the shape of a coal cart. The butterflies decorating the walls undergo an ominous metamorphosis into black lungs. One exits via one-way tracks to the second cabin, symbolic of the miner's adult life, a tomb-like space depicting the "room" where the miner worked. A third cabin contains memorabilia donated by local miners, lists of miners' chores, a group portrait of miners, and the words of the famous coal-mining song "Dark as a Dungeon" by Merle Travis. The last room before entering the mining shaft is a hexagonal rotunda, evoking comparisons to the crypts of the ancient pyramids. The walls' inscriptions include glyphs from the Egyptian Book of the Dead, the six skills necessary to mining (drilling, blasting, undercutting, track laying, timbering, and hauling) and the six hazards of the work (gas, electric shock, hauling system failure, cave-in, flood, and black lung). Work clothes hang from the ceiling, suggesting a final release from work and life.

Leicester's memorials to mining attempt an honest assessment of

Figure 17. Andrew Leicester, *Prospect V–III*, 1982, Frostburg State College, Frostburg, MD. (courtesy Andrew Leicester).

history, acknowledging the requisite skills as well as the dangers of the work, individual accomplishment as well as personal cost. *Prospect V—III* was so favorably received by Frostburg miners and their families that they formed a group specifically to conduct tours and provide funds for maintenance of the piece. These memorials can obviously be appreciated on many levels—formally as art[80] and publicly as a symbol of local history from the point of view of those who lived it.

Athena Tacha: Massacre Memorials

Another artist who creates participatory sculptures that incorporate history, Athena Tacha, has proposed a provocative series of "massacre memorials" that combine a museum experience with the impact of photographic images. Begun in 1983, these included memorials for the *Jewish Holocaust* (fig. 18); *Hiroshima and Nagasaki; India-Pakistan; Vietnam, Laos and Cambodia;* and *Central America* (this last dedicated to an as yet impending massacre).[81] Tacha envisions large-scale walk-

48

Figure 18. Athena Tacha, *Jewish Holocaust Memorial*, 1983, model (courtesy Athena Tacha).

through memorial structures whose form is inspired by some aspect of the subject. She explains:

The *Jewish Holocaust* has the configuration of a tumulus (a traditional shape for a funeral monument) made of tightly packed curvilinear ramp-paths, like the coils of a boa constrictor—a symbol of the Nazi regime squeezing out the life of an entire race. Punctuating the path-loops are flame-like red rocks, a reference to the crematoria and narrow interstices of red earth evoking giant drops of blood. . . .[82]

To the concept of memorial as rite of passage, Tacha added the presence of photographic images and carefully selected text, sand-blasted directly into concrete walls. The viewer would thus confront harsh visual images of suffering and torture as well as individual courage—evidence that these atrocities occurred and could happen again. There is tacit acknowledgment here that photography has replaced more traditional visual media as the official record of public memory. Indeed the *Iwo Jima Memorial* (1954) in Washington by Felix De Weldon was based on a photograph.[83] For most of us who experienced it indirectly, like George Segal, it was the memory of *Life* magazine photographs that "fixed" World War II in our minds visually. For the

49

Vietnam War these images were "fixed" by the television frames that invaded the privacy of our homes via the nightly news. By merging mass-media images and architectural structures, Tacha proposes memorials that function like museums by providing an exhibition of separate visual images that nevertheless approach the narrative buildup of a film.[84] Tacha's proposals for massacre memorials are characteristic of the shift in commemorated subjects from the hero in battle to the victims of violence.

Monuments of Humor and Irony: Claes Oldenburg, Andrew Leicester, Ann and Patrick Poirier

An alternative approach to contemporary monuments and memorials, seen in the work of Claes Oldenburg and Andrew Leicester, has been the adoption of an ironic or humorous style that strips the genre of its authoritarian stance and tone of high seriousness.

Claes Oldenburg tried to rejuvenate the monumental tradition by focusing on decidedly humble, nonheroic objects. Seeking in the commonplace a viable symbol of contemporary consumer-oriented life, he created a body of mock-heroic civic sculpture that is wryly engaging and celebratory. Since the mid-1960s Oldenburg has proposed fantastic projects for monuments—outscaled, stylized sculptures based on familiar objects from the everyday world. Initially a response to traveling, a way of recording his impression of a new place, his imaginary monuments were also a way of taking on the world, frequently from an airplane, and they became for him a way of "composing with a city." Oldenburg used the word "monument" primarily because of its connotation of large scale; his purpose was not specifically commemorative.[85] Rather, he wanted to personalize public sculpture by relating it to life instead of rhetoric. In 1961 he announced:

I am for an art that does something other than sit on its ass in a museum . . . that takes its form from the lines of life itself, that twists and extends, accumulates and spits and drips and is as heavy and coarse and blunt and sweet and stupid as life itself.[86]

For his monuments as well as his gallery sculpture, Oldenburg chose objects that were instantly recognizable and implied a human presence

or identification. He explained: "Usually the object is something the spectator could wear, use, eat or relate his body to. . . . Objects are body images, after all, created by humans. . . ."[87] However, he always transformed these objects, usually through radically altered scale and unexpected materials.

Oldenburg's first realized monument was also his most overtly political. *The Lipstick (Ascending) on Caterpillar Tracks* was commissioned in 1969 for Yale University by the Colossal Keepsake Corporation, a group of students, faculty, and alumni, in response to a remark made by the Marxist philosopher Herbert Marcuse[88] (fig. 19). He observed

Figure 19. Claes Oldenburg, *The Lipstick (Ascending) on Caterpillar Tracks*, 1969, Yale University, New Haven, Conn. (courtesy Yale University, Office of Public Information).

that were one of Oldenburg's proposed monuments actually built, it would

indeed be subversive. . . . I would say—and I think safely say—this society has come to an end. Because then people cannot take anything seriously; neither their president, nor the cabinet, nor the corporate executives. There is a way in which this kind of satire, of humor, can indeed kill. I think it would be one of the most bloodless means to achieve a radical change.[89]

Stuart Wrede, then a Yale architecture student, began at once to organize a group to commission such a sculpture.

Initially the *Lipstick* was seen as an implicit criticism of Yale's acceptance of the Mellon Center for British Art at a time when many felt that the money could have been better spent elsewhere. Later the sculpture was seen as part of the larger political protest against America's involvement in the Vietnam War. Political readings were prompted by the site, Beinecke Plaza, which was surrounded by the president's office, the all-male secret society Skull and Bones, and a World War I memorial inscribed "In Memory of the Men of Yale who True to her Traditions gave Their Lives that Freedom Might Not Perish from the Earth."

Oldenburg had previously used a lipstick in two works still in his collection: *Lipstick with Stroke Attached (for M. M.)* (1967) and a drawing for a proposed monument to replace the Fountain of Eros in Picadilly Circus in London (1966).[90] A version of Oldenburg's original concept of an inflatable lipstick mounted on a movable tank was installed at Yale on May 15, 1969. Subsequently an erect metal tube replaced the inflatable bladder, making the sculpture appear more serious, somewhat menacing, and decidedly phallic. In the protests that followed, the sculpture was encased in a giant plastic bag by Zero Population Growth. Erotic associations abound in Oldenburg's work. He feels that "any art that is successful in projecting positive feelings about life has got to be heavily erotic."[91] Unfortunately, subsequent defacements of the *Lipstick* were so destructive that within a year Oldenburg had it removed. By 1974, after repeated petitions by students and faculty to reinstall the sculpture, it was repaired at Yale's expense and sited in the locked courtyard of Morse College, a less politically valent and more remote, protected space.

In its brief first life *Lipstick* took on a mantle of political protest. By the time of its reincarnation in more permanent materials, the original circumstances had, like the political interpretations of the moment, become part of its history. At the second dedication, Oldenburg expressed his hope that the piece would be used as a platform for public speaking and admired for its formal qualities.[92] However, in a discussion of monuments content is always germane. At the time, critic Barbara Rose aptly observed:

With this marriage of the erotic and the warlike, Oldenburg has created a phallus—lipstick—missile image, which clearly implies that the issue of America's "potency" is a psychosexual problem. The American need constantly to ejaculate phallic warheads is revealed as a symbolic act of frontier "machismo," while the collapsing, soft vinyl tip of the lipstick raises the implicit question: how long can America keep it up?[93]

None of Oldenburg's subsequent monuments have the same political implications. The forty-five-foot-high *Clothespin* installed in 1976 at Center Square Plaza in downtown Philadelphia was commissioned by a real-estate developer in compliance with the local percent-for-art ordinance (fig. 20). A useful object with human and architectural associations, it, too, was an image that the artist had been considering for some time for a variety of civic monuments. In 1967 Oldenburg envisioned a clothespin as a *Late Submission to the Chicago Tribune Architectural Competition of 1922.* Later he considered using a clothespin for a sculpture for the Dallas–Fort Worth Airport. The artist felt that beyond its formal similarity to an airport tower, the clothespin would appropriately express the link between the two cities joined by an airport located midway between them. When Oldenburg developed the clothespin for Philadelphia, the city of brotherly love, he was also thinking of Brancusi's sculpture *The Kiss* (in the Philadelphia Museum of Art) "because both contained two structures pressing close together and held in an embrace."[94] After seeing the clothespin in a variety of Oldenburg's guises, any metamorphosis seems possible and appropriate, but only if the audience is privy to the artist's thinking.

At 100 feet Oldenburg's steel openwork *Batcolumn* in Chicago is transformed almost beyond the point of recognition (fig. 21). Located in front of the Social Security Building, a few blocks west of the Loop, the sculpture was commissioned by the General Services Administra-

Figure 20. Claes Oldenburg, *Clothespin,* 1976, Center Square Plaza, Philadelphia, Pa. (Austin, courtesy Redevelopment Authority of the City of Philadelphia One-percent Fine Arts Program).

54

Figure 21. Claes Oldenburg, *Batcolumn*, 1977, Chicago, Ill.
(courtesy Leo Castelli Gallery).

tion (GSA) in 1975 and installed two years later. Oldenburg explained
its evolution as follows:

There are several reasons why I should come to the *Bat* as a Chicago
subject. One is the insistent presence of chimneys, because of the
horizontality of the landscape. The chimney, the sort of ordinary sub-
ject I like to use, subjected to inversion—a favorite device of dislocating

55

the object from its function, freeing it for art—gives the *Bat* shape. The *Bat* itself is of course an ordinary subject, and like the chimney has the formal values that lend themselves to development as art. The *Bat* has no up or down but is presented here as being held. The *Bat* points to the sky, calls attention to the sky, to space. I find the heightened awareness of space characteristic of Chicago. . . .

Some coincidences: the columns of the Northwestern station to the east of the city which were the first thing I noticed about the site.

The site is open with chimneys and water towers on their linear silhouetted bases much in evidence.

The top of the Salvation Army Mission to the west is a replica of a lighthouse, also a column form. . . .

The diamond pattern which is repeated throughout the structure refers to Brancusi's *Endless Column,* and the diamonds are an unintended visual pun reference to baseball, as in the (batting) 'cage.'

The *Bat* could be called a monument to baseball and to the construction industry. And undoubtedly to the ambition and vigor Chicago likes to see in itself.

The *Bat* stands on Madison Avenue which is the dividing line between north and south numbering in the city. A compass, or circular and symmetrical form, has been part of the concept from the beginning.[95]

Again, unfortunately, none of this visual thinking is apparent to an uninformed viewer.

Oldenburg, who grew up in Chicago, had previously planned to use a bat for a sculpture for his alma mater, the Chicago Latin School. His *Bat Spinning at the Speed of Light* (1967) was based on the concept that

if it was spinning at the speed of light, it would disappear, and that it would be nice to have an object that was invisible. Thinking about school, it was also a sort of anti-masturbation monument, in that if you touched it, your fingers would be burned right up to the shoulder.[96]

Needless to say, this sculpture was not built, but Oldenburg thought again of the spinning bat at the time of the GSA commission, when he saw a photograph of a tornado on the front page of a Chicago newspaper.

The tornado that accompanied the *Batcolumn*'s dedication, however,

was of a different order. Unfortunately postponed for a week to April 14, so that it coincided with the national tax deadline, it prompted Walter Cronkite to end his nightly news broadcast by calling viewers' attention to this outlay of tax dollars just at the time when their returns were due. This offhand media quip resulted in a flood of protest letters to the GSA.

The problems with the sculpture, however, have nothing to do with its cost. (*Batcolumn* actually cost the artist money to make, not an unusual occurrence in public art.) Its proximity to the GSA building and its gray color render it unreadable at close range. At eye level the bat looks like "a welding job," as one employee put it. Its color emphasizes its industrial materials rather than its playful subject. The concept remains more engaging than its realization.

Oldenburg's transformations of humble objects have the potential to provide an Alice-in-Wonderland experience, creating a sense of surprise and delight, compelling us to see things anew. As expressions of materialism in a secular society, they imply that our commonality lies in shared objects rather than ideas or ideals. In their mock-heroic stance they adopt the prevalent mood of our time. Although Oldenburg's *Clothespin* and *Batcolumn* are contemporary efforts at creating civic monuments, their relationship to their site exists more in the artist's imagination than in the images themselves. Some of Oldenburg's later projects, notably his fountains for Minneapolis and Miami, created in conjunction with Coosje van Bruggen, use a more obvious civic symbolism, with varying degrees of success.[97]

Like Oldenburg, Andrew Leicester adopts a humorous approach to civic memorials. *Cincinnati Gateway* (1988), the entrance to Bicentennial Park, is a celebratory structure with specific local historical references (fig. 22). Viewers can walk through the 400-foot-long piece and experience history from a temporal and geographic perspective that is completely site specific. His Ohio River Walk maps the path of the river including the names of bordering towns to provide immediate local recognition and identification. A Flood Column marks the river's greatest height. Many of the forms are decidedly funny, especially the flying pigs set atop towers that resemble riverboat smokestacks. The pigs, referring to Cincinnati's history as a pig-butchering center in the nineteenth century, when it was nicknamed Porkopolis, elicited objections from officials who wanted to erase this aspect of the city's past, but there was sufficient local support to allow them to remain.[98]

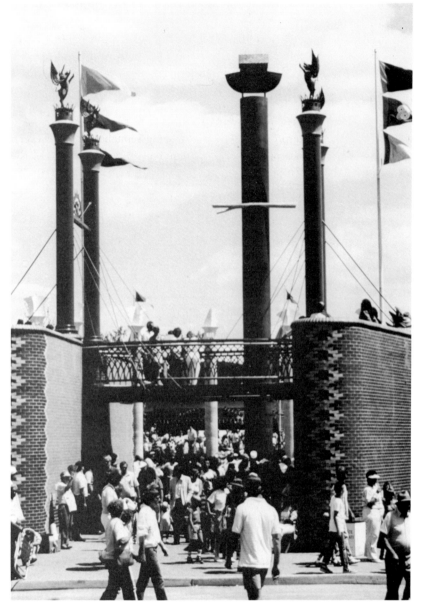

Figure 22. Andrew Leicester, *Cincinnati Gateway,* 1988, detail, Bicentennial Park, Cincinnati, Ohio (courtesy Andrew Leicester).

Leicester, committed to maintaining both an artistic and public focus in his memorials, describes the *Cincinnati Gateway* and his mining memorial, *Prospect V–III,* as follows:

Both these works strive to transcend the purely literal nature of interpretative displays by being semiabstract. However, each work has nearby a descriptive sign explaining the origins of the imagery, thus allowing every visitor to participate in the narrative.[99]

While Oldenburg and Leicester evolved a humorous approach to civic sculpture, Ann and Patrick Poirier ironically restructured the language of the classical past in a contemporary setting. Although not intended as a commemorative sculpture, *Promenade Classique* (1986) can be read as a memorial to the fragmented survival of the classical tradition in contemporary sculpture and architecture. Commissioned to enhance a commercial property, it is located in Alexandria, Virginia, at the Transpotomac Canal Center, a complex of four office buildings situated along the Potomac River.[100] Interested in lost archetypes, the Poiriers placed colossal fragments suggesting classical ruins in the ten-

Figure 23. Ann and Patrick Poirier, *Promenade Classique,* 1986, lower level, Transpotomac Canal Center, Alexandria, Va. (Burt Roberts).

acre site. Along the upper level is a fountain of marble boulders and white birch trees pierced by a thirty-foot bronze arrow, apparently unleashed from on high. A rectangular pool with a huge marble slab ends in a stairway down to the water. Atop the dividing wall separating the two levels are two fragments inscribed with the Latin for "the eye of memory." The fountain wall, punctuated by more fragments of monumental heads, leads to an obelisk framed by two boulders (fig. 23).

Clearly signaling the end of a conception of public sculpture as a single statue, this sequence of sculptural elements choreographs a path of pedestrian movement, defining its setting by calling to mind Washington's white neoclassical monuments across the river. As such, to an art-informed viewer, it reads like a memorial to the classical tradition that once defined commemorative public sculpture.

2

Sculpture and Architecture: A Changing Relationship

The function of sculpture in our democratic society depends primarily on its relation to architecture. . . . Neolithic, Egyptian, Greek, Roman, and medieval architecture all utilized the arts of their time. Vital modern architects will find it necessary to maintain this same cultural concept.

David Smith

Traditionally, sculpture found its way into the urban environment as an adjunct to architecture—most often directly applied to its surface as carved relief or, less frequently, placed in close proximity to a building in order to articulate its function in an allegorical or symbolic way. As architectural styles changed from the American neoclassicism of the late nineteenth century to the streamlined moderne of the 1920s and 1930s, so too did the style of sculpture that accompanied them. During the decades after World War II, with the proliferation of modern architecture based on Bauhaus precedent, the traditional relationship of architecture and sculpture was challenged by a style that provided no place for art. Nevertheless the philosophy of modern architecture called for an integration of the arts through collaboration of architect and artist, and this often-articulated but elusive goal prompted much of the public sculpture of the late 1960s and afterward.

Initially an influential group of successful architects, seeking an ornament after the fact for their modern buildings, were responsible

61

for a large number of significant commissions. Later, as the public art community took up the campaign for collaboration, largely to ensure a greater role for artists, this goal influenced the creation of some significant projects that took into consideration expanded definitions of public sculpture and its role in the larger urban environment.

Sculpture in a decorative mode became an integral part of American architecture and the urbanscape in the late nineteenth century during the American Renaissance. Based on a system of art and architecture modeled after the Ecole des Beaux-Arts in Paris, with many artists and architects studying in Europe, ornamental sculpture and mural painting as well as landscape design were all considered part of the architect's domain. Although the influence of this Beaux-Arts—inspired neoclassical style waned in the decades following World War I, its approach may still be felt in such projects as the Federal Triangle in Washington, D.C. (1926–38) and Rockefeller Center in New York City (1931–40), where sculptural ornament and form were stylistically updated into a moderne mode.

The concept of this European-based urban design with its central core of open space was reiterated decades later at Lincoln Center in New York City (1962–68), but by then the dominant style of architecture had changed to glass-box modern, obviating the need for or even the possibility of sculpture on the building. Modern architecture, with its bare exterior and work ethic, decried the use of ornament. At one time the Viennese architect Adolf Loos went so far as to equate the use of ornament with crime and the mark of a barbarian civilization.[1] Ornament, seen as a manifestation of wasteful extravagance, had no place philosophically in an architecture that championed equality or equal quality for all. Nor was there a place physically for traditional sculptural ornament on modern steel and glass-grid facades. This did not mean, however, that art was to be excluded from modern architecture.

Modern Architecture and the Integration of the Arts

At the Bauhaus in Germany (1919–36), the institution that replaced the Ecole des Beaux-Arts in international influence and that was most closely associated with the birth and dissemination of modern architecture, the integration of the arts was a fundamental part of design philosophy. Art was still seen as basically decorative in function, in the service of an architecture that was deemed the appropriate symbol for a

new, more democratic society. In the famous program for the
Staatliche Bauhaus in Weimar, published in April 1919, Walter Gro-
pius wrote with the zeal befitting a crusader:

The ultimate aim of all visual arts is the complete building! To embellish
buildings was once the noblest function of the fine arts; they were
indispensable components of great architecture. Today the arts exist in
isolation, from which they can be rescued only through the conscious,
cooperative effort of all craftsmen. Architects, painters, and sculptors
must recognize anew and learn to grasp the composite character of a
building both as an entity and in its separate parts. Only then will their
work be imbued with the architectonic spirit which it has lost as "salon
art." . . . Architects, sculptors, painters, we all must return to the
crafts! . . . Together let us desire, conceive, and create the new struc-
ture of the future, which will embrace architecture and sculpture and
painting in one unity and which will one day rise toward heaven from
the hands of a million workers like the crystal symbol of a new faith.[2]

Gropius's insistence that there "is no distinction between monu-
mental and decorative art" and that artists and craftsmen should re-
ceive the same training may be seen as an attempt to erase the stigma
that was already attached to the notion of ornament and decorative art
at the time of the creation of the Bauhaus. But even more problematic
for the realization of Gropius's goal than any theory or polemic was
actual practice. Although integration of the arts was his articulated
aim, Gropius's actual involvement with contemporary painting and
sculpture was slight.[3] Furthermore, he had no clear idea of how inte-
gration was to take place or what specific role painting and sculpture
would play. At no point did he offer any practical or detailed guide to
the process. Gropius seemed to believe that collaboration would
emerge spontaneously from the Bauhaus environment. In fact, it did
not. With few exceptions, true collaboration between artists and ar-
chitects remains a largely unrealized goal, bordering on a utopian
fantasy. Nevertheless the rhetoric persists.

Its spread to the United States was assured with the immigration of
members of the Bauhaus: Gropius and Breuer to Harvard (1937),
Albers to Black Mountain College (1933), Mies van der Rohe and
Moholy-Nagy to Chicago's Illinois Institute of Technology (1938) and
the New Bauhaus (1937), respectively. The campaign for the integra-
tion of the arts through collaboration was continued primarily by archi-

tects. Gropius made no extensive use of painting or sculpture in his own buildings here until he designed the Harvard Graduate School in 1950. He asked the Harvard Corporation for any money left within the appropriation after the bids came in to be used for art. Upon approval, he chose the artists (Albers, Arp, Bayer, Lippold, and Miro), some of whom had actually been at the Bauhaus. Those who lived in the vicinity, such as Albers and Bayer, came to discuss the project with the architect. Albers produced a brick mural and Bayer a wall design for Harkness, both so well integrated that they are almost impossible to find. The last commission was given to Richard Lippold for a stainless steel sculpture placed in front of the Commons building (fig. 24). More than anything, *World Tree* (1951) resembled playground equipment in its appearance and use, raising the question whether that might not have served as well. At this time, however, the idea of useful or interactive public sculpture did not yet exist.

What did exist were numerous discussions and debates as well as a

Figure 24. Richard Lippold, *World Tree*, 1951, Commons Building, Harvard University, Cambridge, Mass. (Harvard University Archives).

growing body of literature on the relationship of art to modern architecture. Henry-Russell Hitchcock and Philip Johnson in their famous primer *The International Style: Architecture Since 1922* (1932) cautiously recommended the use of independent painting and sculpture with modern architecture, provided they "decorate contemporary buildings without degenerating into mere applied ornament."[4] Hitchcock later recognized that although modern art could be appreciated by architects as an "exercise in pure form," it was basically superfluous to modern architecture since "a building was intended to be in itself an abstract plastic composition." Acknowledging that economics frequently necessitated the addition of art only if funds remained after the building was erected, he advised that "associated works of art be independent but complementary, giving richness of colour and form in the near view, perhaps providing concentrated and precise symbolic reference, or else merely the piquancy of anthropomorphism in an abstract setting."[5]

According to Hitchcock, the function of art was to bring some meaning to modern architecture at a more human scale. Implicit here is the notion that art could in some way make up for what was apparently lacking in a building style increasingly viewed as barren and sterile. Hitchcock viewed the integration of art and architecture as desirable and inevitable, and he cautioned architects not to fear it. Thus Hitchcock sensed in 1947 what would be a major area of conflict in the subsequent decades as the process of "integration" began: hostility between architect and artist as the latter was called in to redeem what was already considered a failing architecture.

During the 1950s the debate on how to integrate art and architecture became a common subject among architects in the United States and Europe. In the spring of 1951, Philip Johnson, then Curator of Architecture at the Museum of Modern Art, led a symposium that was typical of many.[6] Most speakers seemed in favor of the idea of the integration of the arts but nobody knew how to achieve it.

The International Congress for Modern Architecture (CIAM 8) had as the theme of its 1951 meeting "The Heart of the City." Among the speakers were several who had also participated in Johnson's symposium. The concluding summary of needs at the core of the city listed as last: "That in planning the core the architect should employ contemporary means of expression and—whenever possible—should work in cooperation with painters and sculptors."[7] This was, however, not a universally held opinion.

A survey published in the June 1951 issue of *Architectural Forum*, two months after the Museum of Modern Art symposium, indicated that many younger architects in the United States were skeptical. A questionnaire sent to twenty-four architects in their thirties and forties included the following query: "Are there new opportunities for integrating sculpture and painting with architecture?" Almost all responded with an astonishing lack of sympathy for or knowledge of contemporary art.[8] One architect approached the issue by stating simply, "I don't believe there will be any opportunities (for integration) . . . until the architect, the painter and the sculptor are on speaking terms about each other's work." When another architect raised the question, "What does anyone mean by sculpture and painting at the present time?" he indicated a problem of considerable magnitude.

Architects were hardly alone in their inability to comprehend or accept contemporary art that was primarily abstract in style. In 1951 the art revolution inaugurated by the Abstract Expressionists in New York City had not received establishment recognition on a national or an international scale.[9] The artists themselves had only recently begun to form a close-knit group, meeting regularly for an exchange of ideas and moral support. At this time painters considerably outnumbered sculptors and were the focus of most of the existing critical attention.[10]

Although there was a growing number of sculptors working in industrial materials, many dealt with Surrealist-inspired themes in a form that lacked the mass appropriate for open urban spaces. As yet no one was working on an architectural or urban scale. Following the austerity of a war economy, neither industrial materials nor funds were available for large-scale sculpture. Furthermore, in the days before Lippincott and other companies that manufactured large sculpture out of durable industrial materials, the ability to build to the proper scale was a real obstacle that had to be overcome before the more problematic issue of determining the appropriate scale could be tackled.[11]

Another obstacle was the stigma that continued to be attached to the notion of decorative or ornamental art. Henry Hope Reed, Jr., took a unique and much-ridiculed position in what seemed in the early 1950s a curiously antiquated appeal for ornament. Reed, at the time teaching in the graduate program in city planning in the department of architecture at Yale, publicly condemned the philosophy of "oppressive puritanism" which regarded as wasteful anything merely pleasing to the eye.[12] Instead he advocated ornament and monumentality in architec-

ture. Ornament, he felt, was necessary to obtain a sense of scale. Lamenting the loss of "all the weapons of illusion" out of which monuments were created, Reed insisted on the significance of the past and writers like Ruskin who championed ornament. Although he was far from alone in his criticism of the modern style, his plea for ornament and monumentality sounded emphatically reactionary. History, however, has proved otherwise.

Although Reed never equated architectural ornament with art, this equation was made by Aline Saarinen two years later. In an article entitled "Art as Architectural Decoration," Saarinen suggested that architects use art either for an

esthetic or formal reason, in which the art is asked to enhance; to embellish; to establish or emphasize or set up new relationships of scale, proportion, form and space; to furnish color, texture, pattern, contrasts of light and shade . . . (or for) expressive motivation in which the art is called upon to communicate.

She concluded that since the vocabulary of modern architecture is itself used for "expressive communication," it logically follows that

modern architecture should want art to serve it as architectural decoration . . . whether it is a freestanding piece of sculpture which defines space by punctuating it or whether it is a mosaic mural incorporated into a facade—it must be accessory to and subordinate to the architecture in both form and expression. [13]

Saarinen saw any use of art together with architecture as an extension of the architect's plans. [14] She even suggested that the architect prepare a model of whatever art he deemed necessary to articulate his structure and reinforce its "emotional expression." In view of Saarinen's subsequent criticism of the failure of contemporary architects to accept modern art, it is difficult to imagine how they might design appropriate spaces, let alone models for it, in their buildings. In any event, Saarinen felt that an artist would be no more restrained by architectural directive than a poet is restrained by the sonnet form. However, this approach would be sharply criticized by the public art community in the decades to come.

Saarinen's opinions were of particular importance since as the wife of a leading architect, she was on familiar terms with other members of the profession. Her views represent an attitude that was apparently widespread among architects, and the procedure she outlined for the inclusion of art was not far removed from what often took place. Many of the methods she suggested for helping to prepare architects for this role (articles in architecture magazines on interesting artists, museum advisors for architects, related gallery exhibitions, and manufacturer-sponsored competitions) subsequently became a reality. What Saarinen did not foresee in 1954 was the future role of government and corporations in the sponsorship of art, independent of the architect's instigation or perhaps even his or her wishes.

Debates about collaboration persisted throughout the decade both in this country and in Europe. But for all the theorizing of the 1950s, artists were infrequently consulted, and the polarization between artists and architects continued.[15] Ada Louise Huxtable in 1959 observed that while the notion of integration was being debated, the chief participants, the architects and artists, were "barely speaking."[16] She labeled integration a "false ideal" based on outmoded historical suppositions. Instead she suggested that opposition, "enrichment by juxtaposition, completion by contrast," be the goal. She called for an end to the practice of "art as afterthought" considered as "extraneous decoration" and pleaded with architects to respect the independent work of artists and to try to include them at the start of a project so that they would understand it better. Although Huxtable posited a different esthetic based on opposition rather than integration, she still relied on the architect to originate and orchestrate the project.

During the 1950s the theme of integration of the arts was taken up as a cause by several architecture journals. In Paris *Architecture d'Aujourd'hui* under the editorship of André Bloc regularly published accounts of relevant projects and activities, and even sponsored a few, while Theo Crosby's campaign for the integration of the arts as editor of *Architectural Design* in London was apparent in his contributions to the magazine and the artists he chose to review. Although other European journals occasionally featured articles or even devoted an entire issue to the integration of the arts, none had the consistent coverage found in *Architecture d'Aujourd'hui* and *Architectural Design*. In the United States similar attention to the issue was found in the *A.I.A. Journal*. In a 1957 capsule review of a century of professional activities, architect and editor Henry H. Saylor recalled the annual meetings of

1927–28 during which "the Institute worked itself into a fever on the subject of collaboration. . . . Result, as before and since after such discussions, collaboration was unanimously approved, though not much was done about it."[17]

The *A.I.A. Journal* regularly published discussions and position papers on the subject. Talks by A.I.A. members at local chapters, museums, and at special meetings were duly reported. In these the need for the inclusion of art in architecture was discussed in terms of the barrenness of modern architecture and was closely related to the growing criticism of the style. In this it differed from the European journals, which began from the assumption that integration of the arts was, a priori, a desirable goal rather than an esthetic Band-Aid.

Art at The United Nations and UNESCO

While discussions proliferated in architecture journals, little was built that accomplished the widely touted goal of collaboration. On an international scale, the United Nations building in New York and the UNESCO building in Paris were looked to as exemplars. Both projects were, of necessity, committee efforts with political considerations paramount. The United Nations building in New York preceded UNESCO by several years with construction completed by August 1950. The architect, Wallace K. Harrison, a logical choice after his experience at Rockefeller Center, was assisted by a ten-member board of design consultants, which included architects from different countries.[18] Official art policy, formulated by Irwin Edman, a professor of philosophy at Columbia University, stated that the United Nations was not and should not become a museum. "The works of art should be an accompaniment rather than a distraction, a background, not the center of interest."[19] Although there were no funds set aside specifically for commissions, the United Nations did have a four-member board of advisors, headed by Harrison, which had the power to accept or reject any offered work of art.

In spite of the formation of various groups to aid the art program and Secretary General Dag Hammarskjold's example of borrowing works of art from the Museum of Modern Art, art at the United Nations remained uninspired and uninspiring. Evidently good, or even acceptable, sculpture was even harder to find than painting. At one time the United Nations even issued a public call for donations of sculpture, apparently with little success. Those gifts of sculpture donated by

various missions were seen as political gestures and not esthetic choices.[20] The only exception and the only sculpture visible from the front of the building is Barbara Hepworth's bronze *Single Form*, erected in 1964 as a tribute to Dag Hammarskjold, the former Secretary General of the United Nations.[21] Although its color and ovoid shape work well with the architecture, it lacks the appropriate scale and is hardly a compelling work. Certainly its specific commemorative purpose can in no way be deduced from its form.

Compared with the United Nations, the art program at UNESCO (1952–58) in Paris was far more ambitious. The three-member architect team included Marcel Breuer (United States), Pier Luigi Nervi (Italy), and Bernard Zehrfuss (France), working with an international advisory committee.[22] From its inception the UNESCO project was seen as an exemplar of the integration of contemporary art and architecture.[23] What occurred, however, was not integration or collaboration, but rather the commission of works of art by artists of international fame, selected by the Director-General of UNESCO, guided by a committee of art advisors. Governments were asked "to offer works of art for the decoration" of the building. The first six artists selected were Picasso, Arp, Miro, Calder, Moore, and Noguchi.[24] The results were generally not well received, with critics objecting to the method of the so-called integration.[25] Instead of collaboration from the start between architects and artists, the works of art had been merely added to the architecture, after the fact. Art was included in the manner of amassing a blue-chip collection rather than creating a collaborative effort. Artists were chosen on the basis of international reputations based on the creation of a body of independent works of art for museum or gallery settings, a precedent that was followed in the United States as public art began to proliferate in the next decade.

The only artist who worked with the site in any meaningful way was Noguchi, but even his attempt at creating a landscape environment for the building was not entirely successful. He included the traditional elements of a Japanese garden (fountains, trees, shrubs, stones, paths, bridges), as well as individual sculptures, a more western practice (fig. 25). This was Noguchi's first attempt at a sculpture garden with elements that were to function symbolically as well as formally.[26] Overall, he remained dissatisfied with the project. In a later assessment he observed, "The planting I see is too much, or too divergent—but what planting is equal to large modern buildings? What stones excepting in strictest isolation?"[27] Although the garden appears to be an entity

Figure 25. Isamu Noguchi, *Gardens for UNESCO,* 1956–58, Paris, France (courtesy The Isamu Noguchi Foundation).

totally separate from the architecture, it nevertheless is a peaceful and refreshing place, an early realization of the concept of pubic sculpture as landscape.

The Noguchi/Bunshaft Collaboration

Noguchi, most often working at the behest of architect Gordon Bunshaft of Skidmore, Owings & Merrill (SOM), prefigured almost

71

every development of public sculpture in the decades that followed. This most consistent example of collaboration between an architect and artist during the period of the late 1950s and 1960s was not really a collaboration in the sense advocated by proponents of the theory of the integration of the arts. At best an unequal partnership, the ongoing relationship between Bunshaft and Noguchi gave the artist an opportunity to experiment with a variety of innovative approaches to public sculpture. Starting in 1956, Noguchi regularly provided sculpture for many of Bunshaft's buildings. The architect's consistent use of Noguchi was typical of the SOM practice of advocating the inclusion of art to the client.[28]

As a result of his Japanese-American heritage, Noguchi was at home with the tradition of Japanese rock gardens and the American tradition of monumental sculpture. Early in his career he apprenticed briefly with Gutzon Borglum, best known for his gigantic presidential portraits carved into Mount Rushmore.[29] Noguchi's subsequent work as a set designer for choreographers Martha Graham, Merce Cunningham, and George Balanchine, among others, provided a valuable experience at creating sculptural environments with active human participants. Noguchi recalled, "It was for me the genesis of an idea— to wed the total void of theater space to form and action."[30] At the same time, during the 1930s, Noguchi began thinking about designing playgrounds.

Noguchi's professional relationship with Bunshaft began in 1952 when the architect suggested that he make some proposals for the exterior area around the Lever Brothers building in New York, which contained a number of planters. None of Noguchi's suggestions, variations, and groupings of individual sculptures reflecting his current gallery art were realized.

A few years later at Connecticut General Insurance Company in Bloomfield Hills, Connecticut, Noguchi accomplished his first public sculpture commission in America (fig. 26). According to the artist:

I had the opportunity to do four interior courtyards and a long terrace outside a completely integrated large office structure, in the country outside Hartford, Connecticut. This was my first perfectly realized garden. The difficulty, as always, was scale: equivalent scale of large buildings and spaces are not necessarily met by bigness but rather by relative scale and simplicity of elements. . . . The large sculptures were originally designed for the terrace outside, but as they grew larger, it became obvious they could no longer belong there.[31]

Figure 26. Isamu Noguchi, *Gardens for Connecticut General Life Insurance Company*, 1956–58, Bloomfield Hills, Conn.
(courtesy The Isamu Noguchi Foundation).

The sculptures of Stony Creek granite were thus placed away from the building, in the landscape. As he had at UNESCO, Noguchi incised their surfaces with "drawings" of regular geometric designs, anticipating his later more sculptural piercing of solid forms.

The commission for First National Bank in Fort Worth, Texas, was more limited (fig. 27). Here Noguchi thought primarily in terms of the designated space:

The area in front of the building was triangular with the entry of the building at the widest part. The problem was to resolve the spaces with sculptural elements to act as a gateway. Since the plaza was triangular,

73

Figure 27. Isamu Noguchi, *Sculptures for First National Bank*, 1960–61, Fort Worth, Texas (courtesy Skidmore, Owings & Merrill).

the sculptures were designed at right angles (rightness—square); the stone is broken; where cut, it is polished, the effect thus balanced. It is also an energy symbol (money is energy).[32]

Indeed, the eighteen-foot-high sculptures of gray-green granite might be mistaken for variations of a corporate logo. In a gallery setting it would, of course, be seen quite differently.

Sculpture here and at the John Hancock Insurance Company in New Orleans (now owned by Katz & Besthoff Drug Stores) was an afterthought. The insurance company replaced its original plan to

74

have a tree in the plaza with the wish for a fountain. In *Mississippi* (1961–62), made of Minnesota granite, Noguchi reinterpreted the original image of a tree in a traditional architectural vocabulary, relating it to the classical column of the nearby statue of General Robert E. Lee (fig. 28). Today Noguchi's sculpture forms the centerpiece of the contemporary sculpture collection amassed by the current owners of the building. Instead of a single sculpture seen in an isolated architectural and civic context, *Mississippi* is now the most prominent part of a larger collection considered by many to be "New Orleans's most important sculpture collection,"[33] even though it has been installed with a less than judicious curatorial eye.

During the early 1960s Noguchi began making "sculpture gardens," rather than independent object sculpture. The most abstract and purely sculptural of these was at the Beinecke Rare Book Library at Yale University (fig. 29). Initial inspiration came from a synthesis of eastern and western influences. "The idea started from the sand mounds

Figure 28. Isamu Noguchi, *Mississippi*, 1961–62, K & B Plaza, New Orleans, La. (Burt Roberts).

Figure 29. Isamu Noguchi, *Sunken Garden for Beinecke Rare Book and Manuscript Library,* 1960–64, Yale University, New Haven, Conn. (courtesy The Isamu Noguchi Foundation).

found in Japanese temples. But soon the image of the astronomical gardens of India intruded, as did the more formal paving patterns of Italy." Noguchi used Bunshaft's building as a frame for his white marble garden, seen most frequently from above (as is the contemporary project at Chase Manhattan in New York). Three abstract geometric sculptures rest on a marble base that forms the floor of the complex.

For Noguchi, the garden is symbolically as well as visually unified, following the Zen garden tradition.

As seen from the reading room, the illusory effect of space is cut by a pyramid (geometry of the earth or of the past), whose apex introduces another point of infinity. To the right, beyond this, dominating the drama, is the circular disk of the sun almost ten feet high. A ring of energy, it barely touches the horizon. Its radiation, like lines of force in

a magnetic field, transfixed it in a curvilinear perspective. The symbolism of the sun may be interpreted in many ways; it is the coiled magnet, the circle of ever-accelerating force. As energy, it is the source of all life, the life of every man—expended in so brief a time. How he does this, is the purpose of education. Looked at in other ways: the circle zero, the decimal zero, or the zero of nothingness from which we come, to which we return. The hole is the abyss, the mirror, or the question mark. Or it may be the trumpet that calls youth to its challenge—from which a note has sounded (as the cube). The cube signifies chance, like the rolling of dice. It is not original energy (sun) or matter (pyramid), but the human condition from whose shadow the rest is seen in light. If the "sun" is primordial energy, the cube is that man-made pile of carbon blocks by which he has learned to simulate nature's processes. The cube on its point may be said to contain features of both, earthly square and solar radiance.[34]

As poetic and elegant as Noguchi's conception is, it is hardly apparent to a casual or even an art-informed viewer. At best, the content of the Yale sculpture garden invites speculation. From a formal point of view, the abstract complex conveys a pristine sense of purity, precision, and timeless geometric perfection.

Noguchi's contemporary project at Chase Manhattan Bank Plaza in lower Manhattan works far less well (fig. 30). Intended as a sunken water garden, punctuated by rocks chosen by Noguchi and Bunshaft in Kyoto, Japan, the circular form with its gently undulating base and jagged natural rocks stands in marked contrast to the rectilinear plaza and architecture above. Plans to make this a fountain with varying water effects unfortunately never materialized. Originally the pond contained a number of goldfish, but they soon died of lead poisoning caused by the pennies thrown from above. As it now stands, color and life are sadly lacking. Since the viewer is always distanced from the work (either by glass or height), the piece remains static and remote, better in concept than actuality—indeed a "sunken art hole," as it was once dubbed.

Far more successful in improving the visual urban landscape is Noguchi's red rhombohedron in front of Marine Midland Bank in lower Manhattan, just west of Chase (fig. 31). Sculpture was considered only after the building was complete and Bunshaft suggested to Harry Helmsley, developer of the project, that there ought to be something in the plaza. Helmsley agreed, "There had to be something there.

Figure 30. Isamu Noguchi, *Garden for Chase Manhattan Bank Plaza*, 1961–64, New York City (Arthur Lavine, courtesy Chase Manhattan Bank).

It didn't seem right without it,"[35] and allowed $25,000 for art. (The building had cost $37,000,000.) Bunshaft once again brought in Noguchi.

Noguchi's first proposal, following Bunshaft's suggestion, involved natural rocks (à la Stonehenge), which would have cost about $90,000, far in excess of the allotted amount. The sculptor then proposed a group of sculptures that could be manufactured, the only economically feasible approach at that point. Every time Noguchi produced a model that Bunshaft liked, the architect would invite Helmsley to his office to see it. Helmsley turned down five ideas before he finally approved the red rhombohedron.

The elongated cube standing on end (reminiscent of the marble cube at Yale) is a bold and dramatic place marker, adding a dynamic dimension to an otherwise static and empty space. An effective counterpoint to Bunshaft's building, its size and placement were a result of negotiation rather than collaboration. The final decision, based on budget and personal taste, was made by Harry Helmsley.[36]

The long-standing "collaboration" between Bunshaft and Noguchi was hardly a partnership of equals and clearly strained the patience of both.[37] In every project the sculpture was treated as an afterthought

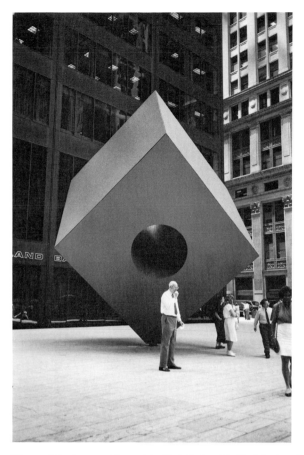

Figure 31. Isamu Noguchi, *Red Cube*, 1968, Marine Midland Bank, New York City (Harriet Senie).

and/or called upon to enhance the image of the building and thereby the value of the property. Even though Noguchi was able to experiment with a number of different approaches ranging from independent object to small-scale environment utilizing both natural and manufactured materials, the sculpture in the end functioned primarily as an ornament for the blue-chip architecture of SOM.

Experiments in Collaboration

The Noguchi/Bunshaft projects realized the goal of the inclusion of art, but it was not the integration of the arts advocated by the Bauhaus or the collaboration championed by subsequent public art rhetoric. Toward that end, in celebration of their 100th anniversary in 1981, the Architectural League of New York organized an exhibition to explore

historical precedents, contemporary approaches, and future visions of collaboration.[38] A primary motive for the League's founding in the midst of the American Arts and Crafts movement was to bring artists and architects together. This exhibition paired eleven such teams with the mandate "to strike a delicate balance between the visionary and the pragmatic—or at least the remotely plausible." The project was seen as a demonstration that, according to Architectural League President Jonathan Barnett, would illuminate "ways of giving new life to old traditions as well as perhaps discovering modes of collaboration that had not been tried before."[39]

Barnett categorized the results according to those that proceeded along traditional lines of collaboration, with the architect determining the structure and the artist embellishing it; those teams that experimented with a more equal partnership between architect and artist, where the results were more integrated (or less separate); and finally, those in which a more theoretical or visionary approach was chosen to address larger urban situations or issues. At the time of the exhibition, however, architecture had changed again, no longer following a neoclassical style based on the American Renaissance or International Style modern; it had entered a postmodern phase.

Postmodern Architecture and Ornament

The shift in architectural style away from the proscriptions of modernist tenets to include historical references and other decidedly decorative elements can be traced to the writings and practice of Robert Venturi. *Complexity and Contradiction in Architecture* (1962) advocated an architectural embrace of popular culture, the esthetic of Main Street,[40] an approach to acceptable imagery that paralleled Pop Art's embrace of mass media and advertising. Hailed in the introduction by architectural historian Vincent Scully as "probably the most important writing on the making of architecture since Le Corbusier's *Vers une Architecture* of 1923,"[41] its influence was felt in the works of Venturi himself, Charles Moore, Robert A. M. Stern, and others. By championing complexity and contradiction (instead of the simplicity and unity of the modern style), Venturi gave architects permission to find inspiration in a variety of sources, including historical precedent, vernacular architecture, and, later, the Las Vegas strip.[42]

Increased interest in historical styles and architectural ornament was also signaled by the exhibition *The Architecture of the Ecole des*

Figure 32. Charles Moore, *Piazza d'Italia*, 1975–78, New Orleans, La. (Burt Roberts).

Beaux-Arts at the Museum of Modern Art in 1977. Nowhere was the new esthetic expressed more fully than in Charles Moore's Piazza d'Italia in New Orleans (1975–78)[43] (fig. 32). Although generally attributed entirely to Moore, the Piazza d'Italia is actually a collaborative effort of two architectural firms: August Perez & Associates, who won the original competition with a design that concentrated on the spatial configuration and its relationship to surrounding buildings, and Charles W. Moore Associates and Urban Innovations Group, who created St. Joseph's Fountain, the dramatic focus of the space.[44] Moore's second-place design seemed to complement Perez's plan, and he was thus asked to collaborate with the winning firm. The original impetus for the project was a political gesture on the part of New Orleans Mayor Moon Landrieu to honor the Italian-American community, and at the same time, spark a revitalization of the downtown factory district.

The community wanted "a new symbolic focus—part gathering place and part memorial."[45] The gathering place is perhaps the most dramatic public space built in the last few decades. Its memorial aspect takes the shape of a map of Italy with the focus on Sicily as a speaker's platform, because the community had a large number of Sicilian residents. The backdrop is a neon-lit stage wall of Tuscan columns dressed in a contemporary array of colors and materials, all part of an elaborate fountain. Sadly and ironically the Piazza d'Italia is in such disrepair

81

today that it resembles nothing so much as an abandoned movie set or the country's most modern ruin. A victim of local politics, the magnificent fountain (admittedly problematic from a maintenance point of view) was a pet project of one mayor, only to be abandoned by his successor. Although the hoped-for urban renewal has largely taken place, the Piazza itself is today visited only by derelicts and architecture buffs. At the time of this writing it seems destined to become part of the entrance and parking lot to a luxury hotel, falling prey to yet another redevelopment scheme.[46]

Frequently cited as an archetypal example of postmodernism, the Piazza d'Italia with its historical references and colorful, decorative forms is a far cry from modern architecture's stark facades of steel and glass. Moore described it as follows:

Here in a fountain built by New Orleans citizens of Italian descent, the contours form Italy. Sicily becomes the speaker's rostrum, and waters flow down the mirrored surfaces of the Arno, the Tiber, and the Po. The (Italian) classical orders of architecture appear, so far as we could manage, in water, with volutes, acanthus leaves, flutes, and fillets, as well as egg-and-dart moldings all formed with jets. But the explicit references (if all this works) will only reinforce the excitement of the water, the marble, and the stainless steel, for the celebration is first of all one of the senses, and then for the mind and memory.[47]

Largely admired by the architectural community, it was greeted with skepticism by many local residents, who interpreted its playful aspects and use of contemporary materials as insulting—not what they expected of "real art." Not surprisingly, they didn't get the architectural in-jokes. However, had the Piazza been properly maintained, these reservations might have disappeared with time and the true celebratory spirit triumphed.

As postmodern styles evolved and architecture once again provided its own color and ornament, public sculpture began to take on other forms besides a freestanding sculpture in front of a building. Like architecture, it too increasingly concentrated on the needs of the larger urban landscape. This new focus is evident in some of the collaborative projects of the 1980s.

Recent Collaborative Projects: The Wiesner Building
and Battery Park City

At the Wiesner Building at MIT (1979–85), a modernist building by architect I. M. Pei that houses the various components of the university's visual arts programs, Kathy Halbreich, then Director of Exhibitions for the MIT Committee on the Visual Arts, initiated an art program that was intended to expand the existing practice of using art strictly as an add-on.[48] To this end she selected six artists and gave them certain areas or problems to address. Scott Burton was given the atrium furnishings, Kenneth Noland the interior wall surface, Richard Fleischner the outdoor areas, Dan Flavin the artificial lighting, James Turrell the natural light, and Alan Shields the atrium. At the time of the artists' involvement, the building design was basically established, although subsequent changes were made, both as a result of continued client and architect discussion, and finally, in response to the proposed art. A substantial design change, necessitated by escalating costs, led to the withdrawal of Flavin, Shields, and Turrell.[49]

Burton, Fleischner, and Noland continued to develop and modify their contributions, each with a different formal and personal approach. Accounts of the project indicate that the overall process of collaboration was not as clearly delineated as it might have been. The artists met individually with the architect but not, unfortunately, with each other. They were treated as consultants, whose fees were included in the building cost, but there was no single coordinator to ease complicated negotiations with the client, the architect, and the various other contractors. Administrative problems were handled by the artists with varying degrees of success and undoubtedly with considerable frustration. However, the end result, realized through this largely ad hoc process, was quite successful.

If one approaches the building without prior knowledge of the artists' work or the nature of the project, it appears to be an integrated whole. Noland's additions of color gave life to an otherwise stark building. *Here—There* is a huge ceramic mural, continuous through exterior and interior walls. Subtle gradations of color in horizontal bands of varying widths, punctuated vertically and horizontally by narrow three-dimensional "lines," create a constantly changing visual experience from exterior to interior, and from one interior level to another. As applied decoration to the surface of a modern building, Noland's

contribution is superb. As the catalogue suggests, to envision the building without it is "to imagine a corpse."

In terms of the collaboration process, however, Noland was the least involved. Not having worked at this scale before, he was unable to feel his way to a solution until he had a scale model of the final design in his New York City loft. Thus Noland worked primarily alone, waiting until the building was nearly complete. This delay necessitated that the paint be applied manually to the finished wall panels at the site, rather than baked in earlier at the factory or prefabricated in strips and then applied. (As it is, color stability is guaranteed only for fifteen years.) This working process could hardly be described as collaboration, unless one counts the constant personal encouragement Noland received from the architect, who had long been an admirer of his art.

Both Burton and Fleischner, with their prior experience of working on public projects, were challenged by the process as well as the end product. By all accounts, Burton's role was the most collaborative. He spent the most time with the architects, and Pei acknowledged that Burton "understands the architect's language better than many architects."[50] Interestingly, Burton's contribution is also the least visible (fig. 33). In designing seating for the atrium lobby, Burton began with the idea of a single bench backed by the stair railing. Initially he wanted to convey "that something is not necessarily one thing at all times." Thus the railing would have served two purposes: one as back support for the bench and the other as a protective boundary to the stairwell. Sculpture and architecture would, in effect, have merged. Code restrictions made this scheme impossible, and Burton eventually solved the problem with two concrete benches—one with a low back echoing the curve and materials of the railing and a smaller arc-shaped slab without a back.

Burton wanted, he said,

to do something that would have a certain, maybe subconscious effect on users of the building. There is a dialectic there, between the benches and the railings. And where one bench has a railing, and becomes a settee, that's a kind of synthesis to me. One of the things I'm trying to do is to make the same form serve two purposes, so people will look at forms in new ways.[51]

Even though the artist's thinking may not be directly communicated to building users, his benches do give a sense of rhythm to the lobby. They

Figure 33. Scott Burton, *Untitled,* 1985, Wiesner Building, MIT, Cambridge, Mass. (©Steve Rosenthal).

85

are almost always in use—as a place to stop, chat, and even have lunch. Much more comfortable than they look, they serve as leaning posts and footrests as well as seating and as a focus for performances and informal gatherings. Burton liked the theatrical connotations.

By integrating art and design elements, as well as use, into the piece, Burton hoped to add an "ethical dimension" and "to get some social meaning back into art." In thinking about the MIT project and public art in general, Burton observed, "Ours is a transitional generation. Maybe the next one will be designers, public-space designers, plaza designers, park designers. . . ."[52] This expanded role can already be seen in Richard Fleischner's contribution to the Wiesner building (fig. 34). His task was to integrate the complex spatial area surrounding the building and provide a link to the adjacent Health Sciences/Health Services building by Mitchell/Giurgola. He accomplished this by a network of diagonal paths, a variety of benches, and a unifying pavement design. Fleischner's geometric patterns respond to both the gridlike exterior of Pei's building and Mitchell/Giurgola's more eccentric facade.

Figure 34. Richard Fleischner, *Untitled,* 1985, Wiesner Building, MIT, Cambridge, Mass. (©Steve Rosenthal).

As the project progressed, Fleischner's role expanded to landscape architect. He saw himself

> as an artist who is trying to address a problem-solving situation. . . . What you have to have is basic access to an area—that simply has to be provided. And then you have points where you want people to be able to sit and gather. And once you start drawing all those parameters, that begins to define the problem you're trying to solve.[53]

Fleischner described his role at MIT as cooperation more than collaboration. Although his part of the project was physically separate from the building, it necessitated his working not only with the architect but a number of different contractors as well. Fleischner's almost constant presence on the site and his personal skills in working with different groups and individuals were much praised.

Fleischner's overall design, with its eccentric linear geometry, is successful in linking disparate areas and levels with diverse architectural facades. However, much of the seating is uncomfortable and stylistically ambiguous. The teak benches recall the more enigmatic sculpture of Richard Artschwager, while the smaller granite pieces that function to protect the side of Pei's building might at first glance be mistaken for Scott Burton's sculpture.

Halbreich viewed the Wiesner Building as "an expensive research project" and, like all research projects, it raised as many questions as it answered. Although it achieved (perhaps more than any other project) the Bauhaus goal of the integration of the arts, it offered no prototype for collaboration except to suggest that art be defined in a broader sense than painting or sculpture. Each artist worked in his own way with his specific "problem." Noland working in isolation in his studio was finally as successful as Burton and Fleischner, who were more actively involved with the architects and the ongoing design process.

Theoretically, in a successful collaboration the artists' signatures disappear in favor of an improved overall design. If the focus of the project is the building, as it was in Bauhaus and subsequent rhetoric, then the results are seen and developed within the parameters of the architecture. This was true of Noland's contribution at MIT; it was less so of Fleischner's. If the focus of the project is the larger urban environment, then the artists' contributions must be judged in that context. In addressing the urban landscape, the architect, artist, and

landscape designer may begin on a more equal footing. Each has a different perspective, but none is technically the boss. This was the thinking behind the inclusion of public art at Battery Park City, a residential and commercial project built at the southern tip of Manhattan in the mid-1980s.

Hailed as a "triumph of urban design" in the popular press,[54] Battery Park City was planned to include residential and commercial buildings, a variety of public parks and waterfront spaces, and the New York City Holocaust Museum. Under the jurisdiction of the Battery Park City Authority (a public benefit corporation, established in 1968, and a subsidiary of the New York State Urban Development Authority), a master plan was developed by architects Alex Cooper and Stanton Ekstut under the direction of Richard Kahan, then chairman of the Authority. The ninety-two-acre landfill site includes luxury apartments designed by Charles Moore, Ulrich Franzen, the Gruzen Partnership, Mitchell/Giurgola, and James Stewart Polshek. The commercial component, the World Financial Center, comprises nine percent of the total area and was financed and built by the developers Olympia & York. Major tenants in the building designed by Cesar Pelli include American Express, Dow Jones, and Merrill Lynch. The master plan allocated 30 percent of Battery Park City to open space, and art was considered a significant element of the urban design. As the project evolved and became uniformly upscale, the art program received increasing emphasis and publicity.[55]

In February 1982, when the exclusive nature of this community had already been determined, a fine arts program was created "to complement the sites' acclaimed architecture and public spaces with appropriate and significant works of art to enhance the public environment and the enjoyment of people working and living at Battery Park City."[56] An eleven-member fine arts committee, including noted art professionals and chaired by Victor W. Ganz, worked pro bono to recommend sites and artists for the public art showcase that Battery Park City was intended to become.[57] The art was financed along the principles of a percent-for-art program from revenues received from lease agreements with the private developers.

In 1985, at the initial press conference introducing the Battery Park City fine arts program, Richard Kahan announced: "We wanted to redefine the traditional role of artist and architect in the design of public spaces. We wanted artists to actually design space and not be assigned spaces in which to do pieces of art." Of the six public art

projects, three were established as collaborative efforts with all partici-
pants involved at the start of the projects. South Cove, the first to be
completed, was designed by architect Stanton Ekstut, sculptor Mary
Miss, and landscape architect Susan Child. North Cove is the work of
architect Cesar Pelli, sculptors Siah Armajani and Scott Burton, and
landscape architect M. Paul Friedberg. The fate of a third collab-
orative project, South Park, is still in question.[58]

South Cove, situated in the residential section of Battery Park City,
terminates one end of the waterfront esplanade (fig. 35). The designers
wanted the site to "provide a major link between the city and the river's
edge" through a series of diverse experiences that juxtapose "the built
and the natural, the land and the water."[59] The focus of the design is
the 260-foot-long lower path abutting the water's edge. Wood is used
throughout—in the boardwalk-like paving, for the low fences marking
the path boundaries, for the pylons that lead the eye into the water, and
for the curved structure at the end of the boardwalk that actually
projects into the Hudson River. The natural greenish wood recalls
seascape settings of an earlier era. A striking note of color is added by

Figure 35. Mary Miss in collaboration with Stanton Ekstut, architect, and
Susan Child, landscape architect, *South Cove*, 1988, Battery Park City,
New York City (courtesy Mary Miss).

the neon blue electric lights in the wooden lampposts. Intended to emphasize the water, their electric glare is somewhat at odds with the natural materials in the rest of the project and the peaceful respite South Cove was meant to be.

Although parties to the collaboration insist that the end result is a joint effort, individual contributions are easy to distinguish. Susan Child's landscaping is clearly circumscribed and Mary Miss's sculptural constructions are recognizable to anyone familiar with her work. Certainly she is responsible for the spiral extension into the water and the black steel spiral tower that is the southern focal point of the design. This openwork structure obviously takes its form from the crown of the Statue of Liberty.[60] In an art context it recalls elements of Tatlin's 1919 design for a monument to the Third International.

On the whole, South Cove is somewhat disappointing. Waterfront access in New York is an unfortunately rare treat, but the design of South Cove doesn't sufficiently open or embellish that experience. Though a welcome respite, it doesn't really draw pedestrians into the vista of the lower harbor. Without special events, it remains a sadly lackluster and underused space, reinforcing the sense of privileged enclave that defines the residential section of Battery Park City.[61]

The grandly scaled 3.5-acre urban waterfront plaza that constitutes North Cove marks the transition between the upscale World Financial Center and the New York City Yacht Club (fig. 36). Seating along the perimeter is provided by Scott Burton's easily recognizable sculpture/furniture in the form of benches, slabs, and low walls. The uninspiring tower, the highest point and centrally located focus of the space, recalls a lighthouse; it is appropriate to the waterfront setting, but its function is ambiguous. Armajani's signature quotations embedded in the waterfront railing impose a curvilinear path and temporal experience, but one that is sadly cut off from the rest of the plaza. As it is, the lines of poetry from Walt Whitman and Frank O'Hara are difficult to read in their entirety.[62] Although it was the artists' intent to integrate their art so fully into the overall design as to be indistinguishable from it, the result here, unfortunately, is rather that the art remains undistinguished.

The collaborative ventures of South and North Coves, as well as the independent works of Ned Smyth, Richard Artschwager, and R. M. Fischer (discussed in Chapter 5), all aim at creating unique urban spaces rather than more traditional object sculpture. In this context, Battery Park City marks the end of an era that saw public sculpture as

Figure 36. Siah Armajani and Scott Burton in collaboration with Cesar Pelli, architect, and M. Paul Friedberg, landscape architect, World Financial Center Plaza, 1989, Battery Park City, New York City (detail) (Timothy Hursley).

an adjunct to architecture.[63] By placing public sculpture in the context of the urban environment, it greatly enlarged its potential to contribute to the quality of public life, albeit here for an economically privileged population of residents and visitors. A comparison with the public found at nearby Battery Park, landing site of ferries to Staten Island and the Statue of Liberty, reveals just how unrepresentative of the population of New York the users of Battery Park City are.

The changing relationship of sculpture and architecture that evolved with the shift from modern to postmodern styles eventually led to an expanded focus and function for public sculpture. The campaign for the integration of the arts that was an integral part of the rhetoric of modern architecture, by the 1950s signaled a growing concern with the proliferation of second-rate modern buildings that accentuated the sterility of the style. This, however, was more appropriately resolved by a change in the architecture than by the addition of art. The call for collaboration that was continued by the public art community was

91

more a response to the limited role accorded to artists when their work was treated as little more than an esthetic Band-Aid.

Questions remain about the effectiveness and desirability of collaboration. Recently Siah Armajani, a sculptor who has worked on a number of collaborative public art projects, stated categorically that in the future he preferred to work alone with greater autonomy. "The whole emphasis in most of those projects is on who can get along best with the others involved," he said "at the expense of vision and fresh thinking."[64] Although the collaborative process is based on cooperation, the creative process thrives on individuality.

Historical examples of collaboration suggest that the process was never total or easy, and that the past—in this arena as elsewhere—may have been as problematic as our own. Furthermore, the rhetoric inherited from the Bauhaus suggests that more was at stake than getting art on or into a building. The continuing pursuit of this utopian ideal may represent an ongoing yearning for societal cohesiveness in a time of increasing fragmentation—or at least an artistic unity of vision in a time of growing pluralism and individual isolation.

But some artistic community must exist before the collaborative process begins. Artists and architects must be on speaking terms, and they must be familiar with one another's work. Few schools today provide, let alone allow, for this condition to evolve. Art and architecture departments are usually in separate buildings, making any crossover difficult. Common requirements are rare. There is precious little opportunity to form friendships, let alone establish a common vocabulary or ground.

To date, the best insurance for an effective collaborative process is still a shared or at least mutually compatible esthetic approach, agreeable personalities, and a real desire (if not preference) among all participants for working this way. But even that does not necessarily guarantee better public art projects than artists and architects going it alone. Even insistence on collaboration at the start of a project may be too late. We develop habits of working and thinking early on. Now, we have to establish a system of education for future architects and artists that leads to an ongoing dialogue based on a mutual understanding of the vocabularies and visions of both disciplines. Only then can productive collaboration become more of a fact and less of a fantasy.

3

The Public Sculpture Revival of the 1960s: Famous Artists, Modern Styles

An urban symbol may be a functional structure like a bridge, a non-utilitarian edifice like the St. Louis Arch, or a piece of land like the Boston Commons.

Yi-Fu Tuan

If it is a bird or an animal they ought to put it in the zoo. If it is art, they ought to put it in the Art Institute.

Colonel Jack Reilly

The sculpture that marked the start of the public art revival of the late 1960s seems today to have been commissioned for all the wrong reasons. Neither understood nor appreciated by large segments of the general public, it was all but ignored by critics, perhaps due to the realization that art was not the issue. Rather, cities desperately needed symbols of civic pride, and establishment institutions badly needed some good public relations. Nevertheless, a few wonderful pieces were created, both esthetically significant in an urban context and civically important to people. By and large, however, the commission of this new public art in the form of individual object sculptures was based on the old tradition of the monument in the square with which it had nothing in common except, perhaps, scale.

The public success of many of these works is difficult to measure,

since it is usually only controversy that is reported, not satisfaction. First-hand observation of public interaction is required. Sometimes, however, the only way to know if a piece is liked is to remove it and see if it is missed. Esthetically, the various styles of modern and contemporary sculpture worked with varying degrees of success in their new public sites. But most were commissioned primarily as ornament, either to the patron, the architecture, or the space it inhabited, and ideally to all three.

Public sculpture has two prerequisites: space and patronage. A city's streets and open spaces are the stage on which we act and interact in public. They define the theater of the public realm, and to a large extent, the quality of urban life.[1] A culture's attitude toward public spaces, indicative of its attitude toward people, is revealed in the prevalence of such spaces and their design. Both urban space and patronage (private and public) became available for public sculpture in the 1960s.

A new focus on the livability of cities resulted in a multitude of urban renewal programs. On a federal level, the Great Society Task Force was created in 1964, the Department of Housing and Urban Development was created in 1965, and a year later the Model Cities Act was passed.[2] On the local level many zoning ordinances were passed offering bonuses to builders for the inclusion of open space.[3] Thus New York City's so-called plaza law of 1961 resulted in a proliferation of urban plazas (more accurately forecourts), which became the sites for public sculpture. For the most part, these sites were either part of urban renewal projects or adjacent to corporate buildings. The former were sponsored by government money (federal, state, or local), the latter by private funding.

The public art in these newly created spaces may be seen as embodiments of official ideologies and attitudes toward art. Art perceived as an emblem of culture and a sign of economic wealth glorifies the patron. As manifestations of the establishment, government and big business are not far apart. Therefore, it is not surprising that they often use the same architects and sponsor the same kind of art.

The public sculpture revival of the 1960s began with the forced marriage of large-scale sculpture by already world-famous artists with modern corporate architecture and/or urban renewal projects. By mid-decade, plans were under way to place works by Picasso, Moore, and Calder in prominent public spaces throughout the country. The purpose of these sculptures, primarily abstract in form but biomorphic

(suggestive of human or animal life), was to humanize the architecture and serve as optimistic emblems of civic identity. Picasso's giant heads, Calder's whimsical creatures, and Moore's natural forms were all stylistically in marked contrast to their urban settings. Blue-chip corporations via blue-chip architects (Skidmore, Owings & Merrill, I. M. Pei, and others) chose blue-chip artists, as did certain communities, to create symbols of identity, prosperity, diversion, and, perhaps, hope. The motivation behind this patronage was no different from that in centuries past. However, modern sculpture by mid-century was largely committed to an abstract esthetic ill understood by a large part of the museum-going public and totally unfamiliar (and therefore at least initially threatening and undesirable) to a more general audience.

The sixties was a decade of unrest and upheaval. The Vietnam War elicited a national protest, particularly by students, children of the middle class. The social order was challenged from within by the civil rights movement and later by feminist groups. In many instances, the struggles of the sixties were fought over urban space—with dissenting groups occupying establishment territory as a means of effecting change.[5] In terms of public policy, public sculpture was an extension of the liberal social-welfare programs of the Kennedy and Johnson administrations. In practice, however, it was often perceived as an extension of the power structures staking out their claims with territorial art markers.

Not surprisingly, these patrons turned initially to the heroes of modern sculpture, artists with established reputations and name recognition like Picasso, Moore, and Calder. William Hartmann, the architect at Skidmore, Owings & Merrill who initiated and pursued the commission of a Picasso sculpture for Chicago's Civic Center (fig. 37), stated quite simply: "We wanted the sculpture to be the work of the greatest artist alive."[5] In 1963, when the sculpture project was begun, Picasso was certainly the most famous living artist, although he had never had a monumental sculpture built and was known to be very negative about commissions in general. By all accounts his interest in Chicago was due to Hartmann's unflagging efforts and their evolving personal friendship.

The Chicago Civic Center was planned as early as 1956 with the creation of the Public Building Commission of Chicago (PBCC). Completely under Mayor Daley's control, the PBCC planned the project and in 1962 hired C. F. Murphy Associates as the supervising architects, together with Skidmore, Owings & Merrill and Loebl,

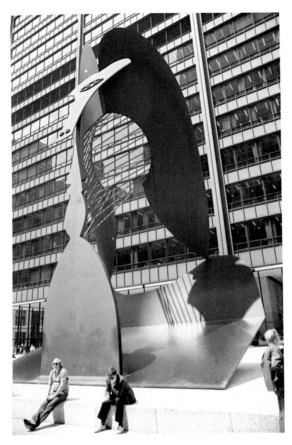

Figure 37. Pablo Picasso, *Untitled*, 1967, Chicago, Ill. (Burt Roberts).

Schlossman, Bennett & Dart as associate architects.[6] Located in a deteriorating section of the Loop in downtown Chicago, their building of Cor-Ten steel housed a variety of courtrooms and offices and was, accordingly, interpreted by Picasso as a "palais de justice."[7]

Significantly, the Civic Center was one of the first modern buildings to include open public space in its design. In an attempt to respond to the nature of the building as well as improve the quality of downtown urban life, the architects were motivated by European precedent. Hartmann explained:

In my own view in the great cities around the world, the physical symbols in past ages were either government—the towers of Parliament in London—or religion—St. Paul's Cathedral in London or St. Peter's in Rome, and that in modern American cities the commercial symbols had taken over. Here was a chance to again show that the city belonged

96

to the people and the people through their government had something symbolic. . . . And so we created a plaza. We said from the beginning that the plaza would serve several functions. A place where people can meet, a place for some tranquility, a place where there might be civic art in some form—whether the form was a tree, or fountain, or sculpture was left up for some further discussion.[8]

The funding for this civic sculpture was entirely private. Picasso ultimately donated the maquette to the city, and the cost of fabrication ($300,000) was paid for by three family foundations.[9] Hartmann emerged as the principal figure in all aspects of the sculpture project because of his personal interest in art, his art-world connections (he was elected to the board of the Chicago Art Institute at this time), and his ability to speak a little French.

Hartmann's introduction to Picasso was arranged by art historian Roland Penrose, who recalled that it took a lot of persuasion on his part.[10] At the initial meeting between the artist and representatives of each of the architectural firms, Hartmann brought ample documentation of the city and the site. Among the souvenirs of local lore were photographs of famous Chicagoans. Picasso, pleased to recognize his old friend Ernest Hemingway, gradually became engaged by the project. At first he offered an existing piece, an open wire sculpture of 1928–29, but the Chicago delegation wanted something new. Penrose later recalled that Picasso "told the delegation that he was honored that Chicago, like Marseilles, two cities famous for gangsters, should both have asked him for a monument." (The Marseilles project did not materialize.)

Although Picasso was given ample information about the site and scale of the project, he had never been and was never to go to Chicago. Over the next few years he worked sporadically on several possible proposals, among many other works of art.[11] For the aging Picasso, the decade of the 1960s was spent with Jacqueline Roque (whom he married in March 1961) at their rural hillside villa, Notre Dame de Vie, near Mougins, France.[12] Toward the end of 1960 Picasso began working in metal cutouts, a technique that took him back to a childhood practice of making paper cutout forms to amuse his cousins.[13] The art of this period is permeated with images of family life, primarily Jacqueline alone or in combination or conflation with other themes.[14]

Finally, in 1965, following inner esthetic directives and at last heeding repeated requests from Hartmann (usually transmitted to the artist

via Penrose), Picasso produced a 41¼-inch maquette, which became the basis of the 50 foot, 162 ton sculpture of Cor-Ten steel, built by the American Bridge Division of U.S. Steel Company in Gary, Indiana, after adjustments were made to ensure structural soundness in the windy Chicago environment.

The immediate response of the Chicago community was somewhat muted by Mayor Daley's known support for the project. "Picasso is the best artist in the world," the mayor said, echoing Hartmann's evaluation, "and that is what we care about."[15] There was, however, some understandable confusion over the sculpture's strange appearance, as it was compared to, among other things, "a baboon, bird, phoenix, horse, sea horse, Afghan hound, nun, Barbra Streisand, and a viking helmet."[16]

Although commissioned as a civic sculpture, the actual subject of the sculpture and its significance have been all but ignored by critics. In 1969 Chicago critic Franz Schulze lamented that

no one paid attention to the art. . . . It is more than irritating, it is depressing to see the meaning of the sculpture sacrificed to press agentry, to the fun and games of the communications media, for it underscores again the enormous extent to which image-promotionalism dominates art in our society. Evidently the last thing we will pay attention to in the *Chicago Picasso* is the work itself.[17]

Finally, even though in an article of 1977 William B. Chappell showed conclusively that the sculpture is a conflated image of Jacqueline and Picasso's pet Afghan hound, Kaboul, the choice of this curious image has not really been questioned.[18] This was not the first time that Picasso had combined the image of woman and dog[19] and it is only by looking at the sculpture in this context that it makes visual sense.

Although the elongated head looks more like an image of an Afghan hound than that of a woman, the large forms surrounding the head suggest equally Jacqueline's hair and an Afghan's long ears. Walking around the sculpture, these two images (of woman and dog) can be read at times separately, at times together, and at times not at all—when the sculpture dissolves into abstract shapes. Picasso's interest in metamorphosis has been well studied and documented; certainly it is present here. Both Jacqueline and the dog were part of the artist's daily domestic life. Picasso's pet was standing next to him when he greeted the architects at their first meeting at Mougins in 1963.[20]

But what kind of iconographic sense does it make to monumentalize these images of private life in a public space? This conflated image of woman/dog represents the objects of the artist's most intimate personal affections. Doubtless there are sexual connotations, particularly apparent from the rear view. Subsequently Hartmann speculated that Picasso "got a bang over the fact that this was Chicago, a strong vulgar city. . . . I thought then that it (the commission) came at a nice point—it was kind of an off-beat interlude in his life. So it might have been a little stimulus and Madame Picasso enjoyed it too."[21]

Had this sculpture been destined for a museum setting, it would already have been subjected to the same kind of analytic scrutiny customarily applied to Picasso's oeuvre by art historians and critics. However, in its public setting, the art content has been either blatantly ignored or perhaps unconsciously repressed. This is the "Chicago Picasso." The significant content is Chicago (both the site and the owner) and Picasso (the artist's name, not his private vision).

The Civic Center is the locus most associated with Mayor Daley's Chicago. Picasso's sculpture, as the focal point of numerous local celebrations, became an anthropomorphic visual image of civic identity. Tellingly, at Mayor Daley's death, a local cartoonist depicted the sculpture shedding a tear. Shortly thereafter the plaza was renamed Richard J. Daley Center Plaza, and plans for a Daley memorial included discussions of moving the Picasso to a different location where it would not compete with the anticipated monument.[22] However, the Chicago Picasso remains—a monument to the fame of the artist rather than the mayor.

The various uses to which the plaza and the sculpture have been put, nevertheless, indicate that some basic civic needs for communal space and visual symbol are met. But disturbing questions remain. Would any Picasso have done the trick? Would any large object in this space have served as well? Would a more appropriate subject or an esthetically superior sculpture have been more effective? When the real issue is image promotion, esthetics and interpretation are often beside the point and therefore ignored.

An immediate esthetic issue raised by Picasso's public sculptures is one of scale. Scale, the relationship in size between objects (in the realm of public art, most frequently between architecture and sculpture), is always perceived in human terms. A work of art also has an inherent scale—a size at which it looks neither like a miniaturized maquette nor an overinflated sculpture. This kind of inherent scale is

tricky; it is often difficult to anticipate at what size a specific model or design will look "right." Simple enlargement rarely works. A sculpture with figural references at fifty or sixty feet suggests gigantism neither inherent nor possibly even intended by the original model. The scale of the Chicago Picasso, rather than its content, underlines its covert message that art = culture = "class" = power.

In its site in the forecourt of a Miesian-style building, the primary message of the Chicago Picasso is that Chicago, already famous for its architecture, also has ART and is therefore, by association, a cultured and civilized place. The public welfare bestowed by the Chicago Picasso is of a decidedly non-art variety. It provides a civic symbol around which people can meet and celebrate local heroes and events. In a public downtown space it attracts a lot of attention and prompts discussion. This, too, provides a positive communal function. Paul Goldberger, architecture critic for *The New York Times*, observed that the Chicago Picasso has "probably done more than any public sculpture in any American downtown to stimulate a public dialogue on the value of such . . . efforts."[23] However, the level of dialogue could have been immeasurably raised if the aim of the commission had been to obtain the best possible public art for the space instead of a signature piece by the most famous artist of the day. But in the late sixties the concept of site-specific sculpture and the issue of public use had as yet not entered public art parlance.

Picasso's public sculpture in New York City, installed in 1968, a year after the Chicago Picasso, had barely any civic impact at all. Picasso's thirty-six-foot-high head of *Sylvette* is located in the open area framed by Pei's three-tower New York University Village Apartments in Greenwich Village, just a few blocks north of Soho (fig. 38). Artistically even less distinguished than the Chicago Picasso, the concrete sculpture is barely visible from outside the housing complex.

A landmark comparable to the Chicago Picasso in the history of recent public sculpture is the Grand Rapids Calder. Installed in Vandenberg Center Plaza in downtown Grand Rapids, Michigan, in 1969, *La Grande Vitesse* was the first sculpture funded by the NEA's Art in Public Places program (fig. 39). It was commissioned in 1967 as part of a downtown urban renewal project.[24] When Henry Geldzahler, then director of the NEA's Visual Arts program, was in town to give a lecture, he discussed the new NEA program with Nancy Mulnix, an officer of the Friends of the Grand Rapids Art Museum and a prominent local citizen. The grant for a sculpture, expedited through the

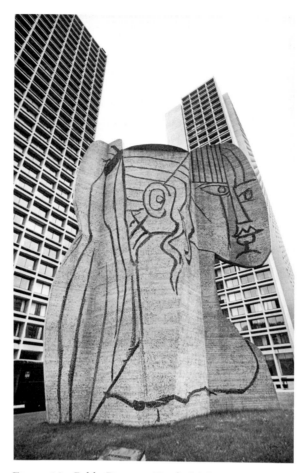

Figure 38. Pablo Picasso, *Head of Sylvette,* 1968, New York University Village Apartments, New York City (courtesy New York University Photo Bureau).

efforts of Representative Gerald Ford and Mayor Sonneveldt of Grand Rapids, replaced previous plans to have a fountain with a reflecting pool in the plaza.[25] The NEA granted the commissioning agency, the Friends of the Grand Rapids Art Museum, $45,000, and an additional $82,900 was raised through private donations.

Calder was chosen for the project by a seven-member committee. The NEA appointed four members: SOM architect William Hartmann, whose firm had designed the two buildings fronting on the site, landscape architect Hideo Sasaki, painter Adolph Gottlieb, and Gordon Smith, then Director of the Albright-Knox Art Gallery in Buffalo. Three local representatives were appointed by the Mayor: businessman Robert Blaich, Walter McBride (Director of the Grand

101

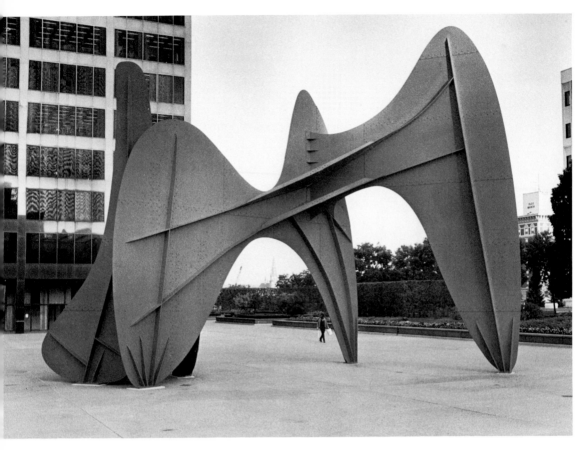

Figure 39. Alexander Calder, *La Grande Vitesse*, 1969, Grand Rapids, Mich. (Teresa Hernández).

Rapids Art Museum), and city planner Paul Jones, who also acted as project coordinator. According to John Beardsley, "The panel selected Alexander Calder, in part because of his stature as an artist, and in part because the scale, color and composition of his work could be relied upon to provide a commanding focal point for the large plaza."[26]

Calder's first public sculpture, the mobile *Flight* (installed at Kennedy International Airport Arrivals Building in 1957) was commissioned by the Port Authority of New York and New Jersey.[27] At the time of his death in 1976 at the age of seventy-eight, Calder was probably the best known and most prolific American public sculptor. John Russell, in an obituary on the front page of *The New York Times*, noted that "more than any other American artist, Calder penetrated the awareness of the public at large" both through his lobby mobiles and stabiles "which can be seen outdoors at Lincoln Center and the

102

World Trade Center in New York, on the Empire State Plaza in Albany, in the Federal Center Plaza in Chicago, in a plaza in Grand Rapids, Michigan, and in open spaces throughout Europe, Japan, Australia and South America."[28]

Like the Chicago Picasso, Calder's public sculptures were not created by the artist's own hand. Calder began by making a small model; he then cut full-size parts in paper (templates) which were turned into metal plates at the foundry where the pieces were fabricated.[29] As a trained engineer, Calder was able to handle questions of structure with relative ease.

Calder's public pieces, more than Picasso's, seem comfortable at a large scale. Without the direct figural references of Picasso's work, Calder's anthropomorphic forms appear friendly rather than gigantic or inflated, even at a great height. His basic vocabulary of artistic forms remained relatively constant. It was established almost immediately after his conversion to sculpture in the 1930s, inspired by the primary colors of Mondrian and the whimsical biomorphic shapes used by Miro.[30] His cheerful, lively sculptures provided a welcome contrast to the harsh geometry of modern architecture and the often barren urban spaces in front of these buildings.

In Grand Rapids, Calder's sculpture became the focal point for much more than an empty urban space. Initially it inspired a public controversy focusing on Calder's living and working in France, his abstract style, and the choice of sculpture to replace the originally intended fountain.[31] Ultimately, however, the sculpture became a literal civic symbol, the logo on official stationery and city vehicles, including garbage trucks. A brochure published by the Grand Rapids Chamber of Commerce tells visitors that to "gaze up along its massive, sweeping planes is to catch something of the vitality, newness and progress that is Grand Rapids today." *La Grande Vitesse* gave the city a new image. A local businessman remarked, "We had lost our identity. The Calder was like a great big heart bringing us to life again,"[32] an unusual function for a sculpture without commemorative or other recognizable content. However, one of the "virtues" of abstract modernist sculpture in a public context is that almost any interpretation may be attributed to it.

The Calder became "the symbol of urban optimism the civic group desired."[33] The community's experience with the Calder inspired the Women's Committee of the Grand Rapids Art Museum to sponsor a city-wide exhibition of large-scale outdoor sculpture a few years later,

in 1973.[34] As a result of *Sculpture Off the Pedestal,* the city acquired a permanent land reclamation sculpture by Robert Morris (see Chapter 5) as well as a familiarity with the work of Mark di Suvero that led to subsequent community support for a problematic GSA commission (discussed below). Calder Plaza, as it came to be called, continues to be used for a variety of local events ranging from cultural performances to ethnic food fairs.

One of the negative results of this use of art is that it is no longer seen as art—either by the general public, for whom it may become something of a totem, or for art critics, who have largely ignored public art anyway. In any event, *La Grande Vitesse* is not a particularly inspiring Calder. Rather clunky from a variety of views, with too many ribs to allow a sense of grace, it is nevertheless big enough and red enough to make a difference in Grand Rapids' dreary downtown area. As a work of art it is markedly inferior to Calder's *Flamingo* in Chicago, a GSA commission of 1973[35] (fig. 40). In the open area in front of Chicago Federal Center, designed by Mies van der Rohe, *Flamingo's* soaring red arches provide a source of energy and visual excitement. People walk through the fifty-four-foot-high sculpture as a matter of course. In its

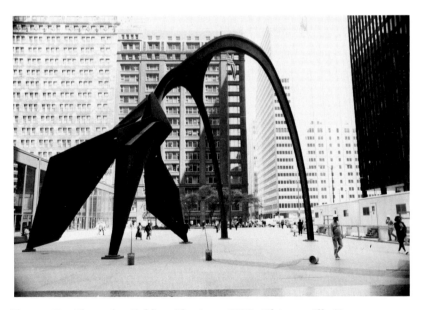

Figure 40. Alexander Calder, *Flamingo,* 1973, Chicago, Ill. (Burt Roberts).

eccentric placement the sculpture reaches out into the open urban space and appears to gather it together.

This GSA commission was the first after the reactivation of the program in 1972. The choice of Calder was championed by one of the architects of the building, Carter Manny, Jr., who, as a member of C. F. Murphy Associates, had also been involved with the Chicago Picasso project. In his application to the GSA, Manny stated, "Clearly the artist should be an American, and someone of comparable stature to Picasso and Chagall. There is only one man who meets these two requirements: Alexander Calder."[36] By the early seventies Chicago already had major public pieces by both European artists. Given the criteria of international reputation and, in Calder's case, even experience with large-scale public commissions, Manny's assessment was accurate. He fueled his argument by noting that Mies was known to have admired Calder's work.

Calder in circus garb was present at the dedication on October 26, 1974, where Manny, functioning as the ringmaster, hailed him as Alexander the Great. Chicagoans by now knew how to launch a public sculpture public-relations spectacle, and this dedication with "marching bands, calliopes, clowns, antique red-and-gold circus wagons, elephants, and balloons" was no exception.[37] In our pageant-poor society, events such as these at least provide some occasion for communal celebration as well as self-congratulation. On this occasion, however, there was also something real to celebrate. *Flamingo*, a truly successful public sculpture, enlivens its environment and apparently the spirits of its many viewers.

Another early titan of the recent wave of public sculpture, Henry Moore, once said, "I don't like sculpture used as costume jewelry, which is what happens when it is pinned onto a building."[38] He was referring to a bronze relief on the wall of the Israel Museum in Jerusalem, a work of 1959. Since the late 1940s Moore had also been making freestanding sculptures placed in various outdoor locations in Europe. For Moore the ideal site for his sculpture was nature:

To display sculpture to its best advantage outdoors, it must be set so that it relates to the sky rather than to trees, a house, people, or other aspects of its surroundings. Only the sky, miles away, allows us to contrast infinity with reality, and so we are able to discover the sculpture's inner scale without comparison. Such viewing frees the imagination.[39]

Indeed, Moore's sculptures with their gently undulating curves and combined allusions to figure and landscape seem most comfortable when sited in nature. Moore worked in the English countryside, where the open spaces around his studio in Much Hadham served as direct inspiration. Much of his formal vocabulary derives from his response to this setting.

Moore's status as a major twentieth-century sculptor was established on an international scale after his retrospective of 1946–47 at the Museum of Modern Art in New York, organized by James Johnson Sweeney.[40] By the time of his death in 1986, more than 75 percent of his works were in America, and his fame was comparable to Calder's. During the 1960s there was a general increase in Moore's public commissions, and the sculptor thought a great deal about the problems of siting his works. He was wary of working with architects and architectural sites. Nevertheless, he was a favorite of Mies van der Rohe, I. M. Pei, and Gordon Bunshaft, among others, who admired his work and used it in conjunction with their buildings.

At one time Mies had wanted Moore to make two sculptures for the forecourt of the Seagram building in New York, in an area now occupied by two rectangular pools. However, the sculptor declined because he didn't want to work in pairs and didn't like the variables of the Park Avenue site, especially the adjacent buildings.[41] I. M. Pei was more successful. He obtained Moore sculptures for several of his buildings, including the library in Columbus, Indiana (1969), the East Building of the Washington National Gallery (1978), and the Dallas City Hall (1978). Of these Paul Goldberger observed:

In each case the work of art exists as a kind of antidote to the architecture—as a lightening device, a softener. The plastic forms of the Moore sculpture provide a formal counterpoint to the hard edges of the building, suggesting that the architect's desire was not solely to create harsh forms . . . it says that the architect does respect humanist values and that he does seek to have them present in his work.[42]

Gordon Bunshaft of SOM was instrumental in obtaining a Moore sculpture for Lincoln Center in New York City in the mid-1960s. Involved with the completion of the Vivian Beaumont Theater, designed by Eero Saarinen, he was also a member of the Lincoln Center art committee, which included Alfred Barr, Andrew Ritchie, Frank

Stanton, and John D. Rockefeller III. Rockefeller secured a commitment of funds from Albert List,[43] and Moore was subsequently chosen by the art committee, whose members were all familiar with his work. Bunshaft, who had by this time established a practice of including art in SOM projects, was the one to approach Moore.

The sculptor chose *Reclining Figure,* a previously conceived work to be built at a scale that would not have been economically feasible without a special commission[44] (fig. 41). Moore dismissed as impossible any attempt to relate the sculpture to four different buildings and concentrated instead on "the space of the square" and the pool. Wanting to maintain continual visual interest and provide "a contrast to the architecture which, like all architecture, is rather geometric and static," he used visual allusions to "natural forms of both the figure and of landscape and of rocks."

The Lincoln Center Art Committee made all the arrangements for the Moore sculpture to be sited in the pool between the Vivian Beaumont Theater and the Metropolitan Opera House, and at the same time for Calder's *Le Guichet* to be placed near the entrance to the Library of the Performing Arts (fig. 42). This was done privately without consulting the Art Commission (which in New York City must approve all works of art permanently placed on public property) or the

Figure 41. Henry Moore, *Reclining Figure,* 1965, Lincoln Center, New York City. (Susanne Faulkner Stevens, courtesy Lincoln Center for the Performing Arts).

Figure 42. Alexander Calder, *Le Guichet*, 1965, Lincoln Center, New York City. (Susanne Faulkner Stevens, courtesy Lincoln Center for the Performing Arts).

Department of Parks, under whose jurisdiction Lincoln Center came. Then, in 1965, when plans for the sculptures became known, they were almost rejected by various members of the Art Commission in New York City, by then the acknowledged capital of the art world for some twenty years.

Newbold Morris, the Parks Commissioner, at first refused the Calder because of his dislike of abstract art. According to Morris:

Art is supposed to transmit thought, not be decorative. Unless it transmits thought to me, I don't get it. I'm in love with representational art. Give me a 19th century French painting and I go to pieces. Moses [Robert Moses, his predecessor as Parks Commissioner] was here for 26 years. It was hard to get anything abstract past him.[45]

Thus Morris appeared to make anti-abstraction a Parks Department policy. For a politician Morris was uncommonly blunt about his convic-

tions; here too he seemed to be following in the footsteps of his predecessor.

At this juncture some behind-the-scenes lobbying took place.[46] The Art Commission was split on the actual vote, and Arnold Whiteridge, president of the commission and trustee of the Metropolitan Museum of Art, cast the deciding vote in favor although he "regretted his responsibility." The negative votes of both the painter and sculptor members are of particular interest. Sculptor Eleanor Platt voted on the basis of her position at the National Sculpture Society. She said at the meeting that although she liked the sculpture well enough to approve it, she traveled in conservative circles and many of her clients who were lawyers and judges would not approve of such a choice. Painter Frank Reilly also voted against the sculptures because of his artistic affiliation with the Art Students League. By his negative vote he was objecting to the lack of funds for similar projects for members of this group. Thus the artist members voted along lines of professional self-interest.

It is difficult today to think that Moore and Calder, along with Picasso, could in the 1960s be considered avant-garde or revolutionary. Rather, these artists seem safe choices of "establishment modern," offering the same reassurance as a brand name. If you order a Moore or a Calder, you pretty much know what you will get. Indeed, the Lincoln Center sculptures neither add to nor detract from our conception of these sculptors' ideas and works.

Moore was happy with the *Reclining Figure* in that he felt "its size in relationship to the four buildings all around it and to the plaza is just about right."[47] However, he was disappointed by the water level in the pool because it "has never been the height I was told it would be, and which I allowed for when making the sculpture. The level is always too low; sometimes the pool is nearly empty. In consequence, too much is visible of what was meant to be the underwater part of the supporting 'legs.'"[48]

Although he clearly considered the site, Moore's primary focus was on the sculptural object. Moore's public sculpture, often made in editions of three or four, can today be seen in several different settings. This practice emphasized the sculptor's approach of creating independent works of art rather than making something for a specific site. According to Moore, "A successful piece of sculpture must work well everywhere. As I work on a piece, I am not concerned with making it suitable to the outdoors or the indoors—except under very unusual

circumstances. A fine person cannot just be good at a party, he must behave consistently everywhere."[49]

For the first decade of the public sculpture revival of the late sixties, this appeared to be a viable approach. Although esthetic considerations played a part in the selection of artists such as Picasso, Calder, and Moore, it was reputation rather than style that was primary. Picasso had done no large-scale public sculpture, so the Chicago commission could not have been based on precedent. It was motivated by the name "Picasso." Certainly, the artist's Cubist-inspired style hardly made sense to a general audience. Calder and Moore also enjoyed international reputations. However, their individual styles of biomorphic abstraction seemed more accessible once the initial public resistance to anything abstract was overcome. By the mid-1960s neither Cubist-derived nor biomorphic styles represented the latest developments in contemporary sculpture. Rather, they were styles established in Europe earlier in the century, familiar to an art audience (almost to the point of invisibility) but unfamiliar (often radically so) to the general public.

Louise Nevelson entered the public art field only slightly later than her more famous male contemporaries. In 1969 she was commissioned by Princeton University to create her first monumental sculpture in Cor-Ten steel.[50] The Putnam Sculpture Collection, established in 1968, was the result of an endowment donated to the university as a memorial for John B. Putnam, Jr., a twenty-three-year-old Princeton student who interrupted his studies to enlist in World War II and died while flying a combat mission. The Putnam gift was motivated by a belief that modern sculpture was "becoming a symbol of a new creative freedom in man."[51] The collection, under the stewardship of the university's art museum, may be seen as an extension of the museum's collection. Art professionals were involved in the selection of objects, and the teaching function of art was always emphasized.[52]

Nevelson's *Atmosphere and Environment X* was among the first seven works purchased for the collection[53] (fig. 43). It was sited adjacent to Firestone Library, where it could also be seen from Nassau Street (the town's main street), thereby ensuring the greatest possible public visibility for the piece. This sculpture became the first of several pieces that Nevelson executed in Cor-Ten steel during the next decade. The indoor pieces for which she was already famous were primarily constructed of wood, a material that allowed for greater flexibility and variety of shape and texture. In general, the open metal pieces capture

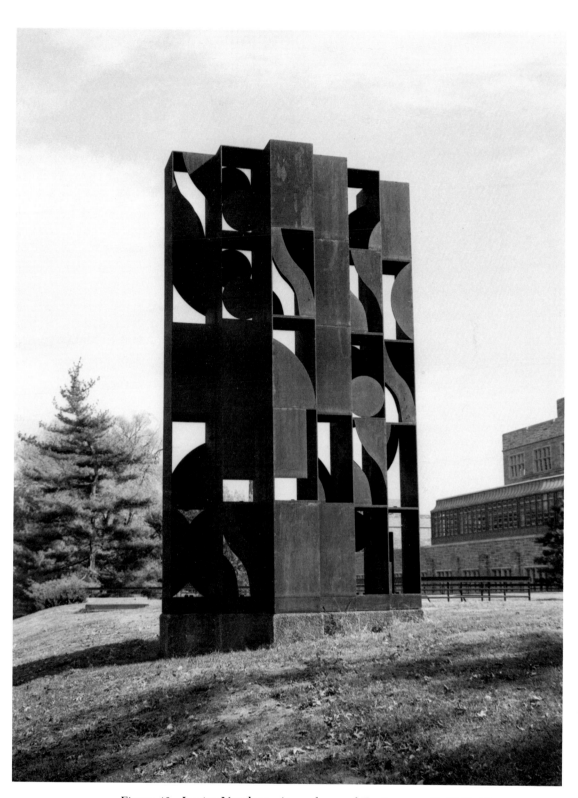

Figure 43. Louise Nevelson, *Atmosphere and Environment X*, 1969–70, installed 1971, Princeton University, Princeton, N.J. (courtesy The Art Museum, Princeton University, The John B. Putnam Jr. Memorial Collection).

some the formal qualities of the wooden assemblages but lack their mysterious and somewhat magical content.[54]

Nevelson's twenty-one-foot-high sculpture at Princeton assumes the proportions of an architectural wall or screen.[55] The artist frequently referred to herself as both an "architect of shadow" and an "architect of light," while Martin Friedman, then Director of the Walker Art Center in Minneapolis, described her work as "phantom architecture."[56] At Princeton, Nevelson's "architecture" bears little relationship to its surroundings. The phantom quality of much of Nevelson's indoor work is dissipated by the benign suburban setting. Its inclusion here, the only work by a woman artist in the Putnam collection, is surely a testament to her established art-world reputation.

A more significant reflection of her status is the commission for Louise Nevelson Plaza in lower Manhattan, dedicated in 1978 by Mayor Koch and David Rockefeller (fig. 44). Although the so-called vest-pocket park had been planned for some time, city budget constraints held up the project. The sculpture was donated by the same private foundation that endowed the Princeton collection, the Mildred

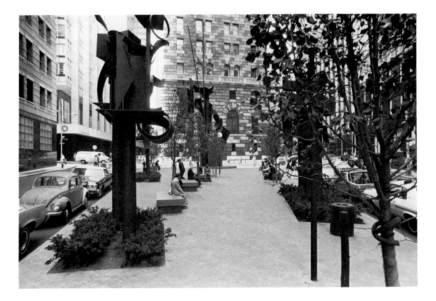

Figure 44. Louise Nevelson, *Shadows and Flags,* 1978, Louise Nevelson Plaza, New York City (William R. Devine, courtesy The Chase Manhattan Bank).

Andrews Fund. Funding for construction, maintenance, and security was obtained from a combination of local corporations.[57] The seven black welded-steel sculptures entitled *Shadows and Flags* were conceived by the artist to "appear to float like flags" with some tall shafts as high as seventy feet, like official art banners. However, in the cavernous pits of Wall Street, this dark grouping is scarcely noticeable.

At the initial dedication of the site (then still referred to as Legion Memorial Square), Nevelson was hailed by Mayor Beame as a native New Yorker, and her sculpture seen as an antidote to a spate of recent violence in the city. "But this is the New York City we care about," the mayor stated, "and want to preserve."[58] The marriage of high art and finance to promote a desirable civic image could hardly be articulated more clearly.

Another marriage of public art and big business occurred in Nevelson's *The Bendix Trilogy* (1979) for Bendix corporate headquarters in Southfield, Michigan (fig. 45). Once again dedication remarks proved most telling. The chairman and chief executive officer of Bendix, William M. Agee, observed that the sculpture was "helping Bendix develop its corporate personality to its full potential."[59] He also acknowledged that the "architectural environment . . . begged for a complement of appropriate art." Nevelson was chosen as "one of the world's most acclaimed contemporary artists," and the choice of abstract art praised for allowing a range of individual experiences and interpretations. ("Each of us can and will react in our own way to the way Ms. Nevelson applied her powers of fantastication to *The Bendix Trilogy*.") Thus Agee acknowledged the function of the sculpture (named after the corporation) as corporate public relations, architectural ornament, and public munificence. In the choice of artists, once again, fame was cited as the main factor.

The Figurative Tradition: Lipchitz, Dubuffet, King

Once a public art patronage system was established (via government programs and corporate support) and precedents set, the proliferation of public art was assured. The selection of artists expanded to include other sculptors whose names alone did not immediately confer credibility on the patron. Initially there may have been public expectations that the nineteenth-century tradition of figural sculpture in the public realm would continue, perhaps in an updated mode. However, during the 1960s few sculptors were working in styles with recognizable

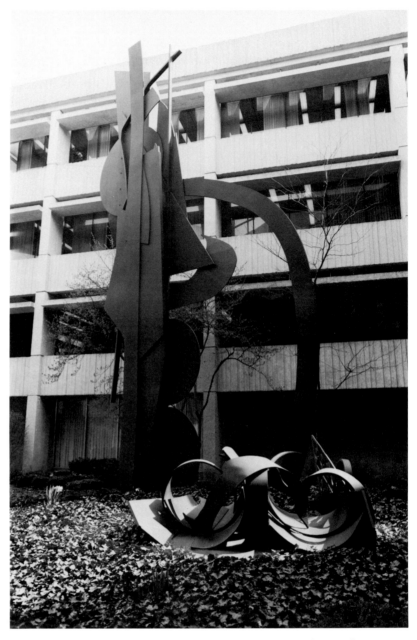

Figure 45. Louise Nevelson, *The Bendix Trilogy*, 1979, The Bendix Corporation, Southfield, Mich. (detail) (courtesy Allied-Signal Inc.).

imagery—and even fewer on a scale able to withstand the visual competition of the contemporary urban environment.

One notable exception was the Lithuanian-born Jacques Lipchitz, who came to this country in 1941. Initially working in Paris in a Cubist style, he eventually evolved an expressionistic abstraction characterized by recognizably human and animal shapes. Their violently compacted energy and dense convoluted forms reflected Lipchitz's emotional response as a Jew to the events of World War II.[60] They convey struggle, torment, and agony.

Bellerephon Taming Pegasus, installed on the overpass in front of Columbia Law School in 1977, is typical of Lipchitz's mythological references[61] (fig. 46). Purchased through a special law school fund, the thirty- by twenty-eight-foot sculpture achieved the artist's ambition of architectural scale. Although the sculpture certainly can be adequately seen from its environs, it is not as easily understood. The subject is hardly obvious or even familiar to a contemporary audience. Furthermore, it is in no way directly related to its site at the law school.

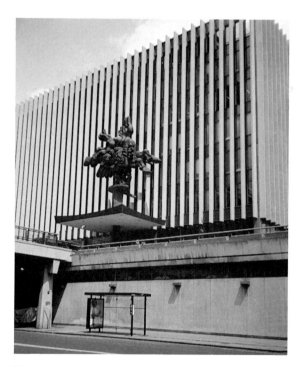

Figure 46. Jacques Lipchitz, *Bellerophon Taming Pegasus,* 1977, Columbia University Law School, New York City (Harriet Senie).

Rather, the sculpture derives its significance from being art, or perhaps more accurately, standing for modern art. Albert Elsen wrote that *Bellerophon Taming Pegasus* "should daily remind those who see and pass under it that it is the law's function to maintain a society in which the creative individual is free not only to choose and pursue purposes, but to forge his own intellectual claims."[62] Here art in general, and modern art specifically, stands for freedom of thought and expression. As with the Chicago Picasso, any example of modern art would serve as well.

Although more playful and accessible, the figurative works of Jean Dubuffet also function in this generic way. His *Group of Four Trees*, installed in 1972 at Chase Manhattan Plaza in New York City, was part of a larger pattern of art collecting at the bank (fig. 47). The building, erected in 1961, was designed by SOM with Gordon Bunshaft as the partner in charge. Bunshaft saw the plaza art, as well as the art inside the offices, as a benefit to employees akin to health insurance and vacations.[63] Bunshaft's commitment to art reflected his personal taste in collecting, a commitment shared by David Rockefeller, Chase Manhattan's chairman of the board. At Chase an art committee of museum officials (Alfred Barr, James Sweeney, Robert Hale, Perry Rathbone, Dorothy Miller) and Bunshaft was created to advise on the purchasing of art. Eventually the Chase collection came to include more than 6,000 works of art and required a full-time curator.[64]

Noguchi was chosen to design the plaza (an enormous boon of open space to downtown Manhattan) and the sunken rock garden that illuminates the lower levels of the bank.[65] In addition, according to David Rockefeller, the art committee felt that the 2½-acre plaza "needed a vertical counterpoint to stand against the assertive personality of the Chase building and at the same time offer informal relief from the severe lines of the immediate architectural landscape."[66] As might be expected, the most obvious and established names were considered first—Calder, Moore, Noguchi—but all, surprisingly, were deemed unsuitable. Giacometti was involved briefly, but he died before he could develop a suitable proposal.[67]

After a frustrating ten-year search, Alfred Barr suggested the French artist Jean Dubuffet, and Bunshaft offered to see the sculptor immediately to interest him in the commission. After studying the problem, Dubuffet sent a number of small models, ranging in height from one and one half to two feet, for the art committee's consider-

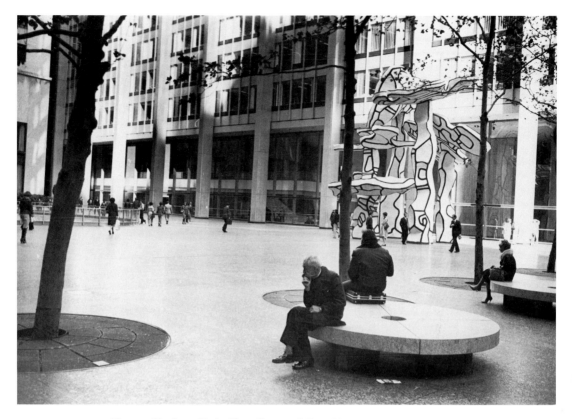

Figure 47. Jean Dubuffet, *Group of Four Trees,* 1969, installed 1972, Chase Manhattan Plaza, New York City (Frank Leonardo).

ation. When these were placed in front of an enlarged photograph of the building, the committee unanimously agreed on *The Four Trees,* which was, according to Dorothy Miller, the least complicated piece.[68]

The sculpture was presented to Chase and the downtown business community by David Rockefeller in 1972 to celebrate his twenty-fifth anniversary on Wall Street. *The Four Trees* adds a welcome note of whimsy to the plaza while softening the harsh geometric monotony of the building facade. However, its close juxtaposition to the architecture, necessary to have the sculpture in view from Broadway two blocks away, creates a visually uncomfortable squeeze on the bank's own plaza.

A different kind of tension is created by Dubuffet's *Monument à la Bête Debout* (Monument with Standing Beast) in Chicago (fig. 48). Placed in front of Helmut Jahn's State of Illinois Building in 1985, the twenty-nine-foot-high fiberglass sculpture was conceived by Dubuffet in 1969 around the same time as *The Four Trees.* Both are part of the

117

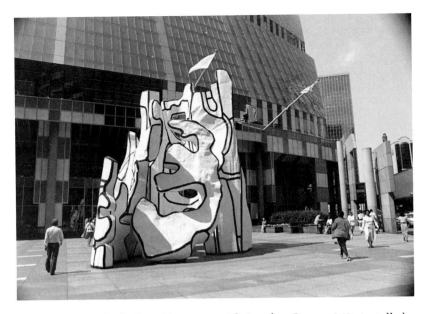

Figure 48. Jean Dubuffet, *Monument with Standing Beast*, 1969, installed 1985, State of Illinois Building, Chicago, Ill. (Burt Roberts).

artist's *L'Hourloupe* cycle, begun in 1962 "as the figuration of a world other than our own." Dubuffet made up the name *L'Hourloupe* because, "In French, these sounds suggest, at the same time, some fantastic or grotesque object or creature, as well as evoking something rumbling and threatening with tragic overtones—indeed both of these things together." He intended the sculptures of this cycle to promote "an awareness of the illusory character of the world which we think of as real, and to which we give the name of the real world" and to introduce "a doubt about the true materiality of the everyday world."[69] This interpretation, however, is not accessible to many.

The Chicago Dubuffet, privately funded like its New York counterpart, consists of four pieces.[70] Not easily identifiable, it appears to cause some discomfort among the general public.[71] Although *Monument à la Bête Debout* is an interesting piece to explore, people tend to walk around it, either ignoring or consciously avoiding the sculpture. Unhappily cramped in its location and overpowered by Jahn's aggressive and colorful postmodern building, the sculpture cannot hold its own. At Chase Manhattan, *The Four Trees* provides a welcome contrast to Bunshaft's pristine geometric design, but at the State of Illinois Building, Dubuffet's sculpture competes unsuccessfully with the monumental playfulness of the architure.

Although the images of Lipchitz or Dubuffet may produce some

118

consternation among the public, this is never so with the friendly work of William (Bill) King. The American sculptor, committed to figural sculpture since his student years at Cooper Union (1954–58), began to pursue work in the public realm in 1973, when he was invited by the State University of New York (SUNY) to visit three of its campuses and create a sculpture with the aid of local students at each location.[72] This project, sponsored by a university-wide committee on the arts and the Edward John Noble Foundation, resulted in three permanent pieces, one each at SUNY Potsdam, New Paltz, and Fredonia, entitled *Books* (fig. 49), *Twins,* and *Words,* respectively.

While King has experimented with a number of different materials, his sculptures are always recognizable—tall thin figures (echoing the sculptor's physique) whose simplified gestures convey their essential humanity.[73] A gesture of helpfulness is the essence of *Learning* (1975) at Lincoln Hospital in the Bronx. Seen in silhouette, a nine-foot-high adult figure bends over to assist a small child. In *Help* (1979), a thirty-two-foot-high sculpture at Detroit Receiving Hospital, a large figure

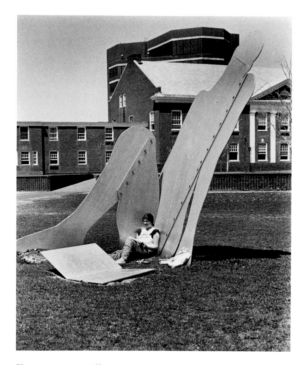

Figure 49. William King, *Books,* 1973, SUNY Potsdam, N.Y. (courtesy Potsdam College of the State of New York).

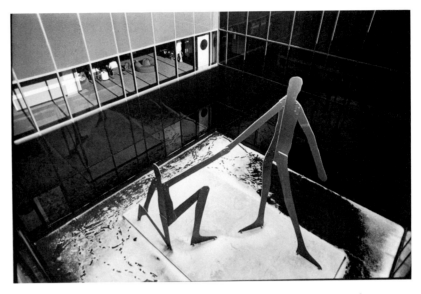

Figure 50. William King, *Help*, 1979, Detroit Receiving Hospital, Detroit, Mich. (Francis Schklowsky, courtesy Terry Dintenfass Gallery).

also extends a helping hand to a smaller one (fig. 50). The New York City piece was sponsored by public money; the Detroit piece by private funds. Both sculptures address emotions appropriate to their hospital locations.[74]

Since the early 1970s King has produced a body of public sculpture that eschews cosmic themes in favor of the details of the human comedy. Far from the histrionic or ironic stance of much recent art, King's work is warm, witty, and gentle. He captures revealing postures that define a way of being in the world.[75] His public sculpture is a friendly comment, without rhetoric, on the human condition. Although figurative and accessible, his work to date has remained largely outside the critical mainstream of recent public art.

The Constructivist Tradition: Rickey, Snelson, di Suvero

Far stronger in recent public sculpture than the figurative tradition, as expressed variously in the works of Lipchitz, Dubuffet, and King, is the heritage of Constructivism. Both its emphasis on technology and the use of industrial materials gave it a modern look congruent with the contemporary urban landscape. The Russian Constructivists embraced technology both as a tool for building and a symbol of a new society in which artists were to play an integral role. Tatlin's well-known

120

unbuilt project for a *Monument to the Third International* of 1920 be-
came the symbol of this aspect of Constructivist art and seemed to
prefigure many later developments in twentieth-century sculpture.
Planned for a colossal size (1300 feet, over 300 feet higher than the
Eiffel Tower), it rivaled architecture in scale as well as form. Intended
as a kinetic structure, it was to include a variety of modern industrial
materials, among them metal and glass.

Constructivist theory was committed to public art. In the famous
Realist Manifesto of 1920 by the brothers Naum Gabo and Antoine
Pevsner, written to coincide with an outdoor art exhibition, Gabo
announced the desired link between Constructivist art and the public:

Today we proclaim our works to you people. In the squares and on the
streets we are placing our work convinced that art must not remain a
sanctuary for the idle, a consolation for the weary, and a justification for
the lazy. Art should attend us everywhere that life flows and acts . . . at
the bench, at the table, at work, at rest, at play; on working days and
holidays . . . at home and on the road . . . in order that the flame to live
should not extinguish in mankind.[76]

Unfortunately, when the "First Exhibition of Russian Art" was held
at the Van Diemen Gallery in Berlin in 1922, the public art aspect of
Constructivism was not emphasized, and Constructivism was subse-
quently disseminated throughout western Europe without it.[77] Gabo
himself did not accomplish this goal until almost forty years after the
publication of the *Realist Manifesto*.[78] Latter-day Constructivists like
George Rickey, Kenneth Snelson, and Mark di Suvero used technology
as a formal element in their work, without the accompanying sense of
revolution in politics or art. Rickey, utilizing a simple system of ball
bearings, created a lyrical body of work. Snelson made elegant, almost
visionary scientific-looking structures and di Suvero transformed in-
dustrial materials into powerful but accessible sculpture.

George Rickey shares Henry Moore's commitment to sculpture as an
independent object—art before public art. For Rickey "all good art is
public."[79] The subject of his sculpture is movement—a slow, graceful
motion activated by natural air currents. His simple geometric shapes
of stainless steel have surfaces that are ground to catch and respond to
light. Thus Rickey establishes a partnership with nature, allowing
wind and light to enliven his work in constantly changing ways. For the

artist, "aesthetic demand is always pushing against technical re-sistance." Using a simple technology based primarily on pendulums, gimbals, ball bearings, and shock absorbers, he is fond of saying that the Romans had the means to make his sculptures if they had so desired.

Rickey considers the architecture, landscaping, and the natural factors of wind and sun before offering clients a choice of possible pieces. For the Albany Mall, the remodeled center of the New York State capitol, Rickey made three proposals.[80] The first was to cover one of the pool surfaces with undulating squares of stainless steel, which

Figure 51. George Rickey, *Study for Albany Mall Commission*, 1966–67 (courtesy George Rickey).

would lock in winter to form a continuous surface impervious to snow (fig. 51). When the Albany Mall art committee members (architect Wallace Harrison, museum directors Rene d'Harnoncourt and Robert Doty, and art patron Seymour Knox) rejected this proposal,[81] Rickey suggested *Lumina I*, a tower with many rotating parts. The committee, however, preferred a more typical Rickey sculpture, and in the end his third proposal, *Two Lines Oblique* (1967–71), was accepted. Rickey then rejected the offered site on the roof of a covered walkway and all finally agreed on the current placement on the mall (fig. 52).

What makes kinetic sculpture particularly suitable for public spaces is the immediate interest evoked by anything that moves. Since Rickey's work is wind driven (even though the movement is controlled), it is seen in constantly changing configurations. At the Albany Mall, Rickey's fifty-four-foot-high graceful linear blades are seen to good advantage against the blocklike facades of the modern buildings that define its immediate visual environment.

A more complex piece, *Triple L Excentric Gyratory, Gyratory II* (1980), works equally well with the postmodern facade of Coca-Cola Headquarters general reception building in Atlanta, designed by the local firm of Heery Architects and Engineers, Inc[82] (fig. 53). Each L rotates independently, creating a constantly changing choreography. The metallic surface, elegantly set off by the stark white of the building facade, reflects the changing natural light patterns. Awarded the Atlanta Urban Design Commission Award of Excellence in 1986, the year of its installation, it was purchased as part of the celebration in honor of the company's hundredth anniversary. Accordingly, *Triple L Excentric Gyratory, Gyratory II* (an awkward title, at best) was renamed *Leadership* by Coca-Cola executives, presumably to relate it to company rhetoric. A color brochure advertising the corporate art collection states:

We have selected this sculpture because of the evocative connection between the three L's forming its main motive and LEADERSHIP, the name by which we now know it. Leadership distinguishes our Company: leadership in people, leadership in products, and leadership in integrity. This sculpture symbolizes this style of leadership. Its free movement, seemingly random but finely controlled, uses the potential adversity of wind and turns it into advantage. Its elements interact in a whole range of motions and eventually come together in never static harmony.

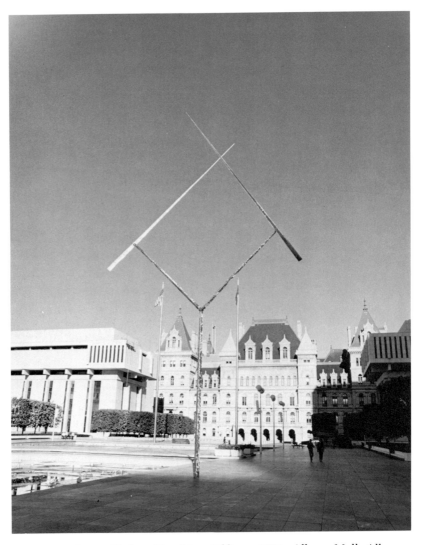

Figure 52. George Rickey, *Two Lines Oblique*, 1971, Albany Mall, Albany, N.Y. (courtesy State of New York, Governor Nelson A. Rockefeller Empire State Plaza Art Collection).

In spite of this offensive corporate appropriation of art, *Triple L* succeeds esthetically and publicly. Both employees and visitors notice it, talk about it, and genuinely seem to like it.

Kenneth Snelson creates sculptures that, like Rickey's, are very elegant. Snelson's art is firmly linked to the Constructivist tradition by its use of industrial materials (primarily stainless steel tubes and cables) and its emphasis on structure. In 1948–49 at Black Mountain

124

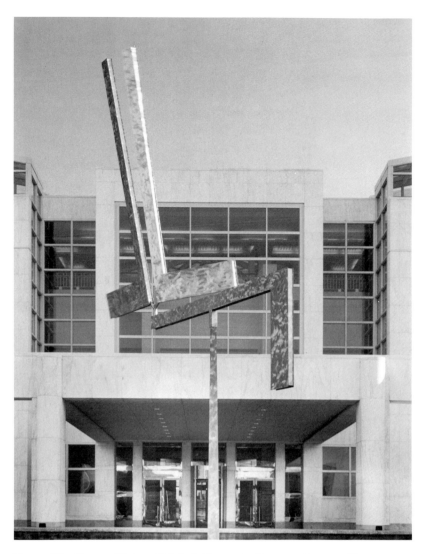

Figure 53. George Rickey, *Triple L Excentric Gyratory Gyratory II*, 1986, Coca-Cola Headquarters, Atlanta, Ga. (courtesy The Coca Cola Company).

College, Snelson first began to create free-floating fragile-looking linear networks of forms by experimenting with what Buckminster Fuller later called "tensegrity."[83] By the late 1960s, Snelson had defined his work as being about "the conflict between tension and compression resolved in a closed system," or, more casually, "a dialogue between push and pull."[84]

Snelson's structures are an expression of his concern with the theoretical structure of the universe.[85] Since a scientific basis is implicitly

conveyed by the appearance of the work, the siting of *Easy Landing* (1977) in front of the Maryland Science Center seems particularly appropriate (fig. 54). Commissioned by the city of Baltimore for Inner Harbor, Snelson's sculpture may be seen both against the building facade and the bustling waterfront that is the showcase of Baltimore's urban renewal efforts.[86] The large composition of stainless steel compression tubes and tension cables measuring 30' × 85' × 65' easily captures the attention of pedestrians along the Inner Harbor promenade. Evocative of scientific principles and engineering feats, it elicits many questions and discussions about how it is made and what holds it up. Featured on the cover of the local publication *Baltimore's Public Art: 1960–1980,* and credited by the city's art-minded Mayor William Donald Schaefer as embodying "optimism, vitality, [and] strength," it also conveys a faith in science and technology that seems to belong to a more optimistic time.

Like Rickey and Snelson, Mark di Suvero also works in a Constructivist-inspired style.[87] His *Under Sky/One Family* (1979), located diagonally across from Snelson's sculpture at Baltimore's Inner Harbor, just east of the World Trade Center, is far less successful in either form or

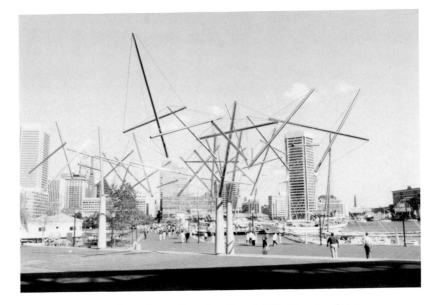

Figure 54. Kenneth Snelson, *Easy Landing,* 1977, Maryland Science Center, Baltimore, Md. (Burt Roberts).

siting (fig. 55). Partially funded by the NEA's Art in Public Places Program, it consists of a fifty-five-foot-high tripodlike construction of steel I-beams and adjacent to it a ship's propeller and a section of steel beam, lying on the ground. Di Suvero took his title from a Confucian ideogram and said at the dedication ceremony that he wanted the sculpture to "symbolize progress and forward-looking urban policy."[88] His words, more than the work, expressed the city's wish for a sculpture symbolic of, or in the spirit of, its renewal efforts.

The visual appearance of the work is confusing. Although the cross bar of the sculpture suggests a cruciform shape, this can hardly be interpreted as the content of the piece or even its primary visual reading. If anything, the grounded disconnected propeller suggests a shipwrecked ruin, and the vertical element with its abruptly truncated

Figure 55. Mark di Suvero, *Under Sky/One Family,* 1979, Baltimore Inner Harbor, Baltimore, Md. (Burt Roberts).

apex suggests a fallen banner or symbol. However, such a negative interpretation would be inconsistent both with the sculptor's work and this site. As it stands today to one side of the busy redeveloped waterfront, the sculpture appears to be largely ignored, even by those seated in the grassy area immediately around its base. There has been little controversy over the piece, largely as a result of a carefully planned and cautiously scheduled official public introduction. However, there has been some expression of disappointment that it is not more like a typical di Suvero sculpture. That is to say, it has no movable parts or climbable components—those aspects of the sculptor's work that make it physically, if not intellectually, accessible.

At times, however, these elements have also been perceived as dangerous. Di Suvero's *Moto Viget* (strength and activity), a GSA sculpture installed in Grand Rapids in 1976, today has a yellow "danger" sign in front of it (fig. 56). The fifty-four-foot-high sculpture consists of three intersecting I-beams with a suspended rubber tire swing. Situated around the corner from the city's famous Calder, the sculpture occupies a far less prominent site and has had far less local impact. Near the time of its installation, however, it became the focus of considerable controversy when a GSA administrator in Washington objected

Figure 56. Mark Di Suvero, *Moto Viget*, 1976, Grand Rapids, Mich. (Burt Roberts).

that its appearance had changed greatly from the sculptor's original proposal.[89] Local support for the piece came primarily from Mary Ann Keeler, a great admirer of the sculptor's work, who was instrumental in obtaining the original commission. Her well-funded and well-orchestrated local campaign was ultimately successful, another triumph of good public relations. As a result, the Keelers became known locally as "the Medicis for public art."[90]

In the small industrial French city of Chalon-sur-Saône, where contemporary art was not well known, di Suvero exhibited a number of works in public places in 1973–74 that reportedly met with widespread acceptance. This opportunity came about through the efforts of a nearby regional museum director, Marcel Evrard, and the local mayor, Roger Lagrange, who saw the exhibition as a way to promote the city as "la premiere ville-musée de France."[91] For di Suvero, living in Europe since 1970 as a protest against United States involvement in the Vietnam War, this was a welcome opportunity. He lived in the local factory, where he made the work himself and engaged the public personally, explaining his art and listening to their questions and responses.

The following year, in 1975, in conjunction with a retrospective at the Whitney Museum of American Art, di Suvero's sculpture was placed at ten sites throughout the five boroughs of New York City.[92] In helping to select the sites for the outdoor portion of the Whitney retrospective, he said, "I want human sites, places where people go. For example, the Bronx Zoo. I like the people I've seen there."[93] Other sites were scattered throughout the five boroughs, removed from the Whitney's art-world setting. A similar exhibition took place in 1988 in Stuttgart at the Wurtembergischer Kunstverein and at eight outdoor sites around the city.[94]

The same esthetic links di Suvero's museum pieces and those in the outdoor environment. His industrial-looking sculptures are imbued with personal meanings that the artist indicates through titles. The works convey the spirit, the titles their specificity. Some are inspired by individuals and some by concepts, but the connotations remain obscure. Stylistically di Suvero's work has been associated with Abstract Expressionist gesture, as seen particularly in the black and white paintings of Franz Kline. His use of industrial materials relates his work to Minimal sculpture, while the combination of materials (rubber tires, chunks of wood, etc.) also links him with those who make assemblages. His methods are Constructivist and his use of movable parts makes the work kinetic. What di Suvero adds to all these ele-

ments is the human connection—the invitation to climb, sit, swing, curl up in. This invitation to use the work links di Suvero's art with the functional public sculpture of the 1980s, which established public content primarily through physical contact and use rather than specific imagery.

Minimal Sculpture: Newman, Smith, Bladen, Serra

Minimal Art, the style that came of age with the public art revival of the 1960s, was in many problematic ways ideally suited to it. Large-scale Minimal sculpture had the same cool look as the modern architecture that usually defined its urban environment. Both obviously referred to an industrial age and a machine- or technology-based esthetic. While modern architecture lacked the humanizing elements provided in the past by sculptural ornament, Minimal sculpture lacked the human touch of the artist's hand. Although modern architecture and Minimal sculpture frequently looked good in combination, together they failed to address the expectations and needs of the general public.

Minimal sculpture became a recognized style in New York City in 1963 with the first one-person exhibitions of Donald Judd and Robert Morris,[95] just a year after Pop Art exploded on the scene. Three years later, in 1966, the exhibition of "Primary Structures," curated by Kynaston McShine at the Jewish Museum in New York, featured the work of thirteen sculptors working in several variations of a Minimal style.[96] "American Sculpture of the Sixties," curated by Maurice Tuchman at the Los Angeles County Museum in 1967, offered an even broader look at the field, including 166 works on two floors and two large outdoor areas.[97] Of these, twenty-five were created specifically for the exhibition. According to Tuchman, the exhibition emphasized scale.[98] The art critic Hilton Kramer identified the most significant new factors as "scale, materials, technology."[99]

Later the same year in New York "Sculpture in Environment," an exhibition sponsored by the Department of Cultural Affairs under the aegis of Doris Freedman, then special assistant for the department,[100] placed the works of twenty-four artists in a variety of city spaces. All the artists were involved with the choice of sites, and more than half created works that were site specific. The exhibition was defined as an effort "to integrate art and the urban environment," seen in the larger context of urban renewal. "The public (including artists)," art histo-

rian Irving Sandler wrote, "increasingly cares about the need to renew our cities and is becoming aware of the role that art can play in this. City planners agree that one way to give a neighborhood an identity is through the introduction of a landmark, and some are beginning to recognize that artists can be employed to create such monuments."[101] Typical of the thinking at the time, this placed an impossible burden on the sculpture (urban sculpture is not urban renewal) and ignored the vast alienation of the general public from contemporary art.

More than half the artists in the exhibitions worked in a Minimal or proto-Minimal style.[102] Significantly, these included Barnett Newman and Tony Smith. Newman's *Broken Obelisk* (1963–67), temporarily placed in front of the Seagram Building, provided a riveting focus for the building's forecourt.[103] Behind the Rothko Chapel in Houston, where it now stands in the middle of a rectangular pool, it creates a timeless evocation of history in the form of a deliberately modern ruin (fig. 57). In using the pyramid and the obelisk, Newman quoted the oldest known historical precedents for public sculpture, but by upending one form upon the other, he also portrayed a tradition consciously uprooted. These forms, traditional in one sense, can also be seen in the context of an emerging Minimal esthetic that Newman had for some time been exploring in his paintings.[104]

The Minimal esthetic had even more direct links to the forms of modern architecture in the work of Tony Smith. Smith, who trained and worked as an architect, was Frank Lloyd Wright's apprentice for two years.[105] He first began making sculpture in 1960 while teaching a design course at Pratt Institute and by 1966 had major exhibitions of his work at the Wadsworth Atheneum in Hartford and the Institute of Contemporary Art in Philadelphia.[106] When a group of Smith's works was exhibited in Bryant Park in New York in February 1967 (predating the "Sculpture in Environment" exhibition by a few months), one critic referred to him as "the original Primary Structuralist."[107] His work seemed to offer the perfect esthetic solution for public sculpture in an urban environment. It spoke the language of architecture in a human scale. Hilton Kramer suggested that by 1967 it was this kind of sculpture that was preserving the purity of vision of the International Style.[108]

Central to Minimal Art's relation to architecture was the new large scale necessitated by an urban setting. Initially scale was seen as the basic content of the work, as evidenced by the exhibition "Scale as Content," curated by Eleanor Green at the Corcoran Gallery in Wash-

Figure 57. Barnett Newman, *Broken Obelisk*, 1963–67, The Rothko Chapel, Houston, Texas (Hickey & Robertson, courtesy The Rothko Chapel).

ington, D.C., in 1967, featuring work by Tony Smith, Barnett Newman, and Ronald Bladen.[109] Interior works by Smith and Bladen were determined by the dimensions and configuration of the gallery spaces and were therefore site specific.

For Minimal sculpture, manufacturing also became an intrinsic part of the esthetic. While earlier artists had bronze pieces cast at a foundry, Minimal sculptors had their pieces manufactured by specialized fabricators such as Don Lippincott, who were "banking on the

trend toward large-scale architectural works"[110] and agreed to manufacture noncommissioned sculptures and display them on a five-acre field for prospective clients in return for a percentage of the eventual sale. He began with artists James Rosati, Robert Murray, Bernard Rosenthal, Marisol, Clement Meadmore, Robert Morris, Barnett Newman, Eduardo Ramirez, and William Underhill. Reported in art and architecture periodicals alike,[111] manufacturing large-scale sculpture had become a recognized practice eagerly embraced by the art world. With the anonymous look of manufactured objects, Minimal sculpture spoke in the contemporary industrial vernacular.[112]

Minimal artists, by denying any referential or humanistic content in their work, can be seen as a reflection of contemporary society.[113] By focusing their energy inward on the pure forms of art, the best of the Minimal sculptors infused their work with enormous energy and power. (How communicable this was to a non-art audience remains debatable, however.) Without the dense implosion or visual complexity of Tony Smith's best works or the dynamic explosion of Ronald Bladen's sculptural forms, much minimal sculpture remains an empty exercise in design, especially when seen in the barren spaces often accompanying modern architecture.

Tony Smith was well aware of the danger of an architectural backdrop reducing a three-dimensional sculpture into a sign. "What was plastic in suburbia became graphic in the city," he observed.[114] His GSA commission for the Department of Labor Building in Washington, D.C., installed in 1976, addressed this very problem.[115] Although Smith conceived *She Who Must Be Obeyed* earlier for an exhibition at the Whitney Museum of American Art, he carefully considered the Washington site and adjusted the sculpture accordingly (fig. 58). Located on the east plaza lawn, it is placed on a mound necessitated by structural requirements. The shape, described by Smith as "the cross-section of a space frame made up of tetrahedra and octahedra," was chosen to offset the regular geometric grid of the building facade.

The original piece was black, but Smith felt that color was necessary to ensure visibility against the building. He rejected red for iconographic reasons: "I realized that for the Labor Department to paint something red—especially since it looked like a flag anyhow—really wasn't very appropriate." Smith's sensitivity to a potential public reading of the piece was unusual. It prompted him to choose blue in order to eliminate as many non-art references as possible.[116] What interested Smith and what he wanted the viewer to concentrate on was the

Figure 58. Tony Smith, *She Who Must Be Obeyed,* 1976, Department of Labor, Washington, D.C. (Burt Roberts).

variety of visual configurations the piece provided when it was seen from different perspectives:

If you look at the end it is very difficult to know what it looks like head on. But then if you look at it from any of the angles, it's also difficult to be able to project what the opposite angles are. This is something that I have never incorporated in my work on any conscious basis, but I think it's somewhat inherent in the character of the components that I use, either the tetrahedra and octahedra or the rhomboidal elements.

The visual intricacies of these formal elements are indeed fascinating. However, the actual courtyard site provides no opportunity to walk around it, and on a recent visit, many views were obstructed by trees. Furthermore, the piece is in poor repair, with paint visibly peeling in a number of spots.

At Princeton University, *Moses,* situated in front of the faculty dining facility (Prospect House), is also often obscured by trees that require frequent pruning (fig. 59). Based on a model of 1967–68, it was fabricated and installed at the university the following year. A second version of *Moses* was acquired by the city of Seattle in 1974 and later installed in a corner of the Seattle Center (former site of the 1962

134

Figure 59. Tony Smith, *Moses,* 1967–68, installed 1969, Princeton
University, Princeton, N.J. (Tom Bailey, courtesy Paula Cooper Gallery).

World's Fair), near the Seattle Resident Theatre and the Coliseum.[117]
In Seattle the piece is totally dwarfed by its surroundings and lost in a
poorly defined space, while at Princeton it appears sheltered on the
enclosed green. The title was added after the conception of the piece
when Smith was struck by the sculpture's formal resemblance to
Michelangelo's well-known sculpture of Moses for the Tomb of Pope
Julius II and Rembrandt's painting *Moses Smashing the Tablets of the
Law.*[118] The visual analogy of the horns may be apparent to an art-
informed viewer, but remains inaccessible and merely puzzling to oth-
ers.

Like Smith, Ronald Bladen was associated from the start both with

the Minimal style and its public art component. Although Bladen's forms clearly derive from a Minimal Art vocabulary, their active thrust into space suggests the Abstract Expressionist roots of his style. His piece at the Jewish Museum's "Primary Structures" exhibition notably dominated its space.[119] His giant *X* at the Corcoran's "Scale as Content" exhibition appeared to hold up the walls with highly charged vectors of energy. For Bladen, at the time, scale was a means to achieve content of a sublime nature. In 1965 he said:

My involvement in sculpture outside man's scale is an attempt to reach that area of excitement belonging to natural phenomena such as a gigantic wave poised . . . or man-made phenomena such as the high bridge spanning two distant points. The scale becomes aggressive or heroic. . . . The drama . . . is best described as awesome or breathtaking.[120]

That is certainly the effect of *Black Lightning* (1981), an enormous sculpture (60'4½" × 44' × 4') located in the midst of Seattle Center, in front of the Center House and behind the Flag Plaza Pavilion (fig. 60). Surrounded by benches and inappropriately delicate plantings, the sculpture totally dominates its space and suggests any number of interesting visual configurations as you walk around it, providing a dramatic focal point for this area in the old world's fair grounds.

Richard Serra added to the vocabulary of Minimal sculpture the consistent use of Cor-Ten steel with its evocative (and frequently provocative) rusting surfaces, a truly architectural scale, and a sometimes aggressive site specificity. Since he first began making sculpture in the late 1960s, Serra was concerned with balance, stability, and tension. His early propped and stacked pieces, such as *One Ton Prop (House of Cards)* of 1969, composed of four lead plates, balance in such a way as to inspire an extreme and compelling sense of precariousness. The apparent, although unreal, threat of imminent collapse introduces a strong element of drama and visceral as well as psychic tension. These pieces were precursors of the monumental balancing acts of Serra's later public sculptures.

Carnegie was Serra's first major permanent vertical piece to be installed in the United States (fig. 61). Purchased as part of the 1985 Carnegie International, it now stands in Pittsburgh in front of the

Figure 60. Ronald Bladen, *Black Lightning,* 1981, Seattle Center, Seattle, Wash. (Charles Adler, courtesy Seattle Art Commission).

Sarah Scaife Gallery of the Museum of Art at the Carnegie Institute.[121] Earlier in 1980 there was a temporary installation of *TWU,* another vertical piece, at West Broadway and Franklin Street in lower Manhattan. Composed of three thirty-six-foot-high Cor-Ten plates, this piece was related to *Sight Pod* (1971–75), also composed of three huge steel plates, installed outside the Stedelijk Museum in Amsterdam. More ambitious and more closely related to *Carnegie* is *Terminal* (1977), made up of four plates and permanently installed in the German city of Bochum. The vertical pieces are architectural in scale but sculptural in feeling, relating to structure, stress, mass, plane, external form, and interior spaces. Serra strongly discourages symbolic readings of his works, but their strength and almost brutal physicality, as well as their apparent precariousness and fragility, are all too easily read by those accustomed to visual thinking as metaphors for the human condition, especially in an urban environment.

The installation of *Carnegie* was a community effort. The steel was rolled at Lukers Steel in Coatesville, Pennsylvania—the only steel mill in the country capable of rolling forty-foot plates. There was a trial erection of the piece at the Pittsburgh–Des Moines Corporation. Finally, the piece was installed at the museum by Century Steel Erec-

137

Figure 61. Richard Serra, *Carnegie*, 1984–85, Museum of Art, Carnegie Institute, Pittsburgh, Pa. (courtesy Richard Serra).

tors, also the general contractors for the project. John R. Lane, Director of the museum, commented: "One could hardly imagine a more appropriate conjunction of artist, material, and location than Serra, steel and Pittsburgh."[122]

The artist's association with steel began at the age of seventeen, when he first worked at U.S. Steel in California. A few years later and

138

again in his mid-twenties he worked for Bethlehem Steel and Kaiser Steel. His experience in steel mills not only gave him a strong technical foundation for working with the material but also made him acutely aware of the condition of the steelworker. In Pittsburgh, the city and the artist shared a history of steel. Lane used this fact to turn the sculpture's material into part of the content of the piece, thereby relating it directly to its location—making it site specific.

The concept of creating a site specific work can be linked to developments in gallery art during the later 1960s. Trying to shift the focus from the precious-commodity nature of art,[123] artists began concentrating on the environment in which it was seen. Thus the Minimal sculpture of that time derived much of its formal content from its gallery environment. This development led to an increased emphasis on gallery installations rather than exhibitions.[124]

Site specific public sculpture is work that an artist makes for a particular space. The work of art may be linked to that space through formal references, e.g., shape or color, or by embodying references to the history or nature of the site. For example, South Cove at Battery Park City refers to its nautical setting through the use of pilings and alludes to its neighbor, the Statue of Liberty, with a curved stairway and observation platform that echo the shape of Liberty's crown.

The development of site specific public sculpture was an acknowledgment that placing an art object in a public space was not enough, unless that space was a sculpture garden. To justify the placement of sculpture in the public domain, it was now felt, the work had to have some unique relationship to the site. However, while site specificity was basically a good idea, it didn't always translate clearly into the visual vocabulary of contemporary sculpture. Thus, to a non-art audience, the nature of that site specificity often remained as obscure as the works themselves.

4

Landscape into Public Sculpture: Transplanting and Transforming Nature

*As the migration to the suburb and the country shows, it may well be that
the image of nature is the greatest perceived deficiency in the modern city,
and providing this may be the key to success.*

Ian L. McHarg

*Public art's best chance, in this age of the corporate and bureaucratic hold
on public experience, may lie in intimacy, in providing an oasis, a garden, a
home in the vastness and impersonality of public contexts.*

Lucy R. Lippard

Nature became a significant element in contemporary art during the
late 1960s, coinciding with a national focus on environmental issues at
home and abroad. In 1969 Congress passed the National Environmen-
tal Policy Act mandating "protection of the environment," an ex-
pression of the growing concern with the destruction of natural re-
sources and the environment as a whole. During the following decade
ecology became a pervasive theme in politics and literature alike.[1]

In Vietnam the United States was involved with (among other
things) the defoliation of a foreign terrain that appeared impossible to
control. As shown on television and in subsequent films for the general
public, the jungle landscape of Vietnam was a palpable factor; often it
seemed to be the enemy itself. Themes of conquering and saving the
landscape appeared in contemporary art as well. Although they also

140

had art historical precedents, these themes took on a new urgency during the late 1960s, when they also mirrored contemporary political issues.

Nature became an integral part of the content of contemporary sculpture with the earthworks of Walter De Maria, Michael Heizer, and Robert Smithson.[2] This development has since been related to the ancient mounds of the American Indians, Egyptian pyramids, Stonehenge, and the more recent eighteenth-century romantic art associated with the concept of the sublime, the parks of Frederick Law Olmstead, and the sculpture of Gutzon Borglum at Mt. Rushmore.[3] In looking to history and even prehistory for inspiration, artists were reversing the modernist exclusive focus on the future. They sought instead a postmodern "synthesis rather than analysis" that "relates to the map instead of the modernist grid."[4] In this way artists tried to establish a spatial and temporal connection to the land and to history at the same time. Thus they went to remote regions to mark the earth in various ways that seemed quite revolutionary at the time. By no means was this new earth art public; its very location precluded a large audience.

Although an avowed impetus for the new land art was the desire to escape the gallery scene and the precious-object nature of gallery art, this work was nevertheless well supported by the galleries (most notably Virginia Dwan), which also showed other work by these artists. In addition, some important private patrons supported this new art form. Robert Scull, for example, commissioned one of Heizer's early excavation pieces in Nevada.[5] In a sense the remote location of these earthworks actually made them more elitist than gallery art, or certainly available only to much smaller audiences. Many of the early earthworks today look like a combination of Abstract Expressionist gestures and Minimal sculptures transferred to the desert.[6]

As the earth artists insisted that their work was about art and not the landscape,[7] this development might also be seen as an instance of artists staking out a new territorial claim—an interesting corollary of the concurrent practice of government agencies and corporations using public art to mark their turf in urban sites. Located in remote and unpopulated areas, earthworks are certainly not public art either in terms of access, amenity, or understandability. However, their focus on a nonurban environment as well as their incorporation of site into the work of art as part of its content were concepts easily transferred to the predominantly urban realm of public art.

Nature can be incorporated in public sculpture in any number of ways. Most simply, natural elements, specifically water or rocks, may be used to create a sculpture. Then, too, public sculpture may refer to or focus on natural elements by its siting. Public sculpture on a larger-than-object scale may involve the creation of a park or parklike setting. And finally, in a directly interactive mode with nature, public art may take on an ecological mission by incorporating land reclamation or other conservation devices. All these approaches to public sculpture were implicit in the earthworks of the late 1960s and early 1970s and explicit in the writings of their creators, especially Robert Smithson.[8] By the end of the decade, nature, in one form or another, was also a major factor in public sculpture. Whatever form it took, the incorporation of nature or landscape elements into public art was an acknowledgment of a specific deficiency in our urban spaces, one that artists could address either symbolically or directly.

Stone Sculpture: Noguchi, Heizer, Andre

The earliest known form of public sculpture was natural rock. The stones of the earth have always been silent witnesses to history and the awesome force of nature; as such they always have the power to move us.[9] Stonehenge remains an archetypal reference. Noguchi, following a well-established Japanese tradition, was one of the first artists to introduce the use of natural rocks into contemporary public sculpture. Many of his early "collaborations" with Gordon Bunshaft involved the use of such stones; for Chase Manhattan he and the architect actually went rock fishing in Japan to select the materials.[10]

More recently Noguchi used natural stones in *Landscape of Time*, a GSA sculpture for the Seattle Federal Building completed in 1975 (fig. 62). He selected and carved five granite boulders in his studio in Japan with the Seattle site in mind. They were then installed with the idea that they, together with the trees, surrounding traffic patterns, and architecture, would become a total composition to be "completed by the factors of use over the years." In the dedication speech Noguchi distinguished his piece from Stonehenge and Japanese rock compositions by insisting on the importance of their continuity in the Seattle site. Later he commented that he intended "a reconciliation with nature and not pretentious monuments."[11]

Unfortunately *Landscape of Time* lives up neither to its title nor the artist's intentions. Although the individual rocks are interesting, the

Figure 62. Isamu Noguchi, *Landscape of Time*, 1975, Federal Building, Seattle, Wash. (Burt Roberts).

piece is overwhelmed in scale by its placement in proximity to the architecture. It is not well integrated with the rest of the open space around the building, with seating too far away to allow for a prolonged view of the sculpture. This piece would work much better in a landscape setting with some grass around it. In this urban site it never establishes a space of its own, its color only serving to make it less distinguishable from the architecture and ground surfaces. An actual arch taken from a demolished building formerly on the site was placed along the plaza's perimeter and is a much more successful public sculpture, forming an interesting gateway to the site and a symbolic link to the past.

A far more dramatic use of natural rock may be found at Myrtle Edwards Park in Seattle, where in 1977, just two years after Noguchi's *Landscape of Time* was installed, Michael Heizer created *Adjacent, Against, Upon* for a waterfront site along Puget Sound (fig. 63). Heizer's massive piece consists of three groups of two elements, illustrating the relationships stated in the title. Each pair consists of a granite boulder quarried in the nearby Cascade Mountains together with a concrete base cut into a simple geometric shape. *Adjacent, Against, Upon* reflects the artist's interest in scale, minimal forms, and formal relationships. The simplicity of the title is reminiscent of Richard Serra's *Verb List* of 1967–68, which defined many possible ways to

143

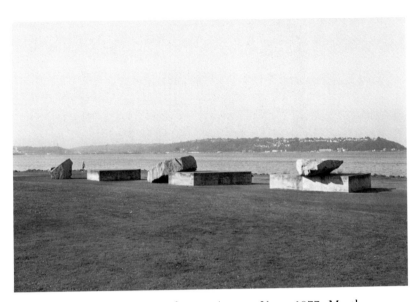

Figure 63. Michael Heizer, *Adjacent, Against, Upon*, 1977, Myrtle Edwards Park, Seattle, Wash. (courtesy Seattle Arts Commission).

make sculpture;[12] the simplicity of the piece could serve as a visual primer of basic sculptural relationships. The use of contrasting materials (granite and concrete) and contrasting shapes (irregular and geometric) relates, as John Beardsley has observed, to the contrast between the natural and architectural landscapes that frame the site, the Olympic Peninsula and downtown Seattle.[13] Symbolically the positioning of the elements suggest the possible relationships between the natural and the built environments. This reading of the piece, however, presupposes a degree of visual thinking not prevalent in our culture.

The public at Myrtle Edwards Park is composed largely of workers from nearby offices and joggers. Even though initial press reports related this piece, like Noguchi's *Landscape of Time*, to the pet rock craze and thus considered it an insult to the city council member for whom the park was named,[14] it now seems to be generally accepted, used, and even discussed.

Carl Andre's *Stone Field Sculpture* (1977) in Hartford, Connecticut, partially funded by the NEA, consists of thirty-six glacial boulders placed in eight rows on a roughly triangular site (fig. 64). The configuration, with the largest stone at the apex of the triangle and the smaller ones grouped together to echo the triangle's base, is similar to Andre's floor pieces arranged in response to the dimensions of gallery spaces. Andre used natural rock in Hartford both as a response to the outdoor

144

Figure 64. Carl Andre, *Stone Field Sculpture*, 1977, Hartford, Conn. (*The Hartford Courant*, courtesy Paula Cooper Gallery).

grassy site and as a visual reference to the tombstones in the adjacent cemetery behind Center Church. According to Andre, he wanted to "extend the serenity of the graveyard,"[15] but here again this concept is readily communicated only to whose with some art experience.

John Russell observed in *The New York Times* that, "At one stroke Carl Andre has brought prehistory to life and given a new dimension of time, feeling and experience to an area badly in need of it."[16] Lucy Lippard in *Overlay* responded to the sense of timelessness and permanence that the sculpture conveys, observing that Andre's "rows look as though they were there before anything else and will outlast everything else."[17] Undoubtedly Andre's piece generated more reported controversy than Heizer's because of its accessibility to East Coast critics. In addition, Seattle's citizens were more accustomed to public art than Hartford's. More than ten years later, in 1989, local residents in Hartford seemed either unaware of or indifferent to its presence, in spite of its proximity to the Hartford Atheneum. This suggests that the passage of time renders most things, art included, first familiar and

145

then invisible. Even the most controversial public art is eventually absorbed into the visual landscape.

Fountains: Noguchi, Oldenburg and van Bruggen, Holt

While the use of natural rock suggests references to prehistoric monuments as well as nature, water, traditionally a familiar part of urban environments in the form of fountains,[18] is also laden with symbolic significance. As one critic observed, "From earliest times it was a symbol of the fundamentals of human existence, being the element which generated and sustained life, yet within which man cannot survive. . . . Even a fountain in a square, a pool or a river had this profound binary symbolism."[19]

Although fountains import a natural element, they are seen primarily as urban amenities and are discussed, for the most part, neither as sculpture nor architecture. Initially built to provide a necessary water supply (before adequate plumbing was widely available) or as part of urban renewal projects and the focal point of plazas, fountains were an integral part of the western European urbanscape.[20] In America they were less popular and in the later twentieth century they have become unfortunately scarce. Certainly fountains have not been of much concern to contemporary sculptors. There are, however, some notable exceptions.

When Noguchi completed the *Horace E. Dodge & Son Memorial Fountain* in 1978 for Hart Plaza in Detroit, he observed, "I wanted to make a new fountain, which represents our time and our relationship to outer space"[21] (fig. 65). Indeed, the twenty-four-foot-high circular silver metal ring with its computerized water flow establishes a sci-fi ambience for the eight-acre plaza also designed by the artist. Adjacent to the Renaissance Center, the plaza serves a number of public uses, including entertainment, shopping, eating, and socializing. Noguchi viewed the site as an esthetic totality:

The plaza as a whole will present a series of pyramidal shapes: that of the fountain, that of the stepped pyramid of the theater, the blue exhaust stack of the road and the greater pyramid of the festival amphitheater as it rises to the plaza plane. The whole will be seen as a low mound with the bend in the river and the river beyond. I like to think the effect will be American, unlike anything elsewhere.[22]

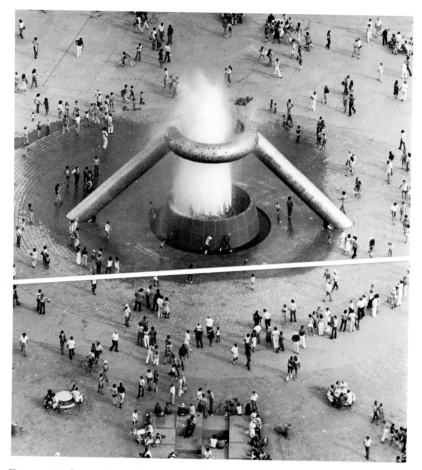

Figure 65. Isamu Noguchi, *Horace E. Dodge and Son Memorial Fountain*, 1978, Hart Plaza, Detroit, Mich. (Balthazar Korab).

Judging from the result, what Noguchi perceived as uniquely American is a sense of constant movement in a high-tech atmosphere. Rather than a place in which to sit and relax (i.e., do nothing), Hart Plaza is a place in which people are activity oriented—they shop, watch a performance, or keep walking. Neither the scale nor the design of the fountain or plaza is intimate. It is, however, impressive.

The fountains by Claes Oldenburg and Coosje van Bruggen are more approachable. Working with recognizable objects, albeit altered and enlarged, the fountains embody some of the whimsy of Oldenburg's earlier public sculptures but on a decidedly less monumental note. They reflect van Bruggen's preference for asymmetry and forms that are less phallic.[23] Their collaboration has resulted in two recent foun-

147

tains: the *Spoonbridge and Cherry* (1988) in the Minneapolis Sculpture Garden (fig. 66), and the *Dropped Bowl with Scattered Slices and Peels* (1990) in the Downtown Government Center in Miami (fig. 67).

In Minneapolis, Oldenburg and van Bruggen deliberately worked against the formal structure of the sculpture garden adjacent to the Walker Art Center. Van Bruggen commented, "The garden itself is very formalistic. It reminds me of Versailles. Louis XIV was known for the etiquette he enforced in the palace. So the spoon and cherry kind of fit right in, as a parody of table manners."[24] Certainly the eccentric curvilinear shape and playful connotations are in marked contrast both to the geometric plan of the garden and the downtown Minneapolis skyline. Since 1962 Oldenburg had owned a novelty spoon resting on a base of fake chocolate, which he used as a theme in a number of works culminating in the fountain.[25] Van Bruggen added the cherry, providing a colorful and playful focus. The fountain rests on a mound in the shape of a linden tree seed, a reference to the linden trees that line the garden. This reference, however, is hardly apparent to the viewer.

Water jets out of the base of the cherry stem, giving a shiny glow to its bright red surface and creating a haze that occasionally casts a

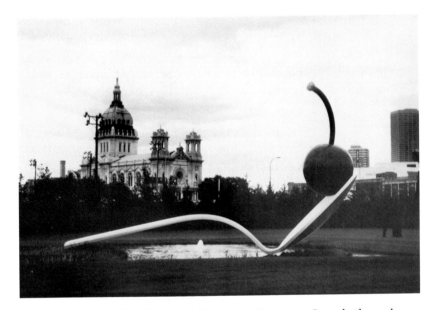

Figure 66. Claes Oldenburg and Coosje van Bruggen, *Spoonbridge and Cherry*, 1988, Minneapolis Sculpture Garden Minneapolis, Minn. (Burt Roberts).

Figure 67. Claes Oldenburg and Coosje van Bruggen, *Dropped Bowl with Scattered Slices and Peels,* 1990, Downtown Government Center, Miami, Fla. (Metro-Dade Communications).

rainbow over the site. In the winter when the water is shut off, the sculpture catches the snow (plentiful in Minneapolis) and suggests "the vision of a super ice cream sundae." More specifically, however, it suggests the Minneapolis logo of a mini-apple. Although the cherry is clearly not an apple, the similarly rounded shape and bright red color make the association inevitable. The fountain typically elicits responses of delight. Its appeal is immediate, evoking a sense of joyful surprise, all too rare in a public space.

References to food and civic imagery also permeate Miami's *Dropped Bowl with Scattered Slices and Peels* but with far less success. Here visual associations are far from positive and the artists' intentions are not readily communicated to a non-art public. According to a prepared statement of November 1989 (a few months before the dedication):

The subject, a bowl of oranges, is in line with our approach of altering a stereotype of a particular place to serve our point of view on the situation—formally and culturally. The bowl color and pattern combine typical imagery from Spanish-Indian bowls with souvenirs in "streamline moderne." The slices and peels are of course yellow and orange, but the carefully selected hues, as well as the scale of the parts, the assertion of the industrial materials and the emphasis on universal geo-

149

metrical and biological forms remove the components from the area of direct representation.

One traditional form of a fountain is round and symmetrical, which is here translated first into a plate and then into a bowl, "broken" and scattered in space in order to decentralize the focus. Each bowl fragment has its own identity yet all obey the same physical laws and can be fitted together again to form a whole. The primary effect of randomness, a variety of forms and colors shifting unpredictably in space and time, represents our view of the city of Miami, a place that has grown with a minimum of planning and has its own polyglot character. It would be a mistake, we think, to impose a Versailles-like, centralized order on such a community. Miami is not whole, neither in its opposing architectures nor in the composition of its varied and clashing population. It is a city in process, deriving its particular order out of the disorder accompanying its evolution. [26]

The imagery, however, conveys a very different reading. The orange is commonly associated with Florida, and the Orange Bowl football game is played in Miami. But this bowl is broken, and the familiar civic image shattered. Shards and peels suggest discarded garbage to a general audience rather than an image of urban diversity, as the artists intended. [27] The piece thus becomes a symbol of destruction and potential decay. This reading is only enforced by the composition of scattered elements, which lack both the formal cohesion and immediate recognizability of some of Oldenburg's and van Bruggen's other public sculpture.

However, the originality of *Dropped Bowl with Scattered Slices and Peels* as a fountain should not be obscured by its unsuitable imagery for this particular site. Here, as in *Spoonbridge with Cherry*, the artists have reinterpreted the concept of fountain in terms of their sculptural language. The water, instead of being the focus of the fountain, becomes a significant participant in a sculptural dialogue between artificial and natural materials as well as static and active elements.

Another original contemporary fountain, Nancy Holt's *Waterwork* (1983–84) on the campus of Gallaudet College in Washington, D.C., is a system of pipes that expresses the artist's interest in the hidden technological systems that keep society functioning (fig. 68). Holt explains:

Since 1981 I have been making art out of functional systems—electrical, drainage, heating, plumbing—those basic building components

Figure 68. Nancy Holt, *Waterwork*, 1983–84, Gallaudet College, Washington, D.C. (Nancy Holt).

that architects so often like to shun. These fundamental technologies which reached their "state of the art" in the early 1900s, and which are so essential now to our existence, are usually hidden from sight and forgotten until a breakdown occurs. In constructing these works, standard industrial materials and methods are used, each sculpture being a channel system for conducting the flow of substance and energy, an external fragment of the buried network of pipes, valves and connectors that make up a vast regional system.[28]

These concerns, although quite compelling and clear upon explanation, are not conveyed by the works themselves.

At Gallaudet, a residential school for deaf students from kindergarten through college, Holt "thought about human scale, both child and adult proportions. Some of the pipes have been placed at varying heights providing convenient sitting for everyone, and there are pathways and pipe arches for walking in and around the work." Indeed, at first glance, the piece might be taken for a novel design in playground

151

equipment: the wheels of the gate valves can be turned on and off to run water as desired (like a faucet), and the sand pits may be used with either wet or dry sand. Thus *Waterwork* is a fountain under audience control and one that reverses conventional expectations in that the predominant mode is off rather than on.[29] Although formally and conceptually interesting, it suffers from a remote siting behind the elementary school. Barely visible beyond its immediate environment, it is seen and used only by a small group of children and then only occasionally.

Before *Waterwork,* Holt used running water in two other large-scale outdoor projects. *Catch Basin* (1982), in St. James Park in Toronto, was commissioned by the Visual Arts program of Ontario. With simple technology, the piece actually functions to correct a drainage problem in the landscape. Holt observed that "as a land drainage system, *Catch Basin* is part of an ancient technology, some of the oldest systems having been in use for as long as 5,000 years in Crete, Egypt, and Babylon."[30] *Sole Source* (1983), commissioned by the Independent Artists of Ireland and built in Marlay Park in Dublin, is also a plumbing system. In addition it uses an eighteenth-century landscape device known as a ha-ha, referring to the expression of surprise when one suddenly comes upon a trench that is not apparent at a distance. Formally elegant as well as functional, *Sole Source* is made of humble materials. Unexpectedly playful, it transforms basic plumbing into art on a large scale—something of a contemporary art surprise.

Public Sculpture as a Focus on Nature: Holt, Christo

The element of nature introduced by Nancy Holt's "fountains" is a reference to water tamed by technology. Holt's initial forays into public sculpture, however, involved focusing on basic natural cycles and events. Her first large-scale outdoor piece was not really a public sculpture due to its remote site. *Sun Tunnels* (1973–76), in the Great Basin Desert in northwestern Utah, consists of four concrete cylinders punctured by openings in the configuration of four different constellations (Draco, Perseus, Columba, and Capricorn). The "tunnels" are aligned to frame the sun for a few days around the summer and winter solstices. This framing device reflects Holt's earlier work as a photographer while the actual siting, in accordance with natural phenomena, is Holt's way of bringing nature into human focus.

Holt's *Stone Enclosure: Rock Rings* (1977–78) at Western Wash-

ington University in Bellingham is aligned with the North Star (fig. 69). Two concentric stone walls made of local hand-quarried schist are punctuated by four arches ("doors") and twelve holes ("windows"). The arches are aligned on the north-south axis calculated from the North Star in a manner Holt compares to "the way the Northwest Coast navigators plot the courses of their ships."[31] Thus the work relates to a point in the universe, a dead center, a true north, and so becomes astrally fixed on earth. The twelve circular openings bring the horizon back to the center of the work. Here both the materials and the placement of the work refer to its natural setting. Esthetically successful, it remains questionable how much of the content, if any, is conveyed to an uninformed viewer.

It is a pervasive theme and function of Holt's public sculpture to link a site to a larger scheme of things. In *Annual Ring* (1980–81), a GSA commission for the Federal Building in Saginaw, Michigan, Holt relates her piece to the North Star, the spring and fall equinoxes, and the summer solstice (fig. 70). Adjacent to an experimental solar energy building, the domed structure has four circular openings—one at the top and three punctuating the sides. The east-west openings frame the rising and setting sun on the equinox, while the north opening frames

Figure 69. Nancy Holt, *Stone Enclosure: Rock Rings,* 1977–78, Western Washington University, Bellingham, Wash. (Burt Roberts).

Figure 70. Nancy Holt, *Annual Ring*, 1980–81, Federal Building,
Saginaw, Mich. (Nancy Holt).

the North Star. The ring on the ground (formed by light entering through the top and casting a shadow) frames the sun at solar noon on the summer solstice, usually June 21.

Holt's references to nature, especially appropriate for a solar energy building, are easy to understand. They literally fix our place in a global universe. However, these references are not easy to see. Even if a perfect framing is glimpsed by chance, neither the reference nor the significance will be clear. To function fully as a focus on nature, these works need some form of clear documentation at the site.

Public art as a focus on nature has been seen most dramatically in Christo's temporary installations. Although he began wrapping objects such as tables, chairs, and paintings in 1958, the Bulgarian-born artist is best known for his spectacular projects in nature. In 1969, coincident with the development of earthworks, Christo executed *Wrapped Coast* at Little Bay, in Sydney, Australia. Within the next decade he also executed *Valley Curtain* (1971–72) at Rifle Gap, Colorado (some 200 miles west of Denver) and *Running Fence* (1976) in northern California (fig. 71). More recently in *Surrounded Islands* (1983) he wrapped a number of islands located in Biscayne Bay in Greater Miami in bright pink propylene. Christo's work has been well documented both in the popular and art press,[32] receiving much more attention in the media than other earthworks due to their theatrical nature.

Christo's wrappings are privately financed by the artist's sale of other works (mostly drawings and prints), and they are always temporary. They are, however, public in terms of the artist's involvement in local politics and procedures as well as their focus of public attention on an aspect of nature otherwise largely ignored.[33] For the artist the public process requiring the cooperation of local politicians, landowners, businessmen, and a large number of assistants is a significant aspect of the work. This participation in a basically theatrical event (with a limited run) guarantees that the piece will live on for a time in local memory.

Public Sculpture as Park or Garden: Noguchi, Holt, Zimmerman, Sonfist, Tacha

The most direct way of incorporating nature into public art is to build a park or garden, thereby creating a respite from the larger urban environment. As Lucy Lippard observed, "The park is probably the most effective public art form there is—the park itself is an ongoing process,

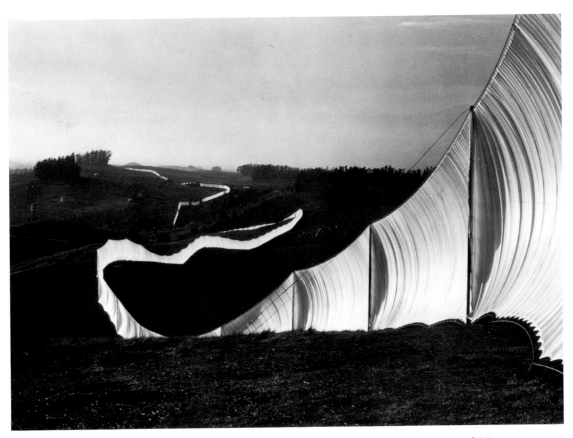

Figure 71. Christo, *Running Fence*, 1972–76, Sonoma and Marin counties, Calif. (Jeanne-Claude Christo).

the domain where society and nature meet."[34] A rich history of garden design provides any number of evocative precedents for artists appropriating a domain traditionally allocated to architects or landscape architects.[35] Some sculptors have followed a formal approach, largely based on well-established traditions; others have sought a solution that combines elements of contemporary sculpture with landscape design.

Early in the recent history of public sculpture Noguchi looked to his Japanese heritage for inspiration in designing sculpture gardens. As early as 1949 he expressed impatience with the constricting definitions that limited the focus of his creative imagination and looked for "a reintegration of the arts towards some purposeful social end . . . in order to enlarge the present outlet permitted by our limiting categories of architects, painters, sculptors, and landscapists."[36] In designing the gardens for UNESCO in Paris (1956–58) Noguchi included the traditional elements of a Japanese garden: fountains, trees, shrubs, stones,

paths, and bridges. Noguchi later called it "a study and a tribute"[37] (fig. 25).

It was the Zen concept of a garden as "not only an object of esthetic enjoyment but a metaphysical exercise in which each element has symbolic meaning" that appealed to Noguchi as appropriate for a world organization dedicated to peace. For Noguchi

The raised paved area in the center of the lower garden recalls the "Happy Land." One arrives on it and departs from it again—with time barriers of stepping-stones between—it is the land of voyage, the place for dancing and music may be viewed from all around the garden and from all levels of the surrounding buildings.[38]

His symbolic reading extended to the large granite fountain of peace where the "calligraphy for peace (Hei Wa) carved backward on the stone and so distorted as to be generally illegible (in the best Japanese tradition)." The link to Japan was emphasized by importing the stones—transposing a piece of nature from one country to another. To experience the piece as Noguchi intended requires both a familiarity with traditional Japanese gardens and the artist's interpretation of them.

The artist's intentions are also unfortunately not clearly communicated in Nancy Holt's *Dark Star Park* (1979–84) in Rosslyn, Virginia[39] (fig. 72). Here the artist took on an increasingly responsible role as the project developed, finally becoming involved with "architectural planning, landscape design, contractors' specifications, engineering, drainage, sidewalk construction" and, of course, a barrage of bureaucratic procedures.[40] Located in front of an office building surrounded by several main roadways, *Dark Star Park* is seen primarily from moving vehicles. Pedestrians, mostly local office workers, cross it when entering or leaving the building and occasionally pause to sit along its low walls. The piece combines tunnels similar to Holt's earlier pieces, along with her preference for significant alignments.

According to Holt:

With *Dark Star Park* I am continuing, among other things, my concerns with the architectural form of the tunnel and its various symbolic ramifications—birth, death, transition, etc. and with illusions of ordinary perception, especially as perception is altered by curvilinear forms.

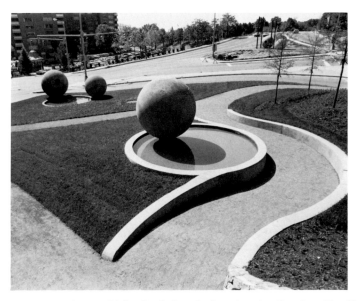

Figure 72. Nancy Holt, *Dark Star Park*, 1979–84, Rosslyn, Va. (detail) (Nancy Holt).

As the viewer walks in the park or drives by it, spheres of different sizes may appear to be the same size, or one sphere may eclipse another in passing, or a sphere may be seen through a round hole in another sphere or through a tunnel or reflected in a pool. Two spheres are seen at the same time through the large tunnel and through the hole in the sphere on the island—in this instance as the viewer steps back, one sphere slowly fills the circular void. When spheres are only partially seen through the holes, tunnels and pools, crescents and ellipses of space, sphere, shadow and reflection visually emerge. The shadow patterns on the ground indicate that the poles and spheres are actually tangent to each other, whereas perceptually they look like they are either closer together or wider apart than the diameters of the spheres. The shadows cast by the poles and spheres line up with the asphalt shadow patterns on the ground at approximately 9:32 AM on August 1 each year, the day in 1860 that William Henry Ross acquired the land that became Rosslyn, merging historical time with the cyclical time of the sun.[41]

This last reference to local history is inevitably obscure. Although the visual experiences Holt describes are available, they are not particularly encouraged by the site. A driver, for obvious safety reasons, cannot be an attentive art viewer, and pedestrian use of the area is limited. *Dark Star Park* remains a strong, formally interesting piece, which is actually better experienced through Holt's photographs than

158

at the site. In an art park or sculpture garden—a different setting with a different audience—it would be more successful, because *Dark Star Park* is basically more concerned with abstract art issues than it is with being a useful park.

Some of the sculpture complexes of Elyn Zimmerman strike a better balance. At *Marabar* (1984) for National Geographic Headquarters in Washington, D.C., she designed a plaza with huge boulders in a pool to complement and link a diverse architectural setting consisting of a new ziggurat-shaped pink granite building by SOM and two older buildings in different modern styles (fig. 73). *Marabar* takes its title from the caves in E. M. Forster's novel *A Passage to India*.[42] The stone boulders jut into the geometric shape of the pool, suggesting a natural placement. In each boulder highly polished surfaces contrast with natural contours, evoking a dialogue between the artificial and the natural landscape. In addition, the mirrored surfaces multiply and orchestrate a variety of visual images. These effects were apparently much appreciated by children observed climbing around the sculpture.

Since her first environmental project, Zimmerman has been holding mirrors, usually of finely polished stone, up to nature: the mesa walls of New Mexico (*Mirror Wall*, 1972), the sky above a gorge along the

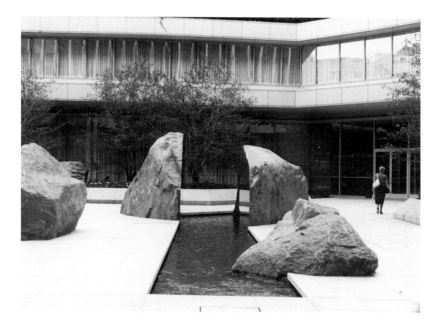

Figure 73. Elyn Zimmerman, *Marabar*, 1984, National Geographic Building, Washington, D.C. (Elyn Zimmerman).

Niagara River (*Monarch's Trough*, 1978, Artpark, Lewiston, New York), and the palisades along the Hudson River (*Palisades Project*, 1981, a photomontage of a view from the Hudson River Museum in Yonkers). This followed a precedent set by Robert Smithson in his gallery "non-sites" (1968) and in the Yucatan (1969). Mirrors can be understood both as a literal and symbolic image of the artist's role in nature. The polished surface of a natural material serves to include other views of a site, accomplishing the artist's aim of enlarging the spectator's vision.

In *Keystone Island* (1985–88), commissioned by the Metro-Dade County Art in Public Places Program for a site adjacent to the North Dade County Court Building by Arquitectonica, Zimmerman used an indigenous material embedded with coral and seashell fossils (fig. 74). *Keystone Island* looks like "an island of natural rock" situated in a lagoon.[43] Connected to its architectural setting by a concrete walkway that appears to be resting on the island (actually it is supported by pillars underneath it), its circular form relates to the sweeping curves of the architecture while the material is in marked contrast to the high-tech appearance of the building. Contrasts abound throughout the work. Within the island Zimmerman juxtaposes rough, unpolished keystone in a seemingly natural formation with smoothly finished steps cut in clear geometric shapes.

Keystone Island was intended to echo the surrounding landscape by including a small tidal pool which, unfortunately, is stagnant today. Because of budgetary restrictions that prohibited the intended expansion of the site, the piece appears abruptly constrained, with no hint of its proximity to the ocean. Situated entirely behind the courthouse building, there is no public signage to indicate its presence. Although employees occasionally use it to enjoy an outdoor lunch, a larger audience could easily be made aware of its existence.

At *Terrain* (1986–88) at O'Hare International Center at the northeast corner of the Chicago airport, Zimmerman was more successful in creating "a space apart" yet integrated with its adjacent architectural setting (fig. 75). In a site surrounded by a network of airport roadways, in the midst of an undistinguished contemporary complex of hotels and offices, Zimmerman created a gracefully landscaped park with a prehistoric aura. The central space consists of a broad expanse of paved area punctuated by twenty-six boulders, "erratics" moved from their original location by glaciers. Zimmerman maintained a sense of random placement and included a long irregular crack in the pavement

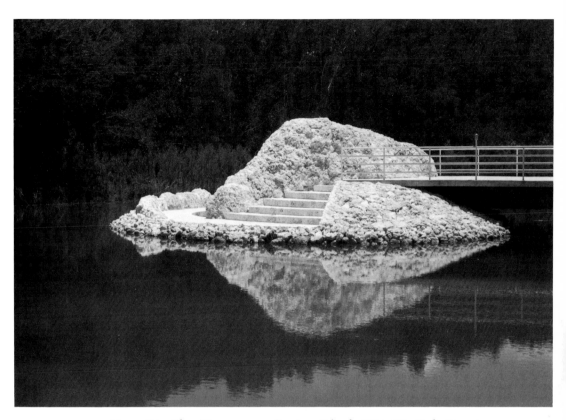

Figure 74. Elyn Zimmerman, *Keystone Island*, 1984–85, Dade County Justice Center, Miami, Fla. (K. Varnedoe).

surface to suggest the massive land movements associated with glaciers. Eccentrically shaped pools have counterpoints in the areas on either side of the main plaza. The lower section has a pond and pebbled paths, while the more densely planted upper area contains two ponds surrounded by trees, flowers, and ample greenery, forming a more sheltered private space. *Terrain* gets frequent use by people soaking up the sun or watching the ducks that have taken up residence in one of the pools. The variety and complexity of the three spaces reward return visits, offering both the seclusion and serenity of an intimate garden and the more challenging experience of contemporary sculpture.

Each of the gardens discussed above is formal in appearance, whether referring to Japanese tradition, prehistoric monuments, or abstract art. Although potential metaphors for nature, each has been reinterpreted in a different idiom. Alan Sonfist has tried to reproduce nature more directly, viewing natural phenomena themselves as public

161

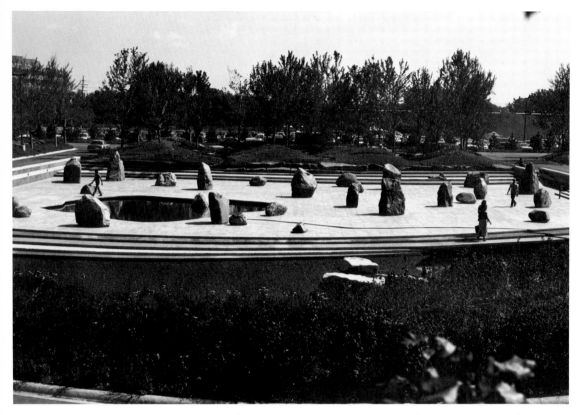

Figure 75. Elyn Zimmerman, *Terrain*, 1987, O'Hare International Center, Chicago, Ill. (K. Varnedoe).

monuments.[44] In *Time Landscape* (1965–78) at the corner of LaGuardia Place and Houston Street in Manhattan, Sonfist tried to recreate the natural environment of the site before it was settled by Europeans by planting grasses, wildflowers, and an assortment of variously sized hardwood trees. Sonfist proposed the piece as one of a number of similar sites throughout the city and saw the project "as renewing the city's natural environment as architects renew its architecture."[45]

Time Landscape, partially sponsored by the NEA, was recently declared a New York City landmark. The idea behind the piece is both appealing and compelling. As Mark Rosenthal observed, Sonfist "wants to rejuvenate a bit of natural history . . . (through) a dialogue between abandoned and current values, between concerns for the land and the priorities of an urban landscape."[46] Unfortunately, the "landscape" itself hardly conveys this. Fenced in on a corner just north of SoHo at a busy Manhattan intersection, *Time Landscape* looks only like an overgrown lot. Even with some readily available explanatory infor-

162

mation to counter this impression, its location is not one to encourage casual or serious viewing. Fenced off as it is, it remains an empty gesture without public meaning.

Simply as a park, without the philosophical and historical interest of *Time Landscape,* Athena Tacha's *Streams* (1975–76), located in Vine Street Park in Oberlin, Ohio, is more accessible (fig. 76). In a more rural site with fewer visual distractions (and much less threat of vandalism), this series of steps and natural rock provides seating and a sense of pleasant rhythmic movement. Because the steps echo patterns of moving water, the overall effect is more natural than formal. Tacha varied the placement of standard concrete blocks and explained that by "changing the steps' three parameters (length, width, and depth) . . . by multiples of the blocks dimensions . . . so the steps are one, two or three blocks high (four, eight, or twelve inches); and two, three or four blocks wide (thirty-two, forty-eight, or fifty-four inches). Combining variations of these three possibilities, I was able to achieve

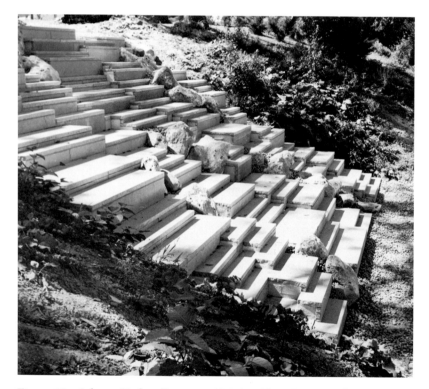

Figure 76. Athena Tacha, *Streams,* 1975–76, Vine Street Park, Oberlin, Ohio (Athena Tacha).

the effect of wind mountain brooks."[47] The sandstone-covered blocks are interspersed with pink pumice rocks, chosen by Tacha because they reminded her "of huge boulders trapped in mountain currents." Sponsored by grants from the NEA and the Ohio Arts Council, *Streams* was Tacha's first executed public commission and a good example of what could be accomplished even within a limited budget.[48] Concerned from the start with user participation and interaction, Tacha preferred to think of her public projects as public works rather than public sculptures.

By creating landscape sites, with or without sculptural elements, public sculptors transposed nature in various forms into an environment where it was lacking. In a sense, these works belong to the tradition of urban parks as much as urban sculpture; they exist as public amenities, offering a respite from harsher urban realities.

Land Reclamation Sculpture: Morris, Bayer, Johanson, Heizer, Tacha

The concept of sculpture as land reclamation was already present in some of the earthworks of the early 1970s. Here again, these remotely located works provided models for later, more public, sculpture. Lucy Lippard referred to Robert Smithson's *Spiral Jetty* (1970), *Broken Circle*, and *Spiral Hill* (both 1971) in Emmen, Holland, as "both . . . reclamations of neglected land and neglected symbols."[49] At the same time, as Robert Hobbs points out, Smithson's intent in the early earthworks was to focus on the process of entropy, and not to try to correct it.[50] After the Emmen project, Smithson began to think directly of land reclamation art and made attempts to work with mining companies and quarry owners. In 1972 he noted, "Art should not be considered as merely a luxury but should work within the process of actual production and reclamation."[51] Unfortunately none of Smithson's proposals for land reclamation were executed.

The first publicly funded land reclamation project was built in Grand Rapids, Michigan, the location of the first NEA-funded Calder. Robert Morris executed *Grand Rapids Project* in 1973–4, also with funds from the NEA and a number of local arts organizations.[52] His proposal for Belknap Park initially was part of the "Sculpture Off the Pedestal" exhibition organized by the Grand Rapids Art Museum in 1973. Morris's two asphalt ramps in the form of a huge X were to stop

the erosion of the park's hillside. His plan, amended slightly by the city parks and recreation department, was permanently installed the following year.

Today the piece is unmarked and overgrown. Were it not for previously published documentation, the piece would barely be recognizable. A letter to the local newspaper in the summer of 1989 suggested that the hillside would be much nicer if there were pretty flowers planted on the site. Indirectly, this raised the issue of whether reclamation art should in any way mask its environmental function by combining it with esthetics. Morris himself addressed this and other critical issues in his keynote speech for a symposium held in conjunction with the exhibition *Earthworks: Land Reclamation as Sculpture* held at the Seattle Art Museum in 1979. For Morris:

The most significant implication of art as land reclamation is that art can and should be used to wipe away technological guilt. . . . Will it be a little easier in the future to rip up the landscape for one last shovelful of non-renewable energy source if an artist can be found (cheap, mind you) to transform the devastation into an inspiring and modern work of art? Or anyway, into a fun place to be? Well, at the very least, into a tidy, mugger-free park?

It would seem that artists participating in art as land reclamation will be forced to make moral as well as aesthetic choices. There may be more choices available than either a cooperative or critical stance for those who participate. But it would perhaps be a misguided assumption to suppose that artists hired to work in industrially blasted landscapes would necessarily and invariably choose to convert such sites into idyllic reassuring places, thereby redeeming those who wasted the landscape in the first place.[53]

Morris's own proposal for the exhibition was subsequently built as a permanent piece by the King County Arts Commission and was partially funded by the NEA (fig. 77). Located on a hillside in southern King County just outside Seattle, the piece consists of a sunken amphitheater of grass-covered terraces and slopes. The simple method of terracing appealed to Morris because it had "been used in ancient times as well as the present. Such a method has produced sites of such widely varying content and purpose as palaces and strip mines, high-

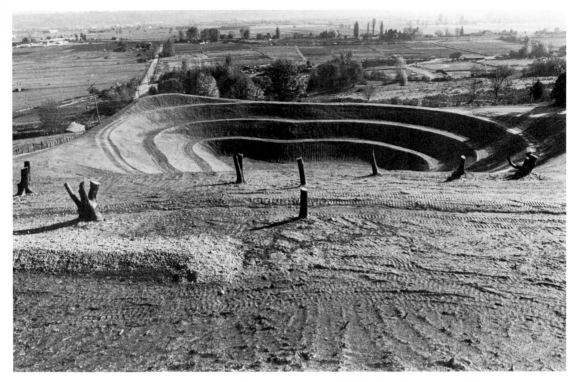

Figure 77. Robert Morris, *Untitled* (land reclamation sculpture),
1979, SeaTac, Wash.
(Colleen Chartier, courtesy King County Arts Commission).

way embankments and mountain side cultivation. Persian and Mogul
gardens were terraced as were the vast amphitheaters of Muyu-uray in
Peru."[54]

Broken tree stumps mark the topmost boundary, theoretically a
reminder of the site's former debased state. To make this symbolic
statement, Morris cut down existing trees and blackened the stumps
with creosote, provoking considerable controversy between environ-
mentalists, who were appalled by the act, and members of the art
community, who saw it as an important part of the content of the
piece.[55] Morris's method addressed the ambiguous morality implicit in
land reclamation art. His blackened tree stumps are a reminder of the
environmental damage that necessitated the piece in the first place.
Whether it is understood as such by most of its viewers is doubtful.
Certainly there is no documentation of this provocative and question-
able act at the site. A small parking lot provides viewing space, since
the relatively obscure location is not otherwise subject to pedestrian

166

traffic. Barely visible from the road, the publicness or privateness of the site remains debatable.

Herbert Bayer's *Mill Creek Canyon Earthworks* (1979–82) in Kent, Washington, was also built as a permanent piece by the King County Arts Commission and documented in the same Seattle Art Museum exhibition. The function of this larger and more public piece is to contain accumulations of heavy rainfall so as to allow for a slow recession. The problem was a result of development along the creek that eroded its natural boundaries. Bayer's solution provided areas for water retention that function very well as a park area during dry times. A series of circular dams creates a gentle, harmonious landscape forming the focal point of a larger park with playgrounds and hiking trails. This incorporation makes conservation efforts an integral part of a recreational and social environment. Not relegated to an outpost, hidden by a fence, or marked by an unsightly or intrusive structure, *Mill Creek Canyon Earthworks* clearly shows that it is possible to address environmental concerns in a way that is both functional and esthetic.

Bayer's early experience at the Bauhaus both as a student and a teacher (of advertising, layout, and typography) made him sympathetic to the concept of functional art. In earlier public sculptures for the Aspen Institute for Humanistic Studies, Bayer had already experimented with the idea of landscape as sculpture, as seen in *Earth Mound* (1955). Its circular form, referring to Japanese and American Indian traditions, prefigures *Mill Creek Canyon Earthworks*.[56] The accompanying piece, *Marble Garden*, is a composition of vertical marble forms arranged around a square pool and fountain. Thus well before the public sculpture revival of the late 1960s, Bayer anticipated several of the forms it would take.

One of Bayer's major concerns at *Mill Creek Canyon Earthworks* was the successful integration of sculptural forms with the landscape. Patricia Johanson resolves this issue by basing her sculpture almost entirely on natural forms. At *Fair Park Lagoon* (1981–86) in Dallas, Texas, she patterned an enormous sculpture after the forms of local flora[57] (fig. 78). Dedicated as a National Historic Landmark, Johanson's sculpture transforms the lagoon into an ecological experience that places the viewer directly in the natural setting and provides shelter for a variety of wildlife. To accomplish this, Johanson considered the project from a variety of perspectives.

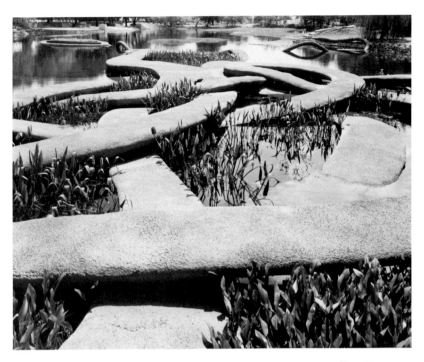

Figure 78. Patricia Johanson, *Fair Park Lagoon*, 1981–86, Dallas, Texas (detail) (William Pankey, courtesy Patricia Johanson).

My planting plans proposed native emergent vegetation (rooted plants that grow in shallow water) because they not only provide wildlife food and habitat, but also reduce water turbidity and help control bank erosion. The *Saggitaria* sculpture became another erosion-control device. Arranging stem-segments, leaves, and the tangled mass of paths (roots) as "lines of defense" breaks up wave action and prevents moving water from ever reaching the shore. *Pteris Multifida,* a multi-span arch bridge based on a Texas fern, creates its own landscape of arches, causeways, and islands, while cutout shapes between the leaflets form small-scale flower-basins and fish ponds. Specific microhabitats were designed as living exhibits for the Dallas Museum of Natural History, and children tend to use the sculptures as a playground that combines running and climbing with exploration discovery.

Another aspect of the lagoon design aimed at providing a place that was poetic, evocative, and contemplative. As one walks out onto these vast sculptures, the "art" dissolves and the person is left with his or her own focus and thoughts. So instead of the imposed vision of the artist, the lagoon allows for the development of a multitude of subjective situations.[58]

168

Johanson's commitment to the ecological function of art is also seen in her most recent public commission, *Endangered Garden* (1988), which links a sewer facility to Candlestick Point State Recreation Area in San Francisco. On the top of Sunnydale Facilities she created a Baywalk in the form of the endangered San Francisco garter snake, and then punctuated it with a series of individual gardens in the twists and turns. The scale of the project is so large that the snake image will be visible only from an aerial view. A similarly monumental butterfly defines the southern end of the project, opposite the pump house. Johanson explains:

The two largest images—the snake and the butterfly—will be explored in the mind, more than seen. The real focus of *Endangered Garden* is the life of San Francisco Bay and its surrounding landscape. . . . The purpose of the Sunnydale Facilities is to prevent overflows of sewage into San Francisco Bay. The purpose of *Endangered Garden* is to convert this functional structure into a public landscape that is life-supporting, but not anthropocentric.[59]

Johanson's aim is to create a harmonious link between the human, animal, and plant worlds—emphasizing their connectedness.

A few years earlier Michael Heizer used a similar approach in his land reclamation sculpture in Buffalo Park, Illinois. He created enormous abstracted images of fauna once indigenous to the Illinois River Valley (seventy-five miles southwest of Chicago) where the sculpture is located. Situated on a 200-acre site, *Effigy Tumuli Sculpture* (1983–85) consists of five separate mounds representing a water spider, frog, catfish, turtle, and snake.[60] Altogether, they constitute the largest public sculpture undertaking since Mount Rushmore (1927–41). *Effigy Tumuli Sculpture,* built with funds obtained from a federal tax imposed on coal mining companies and redistributed to state agencies by the Department of the Interior, reclaims previously eroded and sterile mined land. As a result of Heizer's sculpture, which used as much of the existing land forms as possible and added necessary limestone to the soil, vegetation once again arose, and by the summer of 1989 the animals had taken on a distinctly shaggy coat.

The idea for using mounds in the shape of animals came from the artist's interest in the Indian earth mounds of the midwest, although Heizer's sculptures are much larger and more geometrically ab-

stracted. Thus he implies that the solution for industrially induced destruction may be found in the natural practices of earlier cultures. The lure of the prehistoric pervades much of the sculpture that seeks to cure the wreckage of a postindustrial landscape. Indeed the experience of walking through the site suggests a silent primitive pilgrimage. However, the giant geometrically rendered images are not recognizable from the ground; even with the documentation provided at the entrance to the site, one senses only vast mysterious shapes. Situated in a vast landscape, *Effigy Tumuli Sculpture* provides, for a sympathetic and informed viewer, a curious merging of recent and far past in a successful synthesis of esthetic and environmental concerns.

Nevertheless, the lack of recognizable shapes at ground level remains a problem. Although there is an informative plaque at the entrance to the site, some visitors, unable to see the images as pictured, felt that the artist had perpetrated a huge hoax. This rather common response is indicative of a larger problem. Many people approach art that is not immediately understandable with a basic distrust, rather than curiosity. They are unwilling or unable to meet art half way. For public art the question of how much one can or should expect or demand of the audience is critical.

Figure 79. Athena Tacha, *Green Acres*, 1986, Department of Environmental Protection, Trenton, N.J. (courtesy Athena Tacha).

The message of Athena Tacha's *Green Acres* (1986) is much more accessible (fig. 79). Although not a land reclamation sculpture per se, this courtyard piece for the Department of Environmental Protection in Trenton, New Jersey, includes images that call attention to current environmental problems. Using photographs sandblasted into the granite pavement, Tacha creates a mini-park with a topical theme. Unfortunately, budgetary constraints resulted in a reduction in scale of the seating and landscape elements, but the message conveyed by the images in the ground attains a significant resonance. New Jersey's endangered plants and wildlife pictured above the titles of various departmental agencies represent the department's mission inscribed in stone.

From the inclusion of simple stones to the creation of parks and land reclamation sculpture, the public art focus on the landscape is basically egalitarian. Landscape elements are accessible and appealing to all. Seen in the larger context of city planning, they have a vital function in providing some of the proven restorative effects of nature. Many of these projects function equally as urban amenities and public art, and reclamation sculptures have a specific public use other than the esthetic. As public sculpture evolved, a commitment to actual as well as spiritual use or usefulness became for many artists an integral part of their public art philosophy.

5

Sculpture with a Function: Crossing the High Art–Low Art Barrier

My ideal piece of sculpture is a road.

<div align="right">Carl Andre</div>

I want to get some social meaning back into art. And I'd like to help change art into some kind of design. I think that the moral, the ethical dimension of art has mostly gone, and only in a newly significant relationship with a non-art audience can any ethical dimension come back to art.

<div align="right">Scott Burton</div>

A possible point of reference is the jungle gym, in which physical participation takes the place of iconographical comprehension.

<div align="right">Lawrence Alloway</div>

The expansion of public sculpture from single to site specific object to entire site was accompanied by an expansion of the definition of sculpture itself, which allowed for the inclusion of use. The notion of use in relationship to art, however, challenged well-established definitions of art in western European culture where art, that is to say high art, traditionally was not functional. In this hierarchy, useful art was relegated to the realm of craft or design and deemed of lesser cultural and economic value. An object without practical use was perforce a luxury item, and ownership was restricted to a monied class.

The challenge to this distinction had its most notable twentieth-

172

century precedent in the Constructivist movement associated with the Russian revolution. Although formal elements of Constructivism relating to materials and methods of construction have long since been incorporated into contemporary sculpture, the movement's concomitant call for a useful art was largely ignored. The distinction between art and use was perpetuated by a modernist canon of esthetics that spoke of art in a formalist language far removed from life. According to one of its chief proponents, Clement Greenberg, art was concerned only with its own esthetic parameters, and answered only to the critics who defined them.[1]

Increasingly, this and other premises of modernism came under critical attack. Pop Art's focus on the commercial world brought the depiction of consumer products, if not the objects themselves, into the realm of art. The expansion of esthetic options in an age of pluralism led to a further blurring of boundaries. Feminists were concerned with the traditional denigration of women's work as craft and with the disdain for the decorative, a prejudice also closely aligned with rejection of nonwestern cultures. Although a more interdisciplinary approach to art history and criticism has questioned these and other traditional western European assumptions, the distinction between art and craft (or use) persists, a remnant of a hierarchy that has lost its authority in most other areas.

Today, although the high art–low art distinction is being challenged in theory as an expression of prejudice based on economic, cultural, and gender factors, the categories are still maintained in most museum and gallery classifications. By the end of the 1980s, however, in the arena of public art the boundary between high and low art blurred, perhaps because the scale of public sculpture rendered the craft issue moot.[2] This development coincided with the growing focus on public art as an element of urban design rather than an adjunct to architecture. Thus an exhibition of 1985 at the Los Angeles County Museum, "The Artist as Social Designer: Aspects of Public Urban Art Today," sought to "document the involvement of visual artists in areas of design traditionally reserved for architects and urban planners."[3]

Among contemporary critics, Arthur Danto has been a singular champion of useful public art. A philosopher by training, he recently observed:

It had not especially occurred to me that art and utility were antagonists. . . . My own sense is that public art ought to be useful. There is

a strong distinction to be drawn between public art and what is often confused with it, namely art in public places. The latter is what requires defense, rather than a public art that has some function beyond esthetic delectation.[4]

By art in public places Danto means an art object, usually a piece of sculpture. Although such art may offer more than mere "esthetic delectation," it is not usually functional in a pragmatic sense. Today, however, public art encompasses a range of structures that provide seating or function variously as gates, fences, bridges, and bus shelters. As with public sculpture that incorporates landscape elements, public sculpture that incorporates use may take the form of a single structure or an entire site. In any incarnation, these sculptures function as urban amenities, while addressing the individual imagination.

Public Sculpture/Furniture: Sugarman, Burton, Artschwager, Hollis

Seating, the most obvious and welcome amenity public sculpture can provide, became a familiar element in public art during the 1970s. Although formal solutions varied, seating was one way of making public sculpture immediately accessible—or at least "user friendly." One approach to incorporating seating was to make it part of the overall composition of a piece. Another was to address the hybrid category of sculpture/furniture in a more conceptual way.

George Sugarman began making public sculpture in the late 1960s in a colorful, expansive style that became more popular after the decorative art revival of the mid-seventies.[5] His first public piece, *Untitled* (1969) for the Xerox Building in El Segundo, California, was a translation into polychrome steel of a wooden piece he was working on at the time[6] (fig. 80). Its reception in the public realm changed the way Sugarman thought about art.

Almost twenty years ago I installed my first large public sculpture, which consisted of four open forms spread over a street-level plaza. A few days later the owner called to say that the neighborhood kids were playing in the plaza, crawling through the forms, running back and forth between them.

Figure 80. George Sugarman, *Untitled*, 1969, Xerox Building, El Segundo, Calif. (courtesy George Sugarman).

It isn't too dramatic to say that I was thunderstruck. Formal problems and the fragility of wood had been my concern. It had never occurred to me that I was making art that could be touched, kicked, played with, "used." These were kids, of course. Could adults unlearn the warnings of "Do Not Touch the Art"? Could they learn that here was art that they too could kick or caress?

What I learned was that this kind of relationship with sculpture was something "private" sculpture could not allow, completing the intellectual and emotional meaning by touch, by satisfying the instinctive kinesthetic sensation we all have (and is so often repressed) to another physical presence. And, in a sculpture made up of different and separate forms, the movement of people could be an essential element in the relationship of these forms, creating a changing, shifting composition, making the spatial relationship active, even accidental.[7]

To an art viewer, Sugarman's vibrant sculpture, with its roots in the colorful, rhythmic styles of Matisse and Stuart Davis, seems playful and friendly. Thus the controversy generated by *Baltimore Federal*, a

175

GSA commission of 1975 for a local federal building and U.S. courthouse, came as a total surprise to many (fig. 81). Sugarman, who saw the sculpture as "something the public can stroll in and sit upon; something they'll feel comfortable with," was shocked by the opposition led by a U.S. district judge, who found it a security threat.

To address the judge's concerns, Sugarman opened some of the more enclosed areas of the latticework piece. Objections persisted, but so in

Figure 81. George Sugarman, *Baltimore Federal*, 1975–77, Federal Building, Baltimore, Md. (detail) (courtesy George Sugarman).

the end did the sculpture, with the support of the art community and the local and national press. (Interestingly, the same objections were made a decade later to a dramatically different piece, Richard Serra's *Tilted Arc* in New York City, with radically different results.)

The sculpture's curvilinear forms suggest an arbor of flower petals, and indeed it is used by employees as a place to each lunch or sit and chat. However, the piece is seen primarily as art, not street furniture, and public opinion is still mixed and passionate. During a recent visit, a young guard stationed at the entrance of the building liked the piece as an example of abstract art. His co-worker, a man in his early sixties, vehemently denounced it, observing that "people hate it because it is atrocious. . . ." The former had a context for appreciation; the latter was resistant to the point of fierce hostility.

In his latest public project, the largest to date, *A Garden of Sculpture* (1989) at Koll Center, Irvine North in California, Sugarman spread his colorful sculpture over a 138-foot-wide space, creating a fantasy landscape and providing a variety of seating opportunities and possible paths (fig. 82). Compared with his initial surprise at public attempts to "use" his sculpture, he now feels that "the presence of people completes the composition. Without them it has only latent energy. With them it comes alive."[8]

While Sugarman makes sculpture that includes seating elements, Scott Burton conflated categories of furniture and sculpture.[9] Burton was committed to an art of use almost from the start. As early as 1970 in *Iowa Furniture Landscape,* he photographed store-bought furniture in landscape sites. In his performance pieces called *Behavior Tableaux,* "actors interacted in precise ways with each other and with furniture."[10]

The leap to making actual works that deliberately confounded established categories of "furniture" and "sculpture" combined Burton's early passion for furniture with his more conceptual approach to art. Of the former he said:

I got interested in modern furniture as a teenager but it took nearly 20 years for me to do anything about it. First, I had to run through ambitions to be a painter and a writer and involved in theater. If I were a teenager now, it wouldn't be the same. Modern design has been so absorbed. But in Washington, D.C., in the '50s, where my family had moved from Alabama, modern furniture spelled modernism to me, and modernism spelled liberation. It was still avant-garde then. Furniture

Figure 82. George Sugarman, *A Garden of Sculpture,* 1989, Koll Center, North Irvine, Calif. (courtesy George Sugarman).

companies like Herman Miller, Knoll and Dunbar meant as much to me as Picasso and de Kooning, in much the same way. I was obsessed.[11]

Burton developed this obsession in the context of other architectural and art historical precedents. He espoused Constructivist theory and admired Gerrit Rietveld's "abstract furniture." In a gallery Burton's sculpture was assured a fine-art reading. In the public domain it challenged the esthetic quality of street furniture everywhere, as well as the purpose of public sculpture.

In 1981–83 Burton undertook a public project at the National Oceanic and Atmospheric Administration (NOAA) Western Regional Center, an eight-building complex in Seattle.[12] There five artists (Siah Armajani, Burton, Douglas Hollis, Martin Puryear, and George Trakas), selected with the assistance of the NEA and the Seattle Arts Commission, worked together with a local committee to develop the

178

Figure 83. Scott Burton, *Viewpoint,* 1981–83, NOAA Western Regional Center, Seattle, Wash. (courtesy Seattle Arts Commission).

concept of a shoreline walk on the southern portion of Sand Point Peninsula, an outskirt of the city along Lake Washington. The result was not quite the collaboration that was originally intended. Each artist created a separate piece, linked only by the single path that serves both to connect them and separate them from the rest of the 114-acre site.[13]

Burton's individual contribution, *Viewpoint,* consists of a gridded terrace at the water's edge punctuated by plantings and boulders dredged from the lake to serve as seating (fig. 83). Providing an intimate environment for conversation or communion with the spectacular natural setting, it was criticized for being a "drawing room without walls."[14] However, it is just this suggestion of domestic shelter that makes *Viewpoint* such a hospitable addition to the landscape. Although it was constantly in use during a recent visit, the total remoteness of the site raises questions of how public a work has to be (either in location or population served) in order to qualify as public

art. The NOAA works exist for employees and joggers, and it is diffi-
cult to ascertain how many people actually take advantage of them.

Burton quickly evolved as a public artist capable of a range of sculp-
ture/furniture as well as "ambitious urban design." In 1985, for Pearl-
stone Park in Baltimore, he developed a plan for what had previously
been a neglected urban non-site. The city donated the land; a private
individual (Richard Pearlstone) donated the money; and Burton, using
local materials of brick and sandblasted limestone, designed the entire
park, including landscaping, lighting, and seating arrangements (fig.
84). A unity of design is apparent throughout. A series of paired rec-
tangular concrete benches (much more comfortable than they look) are
placed between concrete and brick lighting fixtures with squared bases
and capitals, along a patterned brick and concrete path. The park,
used primarily as a walk-through, is a handsome addition to an area
surrounded by disparate and incongruous architectural styles.

In 1985–86 Burton designed the entire lobby area for the Equitable
Tower in midtown Manhattan (787 Seventh Avenue). This included a
semicircular seating wall forty feet in diameter, a twenty-foot-wide
marble table with a pond at its center, pilasters, lighting, the floor
pattern, and the plantings. He also designed the seating and planters

Figure 84. Scott Burton, *Pearlstone Park*, 1985, Baltimore, Md. (detail)
(Burt Roberts).

for the open areas alongside the adjacent Paine Webber Building (1285 Avenue of the Americas) on 51st and 52nd Streets, which, according to local zoning ordinances, had to include a requisite number of amenities to ensure maximum economic advantages for the builder (Fig. 85). Burton's first corporate commission provided midtown Manhattan with its most elegant street furniture. The south exterior "plaza" includes groupings of circular marble tables and stools, while its northern neighbor has long triangular planters enclosed by stone and wood benches. Although the busy area is hardly conducive to leisurely repose, Burton's work is both useful and welcome visually, providing a rare opportunity to sit or read or grab a bite of lunch outdoors.

Burton's public art projects, whether single benches or entire sites, create a stage for public life.[15] In this, as well as in the evolution of a formal vocabulary, Constantin Brancusi provided an important precedent. In 1937 at Turgu Jiu in his native Rumania, Brancusi created a memorial dedicated to the town's resistance to the Germans twenty years earlier. The three-part sculpture includes the ninety-six-foot-

Figure 85. Scott Burton, *Untitled*, 1985–86, Equitable Life, New York City (detail) (Harriet Senie).

high cast-iron *Endless Column,* the seventeen-foot-high stone *Gate of the Kiss,* and the round *Table of Silence* (seven feet in diameter) surrounded by stone stools.[16] The project, well known from photographs, suggested that furniture, like gates and columns, might be considered sculpture, and that, sculpture might constitute a place rather than a single object.[17]

Turgu Jiu was not Brancusi's only attempt at sculpture/furniture. In his various experiments with creating bases for his own sculptures, he frequently came up with table-like solutions. Burton's affinity for Brancusi's work was recognized in 1989 when Kirk Varnedoe, curator of painting and sculpture at the Museum of Modern Art in New York, invited the artist to do a special installation of Brancusi's pieces at the museum. Burton's focus on the "doubleness" of Brancusi's "pedestal-tables" reflects the essence of his own sculpture-chairs.

Richard Artschwager's recent foray into public art revealed a more abstract approach to sculpture/furniture than Burton's. An eccentric but continuous presence and influence in the art world, Artschwager has recently received considerable critical attention.[18] Incorporating elements of furniture (chairs, tables, mirrors) and architecture (windows and doors) since the early 1960s, Artschwager's sculptures have always evoked ideas about objects more than their literal or tangible reality.

The pervasive enigmatic quality of his work is evident in his sculpture at Battery Park City, which puzzles as much as it invites use. *Sitting/Stance* (1989), at West Thames Street, consists of an assortment of ambiguous structures (fig. 86). Two large angular forms resemble expanded deck chairs engaged in formal dialogue, but it is unclear whether one should sit or lie down on them. (Indeed, people do both.) Additional seating is provided by a circular surface surrounding a tree whose natural form in this assortment of artificial objects looks strangely out of place. Two vertical structures of stone suggest monumental bookends, although they don't actually frame the space; their steps invite climbing but lead nowhere. Equally perplexing is the sculptural element that resembles a compressed lamp post surrounded by a structure that formally echoes the tree enclosure. The strangeness of Artschwager's ensemble is partially masked by the familiarity of its materials and references. Nevertheless, a sense of mystery predominates.

Although they include the invisible element of sound, Douglas Hollis's "musical chairs" are less obscure. An early practitioner of sound

Figure 86. Richard Artschwager, *Sitting/Stance*, 1989, Battery Park City, New York City (Burt Roberts).

art, Hollis creates public sound sculptures that also often function as public seating. The relatively unstudied area of sound art was explored in a 1981 exhibition entitled *Soundings* at the Neuberger Museum. As Suzanne Delehanty, then director of the museum and curator of the exhibition, observed, "Ambient sound, or the sound that surrounds us, gives us a sense of our proper bodily location in space. . . . The absence of sound is silence, the unknown; inaudible voices have always been metaphors for the visions of mystics and for revelations about an invisible world beyond our ken."[19] In the public domain our awareness of ambient sound is usually deadened by the level of urban noise, and public sound sculpture would appear to work best where there are the fewest aural distractions.

At the NOAA Western Regional Center in Seattle, Hollis created *A Sound Garden* (1982–83), consisting of vertical aluminum pipes with wind vanes accompanied by benches for seating (fig. 87). On top of a

183

Figure 87. Douglas Hollis, *A Sound Garden*, 1982–83, NOAA Western Regional Center, Seattle, Wash. (Burt Roberts).

hill at a short distance from the main path linking NOAA's sculptures, the piece is well sited to respond to the velocity of the wind. Thus the wind vanes turn together to push the pipes, generating a variety of sounds as the wind passes over the open end of the pipes. The viewer seated in its midst feels a profound and eerie visceral connection to the landscapes. As Hollis explains:

What I've been trying to do is use sound to define experiential space within a broader environmental context in a way that simplifies perception. Sound has a terrific influence on our perception but we aren't necessarily conscious of its effects upon us. It actually physically vibrates upon your body. I use acoustic sound . . . which has a more architectural or ambient quality than electronically generated sound. . . . The sound gives a sense of enclosure without there physically being an enclosed space; it's an implied volume.[20]

184

It is unfortunate that the relatively remote setting, in many ways an ideal environment for the sculpture, doesn't have more visitors to take advantage of this unique experience.

At Santa Monica Beach, California, Hollis's site is anything but deserted. As part of the Santa Monica Arts Commission project to bring art to the beach, Hollis created *Singing Beach Chairs* (1987), two fourteen-foot-high chairs resembling lifeguard stations, with backs of hollow steel tubes that vibrate in response to the changing ocean breezes (fig. 88). Esthetically attractive and appropriate to the beach, they provide a pleasant observation perch even if the air is still and the pipes are silent.[21]

Figure 88. Douglas Hollis, *Singing Beach Chairs,* 1987, Santa Monica Beach, Santa Monica, Calif. (courtesy Douglas Hollis).

Gates and Fences: Dennis, Ewing, Fischer

Besides seating, useful public sculpture may take the form of architectural elements that are part of a larger complex and therefore immediately perceived as an integral part of that environment. Thus an entrance, a fence, or a gate is at once part of the architecture or site it delimits and an interface to the immediate surroundings. Lighting too is a familiar and usually undistinguished part of an existing urban environment. Such elements, traditionally considered street furniture, have taken unexpected forms in their recent public sculpture incarnations.

Donna Dennis's fence, *Dreaming of Far Away Places: The Ships Come to Washington Market* (1988), encloses the schoolyard at P.S. 234 in lower Manhattan (fig. 89). Sponsored by the New York City Percent for Art Program of the Department of Cultural Affairs and the Board of Education, it is Dennis's first permanent public commission. Dennis's gallery art, widely exhibited since 1970, consisted primarily of architectural structures such as rural cabins built at a smaller than archi-

Figure 89. Donna Dennis, *Dreaming of Far Away Places: The Ships Come to Washington Market*, 1988, P.S. 234, New York City
(courtesy Donna Dennis).

tectural scale, or subway stations evocative of the vast infrastructure of the urban environment. These sculptures conveyed the mysterious elements of prosaic architecture in a poetic and personal way.[22]

In developing the 254-foot fence for P.S. 234, composed of fourteen cut and welded steel panels measuring ten by fourteen feet each, as well as the nine ceramic medallions for the building, Dennis thought about the history of the neighborhood, its proximity to the Hudson River, and the primary audience of the piece: children.

My designs are meant to honor the history of Washington Market and the New York Harbor. I have tried to connect with my own childhood, which has been a powerful source for my art, to create the kinds of images that would have set me dreaming as a child, dreaming of traveling into the past, into the future, of traveling to distant places. My hope is that these images might set others dreaming their own dreams.[23]

This site was once the center of the food commodities trade and part of the city's vital shipping industry, and Dennis portrayed ships specific to that history: a Staten Island ferry, the *Hunchback* (owned by Cornelius Vanderbilt), an eighteenth-century ketch, and a twentieth-century barge. These vessels seem to sail around the schoolyard, apparently passing through the brick columns that punctuate the fence at regular intervals. Silhouetted on the adjacent sidewalk as the sun permits, the piece appears to change with the time and weather as well as the viewer's movement. Unobtrusively, Dennis's fence provides an evocative visual panorama for an otherwise uninteresting urban corner.

Lauren Ewing's *The Endless Gate* (1985), located at the Seattle Center near the Space Needle, serves no necessary functional purpose (fig. 90). However, punctuating the entranceway to the old World's Fair ground at five regular intervals of twenty feet, it transforms a commonplace experience into a processional event. Five gateway arches, each in a different architectural style, painted a different color, and with a different text printed across the lintel, define a path that few pedestrians resist, either when entering or leaving the area. They read: "The Gate," "A Hinge," "Between the Halves," "Neither One," "Nor the Other." Designated by the Seattle Arts Commission as a work that "may be particularly appealing to young people,"[24] it provides an accessible, engaging, and thought-provoking experience, as well as fun.

R. M. Fischer's gates are decidedly more funky. Involved with tem-

Figure 90. Lauren Ewing, *The Endless Gate*, 1985, Seattle Center, Seattle, Wash. (Burt Roberts).

porary and permanent public art for over a decade, he built his first public project, *Oasis* (1978), as part of the Art on the Beach program sponsored by Creative Time when Battery Park City in New York was still a landfill. In *Oasis* Fischer juxtaposed a billboard-sized photographic image with a constructed garden shelter. From there he went on to make bird baths, fountains, lighting fixtures, and gates.

At MacArthur Park in Los Angeles, Fischer was commissioned by the city's department of parks and recreation to build two gateway arches for the park's western entrances. The 1985 project, sponsored by the Otis Art Institute of Parsons School of Design, resulted in two thirty-foot-high illuminated structures composed of steel, aluminum, brass, zinc, fiberglass, and electric lights (fig. 91). Initially providing the only night illumination at the site, their presence led to a redesign of the park's lighting system.[25]

Rector Gate (1985–89) at Battery Park City is an asymmetrical structure that at first glance suggests a whimsical whirligig (fig. 92). Fischer's amalgams are solid assemblages, combining an array of evocative objects to form the body of the work and providing seating around the base. His gallery work has a "sci-fi," "low-tech," deliberate non-art look that ignores traditional barriers of art and use.[26] In both his private and public work Fischer is intrigued by the element of transfor-

188

Figure 91. R. M. Fischer, *MacArthur Park Gateway*, 1985, Los Angeles, Calif. (courtesy R. M. Fischer).

mation that ultimately leads to a confounding of viewer expectations: "Taking real things and transforming them or transforming their context and content somehow seems more interesting than being a designer. My stuff is about assemblage, collaging or juggling things."[27] That *Rector Gate*, with its odd assortment of parts, manages to look right at home next to such a traditionally manicured park is something of a magic act in itself.

Fischer's sculptures exude a sense of mystery, at once recognizable and seemingly familiar in terms of materials and function, but puzzling in terms of their mixed messages regarding art and use. Fischer's lamps appear to be one thing in a gallery setting and another in a home environment, yet each use (sculpture or lamp) invokes the other. Fischer's gates clearly function as gates, but they go far beyond traditional gateway forms, invoking the playful realm of fantasy and imagination, the movies, junk shops, and world's fairs.

189

Figure 92. R. M. Fischer, *Rector Gate*, 1985–89, Battery Park City, New York City (Burt Roberts).

Light Sculpture: Krebs, Antonakos

Light is an element in art that embodies components of use as well as fantasy. Intangible yet necessary, it can radically transform our experience of any space, defining our sense of scale and mood. Light became a familiar art medium during the late 1960s. A number of museum exhibitions, most notably *Light/Motion/Space* at the Walker Art Center in Minneapolis (1967) and *Light: Object and Image* at the Whitney Museum of American Art (1968), explored the various artistic approaches to light. Artists' experiments with industrial materials and technology, particularly the pioneering work of Lazlo Moholy-Nagy, manifested a fascination with an ephemeral material that both defied existing categories of painting and sculpture and appeared to conflate them. In 1985 the city of Philadelphia under the aegis of Penny Balkin Bach, Director of the Fairmont Park Art Association, embarked on a project entitled "Light Up Philadelphia" to explore a variety of ways in which contemporary artists might utilize light in an urban environ-

190

ment.[28] Proposals by five artists (David Ireland, Leni Schwendinger, Philips Simkin, Mierle Ukeles, and Krzysztof Wodiczko) used light to convey elements of local history or an overt political message. At the time of this writing, plans are under way to implement the project.

Of all existing public sculpture light projects, Rockne Krebs's *Miami Line* (1984–88) is one of the simplest and most immediately appealing. Commissioned by the Metro-Dade Art in Public Places program for the Brickell Avenue station of the local metrorail system, the 154-foot-long anodized steel and neon sculpture creates a nocturnal rainbow. Krebs described the evolution of *Miami Line:*

During my site study for the Brickell station several concerns about this area of downtown Miami became obvious. FIRST at night there is little which clearly defines this city scape as Miami and not some large city in the mid-west or elsewhere. SECOND the element here which harbors the most exciting visual potential is the elevated metro bridge. Its upper edge draws a line through the visual complexity of this urban landscape that could tie it all together. There are no plans to illuminate this structure and at night it too is lost in the visual serendipity of city lights. Ultimately the bridge's long twisting arch over the river and across downtown could become the element of sustaining grace from many points of view. . . . Thus *Miami Line* was conceived as a means to generate visual drama and create an identifying element which is unique to Miami by simply enhancing what is already present.[29]

Krebs has been making light pieces since the mid-1960s. The first to use lasers in large-scale public pieces, he has always been "fascinated by the dematerialization of objects."[30] For the artist, "If you are going to deal with a place esthetically, there is nothing more specific to it than light."[31]

Stephen Antonakos uses light to alter our perception of the spaces and surfaces around us. Since 1978 his public pieces have been concerned with intervals, the relationship of forms, and above all, the elusive combination of light and color inherent in neon itself. *Neon for 42nd Street* (1979–81), commissioned by the 42nd Street Redevelopment Corporation for a blank wall between Ninth and Tenth Avenues in Manhattan, consists of four arcs each of red and blue that transform the wall into an elegant screen of changing light effects (fig. 93). The placement of the arcs suggests a larger circular whole than is represented, while the audience for the piece encompasses more than the

Figure 93. Stephen Antonakos, *Neon for 42nd Street*, 1979–81,
New York City (courtesy Stephen Antonakos).

pedestrian and motor traffic at the site. *Neon for 42nd Street* is visible to
all bus travelers entering and leaving the Port Authority Bus Terminal,
a few blocks away, and thus serves daily as a landmark and welcome
sign to many visitors and commuters to the city.

Given the somewhat fragile nature of neon tubing, some of An-
tonakos's most complex installations have of necessity been indoors.
His recent Port Authority of New York and New Jersey commission
Neons for Exchange Place (1990), at the Path Station in Jersey City, is
notable for the total transformation of its site (fig. 94). Measuring 188
by 27 feet, it extends the entire length of the escalator and offers a
constantly changing experience. Accessible to all and capable of being
appreciated on any number of levels of sophistication, Antonakos's
neon sculptures are particularly appropriate to the public realm.

Figure 94. Stephen Antonakos, *Neons for Exchange Place*, 1990, Path Station, Jersey City, N.J. (detail) (Peter Bellamy, courtesy Port Authority of New York and New Jersey).

Sculpture/Architecture: Acconci, Armajani, Nauman, Adams, Kruger, Kinnebrew

While some public artists were investigating categories of furniture/sculpture or architectural elements, others were addressing the larger issue of architecture itself. Their interest coincided with the growing dissatisfaction with the modern style, articulated by Robert Venturi in *Complexity and Contradiction in Architecture* (published in 1966) and increasingly translated into a variety of postmodern forms by contemporary architects.[32] In 1977, the same year that Venturi,

193

Denise Scott Brown, and Stephen Izenour published *Learning from Las Vegas,* Martin Friedman, Director of the Walker Art Center in Minneapolis, organized an exhibition entitled "Scale and Environment: 10 Sculptors." In the accompanying catalogue Friedman observed: "Their common theme is architecture . . . the building, as a universal form in art, has become almost as prevalent as the human figure."[33] Architecture was seen as a metaphor, signaling a growing concern with humanistic issues.

Architectural forms suggesting habitation imply both human content and a relationship to the larger environment. By offering a conceptual or poetic interpretation of architectural forms, sculptors brought architecture under the scrutiny of a museum audience. In 1978 an exhibition entitled "Dwellings" at the Institute of Contemporary Art in Philadelphia focused solely on sculptural images of shelter and the psychological and theoretical implications of such work.[34] Suzanne Delehanty, curator of the exhibition and director of the ICA, saw the concern with house imagery as a way "to reinstate art's human content." Lucy Lippard suggested that such work indicated "a certain nostalgia, an orphaned avant-garde's need to find a home in a society where art has been separated from life."[35] She saw the dwelling as the "classical symbol of the female body—maternal and/or sexual" and architecture as the "mother of the arts." Although it is debatable whether the works included in these and other similar exhibitions can be seen as architectural analogues,[36] it is clear that a specific reference to architecture is intended. The translation of such architectural sculpture into the public realm, however, immediately raises issues of use. What keeps it from being interpreted as the real thing?

An actual house might be mistaken for just that. Any enclosed space in an urban setting presents a potential safety and health hazard. However, like sculpture/furniture, sculpture/architecture, assuming various degrees of abstraction, is intended to be understood symbolically as well as used. For Vito Acconci, "the house can be used as a place for social interaction and an occasion for cultural reconsideration" and, as such, is "less likely to be met with resistance as 'art.' "[37] After a series of provocative installation/performance pieces that established his art-world notoriety in the 1970s,[38] Acconci increasingly turned his attention to public art in object form. Acconci's public sculptures were seen as a group in an exhibition of 1988 at the Museum of Modern Art, New York, entitled "Vito Acconci: Public Places." For the artist, these works are informed by "the notion of a kind of

town square, the notion of a kind of discussion place, argument place, start-a-revolution place"[39] intended to challenge and provoke a larger audience. Acconci's *Bad Dream House #2* (1988) addresses the basic form that stands for "house" (a triangular roof above a rectangular box), as the origin of our formative relationships with shelter as well as the object of our socialized dreams. Acconci's house, however, contradicts our everyday experience of architecture in the public realm. Repeated three times in different materials, variously flipped, up-ended, and joined by interior ramps, it is, as the title suggests, more evocative of the irrational threatening spaces of nightmares than the stereotypical houses of children's drawings.

At the Museum of Modern Art, *Bad Dream House #2* was both subject to abstract art analysis and climbed on, experienced viscerally. Since the exhibition, the sculpture has been on display along a suburban Atlanta highway, adjacent to the Gwinnett County office and showroom of John Wieland Homes, a corporation with a growing collection of art with architectural themes[40] (fig. 95). In this setting *Bad Dream House* looks like a cockeyed advertisement of company business. Its primary audience consists of company employees and passing motorists, but young children find it especially attractive. "Better than

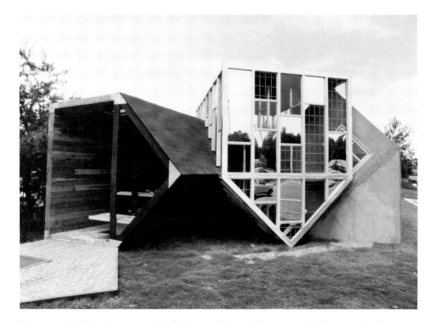

Figure 95. Vito Acconci, *Bad Dream House #2,* 1988, John Wieland Homes, Gwinnett County, Atlanta, Ga. (courtesy John Wieland Homes).

the playground," one informed me. Adults have more varied responses, dependent largely on their familiarity and comfort with contemporary art. Predictably, the more familiar, the more receptive they are.[41]

But does this roadside location, defined by its corporate context, lead to the kind of critical thinking that Acconci hopes to encourage? Recently he wrote:

Our insistence on the form of the house might be a way to insert, inside the public realm, inside the world of courthouse and town square, a world that by convention has been considered male, to insert inside that world a region that has been considered by convention female. . . . The sprouting of tiny multiuse houses all over public and social districts have been permitted; this emergence of houses (make-believe houses, half-houses, substitute houses) is like fucking in the streets, like an orgy in the middle of a town meeting. Inside the house are hallways, attics, basements; places where secrets can fester and bombs can be planted.[42]

The nature of the provocation, however, depends largely on the immediate audience and site.

When *House Cars #2* (1987) was installed temporarily in San Francisco, it unexpectedly became a shelter for the homeless. This, of course, was not what the corporate sponsor intended. Rather than patrol the piece (which would have raised costs as well as stimulated controversy), the decision was made to have it removed. The House Cars, like the Dream Houses, were meant to invite participation but not habitation. The homeless, more in need of shelter than art, were understandably misled, as was the patron who considered the artistic rather than the public aspect of the piece. Acconci is attempting a difficult subversion. Intending to "question" rather than to "attack" public conventions, he risks being absorbed by the public arena. Acconci hopes that "In a world of shopping malls, public art reinserts the town square."[43] But in our culture, where much open space is privately owned by corporations motivated by business interests, not social welfare,[44] this may not be possible.

While Acconci aspires to a public art that is meant to disturb and disrupt, Siah Armajani wants a public art that connects and heals. Also working in the hybrid category of sculpture/architecture, he sees public use as the conduit of meaning. For Armajani:

Public art provides a means of repairing the rupture between contemporary life and the things that we have lost. In view of the important implications of public art, I often contemplate its predicament, exploring my assumptions about its nature in order to formulate a synthesis. The predicament of public art emanates from problems of categories of content, systems of reference, and conditions of events. The assumptions that I hold about public art emanate from my belief that a work of art should be grounded in the structure of its political, social, and economic context because that context gives a work of art its meaning. The synthesis of public art calls for a search for a populist cultural history to support a structural unity between built objects and their public setting.[46]

Armajani found bridges to be a particularly rich public art form. As Janet Kardon observed of his early bridge drawings and structures, "If passage is implied, it is metaphorical. If the bridges are transitive, the movement is toward information rather than another place."[46] In 1980 Armajani began to include information in the form of texts, thereby linking his sculpture to American literary traditions. His two bridges of 1983, part of the NOAA project in Seattle, contain quotations from *Moby Dick* embedded in bronze along their railings and pavements. Providing pedestrian paths over drainage ditches, the bridges today are largely enveloped by surrounding grasses and shrubs, making them barely visible. Although they serve to mark the main pathway connecting the NOAA sculptures, their necessity is questionable. Both their form and their function require more emphasis.

Armajani's Irene Hixon Whitney Bridge (1985–88) in Minneapolis has a vital and immediately apparent function—to provide a dramatic entranceway to the Minneapolis Sculpture Garden at the Walker Art Center and to link it to Loring Park on the other side of the highway[47] (fig. 96). Although it spans a sixteen-lane thoroughfare, Armajani's openwork bridge, painted in pale yellow and blue, suggests a weightless airy passage, reminiscent of Tatlin's famous design for a tower for the Third International (1922). Armajani had long admired the Russian Constructivists and their goal of useful art. His bridge, with its changing geometric pattern and color, emphasizes the change inherent in moving from one place to another. Extensive approach ramps further articulate the experience of ascending, descending, and passing through.

There is always more to the philosophical thinking behind Arma-

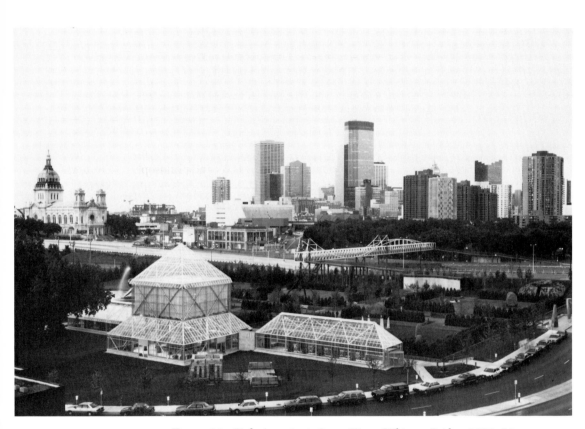

Figure 96. Siah Armajani, *Irene Hixon Whitney Bridge*, 1985–88, Minneapolis, Minn. (courtesy Walker Art Center, Minneapolis).

jani's structures than meets most eyes. Based on his reading of Heidegger, Armajani makes sculptures that explore the layered formal and functional meanings of architecture.[48] In a pristine gallery setting with accompanying wall labels and catalogues, these symbolic references are distilled for the viewer. In the public domain, perception necessarily remains more literal, but appreciation and enjoyment are possible nevertheless.

In the bus shelters of Bruce Nauman and Dennis Adams, additional and sometimes ambiguous content is incorporated in surface imagery rather than implied by the structure. The function of a bus shelter, like that of a bridge, is immediately apparent and understood. Its users, however, are stationary and temporarily captive. They are a public with time, however brief, for looking at art, and as regular commuters (as opposed to chance visitors to the area) even have the opportunity for repeated viewing. Bruce Nauman's 1983 bus shelter along Chicago's State Street Mall invites such prolonged attention[49]

198

(fig. 97). A circle of brightly colored flashing neon words presents a constantly changing message: "life, death, love, hate, pleasure, pain." Overlapping radii alternately read "human nature" or "animal nature."

When Nauman began using neon some twenty years earlier, while still a graduate student at the University of California at Davis in 1965,[50] it suited his conceptual approach to the Pop Art environment of the time. This piece combines ambiguous and philosophical content in a flashing billboard style associated with commercial advertising. The words suggest different connotations, depending on their on/off status of juxtaposition, while the colored light creates an independent esthetic experience. At home in an urban environment composed of many flashing lights and words, the bus shelter stands apart by communicating on a more provocative level.

If Nauman's neon signs reflect the verbal messages of the commercial urban environment, Dennis Adams's photo images address their visual counterparts. These large-scale politically charged photographs penetrate the viewer's consciousness almost subliminally. However,

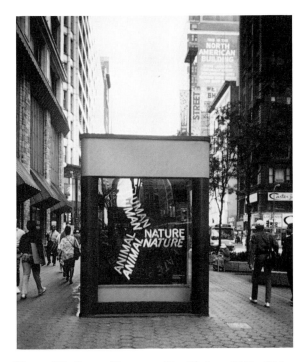

Figure 97. Bruce Nauman, *Bus Shelter,* 1983, Chicago, Ill. (Harriet Senie).

instead of the expected slick images of advertising, they depict Ethel and Julius Rosenberg, Roy Cohn and Joe McCarthy, or the lawyer Jacques Verges, who defended Klaus Barbie in his Nazi war crimes trial. In 1986 Adams installed two bus shelters in New York City at different locations and with changing images[51] (fig. 98).

Adams is concerned with the rapid disappearance of history, but images with only cryptic verbal identification or none can speak only to

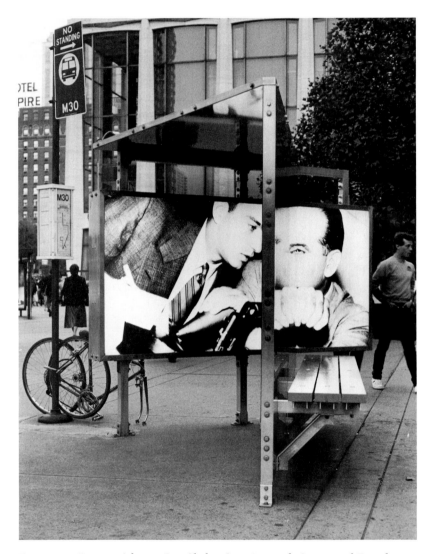

Figure 98. Dennis Adams, *Bus Shelter I*, 1983, 66th Street and Broadway, New York City (Dennis Adams).

those who are already familiar with the specific incidents or episodes evoked. Although Adams's images suggest popular newspaper and television sources, their subjects are not immediately recognizable to most viewers. Without recognition, the desired process of questioning and identification cannot take place.

Barbara Kruger's recent posters for bus shelters address sociopolitical issues more directly. In 1991 three different photographic images addressing the same question were displayed for four months in a number of locations throughout New York City. Part of the Public Art Fund's Public Service Art project, these images replaced advertisements and indeed resembled them, as Kruger's provocative art usually does. In addition to the obviously middle-class white male represented here (fig. 99), other posters featured a black teen-ager and a middle-

Figure 99. Barbara Kruger, *Untitled*, 1991, 130th Street and Amsterdam Avenue, New York City (Timothy P. Karr, courtesy Public Art Fund Inc.).

aged white construction worker. Lured by the guise of a commercial come-on, the viewer begins reading the text and gradually is made to question the issue of reproductive rights from a different perspective. What if men were the ones to become pregnant? As Kruger stated, "In this series of pictures and words I am attempting to raise questions, but to try and do so with humor and a kind of quietly bemused consideration. Hopefully this work can help focus attention on our dreams and who can dare to dream them, and our bodies and who controls them."[52] Although Kruger's public art elicits a range of unpredictable responses from recognition to rage, two things are certain: it cannot be ignored and it lingers in the mind.

One architectural sculpture that seems to require no explanation, once you know it's there, is Joseph Kinnebrew's *Grand River Sculpture* in Grand Rapids, Michigan (fig. 100). Dedicated to the "aesthetic significance of our environment," this concrete structure is actually a fish ladder enabling spawning fish to move upstream. Built in 1975, it is an early example of functional public sculpture that engages a broad public audience. Kinnebrew elaborated on the Michigan Department of Natural Resources' plans for a fish ladder, turning it into an archi-

Figure 100. Joseph Kinnebrew, *Grand River Sculpture*, 1975, Grand Rapids, Mich. (detail) (Burt Roberts).

tectonic structure with ample viewing space, a small adjoining seating area, and a parking lot. Funded by the NEA's Art in Public Places program and various local groups (arts councils, private foundations, and corporations),[53] *Grand River Sculpture* continues to function and attract a public audience, while Robert Morris's contemporary reclamation sculpture, *Grand Rapids Project* (1974), is overgrown and ignored. Both pieces have environmental functions, but Kinnebrew's has live content (jumping fish) and thus includes an unpredictable performance element as its focus. Even without the fun of spotting the fish in action, the riverside location provides additional visual interest totally absent from Morris's inaccessible hilltop site.

Kinnebrew's *Grand River Sculpture* expands the concept of sculpture/architecture from single structure to architectural site. This parallels the expansion of landscape elements to mini-parks or natural environments. The corresponding expansion of architectural sculpture differs in focus more than intent. Although some plantings may be included, the primary objects are artificial, referring to the built rather than the natural environment, and always include elements of use.

Built Environments: Ferrara, Snyder, Smyth, Schwartz, Irwin, Blum, Noguchi

As landscape sculptors have incorporated roles more traditionally reserved for landscape architects, sculptors of architectural sites have increasingly incorporated elements of urban planning, making up for what the planners and the architects have left out. Their sites, creating a stage for public life in an urban context, express an inherent criticism of the way our cities have been built. Sculptors like Jackie Ferrara and Kit-Yin Snyder provide evocative and poetic architecturally defined spaces scaled to human needs. Ned Smyth creates colorful and decorative environments that invoke a variety of artistic and religious contexts. A more conceptual approach is taken by Robert Irwin and Andrea Blum, who focus on elements of phenomenological perception and abstract spatial relationships. In those special built environments for children—playgrounds—pioneering efforts by Noguchi address both visual and visceral thinking as well as the creative imagination.

Jackie Ferrara has been active since the early 1970s as a sculptor of mysterious architectural forms, reminiscent of pyramids belonging to an imagined architecture of the past, yet oddly at home in a contempo-

Figure 101. Jackie Ferrara, *Belvedere*, 1988, Minneapolis Sculpture Garden, Minneapolis, Minn. (Glenn Halvorsen, Walker Art Center, courtesy Michael Klein Inc.).

rary gallery setting. Her stepped structures, at a smaller than life-size scale, suggest interior spaces that can neither be seen nor entered, yet exist concretely in the viewer's imagination.[54] When Ferrara began making outdoor pieces, the empty ambiguous courtyard spaces of her gallery work became platforms or arenas that encouraged a variety of uses.

Belvedere (1988), at the southwest entrance to the sculpture garden at the Walker Art Center in Minneapolis, is a cedar structure measuring 10'6″ × 42' × 34' that serves both as seating and stage (fig. 101). Like Armajani's bridge, Ferrara's sculpture was commissioned in part for its usefulness.[55] On a recent visit people of all ages clustered on the

steps and floor in an ever-changing choreography. More formally, the sculpture is used for musical and theatrical performances. Appropriately, Ferrara considers her public pieces as "timeless places rather than objects" intended to function as "architectural backgrounds for various events."[56]

Although the title *Belvedere* suggests the famous courtyard in the Vatican where the classical Apollo Belvedere torso resides, the T-shaped deck and structure are not identifiable classical or Renaissance forms. The sloping walls invite Egyptian comparisons, but as is typical of Ferrara, no reference is specific. Thus a vague sense of history is incorporated while the specific content is provided by the present, with the public functioning variously as actor and audience.

While Ferrara's sculptures have a mysterious aura, their presence is always palpable and solid. By comparison, Kit-Yin Snyder's structures built of wire mesh are ethereal. At first glance their transparency renders them ghostlike, an urban mirage in a setting where architecture is monolithic and impenetrable. At Margaret Mitchell Square (1986), a busy traffic triangle in downtown Atlanta, Snyder's arches and columns at a less than architectural scale combine an apparent fragility with a sense of structural and formal authority (fig. 102). An odd oasis, especially attractive when the fountain is working, the area is frequently used by office workers for lunch. Although unobtrusive, Snyder's piece insinuates itself in the imagination, calling up visions of a more magical and romantic garden setting.

Ned Smyth's environments too invoke a different kind of architecture—one that is colorful, decorative, and exotic. Along with a number of other artists such as Robert Kushner, Kim McConnell, Joyce Kozloff, Tina Girouard, and Valerie Jaudon, Smyth was already committed to a decorative esthetic by the mid-1970s.[57] In fabric as well as three-dimensional form, Smyth's work recalls the richly patterned surfaces of the Arabic Middle East. In *Reverent Grove* (1978), a GSA sculpture for the federal building and U.S. courthouse in Charlotte Amalie, St. Thomas, U.S. Virgin Islands (fig. 103), Smyth wanted

to create a magnetic and tranquil focus for the courtyard . . . a cool, shaded spot quietly echoing the sound of falling water. . . . It should seduce and beguile with color, sound, texture and articulated forms. At the same time its intention is to relax with its mass, stillness, and archetypal spiritual overtones.[58]

Figure 102. Kit-Yin Snyder, *Margaret Mitchell Square,* 1986, Atlanta, Ga. (courtesy Kit-Yin Snyder).

Smyth combined geometric patterned columns with green leafy forms suggestive of palm trees, covered with a colorful mosaic surface that shimmers in the tropical heat. Although Smyth was concerned with spiritual content and even specific Christian symbolism (the baptismal associations of water and the ideas of rebirth and redemption associated with the palm leaf), he was nevertheless content to have the sculpture appreciated on esthetic grounds alone. Even so, one might question the appropriateness of such specific religious content to this courthouse site.

Similar questions are raised by *Upper Room* (1987) in New York's

206

Figure 103. Ned Smyth, *Reverent Grove*, 1978, Federal Building and Courthouse, Charlotte Amalie, St. Thomas, U.S. Virgin Islands (Bob Wands, courtesy Ned Smyth).

Battery Park City at Albany Street Park, adjacent to the esplanade (fig. 104). Approximately seventy-five by forty feet, this self-contained architectural environment built in pebble aggregate incorporates a range of historical references: a pyramid-roofed pergola and columns, topped variously with palm motifs and stacks of cylindrical discs, suggest Greek, Roman, Egyptian, and Gothic styles. Raised on a stepped platform, the sculpture evokes higher levels of reality by its title (the Hindu Chakra referring to the area of psychic energy above one's head), while its central table with twelve seats recalls *The Last Supper*,

Figure 104. Ned Smyth, *Upper Room*, 1987, Battery Park City, New York City. (Devin Mann, courtesy Battery Park City Authority).

a subject Smyth depicted in an earlier work.[59] These layered references, combined with postmodern abandon, are not accessible to most viewers and, in any event, the evocative symbolism hardly relates to the site.

Upper Room is a place of an undefined ceremonial nature. Even when occupied, it feels rather like an undirected stage set. Radically different in form and mood from its architectural setting, the materials are nevertheless close in color and texture to the surrounding buildings. By attempting both to blend visually and stand apart, it does neither successfully.[60] The effect instead is one of a plop plaza—an environmental transplant without cultural or formal roots to its site that is nevertheless more interesting than the architecture around it.

One of the most effective elements of Smyth's public sculpture is its

suggestion that architecture can be colorful, mysterious, and engaging—a relief from the barren monotony of so many contemporary urban sites. Martha Schwartz accomplishes this effectively in *Garden* (1987), a colorful ceramic tile forecourt in front of the King County Correctional Facility in downtown Seattle (fig. 105). Considering the building an eyesore, Schwartz successfully used a Japanese approach of focusing attention on the ground.[61] She covered the building facade with a mosaic of green, lavender, blue, mauve, and yellow while the equally colorful tiled pavement is punctuated by a variety of sculptural forms, some of which also serve as seating. Schwartz, a landscape architect trained as an artist, called the result a "surreal garden."[62] Visually interesting and active-complex enough to reveal new elements even after repeated viewings, it is especially welcome at this site, suggesting a variety of options for viewing art and, by implication, life.

While Schwartz's *Garden* represents one of the most decorative built urban environments, Robert Irwin's *Nine Spaces, Nine Trees* (1983), just a block away in downtown Seattle, is one of the most conceptual (fig. 106). Its blue chain-link fence structure of nine rooms, each with a single tree, suggests the imprisonment that Schwartz's sculpture determinedly worked against. Even though it provides the most direct

Figure 105. Martha Schwartz, *Garden*, 1987, King County Correctional Facility, Seattle, Wash. (Burt Roberts).

Figure 106. Robert Irwin, *Nine Spaces, Nine Trees,* 1983, Public Safety Building, Seattle, Wash. (detail) (Burt Roberts).

access to the Public Safety Building, it is avoided by most people crossing the courtyard space. As Irwin observed on his first visit to the site in 1979:

This is a very forlorn, isolated, even hostile plaza surrounded by a very grey architecture. The only visitors are a few people paying fines or visiting friends in the city jail, which occupies the second and third floors. . . . Most importantly, the plaza needs greening.[63]

Although the individual plum trees are attractive, they don't achieve an overall greening effect. Furthermore, the blue metal fence creates a grid of isolated spaces hardly conducive to socializing. Rather, the sculpture stands as a metaphor for urban isolation and the impossibility of social interaction that underscores the bleak message of the setting.

Nine Spaces, Nine Trees makes sense in the context of Irwin's work and his concern with the phenomenological aspects of perception, clearly articulated in his book *Being and Circumstance: Notes Toward a Conditional Art* (1985). For Irwin, "The subject of art is the human potential for an aesthetic awareness (perspective)."[64] For art in the

210

public realm, Irwin advocates a site conditioned/determined sculpture.

Here sculptural response draws all of its cues (reasons for being) from its surroundings. This requires the process to begin with an intimate, hands-on reading of the site. This means sitting, watching, and walking through the site, the surrounding areas (where you will enter from and exit to), the city at large or the countryside. Here there are numerous things to consider; what is the site's relation to applied and implied schemes of organization and systems of order, relation, architecture, uses, distances, sense of scale? For example, are we dealing with New York verticals or big sky Montana? What kinds of natural events affect the site—snow, wind, sun angles, sunrise, water, etc.? What is the physical and people density? the sound and visual density (quiet, next-to-quiet, or busy)? What are the qualities of surface, sound, movement, light, etc.? What are the qualities of detail, levels of finish, craft? What are the histories of prior and current uses, present desires, etc.? A quiet distillation of all of this—while directly experiencing the site—determines all the facets of the 'sculptural response': aesthetic sensibility, levels and kinds of physicality, gesture, dimensions, materials, kind and level of finish, details, etc.; whether the response should be monumental or ephemeral, aggressive or gentle, useful or useless, sculptural, architectural, or simply the planting of a tree, or maybe even doing nothing at all.[65]

Unfortunately, the kind of subtle perceptual thinking that Irwin does at a site doesn't necessarily translate into a work of art accessible to a general audience. In a gallery or in a public space that encourages quiet reflection, this communication obviously occurs more easily than in an urban site with distracting visual and audible noise. As Irwin himself observed, "Nothing is separate from its circumstances but is mediated by them to the extent of being imploded onto its site."[66] The degree to which an observer can separate the bleak urban setting and dismal function of the building sufficiently to appreciate Irwin's piece depends on his or her receptivity to and familiarity with contemporary art. As Thomas McEvilley observed, "*Nine Spaces, Nine Trees* may not be the best place for lunch, but it is surely one of the best places to appreciate Irwin's art."[67] Most users of the site, however, are not in a position to "use" it in this way.

Figure 107. Andrea Blum, *Ranier,* 1984–86, State Mental Health Facility, Buckly, Wash. (courtesy Andrea Blum).

Andrea Blum's built environments suggest large architectural drawings, with layers of possible experience, as well as practical amenities like seating. *Ranier* (1984–86) in Buckly, Washington, for the State Mental Health Facility, had specific safety requirements since it is used by patients with severe retardation as well as blindness and other physical incapacities (fig. 107). Built of colored concrete in combination with steel and terrazzo, *Ranier* provides a peaceful place to sit and walk. Low-key in appearance, the subtle qualities of the work and the refinement of details reveal themselves with repeated use.

Rotational Shift (1987–88), the plaza for the Computer Science Building of the University of Wisconsin at Madison, also provides seating in a contemplative space (fig. 108). Blum designed the entire 6 × 75 × 125-foot space of pigmented concrete, including the lighting and plant materials. It can be seen in totality only from above, and at ground level perception changes with the path of approach as well as

Figure 108. Andrea Blum, *Rotational Shift,* 1987–88, Computer Science Building, University of Wisconsin, Madison, Wisc. (courtesy University News and Information Services).

light angle and shadow patterns. This varied and layered perceptual experience cumulatively creates a heightened visual awareness of the environment—one that is determined and built by the individual user.

Playgrounds—those environments created specifically for children—address a different audience with special needs. Young children learning in many ways, physically as well as mentally, absorb playground experiences largely at a visceral level. One of the fist contemporary sculptors to address playground design, Noguchi evolved his approach from an early sculpture, *Play Mountain* (1933), where the earth or ground is treated as a multilevel experience; there is a feeling for what lies beneath the surface as well as the potential for building on it. Despite his long interest, Noguchi realized only two playgrounds.[68]

213

Figure 109. Isamu Noguchi, *Playscapes*, 1976, Piedmont Park, Atlanta, Ga. (courtesy The Isamu Noguchi Foundation).

The first was for Kodono Na Kuni (Children's Land) near Tokyo in 1965–66. Ten years later the second was commissioned by the High Museum of Art and the city of Atlanta. *Playscapes*, installed in Piedmont Park in 1976, consists of a variety of brightly colored shapes that can be experienced literally and figuratively on many levels (fig. 109). Noguchi liked to think of playgrounds as primers of shapes and functions: simple, mysterious, evocative, and thus educational. As public art, they combine both site and sculpture design with use.

By including or focusing on use as an integral factor in public sculpture, artists have acknowledged such mundane public needs as seating and have considered the more complex issue of creating spaces that provide a suitable setting for public life. In essence such public art is egalitarian—open to everyone, accessible to all, regardless of education. Use is undeniably a welcome urban amenity—but by itself it isn't art. An integrated balance of art and potential use is necessary to

214

ensure that a project provides more than a place to sit. Where concep-
tual or abstract concerns remain primary, the public is usually kept at a
distance, both physically and intellectually. However, where both
physical and spiritual needs are successfully addressed, as in most of
the work discussed in this chapter, public sculpture makes a major
contribution to public life and art, providing the opportunity for one
while integrating the experience of the other.

6

The Persistence of Controversy: Patronage and Politics

What has been art to museum goers (a relatively small elite) became to the public such things as insults, irrelevancies, fire hazards, anti-people, bomb threats and insidious threats to security.

Mike Steele

There is a hidden class struggle behind the rumblings that accompany the public art enterprise.

Janet Kardon

Controversy and public sculpture appear to have been joined at birth. In its traditional form as monument or memorial, public sculpture represented the ruling classes and their values, and as such was rightly seen as an extension of their authority. When power changed from one regime to another, so did public art. Public sculpture was only as secure as its patron. Although public art still exists in a political arena, the relationship of art and politics is much less clear. As soon as art is taken out of the sequestered spaces of the museum and the gallery system, it immediately becomes embroiled in a spectrum of non-art issues. With the advent of modern art and the development of abstract styles (understood primarily by the art-educated), the issue of elitism versus populism was added to the other issues of controversy surrounding public art in a democracy. At work, too, are the various conflicting attitudes toward art imbedded in our culture.

Rodin, whose work marks the beginning of modern sculpture, cre-

216

ated a number of monuments whose history was a harbinger of things to come. *The Burghers of Calais* (1885–95) and *Balzac* (1891–98) were rejected by the very groups that commissioned them. The prototypical public art problems encountered by Rodin's *Thinker* (1880–81), documented by Albert Elsen, included the selection process, the rationale for having public sculpture, the problem of siting, issues of interpretation of modern sculpture (especially as seen against traditional standards of decorum and taste), and the vulnerability of public sculpture to attack (both verbal and physical).[1]

A century after Rodin, in 1983, an exhibition at the Milwaukee Art Museum entitled "Controversial Public Art from Rodin to di Suvero" also included works by Maillol, Lipchitz, Picasso, Oldenburg, Calder, and Segal, now considered classic examples of successful modern public sculpture.[2] Common to the controversies surrounding these works of widely divergent styles were problems concerning the understandability of the artist's aesthetic or formal approach, interpretation of political or moral content, and appropriateness of the work to subject or site. Underlying many of these problems were stated and unstated expectations for both the sculptures and the sites.

Recent public sculpture, as we have seen, often took the literal place of traditional monuments without fulfilling their memorial function. Never intended as memorials, these works nevertheless raised public expectation that they would convey some commemorative or, in any event, at least some understandable content. However, most contemporary sculpture does not speak in a visual language accessible to those without some art background. It does not depict easily identifiable subjects, and it does not celebrate common values. Often it occupies sites that are unattractive and inhospitable, problems that the sculpture can hardly solve or even mitigate. Given these circumstances, it is not surprising that controversies are almost as frequent as commissions.

Too often the unstated expectations and agendas that lead to public art controversy are embedded in the patronage system. Who commissions public art and why? To date there are more than 150 public art programs at all levels of government. The best known are at the federal level: the General Services Administration with its Art-in-Architecture program and the National Endowment for the Arts' Art in Public Places program. The GSA had a percent-for-art component in its building program intermittently between 1963 and 1972 and steadily thereafter. The funding premise is that a small percentage of the

building costs (usually around 1 percent) will be used for art. This is also the basis for most local public art programs around the country. Philadelphia, with the first privately funded public art program already in place at the Fairmount Park Art Association since 1872, was also the first to enact municipal percent-for-art legislation in 1959.

Percent-for-art programs are based on the assumption that art is a necessary and desirable part of architecture, and by extension, of the built environment. Indeed the traditional practice of western European architecture throughout history included painting and sculpture in an integral way. In the twentieth century, Bauhaus ideology, having excluded traditional sculptural ornament from modern architecture, nevertheless continued to call for the integration of the arts. The specific impetus for the creation of the GSA's current program came from a report issued in 1962 by the President's Ad Hoc Committee on Federal Office Space. This report, *Guiding Principles for Federal Architecture,* recommended that "where appropriate, fine art should be incorporated in the designs [of new Federal buildings] with emphasis on the work of living American artists."[3] The committee was motivated by what was perceived to be "the increasingly fruitful collaboration between architecture and the fine arts." Then, as now, the idea was attractive even though existing projects were few and successful results rare.

Since percent-for-art programs began with architecture, the commissioning process, at first, began with the architect. He (rarely she) would determine the location for any artworks and recommend at least three possible artists to the GSA.[4] New selection processes were introduced in 1973 that gave the power to recommend the artists (and therefore to determine the kind of art) to a panel of "qualified art professionals" appointed by the NEA. Nevertheless, GSA and other percent-for-art–sponsored projects still begin with the building and usually treat the art as an add-on. Implicitly, therefore, the function of the art is to enhance the architecture or the open space around it.

Although it has resulted in much uninspired art that appears to be "plopped" onto a site without consideration of stylistic or local appropriateness, this premise, much maligned in recent years, does not preclude the creation of good public art. From the vantage point of the art community, this approach narrows the role of the artist, reducing it to one of decorator. However, just because a sculpture may enliven a boring building or urban space doesn't automatically "reduce" it to a "merely" decorative function. A sculpture may be visually good for the

site and good art at the same time. This is true of Calder's *Flamingo* in Chicago (fig. 40) as well as Sugarman's*Baltimore Federal* in Baltimore (fig. 81), both GSA commissions.

The NEA's Art in Public Places program proceeds from a different premise.[5] It offers matching funds to local organizations for art intended for specific sites. Art is thus purchased or created in response to local demand and becomes the property of the locale rather than the federal funding agency. The reasons for local demand are varied and sometimes difficult to ascertain. Often the work of art is part of a larger urban renewal project. There is ample precedent for this. To cite just one famous example, Michelangelo's Capitoline Hill in Rome with the antique sculpture of *Marcus Aurelius* (until recently) at its center, was part of a remodeling project initiated by Pope Paul III in 1537 to strengthen his papacy. Calder's *La Grande Vitesse* (fig. 39), the first sculpture commissioned by the NEA's Art in Public Places program, was also part of an urban renewal project. Subsequently, when an image of the piece appeared, as a civic logo on official stationery as well as garbage trucks, it functioned as a cultural sign of a decidedly upscale urban identity. Thus, although the sculpture itself did not provide actual urban amenities, it helped provide the community with a positive self-image, part of the goal of any urban renewal project.

Problems result not when public art is part of an urban renewal project, but when it is used in place of (rather than as an accompanying sign of) urban renewal. Rafael Ferrer's *Puerto Rican Sun*, installed in a South Bronx community garden park in 1979 as a result of an NEA grant, was intended as a symbol of local pride for an economically deprived residential neighborhood (fig. 110). But no art can make up for a lack of decent housing. Implicitly, commissioning public sculpture for this unstated purpose is comparable to painting the facade of an abandoned building as if it were inhabited—complete with curtains, flowers, and an occasional cat on the window ledge. Both mask actual problems that are then more easily overlooked and consequently remain unaddressed. Urban sculpture is not and cannot be a substitute for urban renewal, although the two are by no means mutually exclusive.

Existing expectations for a site are easily transferred to a work of art, which is then held responsible for not addressing them. In 1985, at the much-publicized hearing for Richard Serra's *Tilted Arc* (fig. 111), commissioned by the GSA for Federal Plaza in New York City, many people expressed the desire for a working fountain, some seating space, and,

Figure 110. Rafael Ferrer, *Puerto Rican Sun*, 1979, South Bronx, N.Y. (courtesy Nancy Hoffman Gallery).

in general, a more attractive open area. *Tilted Arc* clearly did not provide these much-needed urban amenities. Nor was it intended to do so. Many who voiced criticism of the art were actually expressing their dissatisfaction with the plaza. The GSA finally added some catalogue standard-order planters and benches only after the sculpture was removed.[6]

The needs of the site and its public must be considered at the time that the art is commissioned. If useful urban amenities are desirable, then sculptors who regularly incorporate these functional aspects into their work should be considered. Today there are many public sculp-

220

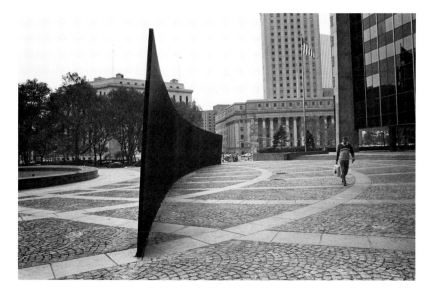

Figure 111. Richard Serra, *Tilted Arc*, 1981, destroyed 1989, Federal Plaza, New York City (David Aschkenas, courtesy Richard Serra).

ture options that may include elements of urban renewal rather than mask their absence. Although public sculpture, as a rule, is not deliberately used to mask deficient urban sites, art used as a cover or a company logo (or both) is a critical issue in corporate sponsorship. There the actual business of the corporation may be masked behind the activity of supporting art. The public thus inhales art and corporate largess instead of noxious fumes or obnoxious politics. Even though corporate support for art has not been predominantly support for public art, many corporations do have public sculptures in front of corporate headquarters. Several also have outdoor sculpture collections open to the public, the corporate equivalent of a museum sculpture garden. Indeed, some enterprising corporations appear to be going into the museum business themselves. A case in point is the recent enlargement of the General Mills outdoor sculpture program in Minneapolis, nearly coincident with the Walker Art Center's foray into this field.[7] Both include specially purchased and newly commissioned work. General Mills even chose two artists not usually known for outdoor sculpture (Jonathan Borofsky and Mel Kendrick) to create works for their collection, thereby adopting an innovative curatorial role for a corporation. Thus, as museums become increasingly entrepreneurial and frequently look like department stores with their restaurants and gift shops, some corporations are beginning to look more and more like museums. To what end?

221

A recent survey of patterns of corporate collecting suggests that businesses acquire works of art mostly for purposes of public relations.[8] A number of years ago architect Gordon Bunshaft of Skidmore, Owings & Merrill bluntly stated, "Art is for the client, just like he buys good furniture."[9] A blue-chip art collection outside corporate headquarters is a sign of prestigious respectability. By transferring a museum aura to the corporation, it changes corporate identity in a subliminal way. It also transforms art into an advertising tool, an enhancer of the corporate image, and as such potentially neutralizes its power. As critic Nancy Princenthal observed, Richard Serra's *Core* at General Mills, like Jonathan Borofsky's *Man with Briefcase,* "frames the corporate structures behind it and is framed by them; it is a kind of logo."[10] The corporate site implicitly changes the content of the piece.

It is reasonable to view corporate support for art with some skepticism. Corporations are in the business of making money and spend it only when they perceive it to be in their best economic interest to do so. But this does not necessarily mean that the resulting art is not also a true public amenity. Some of the most interesting and challenging public sculpture of our time has been privately funded in this way. The Poiriers' *Promenade Classique* in Alexandria, Virginia (discussed in Chapter 1), is one such example. However, the responsibility remains with the viewer to filter out the auxiliary advertising impact of the context.

One advantage to corporate patronage is that the commissioning process may be considerably simplified and restricted to a relatively small number of individuals. When public funds are involved, however, the role of the public in the selection process becomes an important issue. At once a number of difficult questions come into play. Who is the public? Is it restricted to those who live and/or work around the site? Clearly not everyone can have a voice. How do you choose a representative from such a diverse and changing group?

A more basic question, however, is whether a representative of this amorphous public should be given a vote in the selection process. In a representative democracy such as ours, we elect officials to represent us in making decisions on issues with global implications as well as those with only local impact. In most areas we are willing to follow the advice of the professionals that our public representatives consult. This is true of economic and scientific issues, and even architectural ones. But the question of choosing art in our culture appears more problematic.

Does choosing art require professional training and expertise? Even though people outside the art community may answer that question in the affirmative, they often behave as if the opposite were true. As the cliché goes, they know what they like, and they don't want something they don't like in their space. However, what a general audience likes is usually something they already know, something familiar. That narrows the possible choice to something safe and unchallenging, something like standard television programming or canned music. The primary function of art professionals is to provide other alternatives. Artists, art historians and critics, museum curators, and arts administrators with training in looking at art and a broad familiarity with the work of contemporary public artists have experience and expertise in evaluating the potential success of individual artists and specific proposals. Even though these individuals may be subject to the vagaries of art-world politics, by and large they are in a better position to make the best possible choice. However, restricting the votes in the public art selection process to those with proven professional expertise does not mean that members of the public will not be heard.

Here the architecture process may serve as a model. People don't demand a role in the selection of architects or architecture (which has a far greater impact on the quality of their day-to-day lives), presumably because it is viewed as too complex. However, a responsible architect working with a client will go to great lengths to establish the client's needs and wishes. These become the basis of the building program. The design, if possible, both incorporates and transcends these requirements through the architect's vision. Representatives of the using public thus serve as advisors, articulating both essential needs and more general wishes.

In the public art selection process, representatives of the immediate using community (members of local boards and other organizations) should always be invited to express their concerns, problems, and expectations for a specific site. This important information (ranging from safety factors to less tangible aspirations for the community) is only available to those who live or work in close proximity to the intended location and varies widely from one locale to another. Thus, at one meeting of a selection panel for a public art commission in New York, community representatives from the Spanish Harlem section of Manhattan expressed resentment of the "Gramercy Park style" of the already-designed site designated for the art. Accordingly, a Hispanic artist sensitive to a different esthetic was chosen. About two weeks

later, representatives of a community in South Philadelphia with a different minority population expressed the desire for just such an esthetic for a corner park that was part of a redevelopment project. Again, the artist selected was the one who most directly addressed their concerns and wishes.

Using available information, a committee of art professionals can then select the best artist for the project, making sure that he or she is informed of community needs and is willing and able to work with those parameters. The selection process (slide viewing and discussions among panel members and artists) should be open to the community. This both demystifies the process and makes obvious the professional skills involved. It also provides an opportune time for questions. Early open dialogue among all those involved with the commission is the first step toward securing successful public art. As Brian O'Doherty aptly observed:

Though community involvement can be a disguise for many philistin-isms—some of them sophisticated—the concept depends on the patient exercise of a kind of trust intrinsic to the democratic process, which presumes that a body of people—a community—are fundamentally good-willed, and that good will can see beyond short-term goals and immediate self-interests. [11]

At every step of the way of a public art commission, the inclusion of an art-education component is essential. Public art at present is, for the most part, launched into the public domain with little or no infor-mation—far less than is available in a museum as a matter of course to a more informed audience. The larger public for public art must be given access to the art context within which contemporary sculpture can be understood and appreciated. The situation is critical. Art edu-cation in our public school system is totally deficient and shows no sign of improvement. A study sponsored in 1985 by the J. Paul Getty Trust (*Beyond Creating: The Place for Art in America's Schools*) revealed some appalling statistics. [12] Eighty percent of all students graduate from high school without any art courses whatsoever (studio, appreciation, or history). This says nothing about the quality or quantity of art education that the remaining 20 percent have had. In addition, the Getty study found that the public believed that art was not an academic subject but a frill, and that people needed little or no formal education to experience, create, or comprehend it. (It is this attitude that under-lies the belief that anyone is competent to choose art.)

At work here are various conflicting attitudes toward art. Public funding to commission art is sanctioned, while funds for art education are usually the first to be cut. Art in museums is admired and respected, while art in the street is vandalized and despised. Art elicits violent feelings, as evidenced in the recent brouhaha over NEA funding of certain controversial exhibitions, yet the vast majority of people don't look at art (including those most violently opposed to it) and know very little about it. Even though art is generally ignored, except as the object of controversy, theft, or the expenditure of great sums of money, our culture displays a truly ambivalent love-hate relationship toward it. How can we understand the violent feelings that art arouses?

Seeing is a sense we are born with. It is not learned in school. It is a vital process of identification upon which our survival depends. Simplistically, if we can't identify a moving car as such, we are physically at risk. If we can't place a work of art in an understandable context, we are intellectually and emotionally threatened. The impulse is to follow the "looks like" or metaphorical process of identification that gets us safely through the day. It is our way of making the unknown familiar.

When this process is applied to art, the results may be both funny and fatal. A few years ago a proposed public sculpture by Joel Shapiro became the object of a furious debate when the public and press, excluded from art-commission meetings, dubbed the rather innocuous-looking sculpture with a heavy price tag "the headless Gumby." T-shirts with this image were manufactured at once and became an immediate success. Identifying the abstract sculpture with Gumby brought it into an accessible frame of reference and made it an object of easy attack and ridicule. A similar translation of high art into vernacular terms occurred when Noguchi's *Landscape of Time*, a GSA commission of 1975 in Seattle, was related to the contemporary pet rock craze.[13] Michael Heizer's *Adjacent, Against, Upon* (1977), also in Seattle, was subject to the same comparison. Invariably in this context, cost becomes a red flag for controversy. Although material costs are easily grasped, the creative process is difficult to evaluate in monetary terms. Referring once again to Noguchi's *Landscape of Time*, the National Taxpayers Union was quoted as saying:

The rocks . . . look for all the world like common boulders. Though the boulders were available for $5.50 a ton, or a total value of $44, when they were mined, the hard bargainers at GSA purchased the entire collection for $100,000.[14]

If a work of art is not tamed or framed by placing it within a familiar context, a sense of unease persists, sometimes to the point that the work of art itself is perceived as threatening. Richard Serra's *Tilted Arc* was compared to the Berlin Wall, and a physical security specialist for the Federal Protection and Safety Division of the GSA went so far as to contend that the sculpture presented "a blast wall effect . . . comparable to devices which are used to vent explosive forces. This one could vent an explosion both upward and in an angle toward both buildings."[15] Charles Ginnever's *Protagoras* (1974), a GSA commission in St. Paul, was seen as "a potential machine-gun nest" and the "undercarriage of a UFO-type flying saucer."[16] The perceived threat of physical violence is not unique to monolithic Minimal sculpture. George Sugarman's open colorful and playful *Baltimore Federal* (1978), also a GSA commission, was seen as threatening because theoretically it "could be utilized as a platform for speaking and hurling objects by dissident groups . . . its contours would provide an attractive hazard for youngsters naturally drawn to it, and most important, the structure could well be used to secrete bombs or other explosive objects."[17]

Although initially amusing, these comments and others like them reveal that serious issues are at stake for those who utter them. When their anger or unease leads to vandalism, the victim (here the sculpture) is blamed. Thus, at the hearing on *Tilted Arc* the sculpture was blamed for being a magnet for graffiti and encouraging antisocial behavior.[18] Much of this can be addressed through proper art education, which could make the art understandable instead of frightening. Although there have been a number of significant reports advocating the need for increased and improved art education in the public school system, this is unlikely to occur in a time of tight budgets as long as art education is perceived as a frill. In the meantime public art is proliferating, and with it the need for an education component that will provide the context in which to understand (although not necessarily like) a work of art.

A public art education program should begin with representatives of the public educating the selection committee about their community. But it is the responsibility of the sponsoring organization to continue to educate the public. The reasons for the choice of a particular artist, for example, can and should be clearly articulated. The artist (or his or her representative), once the project is designed, can and should "explain" and discuss it with representatives of the public, particularly commu-

nity groups and politicians. The finished work should be accompanied by information about the artist and the piece. This might include a statement of intent as well as critical comments and technical information; the last is often an effective initial "hook" for a general audience.

The forms of public art education program can take are limited only by the imagination of the commissioning agency. Public discussions, news stories, local radio and television coverage, advertising, as well as permanent documentation in any form may all be used. This information should be available as close to the piece as possible with appropriate signage making its existence known. In addition, outreach programs in local schools, libraries, hospitals, and even corporations can be implemented.

An outstanding education program is already in place in the Art in Public Places Trust in Metro-Dade County in Miami.[19] It includes teacher-education workshops given biannually to familiarize participants with the historical context, philosophy, and technology of public art. An instructional package with lessons, slides, and discussion topics is also available. Local college and university students work as interns in the trust's offices and are trained in project, educational, and conservation management. The trust also organizes exhibitions and lectures, offers tours, and produces video presentations and publications on specific projects.

The place of art education in the public art process is evolving. The significance of this component is now regularly addressed at conferences and symposia on public art. What education programs can do is provide information and in this way mitigate the distinctions that separate the public into those who know (who have had a privileged education or are privy to local references) and those who don't (because the context, art or any other, eludes them). Such programs would help deflect the kind of criticism motivated solely by prejudice against or fear of new approaches that challenge the status quo. They cannot (and should not) establish or legislate esthetic criteria, but they can articulate and explain them. This is an important function, since the art expectations of a general audience usually differ greatly from those of an art-informed public.

Without some knowledge of contemporary art and its evolution, the very materials of which it is made can be shocking and enraging. Serra's *Tilted Arc* was criticized so frequently for being rusty that one of the artist's attorneys, Gerald Rosen, observed, "Now the whole thing about rust shows a kind of prejudice against the oxidation of steel." To

an audience familiar with contemporary sculpture, Cor-Ten steel, the self-rusting material frequently used by contemporary sculptors, is as usual (and to some as beautiful) as marble and bronze were in earlier times. Similarly, a neon sculpture by Stephen Antonakos for the Tacoma Dome was attacked by some who felt that neon was appropriate for beer signs but not for art.[20] Information about materials is easily transmitted and easily understood. Having such information obviates the shock value; the material then becomes an element that can be judged on its own esthetic merits. Art is always appreciated on many different levels, depending on the audience, but an informed audience is usually a more open minded one. Familiarity, as a rule, breeds greater understanding, not contempt.

Unfortunately this is not true of all elements in the public art process. Far more difficult to address and even to ascertain are the various hidden political agendas. Usually unstated, they may nevertheless trigger hostile responses and impossible demands. Public art may easily become the pawn of politicians or bureaucrats who use a commission to further their own careers. Public sculpture may also become the focus of any pre-existing community tension and thus mask the actual problem. The more insightful and politically adept the local public art administrator, the more easily these issues can be isolated and resolved ahead of time.

Frequently political issues, and controversy in general, are exacerbated by media coverage. The popular press, an all-too-powerful vehicle in our culture, as a rule, has one driving motivation—to get a good story—and controversy fills the bill. Regardless of accuracy, controversy usually makes the front pages while refutations are relegated to the back. As the focus of public art press coverage, controversy not only encourages but validates whatever antagonism already exists.[21] Journalists may convey that public art is put up in a casual way or that artist and the art establishment are trying to put one over on the public. Naturally glib writers easily create unfortunate comparisons to Gumby, a pet rock, etc. These images lodge in the public mind and often become permanently associated with a work of art. Members of the press are not deliberately pernicious; but they may be unthinking and uninformed. Public art administrators can help the press do a better job by including them in the education process. The same methods used by a museum to provide the press with information may be used to advantage by a public art agency. Members of the press should be

invited to observe the selection process at various stages, thereby en-
suring their understanding of the seriousness of the endeavor.

Even with an ideally informed audience and press, the continuing
proliferation of public art will continue to pose serious questions.
Before any commission is undertaken, it should be considered whether
public art in any form is desirable. "Never use a sculpture where a tree
will do as well" is a precept that might be considered, the burgeoning
public art industry notwithstanding. The needs of the site and the
surrounding community must be carefully and thoughtfully scru-
tinized.[22] Public art should not be confused with public amenities,
although they are by no means mutually exclusive.

If public art is deemed desirable, what form should it take? Would
an independent or site specific object be best or should the public art
component comprise the entire site? Although there has been much
criticism of independent object public sculpture, it should not be dis-
missed out of hand. As George Sugarman observed, "If you give up the
object, you give up a sense of astonishment."[23] Some might argue that
you also give up sculpture (or art) altogether. In general, such public
sculpture works best on a site that already has urban amenities and is
quiet enough to allow for the concentration that looking at and experi-
encing art requires and rewards.

At what point should the artist be brought into the process? Ideally,
artists should be involved in the initial planning process, determining
where public art is desirable and what forms it might take. An artist
may be part of a design team at the start of a commission. Working with
the architect(s), an artist may help to develop the art program as a
whole or determine the nature and placement of a specific piece.
Collaboration between artists and architects has been much praised in
theory but has been difficult to implement. It is time-consuming and
requires a very careful pairing of personalities as well as esthetic ap-
proaches. If an artist is not to be involved at the start of a commission,
at what point should he or she be engaged? A cogent but perhaps
unpopular argument could be made to involve the artist only after the
basic parameters of the project have been established. One of the
problems encountered by some of the artists initially involved in
the Wiesner building at M.I.T. was that the areas they were assigned
to work on changed radically during the development of the building
design. As a result, much of their work was unnecessarily frustrating,
and on occasion, totally unnecessary. The advantage of involving an

artist only after the building or site is nearing or at completion is that they then know exactly what the site looks like and any practical limitations it may pose. The obvious and significant disadvantage is that the artist can play no role in determining the nature and scope of the project.

Regardless of the degree of the artist's involvement, esthetic criteria for public art remain a murky issue. The public art revival of the mid-sixties began with the unstated assumption that a successful museum and gallery artist would be a successful public artist. However, as has been amply proven, this is not necessarily the case. Certain esthetics don't translate well from a carefully controlled environment to the changing unpredictability of contemporary urban spaces. Concepts of site specificity evolving from museum and gallery installations are much more problematic in an urban environment. Unlike a pristine gallery setting with fixed delimiters and no distractions, an urban location is full of competing visual stimuli. Furthermore, it is always subject to change. The very buildings that once defined a site may be razed or radically altered. New buildings in a different style may be added to the visual parameters. The landscape is subject to seasonal change as well as long-term alteration. A sculpture that now sits happily next to a sapling may be totally hidden by the mature tree. Nevertheless, public art will continue to be judged on its appropriateness to its site, even though the artist can do no more than consider the physical characteristics and needs of a site or a community at the time of commission.

The recent proliferation of public sculpture is a sign of a culture in search of unifying symbols. But we have diverse and often conflicting cultural values, and most of our cities, deteriorating at an alarming rate, lack a coherent civic identity. In the public domain the fame of artists may supply the illusion of culture, but not the content. Although civic logos may be commercially useful, they offer little in the way of inspiration. Images of victims and a shattered past remind us of what we have lost or destroyed. Although it may lack an identifiable art content, public sculpture that creates new sites and spaces has thus far made the most significant contribution to the quality of contemporary urban life.

Assessing the success of art is never easy, but in the realm of public art it is especially difficult. Controversy is loud and appreciation often silent and unmeasurable. Submitting public art to a popularity contest is hardly a valid criterion by any standard. The public and art factors

must both be considered, but in different ways. Public concerns may be addressed through an open, informed public art process. Art concerns must be addressed by artists, because the esthetic function of public art, no matter what form it takes, must be the same as that of museum art: to communicate a vision according to the formal vocabulary chosen by the artist. If art concerns become less than primary, we end up with something that is not primarily art and that is to no one's best interest.[24]

What we need in public art today is not consensus but communication. Public art can provide a genuinely enriching experience—more than a civic logo or urban amenity. Good public art (good for the public and for art) functions as an invitation to dialogue, not an inaccessible monologue. It exists as an affirmation that art has an active and meaningful role in public life. Although dependent on the patronage of establishment organizations, artists still find room for individual creative expression. The fact that some of the most interesting artists of our time are once again willing and even eager to work in the difficult arena of public art is both a welcome sign of private commitment to public good and a step in the healing process of a fractured society.

Epilogue

The political climate and economic conditions have changed radically since the late 1960s, and so has public art and the public art process. The past two decades of public sculpture are currently being re-evaluated by federal funding agencies and artists, suggesting that future projects may take a different direction. Public art programs in the NEA and GSA are being revamped, and temporary projects focused on political issues are becoming more popular with a new generation of public artists.

Within the past few years there has been a marked decline in the number of applications to the NEA's Art in Public Places Program.[1] This factor, together with budget cuts prompted by recent attacks on the NEA by conservative politicians,[2] have led to a re-evaluation of the program. Responding to a federal directive to give priority to art education, plans are now under consideration that would consolidate the Art in Public Places Program with design arts and public education projects. The effects of such a reorganization cannot be anticipated yet, but it is already clear that there will be less money available for community-initiated public art. If, in the long run, this means that public art and public education are more closely connected, thereby increasing the accessibility of public art to its audience, this would be an improvement. Viewed by some as a necessary and salutary intermediate step, it would further open the public art dialogue. For if we have learned anything from the mistakes of the past two decades, it is that there is an urgent and ongoing need for public input and involvement.

During the last year, by mutual agreement, the NEA has ceased to be involved with the choice of arts professionals to serve on GSA selection panels. The GSA, long in the process of revamping its official procedures for selecting art for its Art-in-Architecture program, has

233

begun to put together its own selection panels, in consultation with community leaders who also serve on the panels with an equal vote. Again, too little time has passed to evaluate the results of this shift. However, by increasing the number of community representatives voting on the selection panels, the potential for local political control is increased and the possibility for new or difficult art potentially diminished.

The GSA, like the NEA, is sensitive to public opinion, and recent controversies surrounding public art, particularly the one over Serra's *Tilted Arc,* have taken their toll. In both agencies a more conservative attitude is apparent, with leaders unwilling to risk negative publicity or take a strong pro-art stance.

Coincident with these developments on the funding front, increasing numbers of artists have turned their attention to the pressing problems of poverty, AIDS, and various ongoing forms of discrimination. In the public art arena, their work has often taken the form of temporary interactive projects addressing specific social and local concerns, with issues of site and content paramount.[3] It is to be hoped that some of these temporary projects will provide useful models for future permanent public art.

It remains to be seen how and if these current two developments— decreased federal funding and increased artistic focus on temporary projects with a political theme—will mesh. In any event, temporary projects cannot replace a significant commitment to permanent public art. In a culture focused on the present, permanent public art serves an important function. Art is a vision of possibilities and potential. It becomes public art when that vision is communicated to as large an audience as possible because then it does more than define our common ground. It becomes an actual and symbolic connector not only between diverse members of a single community, but a vital link to the past and to the future.

Notes

Introduction

1. Early attempts at public art were analyzed by Beverly Held in "Money, Morality and Monuments: The Debate Begins," a paper delivered at the College Art Association annual meeting in 1990 in New York.

2. An earlier version of some of these observations appeared in Harriet Senie and Sally Webster, "Editors' Statement: Critical Issues in Public Art," *Art Journal,* Winter 1989, pp. 287–290. For a complete discussion of the early history of American public art, see Lillian B. Miller, *Patrons and Patriotism: The Encouragement of Fine Arts in the United States, 1790–1860* (Chicago: University of Chicago Press, 1966).

3. The most notable examples are Jean-Antoine Houdon's George Washington (1786–92) for the Virginia State Capitol in Richmond and Antonio Canova's Washington (1817–21), formerly in the North Carolina State Capitol in Raleigh, each with an extensive bibliography. See also Ilene D. Lieberman, "Sir Francis Chantrey's Monument to George Washington: Sculpture and Patronage in Post-Revolutionary America," *Art Bulletin,* June 1989, pp. 254–268.

4. An excellent introduction to and history of this period is provided by the exhibition catalogue *The American Renaissance: 1876–1917* (New York: The Brooklyn Museum, 1979), with essays by Richard Guy Wilson, Dianne H. Pilgrim, and Richard N. Murray.

5. Recent publications on the influential World's Columbian Exposition are: David F. Burg, *Chicago's White City of 1893* (Lexington, Ky.: University Press of Kentucky, 1976); Reid Badger, *The Great American Fair: The World's Columbian Exposition and American Culture* (Chicago: N. Hall, 1979); Jeanne Madeline Weimann, *The Fair Women* (Chicago: Academy Chicago, 1981); Stanley Applebaum, *The Chicago World's Fair: A Photographic Record* (New York: Dover Publications, 1980); and Daniel Burnham, *The Final Official Report of the Director of Works of the World's Columbian Exposition* (New York: Garland, 1988).

6. This development is discussed by Daniel Robbins in "Statue to Sculpture: From the Nineties to the Thirties," in *200 Years of American Sculpture* (New York: Whitney Museum of American Art, 1976), pp. 112–159. See also Michele H. Bogart, *Public Sculpture and the Civic Ideal in New York City, 1890–1930* (Chicago: University of Chicago Press, 1989).

7. For a detailed history and analysis of Hastings's arch, see Bogart, pp. 271–292.

8. For this development see John R. Lane and Susan C. Larsen, *Abstract Painting and*

235

Sculpture in America: 1927–1944 (Pittsburgh: Museum of Art, Carnegie Institute, 1983).

9. For an excellent discussion of this monumental project, see George Gurney, *Sculpture and the Federal Triangle* (Washington, D.C.: Smithsonian Institution Press, 1985).

10. Gurney, p. 13.

11. See essays by sculptors in Francis V. O'Connor, *Art for the Millions* (Boston: New York Graphic Society, 1975), pp. 83–112.

12. For a discussion of this widespread stylistic development, see Donald J. Bush, *The Streamlined Decade* (New York: George Braziller, 1975).

13. This sculpture and others for the building are discussed in detail by Gurney, pp. 335–402. See also Richard D. McKinzie, *The New Deal for Artists* (Princeton: Princeton University Press, 1973), p. 66, and Marlene Park and Gerald E. Moskowitz, *Democratic Vistas: Post Offices and Public Art in the New Deal* (Philadelphia: Temple University Press, 1984), pp. 145ff.

14. See Park and Markowitz, pp. 10–28.

15. For a study of the project, see Carol Herselle Krinsky, *Rockefeller Center* (New York: Oxford University Press, 1978).

16. *A Digest of Facts about Rockefeller Center* (New York: Rockefeller Center Public Relations Department, 1972), p. 15.

17. Krinsky, pp. 7–9.

18. A standard work delineating this altered view of history can be found in Karl Popper, *Popper Selections* (New York: Harper & Row, 1977). An interesting interpretation of the gradual shift in our understanding of history is found in J. B. Jackson, *The Necessity for Ruins and Other Topics* (Amherst, Mass.: University of Massachusetts Press, 1980). Based on his observations of the increasing popularity of "restored (or invented) historical environments" and other factors, he concludes that we now see "history . . . as dramatic discontinuity" or creation, oblivion, and restoration, related to "some ancient myth of birth, death, and redemption."

19. The subject of "the public" looms large today both in intellectual circles, and in a more pragmatic vein, in the public art community. For a recent anthology of critical thinking on the topic, see Hal Foster, ed., *Discussions in Contemporary Culture*, Number One, Seattle, 1987. Essay topics include "The Cultural Public Sphere" and "The Politics of Representation." For a discussion of the decline of public life, see Richard Sennett, *The Fall of Public Man* (New York: Vintage Books, 1978).

Chapter 1

1. For a discussion of this development, see Michele Bogart, *Public Sculpture and the Civic Ideal in New York City, 1890–1930* (Chicago: University of Chicago Press, 1989), especially the chapter on "The Rise and Demise of 'Civic Virtue.'"

2. This development is discussed by Daniel Robbins, "Statue to Sculpture: From the Nineties to the Thirties," in *200 Years of American Sculpture* (New York: Whitney Museum of American Art, 1976), p. 133ff.

3. For a history of the project, see the Ph.D. dissertation by Sharon Alice Brown, "Making a Memorial: Developing the Jefferson National Expansion Memorial National Historic Site, 1933–1980" (St. Louis University, 1983—University Microfilms #84–18621).

4. In the midst of the public controversy, a favorable editorial in a local newspaper speculated that Saarinen's arch would "rank with these other symbols." See "The Vision of the Riverfront—Part V," *St. Louis Star-Times*, December 2, 1949.

5. See "Saarinen Tells How *Gateway* Was Conceived," *St. Louis Post-Dispatch,* March 7, 1948. Yi-Fu Tuan, *Topophilia: A Study of Environmental Perception, Attitudes, and Values* (Englewood Cliffs, N.J.: Prentice Hall, 1974), p. 200, analyzes the traditional meaning of the arch as follows: "like the dome it symbolizes heaven, the limbs leading the eye upward to the round curve at the apex; and in analogy to the monumental portal that opens into the city or palace it regally beckons the traveler to enter the promised land."

6. William H. Gass, "Monumentality/Mentality," *Oppositions,* Fall 1982, p. 142.

7. Cited as an important historical precedent, an article of 1919 by Frederick Law Olmstead advocating parks as war memorials was reprinted in the April 1945 issue of *Landscape Architecture* and read at a meeting of the American Federation of the Arts. See Frederick Law Olmstead, "Parks as War Memorials: Possibilities and Limitations Controlling a Choice," *Landscape Architecture,* April 1945, pp. 104–7.

8. A number of articles published in 1944–45 contain the main arguments made for and against "living memorials." In chronological order these are: Kenneth Reid, "Memorials? Yes—But No Monuments!" *Pencil Points,* May 1944, p. 35; Fletcher Steele, "Worthy Memorials of the Great War: Among the More Potent Advocates of Peace Upon Earth," *Landscape Architecture,* July 1944, pp. 121–24 (reprint of January 1920 article); "Living Memorials," *Architectural Forum,* September 1944, pp. 107–12, 166–70; "War Memorials," *Architectural Forum,* December 1944, pp. 96–100; "War Memorials," *AIA Journal,* January 1945, pp. 18–38; Margaret Cresson, "Memorials Symbolic of the Spirit of Man: Should War Monuments Be Beautiful or Useful?", *Landscape Architecture,* July 1945, pp. 140–2. (The author was the daughter of the American sculptor Daniel Chester French.)

9. For a candid analysis of the structure and leading figures in this commissioning system, see Charlotte Devree, "Is this statuary worth more than a million of your money?" *Artnews,* April 1955, pp. 34–37, 67.

10. Philip Johnson, "War Memorials: What Aesthetic Price Glory?" *Artnews,* September 1, 1945, pp. 8–10, 24–5.

11. "War Memorials," *AIA Journal,* January 1945, pp. 27–8.

12. Quoted in the official guidebook of the shrine entitled *Yad Vashem,* published by the Holocaust Martyrs' and Heroes' Remembrance Authority, Jerusalem.

13. See James E. Young, *The Texture of Memory: Holocaust Memorials and Meaning in Europe, Israel, and America* (New Haven: Yale University Press, 1992).

14. James E. Young, "Holocaust Memorials in America," in Harriet Senie and Sally Webster, eds., *Critical Issues in Public Art* (New York: Harper Collins, 1992).

15. Suzanne Stephens, "What becomes a monument most?" *Progressive Architecture,* May 1979, p. 87, observed: "Instead of the traditional triumphal arch, temple, and palace, museums, cultural and civic centers, and corporate headquarters were to inherit the mantle as building types."

16. For a discussion of recent efforts at successful Holocaust sculptures see James E. Young, "Holocaust Memorials: The Art of Memory, the Permanence of Monuments," *The Journal of Art,* February 1990, p. 4.

17. Proposals for all these projects were submitted to the Art Commission, and photographs and other documentation are available there. Progress reports and problems were reported in the local press. Until 1960 all proposals had to coincide with the conservative taste of New York City's Parks Commissioner, Robert Moses, who had jurisdiction over the intended sites. Although he was succeeded in 1960 by Newbold Morris, Moses's policies remained in effect until Mayor John Lindsay reorganized the parks department in 1968.

18. In the United States, most commissions for traditional World War II memorials

had gone to a handful of men who worked in conservative styles and belonged to official organizations like the National Sculpture Society. An excellent article delineating the patronage of war memorials in the United States is Charlotte Devree, "Is this statuary worth more than a million of your money?" *Artnews*, April 1955, pp. 34–7, 67.

19. Jury members were Mulk Raj Anand (Asia), Herbert Read (Great Britain), Mrs. R. G. Casey (Australia), George Salles (France), Will Grohmann (Germany), Giulio Carlo Argan (Italy), James Johnson Sweeney (United States), Jorge Romero Brest (South America), and Professor Kremenov (Russia).

20. The jury consisted of Andrew C. Ritchie, Director of Painting and Sculpture at the Museum of Modern Art; Daniel Catton Rich, Director and Curator of Painting at the Art Institute of Chicago; Hans Squarzensky, Fellow in Research at the Boston Museum of Fine Arts; Charles Seymour, Curator of Renaissance Art at the Yale University Art Gallery; and Henry Marceau, Associate Director and Chief of the Division of Painting and Sculpture at the Philadelphia Museum of Art.

21. For popular press accounts of the various protests, see "To the Political Prisoner," *The New York Times*, March 22, 1953, Section IV, p. 66; "New Sculpture Protest," *The New York Times*, March 23, 1953, p. 25; "Sculpture Foe Spared," *The New York Times*, April 18, 1953, p. 6; "Churchill Defines Creed as An Artist," *The New York Times*, May 1, 1953, p. 23; "Disputed Sculpture Here," *The New York Times*, June 24, 1953, p. 27. For accounts in the art press, see William Gaunt, "London Sees 'Prisoner' Finalist," *Art Digest*, April 1, 1953, pp. 9, 29; "Storm Over the Unknown Political Prisoner," *Artnews*, April 1953, p. 62; Denys Sutton, "London," *Artnews*, May 1953, p. 48; Larry Campbell, "Sculptor's Guild," *Artnews*, Summer 1953, p. 66.

22. See William Gaunt, cited above, p. 29. Gaunt also compared Butler's sculpture to Kafka's *The Trial* in its sinister message, quoting Butler's description of his work as "empty, deliberately so, for the corporal substance of the prisoner is transcended."

23. For an interesting history and interpretation of anonymous memorials, see J. B. Jackson, *The Necessity for Ruins and Other Topics* (Amherst, Mass.: University of Massachusetts Press, 1980), pp. 94ff.

24. The Eiffel Tower has been analyzed effectively in this context by Roland Barthes, *The Eiffel Tower and Other Mythologies* (New York: Hill and Wang, 1984), pp. 3–17. See also Patricia Mainardi, "The Eiffel Tower and the English Lighthouse," *Arts Magazine*, March 1980, pp. 141–44. Robert Hughes in *The Shock of the New* (New York: Alfred A. Knopf, 1981), p. 1, calls the Eiffel Tower "the one structure that seemed to gather all the meanings of modernity together." Furthermore (p. 11) "it summed up what the ruling classes of Europe conceived the promise of technology to be: Faust's contract, the promise of unlimited power over the world and its wealth."

25. William A. H. Bernie, "Berlin's Wall of Infamy," *Reader's Digest*, December 1961, p. 73, called it an "affront to civilization" and commented on its omnipresence. "The Walled City," *Architectural Review*, January 1962, p. 1, saw the Wall in the context of architecture. Nan R. Piene, "Report from Berlin," *Art in America*, January 1967, p. 106, observed that the Wall is "the only one of East or West Berlin's new monuments that is architecturally interesting. . . ." Even before the physical separation of East and West Germany, Berlin was considered something of a symbol. Donald Richie, "Letter from Berlin," *The Nation*, February 19, 1961, p. 152, observed that "Berlin is both symbol and symptom of the age . . . in terms of alienation, rootlessness, insecurity, completely isolated, completely divided." Alan Shadrake, *The Yellow Pimpernel*, (London: Hale, 1974), p. 26, called the Wall "an ugly scar symbolizing the division of our times and the threat that overshadows all our lives."

26. Joseph Wechsberg, "Letter from Berlin," *The New Yorker*, May 26, 1962, p. 131, reported that "after nine months West Berliners still find the sight of the Wall embit-

tering and frustrating, because there is absolutely nothing they can do about it." Rainer Hildebrandt, *Die Mauer Spricht/The Wall Speaks* (Berlin: Verlag Haus am Checkpoint Charlie, 1982) documents and discusses the changing appearance of the Wall through four generations. Descriptions and photographs of the Wall abounded in the popular press in Germany and the United States.

27. The symbolic use of the Brandenburg Gate is discussed by Joseph Wechsberg, "Thoughts at Berlin's Symbolic Gate," *The New York Times Magazine,* November 19, 1961, pp. 27, 126ff.; and Norman Gelb, *The Berlin Wall* (London: Michael Joseph, 1986), pp. 161, 190, 245. It is tacitly assumed in any number of newspaper articles and photograph captions. See, for example, articles and photographs pertaining to Berlin in *The New York Times,* August 14, 1961 and August 15, 1961.

28. The comparison between the Berlin Wall and the Great Wall of China was frequently noted. See, for example, Joseph Wechsberg, "Letter from Berlin," *The New Yorker,* November 4, 1961, p. 153, and Rainer Hildebrandt, cited above, n.p. In "Berlin," *Newsweek,* September 4, 1961, p. 15, the Berlin Wall is simply referred to as the "Chinese Wall near the Brandenburg Gate." Subsequently it is called an "eighth Wonder of the World."

29. Gelb, p. 273, recounts one person's telling experience: "Shortly before the Wall was built, I visited Jerusalem and looked at the wall that stood at the time between the Jewish and Arab sections of the city. I thought such a thing could only happen in a place where the people on the two sides had different cultures, different ethnic backgrounds, different languages and hated each other. Here in Berlin, we were one people, one culture, one background. I never believed it could ever happen here."

The Jerusalem Wall gets its name from the lamentations of the Jews for the destruction of the Temple. It was built by King Solomon (960–926 B.C.) and completed circa 950 B.C. by the Babylonian Nebuchadnezzar. Rebuilt several times, it was finally destroyed by the Romans in A.D. 70. The Wailing Wall today, 158 feet long and 60 feet high, is an active synagogue (with separate areas for men and women) and a focus of religious, political, and tourist interest within the old city of Jerusalem.

30. Borofsky's piece, *Running Man,* is discussed by Kynaston McShine, *Berlinart* (New York: Museum of Modern Art, 1987), p. 19. See also Arthur Danto, *The State of the Art* (New York: Prentice Hall, 1987), pp. 38–42.

31. See "Keith Haring Paints Mural on Berlin Wall," *The New York Times,* October 24, 1986, p. C9.

32. See John Tagliabue, "What Divides Berlin Now?" *The New York Times Magazine,* April 7, 1991, pp. 30–31, 56–60.

33. For a succinct history of the project, see the pamphlet *Walking Tour and Guide to the Great Wall of Los Angeles,* published by SPARC in 1983.

34. *Guide to the Great Wall,* p. 1.

35. *Guide to the Great Wall,* p. 1.

36. For a history of the contemporary mural movement of which the Great Wall is a part, see Eva Cockroft, John Weber, and James Cockroft, *Towards a People's Art* (New York: E. P. Dutton, 1977).

37. Nancy Angelo, "A Brief History of S.P.A.R.C.," *Los Angeles Times Magazine,* March 27, 1988, p. 73.

38. *Guide to the Great Wall,* p. 18.

39. Diane Neumaier, "Dissolving Boundaries," *Los Angeles Times Magazine,* March 27, 1988, p. 61.

40. Neumaier, "Dissolving Boundaries," p. 75.

41. Scruggs made these observations in a talk at SUNY, Purchase, in October 1988.

42. A detailed history of the *Vietnam Veterans Memorial* is provided by Jan C. Scruggs

and Joel L. Swerdlow, *To Heal a Nation: the Vietnam Veterans Memorial* (New York: Harper & Row, 1985). See also Nicolas J. Capasso in Tod Marder, ed., *The Critical Edge: Controversy in Recent American Architecture* (Cambridge, Mass.: MIT Press, 1988), pp. 189–99, and Elizabeth Hess, "A Tale of Two Memorials," *Art in America*, April 1983, pp. 121–4, who described Scruggs's goal as a "sincere if somewhat naive aspiration to replace the veterans' nightmare with the American dream."

43. Veterans' problems were exacerbated by the rejecting attitude of a significant part of the American public, who equated the veterans with the war that had become so unpopular that it ended the political career of incumbent President Lyndon B. Johnson. Not only was their service to their country denigrated, but they as individuals were often shunned. Many found the war experience in Vietnam so horrendous that permanent psychological scars remained well after physical wounds had healed. Secondary effects of Agent-Orange, a chemical used as a defoliant, were discovered only years later in the veterans and their children. For many of these individuals and their families, suffering continued long after the war ended.

44. See Scruggs and Swerdlow, pp. 16, 18, 31. For an interesting discussion of various symbolic interpretations of the site, see Charles Griswold, "The Vietnam Veterans Memorial and the Washington Mall: Philosophical Thoughts on Political Iconography," *Critical Inquiry,* Summer 1986, pp. 688–713 (reprinted in Senie and Webster, eds., *Critical Issues in Public Art*).

45. See *The Vietnam Veterans Memorial Fund Design Competition: Design Program,* 1980.

46. Lin made these comments at a symposium at SUNY, Purchase, in October 1988.

47. Quoted in Hess, p. 122.

48. Quoted in Hess, p. 123.

49. Quoted in Scruggs and Swerdlow, p. 100. According to the authors, "After that, no one mentioned making the wall white." It is easy to overlook the inappropriate but highly valent readings that can be attributed to abstract elements. Our language is full of words that suggest a positive interpretation of white and a negative one of black, making racist associations with the color black relatively obvious. The heightened consciousness of a post–civil rights movement era makes covert racial slurs easier to identify and counter.

50. See "Stop that Monument," *National Review,* September 18, 1981, p. 1064. Norman B. Hannah, "The Open Book Memorial," *National Review,* December 11, 1981, p. 1476, wrote, "The memorial is clearly an 'open book' in which Americans can not only honor their dead, but see the Vietnam War in the stream of history. . . . This is the 'open book' memorial. That is what it looks like, and that is what it means." This interpretation is also discussed by Griswold, p. 708. Danto, p. 113, observed, "Everything about it is part of a text. Even the determination to say nothing political is inscribed by the absence of a political statement."

51. Hess, p. 126. Lin complained that throughout the process she was treated like a little girl, a result no doubt of unstated negative feelings about her sex, youth, size, and Chinese-American origin. See also Scruggs and Swerdlow, cited above, pp. 101–2, 106.

52. Scruggs and Swerdlow, p. 94.

53. Scruggs and Swerdlow, pp. 80–81. Carhart's reference to Lin's memorial as "a black gash of shame" was widely reprinted in the press.

54. Scruggs and Swerdlow, pp. 83–5. As they observed, there was no way to represent such a diverse public without "including a mob scene." Subsequent proposed and actual additions have proved this analysis accurate.

55. Perot's role is discussed by Scruggs and Swerdlow, pp. 23, 45, 61, 67, 97, 99ff, 105ff. It is also discussed by Hess, pp. 122–23 and Capasso, p. 193.

56. Scruggs and Swerdlow, p. 93.

57. See, for example, Scruggs and Swerdlow, pp. 82, 85, 117, 121, 130–31, 145. See also Tom Wolfe, "Art Despite War: The Battle of the Veterans Memorial: How the Mullahs of Modernism Caused a Stir," *Washington Post,* December 13, 1982, pp. 131ff.

58. The closed-door meeting is described in Scruggs and Swerdlow, pp. 100ff; Capasso, pp. 194ff; and Hess, pp. 125–6. Scruggs observed (p. 101), "Aesthetically, the design does not need a statue, but politically it does."

59. Scruggs and Swerdlow, p. 115.

60. A different and far more positive interpretation of Hart's sculpture is found in Karal Ann Marling and Robert Silberman, "The Statue Near the Wall," *Smithsonian Studies in American Art,* Spring 1987, pp. 5–29.

61. At the time of this writing the most recent demand for a nurses' memorial has not been resolved. Other groups supposedly gathering support for their own memorial include Air Force pilots, Navy seamen, and American Indians. See "The War on the Wall," *The Nation,* June 4, 1988, p. 780.

62. Scruggs and Swerdlow, p. 83.

63. An important study of the general devaluation of the public realm in contemporary western life is Richard Sennett, *The Fall of Public Man* (New York: Vintage Books, 1978). Christopher Lasch, *The Culture of Narcissism* (New York: Warner Books, 1979) addresses similar issues.

64. See, for example, Harry Maurer, "The Invisible Veterans," *The New York Review of Books,* February 3, 1983, pp. 38–9; C. Krautheimer, "Washington Diarist: Downcast Eyes," *New Republic,* November 29, 1982, p. 42; Tom Morganthau and Mary Lord, "Honoring Vietnam Veterans—At Last," *Newsweek,* November 22, 1982, pp. 80–81.

65. An ad hoc museum of Vietnam veterans' memorabilia was also created in Chicago by Joe Hertel. See William E. Schmidt, "In Bits and Pieces, This Is Their Vietnam," *The New York Times,* March 17, 1988, p. A14.

66. Aljean Harmetz, "Unwanted 'Platoon' finds Success as U.S. Examines the Vietnam War," *The New York Times,* February 9, 1987, p. C13, quotes a number of publishers who cite the dedication of the *Vietnam Veterans Memorial,* November 1982, as "the key factor" in marking the rise of public interest and the ability to sell books about the war. Time-Life's twenty-three-book series *The Vietnam Experience* used a television advertisement featuring a young boy and his father at the *Vietnam Veterans Memorial,* with the child asking what the war was all about. Bill Coutrie's documentary for cable television, *Dear America: Letters Home from Vietnam,* ends with the mother of a slain soldier reading a letter and placing it beneath her son's name on the *Vietnam Veterans Memorial.* The film *In Country* (1989), based on the novel by Bobbie Ann Mason, ends with a trip to the *Vietnam Veterans Memorial,* a journey of reconciliation for three generations.

67. Maya Lin discussed the evolution of her civil rights memorial at a lecture at the Metropolitan Museum of Art in April 1990.

68. The Kent State memorial is discussed in *Controversial Public Art from Rodin to Di Suvero* (Milwaukee: Milwaukee Art Museum, 1983), pp. 53–55; Martin Friedman and Graham W. J. Beal, *George Segal: Sculptures* (Minneapolis: Walker Art Center, 1978), p. 84; Sam Hunter and Don Hawthorne, *George Segal* (New York: Rizzoli, 1984), pp. 99–102; Phyllis Tuchman, *George Segal* (New York: Abbeville Press, 1983), pp. 93–95. It was also widely reported in the popular and art press.

69. See Noreen Thomassi and Tom Moran, "George Segal: An Interview," *Arts—New Jersey,* Summer 1985, pp. 4–5.

70. Friedman and Beal, p. 84.

71. *Gay Liberation* was commissioned by Bruce Voeller, head of the Mariposa Foundation, acting for Peter Putnam, administrator of the Mildred Andrews Fund. The commission is discussed in detail in Joseph Disponzio, "George Segal's Sculpture on a Theme of Gay Liberation," in Senie and Webster, *Critical Issues in Public Art.* See also Hunter and Hawthorne, pp. 104–8; Tuchman, pp. 99–102.

72. Hunter and Hawthorne, p. 104.

73. Hunter and Hawthorne, p. 104.

74. The most detailed study of the various political problems is found in Disponzio, "George Segal's Sculpture on a Theme of Gay Liberation."

75. The history of *Gay Liberation* at Stanford University was related to the author by Albert Elsen.

76. Matthew Baigall, "Segal's Holocaust Memorial," *Art in America,* Summer 1983, pp. 134–36.

77. Quoted in "A Sense of Stillness," *Artnews,* Summer 1983, p. 12.

78. In 1985 the Jewish Museum reinstalled the piece in its main exhibition gallery together with fourteen photographs of the sculpture by Ira Nowinski. For a review of the exhibition, see Michael Brenson, "George Segal—The Holocaust," *The New York Times,* July 30, 1985, p. C26.

79. Erika Doss, "Andrew Leicester's Mining Memorials," *Arts Magazine,* January 1987, p. 37.

80. For a formal reading of these works, see Garth Rockcastle, "Art as Architecture: Leicester Sculpture," *Progressive Architecture,* October 1984, pp. 94–97.

81. For a discussion of these projects, see *Athena Tacha: Massacre Memorials and Other Public Projects* (New York: Max Hutchinson Gallery, 1984), with a catalogue essay by Lucy Lippard and a statement by the artist; also *Athena Tacha: Public Works, 1970–1988* (Atlanta: High Museum of Art, 1989), with an essay by Catherine M. Howett and John Howett.

82. See *Athena Tacha: Massacre Memorials,* np.

83. For a full discussion of the Iwo Jima memorial see Karal Ann Marling and John Wetenhall, *Iwo Jima* (Cambridge, Mass.: Harvard University Press, 1991).

84. For a discussion of Tacha's landscape public sculptures see Chapter 4.

85. For Oldenburg's comments and illustrations of his projects of the 1960s, see Claes Oldenburg, *Proposals for Monuments and Buildings: 1965–69* (Chicago: Big Table Publishing Company, 1969); Barbara Haskell, *Claes Oldenburg, Object into Monument* (Los Angeles: The Ward Ritchie Press, 1971).

86. Oldenburg's often-quoted statement first appeared in the catalogue for a group show, *Environments, Situations, Spaces,* at the Martha Jackson Gallery in New York.

87. See Oldenburg, *Proposals for Monuments,* pp. 31, 33.

88. For accounts of the Yale commission, see Susan P. Casteras, *The Lipstick Comes Back* (New Haven: Yale University Press, 1974); *Controversial Public Art,* cited above, pp. 43–6; David Shapiro, "Sculpture as Experience: The Monument that Suffered," *Art in America,* May/June 1974, pp. 55–58.

89. Marcuse's statement is quoted in Barbara Rose, *Claes Oldenburg* (New York: Museum of Modern Art, 1970), pp. 110–11.

90. Haskell, pp. 94–5.

91. Haskell, p. 10.

92. Oldenburg's comments were reported by Grace Glueck, "Oldenburg Lipstick Rejoins Yale with Cosmetic Repairs," *The New York Times,* October 19, 1974, p. 33.

93. Barbara Rose, *Claes Oldenburg* (New York: Museum of Modern Art, 1970), p. 111.

94. Martin Friedman, *Oldenburg: Six Themes* (Minneapolis: Walker Art Center, 1975), p. 63.

95. Oldenburg's explanation and a detailed discussion of *Batcolumn* is found in Donald Thalacker, *The Place of Art in the World of Architecture* (New York: Chelsea House and Bowker, 1980), pp. 26–31.

96. For this and other incarnations of the bat, see Haskell, pp. 70–71, and Calvin Tomkins, "Claes Oldenburg," *The New Yorker*, December 12, 1977, pp. 50ff.

97. For a discussion of these projects see Chapter 4.

98. For a discussion of the pig controversy, see "Porcine Plan Evokes Squealing in Cincinnati," *Chicago Tribune*, January 12, 1988, p. 4; Lew Moores, "Cincinnati Voices Its Pig Beefs," *Cincinnati Post*, January 13, 1988, p. 1B; "Let the Pigs Soar," *Cincinnati Post*, January 13, 1988, p. 6A; Clare Ansberry, "Perhaps New York Would Accept the Pigs in Trade for *Tilted Arc*," *Wall Street Journal*, January 19, 1988, Section 2, p. 33.

99. Letter to the author, dated July 17, 1990.

100. For a discussion of this project, see Joan Marter, "Collaborations: Artists and Architects on Public Sites," *Art Journal*, Winter 1989, pp. 318–20.

Chapter 2

1. Adolf Loos's famous comment was originally published in *Neue Freie Presse* in 1908. Ironically his inspiration was a remark by Louis Sullivan, whom Loos met during his three-year stay in the United States: "It could only benefit us if for a time we were to abandon ornament and concentrate entirely on the erection of buildings that were finely shaped and charming in their sobriety." See Ulrich Conrads, ed. *Programs and Manifestos in Twentieth-Century Architecture* (Cambridge, Mass.: MIT Press, 1984), p. 19.

2. Gropius's statement has been frequently reprinted. See, for example, Hans M. Wingler, *The Bauhaus: Weimar, Dessau, Berlin, Chicago, Boston* (Cambridge, Mass.: MIT Press, 1969), p. 31.

3. The best analysis of Gropius's relationship to the arts is provided by H. Creighton, "Walter Gropius and the Arts," *Four Great Makers of Modern Architecture: Gropius, Le Corbusier, Mies van der Rohe, Wright* (New York: Columbia University Press, 1971).

4. Henry-Russell Hitchcock and Philip Johnson, *The International Style: Architecture Since 1922* (New York: Museum of Modern Art, 1932), pp. 73–74.

5. Henry-Russell Hitchcock, "The Place of Painting and Sculpture in Relation to Modern Architecture," *Architects Yearbook*, 1947, pp. 12, 22.

6. For a full transcript of the symposium, see Philip Johnson, *Symposium: The relation of painting and sculpture to architecture* (New York: Museum of Modern Art, 1951). A briefer account is provided in Philip Johnson, "A Symposium of how to combine architecture, painting and sculpture," *Interiors*, May 1951, pp. 100–105. Participants in the symposium included James Johnson Sweeney, Ben Shahn, Jose Luis Sert, Frederick Kiesler, and Henry-Russell Hitchcock.

7. See *Proceedings of CIAM, 8th International Congress for Modern Architecture, The Heart of the City* (New York: Pellegriny and Cudahy, 1952).

8. See "The Next Fifty Years," *Architectural Forum*, June 1951, pp. 165–70. One architect felt that "Neither painting nor sculpture have a very important place in our life today," and therefore "the best way of 'integrating' sculpture with contemporary architecture is to melt them down and make bronze hardware out of them." Another

architect felt that a more appropriate question would have been, "Do you believe that sculpture and painting will cease to exist?" Those who did not dismiss contemporary art completely seemed to view the artist as just another workman. One architect concluded, "Where the painter and sculptor are willing to pitch in and be welders and technicians and are good at these trades and can speak the language of the men who do that sort of thing, the possibilities become much greater for real integration."

9. For a discussion and different interpretations of the official acceptance of abstract art in this country, see Irving Sandler, *The Triumph of American Painting* (New York, Harper & Row, 1976) and Serge Guilbaut, *How New York Stole the Idea of Modern Art* (Chicago: University of Chicago Press, 1983).

10. Sandler, in *The Triumph of American Painting*, pp. 269–76, pinpoints the years 1950–52 for the success and dissolution of the "Abstract Expressionist Scene," but this success was limited to a small group of artists and critics and a handful of galleries. The formation and significance of the artists' Eighth Street Club is also discussed by Dore Ashton, *The New York School: A Cultural Reckoning* (New York: Viking Press, 1973), pp. 193–208. Clement Greenberg was almost alone among contemporary critics in touting the possibilities of so-called modernist sculpture before the start of the decade. In "The New Sculpture," *Partisan Review,* June 1949, pp. 637–42, he singled out David Smith, Theodore Roszak, David Hare, Herbert Ferber, Seymour Lipton, Richard Lippold, Ibram Lassaw, Isamu Noguchi, Peter Grippe, Burgoyne Diller, and Adaline Kent. Later in the decade, when he had more power, Greenberg concentrated his critical attention on David Smith. See, for example, his "David Smith," *Artnews,* Winter 1956–57, p. 30.

11. Lippincott was founded in 1966 and was announced in the art press the following year. See, for example, "Lippincott Environmental Arts," *Art in America,* September/October 1967, p. 124.

12. See Henry Hope Reed, Jr., "Monumental Architecture or the Art of Pleasing in Civic Design," *Perspecta 1,* Summer 1952, pp. 51–54. Reed blamed Thorstein Veblen for this condemnation of "the culture of a leisure class" and the theory that "all which was not useful or functional was 'waste.'" It was the spread of Veblen's theories, Reed argued, that made architects and city planners particularly receptive to modern architecture. The Yale community's derisive response to Reed's theories was related by Robert A. M. Stern in a conversation with the author in March 1978. Interestingly enough, many of the things that Reed called for came to pass some twenty-five years later. In January 1979, to cite a particularly glaring example, the Helmsley building at 230 Park Avenue in Manhattan was gilded to call attention to its once-disdained ornamental facade.

13. *Architectural Forum,* June 1954, pp. 132–35.

14. Like Saarinen, Herbert Read also envisioned a kind of super-architect. He referred to the split between architect, sculptor, painter, and craftsman as "a division of consciousness" that could only be resolved by a new kind of architect: "the architect as a comprehensive man of intelligence, a single source of unity and universality" and the sole creative impulse behind the integration of the arts. See Herbert Read, "The Architect as Universal Man," *Arts and Architecture,* May 1956, pp. 32–33.

15. In January 1958 Professor J. M. Richards introduced a discussion at the Royal Institute of British Architects with: "This is yet another meeting about architecture and the other arts. I emphasize that this is 'yet another meeting,' because the subject has been endlessly debated in recent years producing usually a general agreement that architects, painters and sculptors ought to collaborate closely; but nothing very conclusive otherwise." (See "Architecture and the Other Arts," *Royal Institute of British Architects Journal,* February 1958, p. 117.) The hostility between artists and architects

was still very much in evidence twenty years later at the Tenth International Sculpture Conference held in Toronto in June 1978. Sculptor Richard Lippold and Don Thalacker, head of the GSA's Art-in-Architecture program, discussed David Smith's refusal to work with architects, while sculptor Tim Scott on a panel entitled "Sculpture vs. Architecture" spoke sneeringly of the architect's "excruciatingly bad taste."

16. "Art and Architecture 1959," *Craft Horizons*, January/February 1959, pp. 10–15.

17. "The A.I.A.'s First Hundred Years," *A.I.A. Journal*, April 1957, p. 149. The discussions Saylor recalled included sculptors, mural painters, and landscape architects.

18. For an account of Harrison's work at Rockefeller Center, see Carol Krinsky, *Rockefeller Center* (New York: Oxford University Press, 1978), pp. 144–48. The members of the Board of Design at the United Nations, recommended by their respective governments, were: N. D. Bassov (Soviet Union), Gaston Brunfaut (Belgium), Ernest Cormier (Canada), Le Corbusier (France), Liang Ssu-Cheng (China), Sven Markelius (Sweden), Oscar Niemeyer (Brazil), Howard Robertson (England), G. A. Stilleus (Australia), and Julio Vielamajo (Uruguay).

19. See Aline Louchheim, "Art for the United Nations," *The New York Times*, June 17, 1951, II, p. 6.

20. The gardens to the north of the buildings contain donations of sculpture from Yugoslavia (Anton Augustincic, *Peace*, 1954), the USSR (Evgeny Vuchetich, *Let Us Beat Swords into Plowshares*, 1959), and the German Democratic Republic (Fritz Cremer, *The Rising Man*, 1975). The sculpture on the east wall of the United Nations General Assembly was a gift from the National Council for United States Art in 1961. Enzio Martinelli's relief, with its spidery, vaguely Surrealistic form, looks here like the proverbial piece of costume jewelry pinned to the side of a building. Its placement facing the East River assures its relative invisibility.

21. According to Grace Glueck, "Art Notes," *The New York Times*, II, p. 22, Hammarskjold had always wanted a Hepworth sculpture at the United Nations. Hepworth approached the United Nations with a proposal for the monument after she had visited the city to get a sense of the site. Her approach to public sculpture is discussed in Dore Ashton, "A Sculptor's Ideas on Sculpture," *The New York Times*, October 18, 1959, II, p. 15. Hepworth felt that "A sculpture outside a building conditions the approach. People can relate themselves humanly, philosophically. I watch to see how people move in relation to spaces. They move differently." Although Hepworth stated that she liked to work in relation to architecture, she emphasized that she always conceived of her sculpture as independent. The United Nations piece, donated by Jacob Blaustein of the United States, can easily be imagined elsewhere.

22. The advisory committee consisted of Lucio Costa (Brazil), Le Corbusier (France), Walter Gropius (United States), Sven Martelius (Sweden), and Ernesto Rogers (Italy).

23. Numerous accounts of the building campaign exist. One of the most comprehensive is "Le Siège de L'Unesco à Paris," *Architecture d'Aujourd'hui*, December 1958, pp. 4–33. "Le Siège Permanent de L'Unesco à Paris," *Architecture d'Aujourd'hui*, September 1952, p. 90, stated, "L'édifice tout entier sera conçu de façon à intégrer tous les arts plastiques," and "UNESCO: A Preliminary Project," *Architectural Design*, November 1952, p. 315, reported that "Painting and sculpture have been included as an integral part of the architecture in the conception of the project." The emphasis on contemporary art was reiterated in "Le Siège de L'Unesco à Paris," *Architecture d'Aujourd'hui*, February 1955, p. 27.

24. Additional artists included Karel Appel, Roberto Matta, Brassai, Rufino Tamayo, S. Afro, and Artigas.

25. André Bloc, "A Synthèse des Arts et L'Unesco," *Architecture d'Aujourd'hui*, January/February 1955, p. IX, reprints the text of a speech given by Bloc at a Groupe Espace meeting on February 18, 1955.

26. Noguchi's previous garden designs were for *Reader's Digest* in Tokyo (now destroyed), unbuilt projects for Lever Brothers, and the realized project for Connecticut General Insurance Company in Bloomfield, Connecticut (discussed below in the context of the sculptor's collaboration with Gordon Bunshaft).

27. Isamu Noguchi, *A Sculptor's World* (New York: Harper & Row, 1968), p. 167.

28. SOM was one of the first firms to use modern art consistently in their buildings. Notable early examples include the Terrace Plaza Hotel in Cincinnati (1948) with murals by Miro and Saul Steinberg and a mobile by Calder; and Manufacturers Trust Company in New York City (1954) with a large metal wall sculpture by Harry Bertoia. See Paul Goldberger, "Toward Different Ends," in Barbaralee Diamonstein, *Collaboration: Artists & Architects* (New York: Watson-Guptill Publications, 1981), pp. 56–77.

29. For an interesting study of this monumental sculpture see Jim Pomeroy, *Rushmore—Another Look: Surveying the American Icon* (San Francisco Art Institute, 1976).

30. Noguchi, *A Sculptor's World*, pp. 12–15.

31. Noguchi, *A Sculptor's World*, p. 165.

32. Noguchi, *A Sculptor's World*, p. 169.

33. This opinion, stated in the pamphlet, *K & B Plaza Sculpture*, published by the Virland Foundation in New Orleans, was voiced by a number of individuals in the local art community in conversation with the author during a visit in January 1990.

34. Noguchi, *A Sculptor's World*, p. 170.

35. From a telephone interview with Harry Helmsley conducted in March 1979.

36. The circumstances of this commission were relayed to the author by Gordon Bunshaft in an interview in February 1978.

37. Comments by both architect and sculptor on the subject are included in Andrea O'Dean, "Bunshaft and Noguchi, An Uneasy But Highly Productive Architect-Artist Collaboration," *AIA Journal*, October 1976, pp. 52–55.

38. The catalogue, *Collaboration: Artists and Architects*, edited by Barbaralee Diamonstein, contains notable essays by Vincent Scully, Paul Goldberger, Stephen Prokopoff, Jonathan Barnett (then president of the League), and Jane Livingston. The exhibition opened at the New-York Historical Society and traveled to twelve other cities. For a review of the exhibition see the author's "Architects, Talking and Collaborating," *Artnews*, Summer 1981.

39. Diamonstein, p. 90.

40. Robert Venturi, *Complexity and Contradiction in Architecture* (New York: Museum of Modern Art, 1966) was the first in a series of books published by the museum on the theoretical background of contemporary architecture.

41. Venturi, *Complexity and Contradiction*, p. 11.

42. See Robert Venturi, Denise Scott Brown, Steven Izenour, *Learning from Las Vegas* (Cambridge, Mass.: MIT Press, 1972).

43. See Arthur Drexler, ed., *The Architecture of the Ecole des Beaux-Arts* (New York: Museum of Modern Art, 1977). The exhibition was especially significant since the Museum of Modern Art had, since its 1931 exhibition, *The International Style: Architecture Since 1922*, been a champion of the modern style. For a good general introduction to postmodern architecture see Heinrich Klotz, *The History of Postmodern Architecture* (Cambridge, Mass.: MIT Press, 1984). Also of interest are Charles Jencks, *The*

Language of Post-Modern Architecture (New York: Rizzoli, 1977); Paolo Portoghesi, *Postmodern: The Architecture of the Postindustrial Society* (New York: Rizzoli, 1983).

44. The history of the Piazza d'Italia has been well documented. A particularly sensitive account is found in David Littlejohn, *Architect: The Life and Work of Charles W. Moore* (New York: Holt, Rinehart & Winston, 1984), pp. 250–61.

45. Martin Filler, "Piazza d'Italia, New Orleans: The Magic Fountain," *Progressive Architecture*, November 1978, p. 81.

46. See Frances Frank Marcus, "Is Park Saved by Destroying a Part?" *The New York Times*, March 26, 1991, p. A14.

47. Moore is quoted in Gerald Allen, *Charles Moore* (New York: Watson-Guptill Publications, 1980), p. 110.

48. The project is well documented in the catalogue *Artists and Architects Collaborate: Designing the Wiesner Building* (Cambridge, Mass.: MIT Committee on the Visual Arts, 1985). It includes statements by many of the individuals involved as well as an overview of the project by Robert Campbell and Jeffrey Cruikshank.

49. Various reasons for their departure are offered in the project catalogue (pp. 14–15) but, without being part of the actual process, it is difficult to determine what actually transpired.

50. *Artists and Architects Collaborate*, p. 55.

51. *Artists and Architects Collaborate*, p. 63.

52. *Artists and Architects Collaborate*, p. 67.

53. *Artists and Architects Collaborate*, pp. 86–87.

54. See Paul Goldberger, "Battery Park City Is a Triumph of Urban Design," *The New York Times*, August 31, 1986, pp. 1, 23.

55. These developments are traced and documented by Rosalyn Deutsche, "Urban Development: Public Art in New York City," *October*, Winter 1988, pp. 3–45.

56. Undated Battery Park City press release distributed at the dedication of South Cove in July 1988.

57. Members of the original fine arts committee at Battery Park City were Elizabeth C. Baker (Editor, *Art in America*), Amanda Mortimer Burden (Vice President, Architecture and Design, Battery Park City Authority), Michael Graves (Fellow, American Institute of Architects and professor of architecture, Princeton University), Barbara Haskell (Curator, Painting and Sculpture, Whitney Museum of American Art), Richard A. Kahan (Chairman, Battery Park City Authority), Carl D. Lobell (attorney), Linda Nochlin (professor of art history, CUNY Graduate Center), Robert Rosenblum (professor of fine arts, Institute of Fine Arts, New York University), Agnes Gund Saalfield (collector, and founder and President, Studio in the School Association), Linda Balding Shearer (Executive Director, Committee for the Visual Arts, Inc./Artists Space), and Calvin Tomkins (author and staff writer, *The New Yorker*).

58. Originally intended to be a formal garden designed by architect Alexander Cooper, artist Jennifer Bartlett, and landscape architect Bruce Kelly, it was to be located at the southern tip of Battery Park City, adjacent to South Cove. At the time of this writing Bartlett's design for South Gardens has come under severe criticism for its lack of collaboration, blocking of the river view, and ignorance of garden and plant maintenance needs. The final version remains to be determined. For a summary of contemporary objections see Patti Hagan, "Jennifer Bartlett's Walled Garden: 24 Rms, No Rv Vu," *The Wall Street Journal*, October 26, 1989, p. A14; Herbert Muschamp, "Jennifer Bartlett's Soiled Garden," *7 Days*, February 14, 1990, pp. 35, 37.

59. Mary Miss, Stanton Eckstut, Susan Child, *South Cove Design Statement*, n.d. See also Joan Marter, "Collaborations: Artists and Architects on Public Sites," *Art Journal*, Winter 1989, pp. 317–18.

60. Robert Mahoney, "Theory-Praxis Conflicts in Public Sculpture," *Arts Magazine,* November 1988, p. 115, refers to the structure as "Mary Miss's skeletonized eruption of guilt over the blocked view between Cove and Liberty."

61. Peter Schjeldahl, "Future Ruins," *7 Days,* August 31, 1988, pp. 48–9, observed that "Miss' project, when underused, which will be nearly all the time, is as forlornly idle as a jumbo jet parked in a field. Meanwhile, it is the most sensational big-party venue imaginable, needing only the tinkle of ice in a few hundred tumblers to become corporate hospitality heaven." The official opening on July 12, 1988 provided just such an event. With elegant hors d'oeuvres and a variety of sparkling beverages as well as live music, South Cove was transformed into a glamorous Hollywood set. Only Ginger Rogers and Fred Astaire were missing.

62. The quotations read as follows: "City of tall facades of marble and iron—proud and passionate city—mettlesome, mad, extravagant city!" Walt Whitman; and "One need never leave the confines of New York to get all the greenery one wishes." Frank O'Hara.

63. The new focus on public sculpture as part of the urban environment can be seen in publications such as *Arts and the Changing City: An Agenda for Urban Regeneration* (London: British American Arts Association, 1989). Rosalyn Deutsche, "Urban Development: Public Art in New York," *October,* Winter 1988, pp. 3–45, advocates that public art be discussed within "critical urban discourse" rather than "esthetic" or even "critical esthetic" discourse.

64. Calvin Tomkins, "Open, Available, Useful," *The New Yorker,* March 19, 1990, p. 71.

Chapter 3

1. For a succinct discussion for the way in which the quality of public life is determined by a city's urban spaces (plus other factors) see Paul Goldberger, "Why Design Can't Transform Cities," *The New York Times,* June 25, 1989, Section 2, pp. 1, 30.

2. See Mark I. Gelfand, *A Nation of Cities: The Federal Government and Urban America, 1933–1965* (New York: Oxford University Press, 1975), pp. 348–87, for a discussion of federal legislation affecting cities.

3. For a discussion of relevant zoning developments, see Donald H. Elliott and Norman Marcus, "From Euclid to Ramapo: New Directions in Land Development Controls," *Hofstra Law Review,* Spring 1973, pp. 56–91.

4. This view of the sixties uprisings is discussed in Sohnya Sayres, Anders Stephanson, Stanley Aronowitz, and Frederic Jameson, eds., *The 60s Without Apology* (Minneapolis: University of Minnesota Press, 1984), pp. 1–10.

5. A complete study of the commission is found in Patricia Balton Stratton, "Chicago Picasso" (M.A. thesis, Evanston, Ill.: Northwestern University, 1982). According to "The Chicago Picasso," *Progressive Architecture,* November 1966, p. 66, the architects "decided that a monumental sculpture was needed as a focal point on the plaza." Hartmann's quote appears in Ira J. Bach and Mary Lackritz Gray, *A Guide to Chicago's Public Sculpture* (Chicago: University of Chicago Press, 1983), p. 76.

6. Stratton notes the questionable practices of the PBCC, with its few official meetings (and therefore no public records) as well as the political considerations in the choice of three architectural firms representing different ethnic groups: Irish Catholics, "WASPS," and Jews (p. 12).

7. For a description of the functional aspects of the building, see "Chicago Civic Center: Dignity in Continuity," *Progressive Architecture,* October 1966, pp. 244–7.

8. Stratton, p. 213, in an interview with Hartmann on August 11, 1981.

9. The foundations were the Woods Charitable Fund, the Field Foundation of Illinois, and the Chauncey and Marion Deering McCormick Foundation. A complete discussion of the funding of the sculpture is found in Stratton, pp. 125–44.

10. See Marilyn McCully, ed., *A Picasso Anthology: Documents, Criticism, Reminiscences* (London: The Arts Council of Great Britain with Thames & Hudson), pp. 265–7. Roland Penrose's personal recollection, "A monument for Chicago" of 1963, conveys the nature of Picasso's interest and involvement (or lack thereof) very well.

11. A series of preparatory drawings are at the Chicago Art Institute. The standard catalogue of Picasso's works is Christian Zervos and Yvonne Zervos, *Pablo Picasso* (Paris: Cahiers d'Art, 1932–78), usually cited simply as Zervos or Z. The Chicago studies are found in Zervos, XX, 233–245.

12. There are numerous studies of Picasso's art at this time. See especially Helene Parmelin, *Picasso: Intimate Secrets of a Studio at Notre Dame de Vie* (New York: Harry N. Abrams, Inc., 1968); Gert Schiff, *Picasso: The Last Years, 1963–1973* (New York: George Braziller, Inc., 1983).

13. See Lionel Prejger, "Picasso cuts out iron," in Marilyn McCully, ed., *A Picasso Anthology,* pp. 259–61.

14. Parmelin, *Picasso,* p. 14, observed, "All of Notre Dame de Vie is made up of Jacqueline, rests upon Jacqueline, signifies Jacqueline. And all of the paintings are of Jacqueline." See also *Picasso: Eight Works from the Last 20 Years of his Life* (Lucerne: Am Rhyn Haus, 1978).

15. Stratton, p. 29.

16. Stratton, p. 145. See also *Controversial Public Art From Rodin to di Suvero* (Milwaukee: Milwaukee Art Museum, 1984), pp. 40–42.

17. Franz Schulze, "But, of course, It's a Woman," *Chicago Daily News,* August 23, 1969. Quoted in Stratton, p. 33.

18. See William B. Chappell, "The Chicago Picasso Reviewed a Decade Later," *Art International,* October/November 1977, pp. 61–3. The visual proof is convincing beyond any doubt. It is unquestioningly accepted by Mary Matthews Gedo, *Picasso: Art as Autobiography* (Chicago: University of Chicago Press, 1980), pp. 245–6.

19. See, for example, the paintings of 1952 inspired by Françoise Gilot, such as *Woman and Dog Playing,* illustrated in Zervos, XV, n. 246. Gedo, *Picasso,* p. 245–6, also refers to the paintings of the late 1930s in which an image of Dora Maar is merged with that of an earlier pet Afghan, Kasbec.

20. See Stratton, p. 251. The recollection was provided by architect Norman Schlossman of the firm Loebl, Schlossman, Bennett & Dart.

21. Stratton, p. 219, in transcript of an interview with the architect on August 11, 1981.

22. For an excellent summary account of the ill-fated plans for a Daley memorial and their repercussions, see C. L. Morrison, "Yes, They Really Do Want a Mayor Daley Memorial," *Artforum,* November 1978, pp. 48–53.

23. Goldberger is quoted in Barbaralee Diamonstein, ed., *Collaboration: Artists and Architects* (New York: Watson-Guptill Publications, 1981), p. 67.

24. For a discussion of this project in the context of recent public art history, see John Beardsley, *Art in Public Places* (Washington, D.C.: Partners for Livable Places, 1981), pp. 14–24.

25. Political support for the sculpture was most likely a response to the local prominence of the Mulnix family. This is clearly suggested by Robert Sherrill, "What Grand Rapids did for Jerry Ford—and vice versa," *The New York Times Magazine,* October 20, 1974, pp. 31–33, 72–92. Sherrill describes Nancy Mulnix, wife of LeVant Mulnix III,

as "a tall, blonde, arts-socialite dervish." Betty Ford, wife of Gerald Ford, had gone to school with Nancy Mulnix's mother-in-law. Previously Gerald Ford had hardly been an arts advocate. He had, in fact, voted against funding the NEA. *La Grande Vitesse,* however, became for Ford "a fabulous store of political riches."

26. The selection process is described in detail in Beardsley, *Art in Public Places,* pp. 15ff.

27. The architect of the Kennedy International Airport Arrivals Building was Gordon Bunshaft of SOM. For a discussion of this commission and the art collection of the Port Authority see *Art for the Public* (New York: The Port Authority of New York and New Jersey, 1985) with essays by Dorothy C. Miller and Sam Hunter. In 1971 the Port Authority commissioned a Calder sculpture for the World Trade Center in New York City, where it has yet to find a happy placement.

28. John Russell, "Alexander Calder, Leading U.S. Artist, Dies," *The New York Times,* November 12, 1976, p. 1.

29. Calder's working method is described by Robert Osborn, "Calder's International Monuments," *Art in America,* March/April, 1969, pp. 33, 49.

30. For a general discussion of the evolution of Calder's style in various media, see Jean Lipman, *Calder's Universe* (New York: The Viking Press, 1976).

31. For a discussion of the controversy see *Controversial Public Art From Rodin to di Suvero* (Milwaukee: Milwaukee Art Museum, 1984), pp. 48–49.

32. Sherrill, "What Grand Rapids did for Jerry Ford," p. 32.

33. Kathy Halbreich, "Stretching the Terrain: Sketching Twenty Years of Public Art," *Going Public* (Amherst, Mass.: Arts Extension Service, 1988), p. 9.

34. The exhibition catalogue, *Sculpture Off the Pedestal* (Grand Rapids: Grand Rapids Art Museum, 1973), contains statements by a number of local residents directly involved with the project, Grand Rapids Art Museum Director Fred A. Myers, and art critic Barbara Rose.

35. For a discussion of the commission, see Donald Thalacker, *The Place of Art in the World of Architecture* (New York: Chelsea House Publishers with R. R. Bowker Company, 1980), pp. 20–25.

36. Thalacker, *The Place of Art in the World of Architecture,* p. 23.

37. Thalacker, *The Place of Art in the World of Architecture,* p. 20.

38. Quoted in David Finn, *Henry Moore Sculpture and Environ* (New York: Abrams, 1976), p. 87. This book is the most comprehensive document to date of Moore's public sculpture.

39. Quoted in Henry J. Seldis, *Henry Moore in America* (New York: Praeger, 1973), pp. 14–15. Further thoughts on siting in nature are found in Seldis on p. 176 and in Finn, *Henry Moore,* pp. 232, 234.

40. Seldis, *Henry Moore in America,* p. 29.

41. Moore's reason for rejecting the Seagram commission is quoted at length in Seldis, *Henry Moore in America,* pp. 177–78.

42. Diamonstein, ed., *Collaboration: Artists and Architects,* p. 56.

43. According to David Finn, he was the one to convince List to donate money toward the purchase of a sculpture. For Finn's account of his role, see Finn, *Henry Moore,* pp. 324–34.

44. This and subsequent comments by Moore on the Lincoln Center sculpture, unless otherwise noted, are taken from a letter accompanying its submission for approval to the New York City Art Commission, exhibit 3470-G.

45. Richard Witkin, "Morris Rejects Work by Calder," *The New York Times,* April 6, 1965, p. 1. Interestingly, Morris's brother was the abstract artist George L. K. Morris.

46. August Heckscher called Mayor Wagner to tell him that Morris was making a fool of himself. Alfred H. Barr, Jr., had dinner with the mayor to discuss the issue. The mayor in turn told Morris to go ahead and submit the sculptures to the Art Commission, as requested. In the meantime the entire Art Commission was brought to Lincoln Center to view the intended locations together with enlarged photographs of the sculptures. The general response seemed ambivalent; many felt that better examples of the artists' work could have been found. However, the night before the Art Commission meeting of July 12, 1965, Heckscher personally telephoned all the members and told them they would be laughed out of town if they voted down the two sculptures. Information about Heckscher's role and the unorthodox procedure followed here was related to me by Donald Gormley, then secretary of the Art Commission, on February 9, 1978. The Moore sculpture was already on its way at the time of the Art Commission meeting.

47. Seldis, *Henry Moore in America*, p. 176.

48. Finn, *Henry Moore*, p. 334. Supposedly Moore acknowledged that he liked the photographs in the book better than actual views of the sculpture. Public sculpture, however, is rarely seen in such a pristine way. It is subject to constantly changing factors: the vagaries of natural light, people, inadequate maintenance, etc.

49. Seldis, *Henry Moore in America*, p. 14. See also Finn, *Henry Moore*, pp. 44, 190.

50. See Arnold Glimcher, *Louise Nevelson* (New York: Pace Gallery, 1972). The Princeton commission is discussed in Patrick Kelleher, *Living with Modern Sculpture* (Princeton: The Art Museum, Princeton University, 1982), pp. 76–9.

51. Kelleher, *Living with Modern Sculpture*, p. 12. All stipulations of the bequest are recounted here.

52. The selection committee at Princeton was comprised of Alfred H. Barr, Jr., '22; Thomas P. F. Hoving, '53; William H. Millikin, '11; and Patrick Kelleher, M.F.A. '42, Ph.D. '47, then Director of The Art Museum. The role of universities as patrons of public art is one that requires further investigation. Both the collecting patterns and their influence could profitably be explored.

53. Works by Jacques Lipchitz, David Smith, Arnaldo Pomodoro, Michael Hall, Eduardo Paolozzi, and Tony Smith were also purchased at this time.

54. Nicolas Calas, *Icons and Images of the Sixties* (New York: E. P. Dutton, Inc., 1971), p. 21, sees Nevelson's works as "reconstruction[s] of the treasure box."

55. There was initially a question of whether the piece was to be treated as art or architecture under local zoning regulations. The art category sought by university officials eventually prevailed.

56. Quoted in Kelleher, *Living with Modern Sculpture*, pp. 76, 78.

57. See Chase Manhattan Bank News Release, September 8, 1978.

58. Quoted in Jennifer Dunning, "Financial Area to Get a New Park," *The New York Times*, August 5, 1977.

59. This and subsequent quotes are taken from a reprint of *Dedication of the Bendix Trilogy*, June 27, 1979, distributed as part of the publicity press kit.

60. For a discussion of Lipchitz's portrayal of Jewish and Jewish-related themes see Avram Kampf, *Jewish Experience in the Art of the Twentieth Century* (South Hadley, Mass.: Bergin and Garvey Publishers, Inc., 1984), pp. 138–42.

61. Columbia University's public art collection, like that of other universities, also featured works by artists with well-established reputations. A sculpture by Henry Moore, for example, had been installed ten years earlier, in 1967.

62. Albert Elsen, "Duets of Line and Shadow," *Artnews*, March 1978, p. 66.

63. Bunshaft's comments were made during an interview with the author in March 1978.

64. For comments on the Chase art collection see, for example, S. Preston, "Art: Bank Shows Interest in Design," *The New York Times,* October 24, 1959, p. 18; Katherine Kuh, "Art and Industry: First Look at the Chase Manhattan Bank Collection," *Art in America,* April 1960, pp. 68–75; C. Curtis, "Artists Visit Their Friends at Chase Manhattan," *The New York Times,* April 18, 1969, p. 46; Grace Glueck, "Art Notes: Chaste Chase," *The New York Times,* April 27, 1969, p. 35; Richard Reeves, "David Rockefeller, No. 2 Buyer," *The New York Times,* September 15, 1971, p. 49.

65. Noguchi's sculpture at Chase is discussed in Chapter 2 in the context of his collaboration with Gordon Bunshaft.

66. See *Jean Dubuffet's "Group of Four Trees,"* an unpaginated booklet issued by Chase Manhattan at the time of the installation of the sculpture in 1972.

67. Bunshaft, who met Giacometti through Pierre Matisse, had definite ideas about the nature of the sculpture. He envisioned an enlargement of Giacometti's *City Square* of 1948–49 with the figures twenty feet high and the base eight feet high—a square within a square. Giacometti's response was, "Non, c'est impossible." He submitted instead several nine-foot figures, but according to Bunshaft, the scale was not right. Shortly before his death Giacometti visited the site and Bunshaft had a "twenty-foot something" put up in the plaza that convinced the sculptor of the appropriate scale. According to Bunshaft, Giacometti had already instructed his brother to work up an armature, but the sculptor died before he had a chance to work on it.

68. Conversation with Dorothy Miller, March 1979.

69. These statements by Dubuffet are taken from the text of his remarks at the dedication of *The Four Trees* at Chase Manhattan in 1972.

70. Commissioned by the Illinois Central Development Board, the sculpture was donated by the Leonard J. Horwich Family Foundation in memory of Leonard J. Horwich, with additional funding from the Graham Foundation for Advanced Studies in the Fine Arts and an anonymous donor.

71. For a typical account of the public's baffled response, see Kevin Klose, "What's It Supposed to Be," *Washington Post,* November 29, 1984.

72. See *An Artist in Residence: William King* (New York: SUNY, Albany, n.d.).

73. See, for example, Harriet Senie, *William King: Sculpture in Vinyl, Wood, and Aluminum* (New York: SUNY, Old Westbury, 1980).

74. For an account of the public reaction to the Detroit sculpture, see Louis Cook, "Art gets intensive care at new hospital," *Detroit Free Press,* October 1, 1979.

75. For a profile of the artist, see Harriet Senie, "King's Kingdom," *Artnews,* September 1986, pp. 104–110.

76. The exhibition on Twersky Boulevard included work by Naum Gabo and Antoine Pevsner and some younger artists from the Vkutemas. According to George Rickey, *Constructivism: Its Legacy and Its Heirs* (New York: George Braziller, 1967), p. 27, only Gabo showed sculpture. The text of the *Realist Manifesto* is reproduced in Stephen Bann, *The Tradition of Constructivism* (New York: Viking Press, 1974), p. 10. For a discussion of various attitudes towards use within Constructivism, see *Art into Life: Russian Constructivism, 1914–1932* (New York: Rizzoli International, 1990), the catalogue of an exhibition at the Henry Art Gallery at the University of Washington in Seattle.

77. David Shterenberg in the catalogue essay stated: "The greater part of artistic activity in the first phase of the Revolution was concerned with the decoration of public spaces. It would of course be nonsensical to include this kind of work in an exhibition."

78. For an account of Gabo's public projects, see T. Newman, *Naum Gabo: The Constructivist Process* (London: Tate Gallery, 1976), pp. 13–14. These included sketches for a radio station at Serpuchov (1919–20), a physics observatory (1922), a monu-

ment for an airport (1924–25), a monument for an Institute of Physics and Mathematics (1925), a project for the entrance of the Esso Building in New York (1949–52), and a proposal for a Monument to the Unknown Political Prisoner which took second prize in the International Competition of 1953. The only realized works of a public nature were for the interior of the Baltimore Museum of Art, the reliefs for the exterior of the U.S. Rubber Company Building in Rockefeller Center in New York, dating from 1956, and a sculpture for the Bijenkorf Department Store in Rotterdam (1957).

79. For a discussion of Rickey's link to Constructivism see Rickey, *Constructivism*. The best monograph on Rickey to date is Nan Rosenthal, *George Rickey* (New York: Harry N. Abrams, 1977). All quotations by the artist are taken from unpublished essays by George Rickey and from discussions with him during the summer of 1987 in preparation of the exhibition *George Rickey: Projects for Public Sculpture,* curated for the Neuberger Museum, State University of New York at Purchase, October 25, 1987—March 6, 1988.

80. The sculpture was commissioned by the State of New York. For an account of this and other projects spanning Rickey's career as a public sculptor, see the brochure by the author that accompanied the above-mentioned exhibition.

81. Rickey still speaks fondly of this proposal and hopes to build it some day.

82. This sculpture exists in an edition of three. The other two are located at National City Center in Cleveland, Ohio (installed 1980), and at Kellogg Company Corporate Headquarters in Battle Creek, Michigan (installed 1986).

83. For a discussion of Snelson's technique, see Kelleher, *Living with Modern Sculpture,* pp. 116–19.

84. See "Push and Pull in the Park," *Architectural Forum,* January 1969, pp. 68–69.

85. Snelson discusses this aspect of his work in Kenneth Snelson, "A Design for the Atom," *Industrial Design Magazine,* February 1963. It is also discussed by Stephen A. Kurtz, "Kenneth Snelson: The Elegant Solution," *Artnews,* October 1968, pp. 48–54; Richard Whelan, "Kenneth Snelson: Straddling the Abyss Between Art and Science," *Artnews,* February 1981, pp. 68–73.

86. Baltimore, dubbed the Monumental City by President John Quincy Adams, was in 1964 the second city in the United States to institute a percent-for-art program, following Philadelphia in 1959. This formed a part of the city's overall efforts at redevelopment through a partnership of public and private resources to support the arts as an integral part of urban life. For a discussion of Baltimore's numerous art activities, see *Baltimore: The Arts in a Proud City* (Washington, D.C.: National Endowment for the Arts, Challenge Grant Program, 1983).

87. John Klein, "Idealism Realized: Two Public Commissions by Mark di Suvero," *Arts,* December 1981, pp. 80, 84ff., links the sculptor's "idealism, collectivism, and dynamism" with the Constructivist spirit as well as the commitment to a meaningful public art. The two commissions discussed are *Isis* in Washington, D.C., and *Under Sky/One Family* in Baltimore.

88. See Klein, "Idealism Realized," p. 85.

89. For a discussion of *Motu Viget,* see Thalacker, *The Place of Art in the World of Architecture,* pp. 48–53, and Mary Ann Tighe, "Di Suvero in Grand Rapids," *Art in America,* March/April 1977, pp. 12–15.

90. See Thalacker, *The Place of Art in the World of Architecture,* p. 52.

91. For a detailed discussion of this project, see Elizabeth C. Baker, "Mark di Suvero's Burgundian Season," *Art in America,* May/June 1974, pp. 59–63.

92. See James K. Monte, *Mark di Suvero* (New York: Whitney Museum of American Art, 1975). This exhibition received almost unanimously excellent reviews. See, for example, Donald Goddard, "Mark di Suvero: An epic reach," *Artnews,* January 1976,

pp. 28–31; Thomas B. Hess, "Mark Comes in Like a Lion," *New York,* December 15, 1975, pp. 94, 98; Hilton Kramer, "A playful storm of sculpture," *The New York Times Magazine,* January 25, 1976, pp. 10–11, 42, 47–48, 50; John Russell, "Irresistible Sculpture by di Suvero," *The New York Times,* November 13, 1975, p. 50. John Perreault, "Now That The War Is Over," *SoHo Weekly News,* November 27, 1975, p. 18, objected to the "monumentality" of the outdoor pieces, ignoring their physical accessibility.

93. Quoted in Grace Glueck, "Art Notes: Big Outdoor Sculpture Show," *The New York Times,* June 29, 1975, Section II, p. 28.

94. See *Mark di Suvero* (Stuttgart: Württembergischer Kunstverein, 1988) with catalogue essays by Tilman Osterwold, Donald Goddard, Thomas B. Hess, and Sidney Geist. (The last three are reprints of earlier articles.)

95. These exhibitions were both held at Richard Bellamy's Green Gallery. See Irving Sandler, *American Art of the 1960s* (New York: Harper & Row, 1988), pp. 242–91, for a general discussion of the advent of Minimal Art, its artists and implications.

96. For a review of the exhibition, see Corinne Robins, "Objects, Structure or Sculpture," *Arts Magazine,* September/October, 1966, pp. 34–37.

97. See Maurice Tuchman, ed., *American Sculpture of the Sixties* (Los Angeles: Los Angeles County Museum, 1967). The catalogue includes ten essays by noted critics on various aspects of contemporary sculpture.

98. See Grace Glueck, "Art Notes: A Sculpture Spectacular," *The New York Times,* April 9, 1967, II, p. 27; D. T., "American Sculpture of the Sixties," *Arts and Architecture,* June 1967, pp. 6–9.

99. Hilton Kramer, "Sculpture: A Stunning Display of Radical Changes," *The New York Times,* April 28, 1967, p. 38.

100. Doris Freedman, daughter of the builder Irwin Chanin, was crucial to the development of public art in New York City in her later role as founder and Director of the Public Art Fund. The exhibition catalogue, *Sculpture in Environment* (New York: Department of Cultural Affairs, 1967) contains a foreword by August Heckscher, then Commissioner of Cultural Affairs, and an essay by Irving Sandler.

101. Sandler, *Sculpture in Environment,* n.p.

102. The artists represented were Stephen Antonakos, Alexander Calder, Chryssa, Paul Frazier, Charles Ginnever, Lyman Kipp, Bernard Kirschenbaum, Josef Levi, Les Levine, Alexander Liberman, Marisol, Preston McClanahan, Antoni Milkowski, Robert Murray, Forrest Myers, Louise Nevelson, Barnett Newman, Claes Oldenburg, George Rickey, Bernard (Tony) Rosenthal, Anthony (Tony) Smith, David Smith, and David von Schlegell.

103. Lucy Lippard, "Beauty and the Bureaucracy," *The Hudson Review,* Winter 1967–68, called it "the only example of a first-rate work in a first-rate site." The sculpture, existing in an edition of three, today stands adjacent to the Corcoran Gallery in Washington, D.C., and in a pool outside the De Menil Chapel in Houston.

104. A good case can be made for the sculpture of the 1960s owing more to recent painting than older sculpture. See, for example, Hugh M. Davies and Sally E. Yard, "Some Observations on Public Scale Sculpture," *Arts Magazine,* January 1976, pp. 67–69. This link is particularly clear in the work of Newman.

105. For a discussion and illustrations of Smith's early career as an architect, see Sam Wagstaff, Jr., "Talking with Tony Smith," *Artforum,* December 1966, pp. 14–16.

106. For a discussion of these exhibitions and Smith's career at the time see Gene Baro, "Tony Smith," *Art International,* Summer 1967, pp. 27–30 and Lucy Lippard, "Tony Smith: The Ineluctable Modality," *Art International,* Summer 1967, pp. 24–26.

107. See Corinne Robins, "New York: Public sculpture in public places," *Arts Magazine,* Summer 1967, p. 50.

108. Hilton Kramer, "Art: A Sculpture Show in Bryant Park," *The New York Times,* February 2, 1967, p. 32.

109. For a critical discussion of the exhibition, see A. Hudson, "Scale as Content," *Artforum,* December 1967, pp. 45–47; Lucy Lippard, "Escalation in Washington," *Changing: Essays in Art Criticism* (New York: E. P. Dutton & Co., 1971), pp. 237–54.

110. Quoted in Grace Glueck, "Art Notes," *The New York Times,* July 16, 1967, II, p. 19.

111. See for example, "Welded Giants," *Architectural Forum,* April 1967, pp. 52–57; "Lippincott Environmental Arts," *Art in America,* September/October 1967, p. 124. Lippincott's work was highly praised in Barbara Rose, "Blow Up: The Problem of Scale in Sculpture," *Art in America,* July 1968, pp. 80–90.

112. For discussions of Minimal sculpture in terms of its industrial vocabulary, see Gregory Battcock, "Monuments to Technology," *Art and Artists,* May 1970, pp. 52–55, and Martin Friedman, "14 Sculptors: The Industrial Edge," *Art International,* February 1970, pp. 31–40, 55.

113. For an interesting interpretation of the actual content of Minimal Art, see Anna C. Chave, "Minimalism and the Rhetoric of Power," *Arts Magazine,* January 1990, pp. 44–63.

114. Quoted in "Statements by Sculptors: Cecile Abish, Carl Andre, Beverly Pepper, Tony Smith," *Art Journal,* Winter 1975/6, p. 129.

115. The best account of this commission is found in Thalacker, *The Place of Art in the World of Architecture,* pp. 184–88. Smith was initially suggested by the building architects, Max Brooks and Kirby Keahy. Subsequent quotes, unless otherwise noted, are taken from Thalacker.

116. The standard blue Smith chose from available automobile lacquers proved to be too light, and he had the sculpture repainted darker "because the whiteness of the limestone (of the building) bleached it out."

117. Acquired through a combination of city, private, and NEA funds, the piece was moved from its original site to its present location in 1983. See *Artwork Network* (Seattle: Arts Commission, 1984), p. 5.

118. For Smith's explanation of the title, see Kelleher, *Living with Modern Sculpture,* pp. 112–15.

119. Robins, "Objects, Structure or Sculpture," suggested that it dominated the entire show.

120. Quoted in Barbara Rose, "ABC Art," *Art in America,* October/November 1965, p. 63.

121. The discussion of *Carnegie* is adapted from the author's *Sculpture for Public Spaces* (New York: Marisa del Re Gallery, 1986).

122. Carnegie International news release, #4123-MOA-053, 1985.

123. Some of the criticism of independent-object public sculpture is related to criticism of the art object per se. As Robert Hobbs ("Editor's Statement: Earthworks: Past and Present," *Art Journal,* Fall 1982, p. 193) aptly observed, "In the seventies and eighties the art object—the golden calf of aesthetic pleasure, the traditional locus of study—no longer maintains its unassailable position. More and more the art object . . . is beginning to appear a Western capitalistic invention. It seemed to fulfill a need for a transportable object of value, a receptacle of spiritual beliefs and longings that was different from money, and yet, like money, available as a commodity of exchange."

124. See Brian O'Doherty, *Inside the White Cube: The Ideology of the Gallery Space* (Santa Monica: The Lapis Press, 1986), originally published ten years earlier in slightly different form in *Artforum*.

Chapter 4

1. See Michael Auping, "Earth Art: A Study in Ecological Politics," in Alan Sonfist, ed., *Art in the Land* (New York: E. P. Dutton, Inc., 1983), pp. 92–104.

2. For a good general account of this development, see John Beardsley, *Earthworks and Beyond* (New York: Abbeville Press, 1989). See also John Beardsley, ed., "Earthworks: Past and Present," *Art Journal*, Fall 1982.

3. The historical precedents for earth art have been widely discussed. Of special interest are Craig Adcock, "The Big Bad: A Critical Comparison of Mount Rushmore and Modern Earthworks," *Arts Magazine*, April 1983, pp. 104–107; and John Beardsley, "Traditional Aspects of New Land Art," *Art Journal*, Fall 1982, pp. 226–32.

4. George Hargreaves, "Post Modernism Looks Beyond Itself," *Landscape Architecture*, July/August 1983, p. 60.

5. See, for example, comments by Lawrence Alloway, "Site Inspection," *Artforum*, October 1976, p. 55; and Nancy Foote, "Monument—Sculpture—Earthwork," *Artforum*, October 1979, p. 37.

6. For a discussion of this aspect of earth art see Mark Rosenthal, "Some Attitudes of Earth Art: From Competition to Adoration," in Alan Sonfist, ed., *Land Art* (New York, E. P. Dutton, Inc., 1983), pp. 60–84.

7. Beardsley, *Earthworks*, p. 19, quotes Heizer as saying, "It's about art, not about landscape."

8. The most complete publication of Smithson's writings is Nancy Holt, ed., *The Writings of Robert Smithson* (New York: New York University Press, 1979).

9. Lucy R. Lippard, *Overlay* (New York: Pantheon Books, 1983), begins her study of contemporary art and the art of prehistory with a chapter on stones. She observes (p. 2), "Stones touch human beings because they suggest immortality, because they have so patently survived." For a discussion of contemporary uses of stone, see Marc Treib, "Design Vocabulary III: Rock," *Landscape Architecture*, May/June 1981, pp. 80–85.

10. For a fuller discussion of Noguchi's earlier collaboration with Bunshaft, see Chapter 2. For an interesting discussion of the history of stone in Japanese art, see Robert Murose, "The Language of Stone," *Landscape Architecture*, November 1979, pp. 589–95.

11. For an account of this commission, see Don Thalacker, *The Place of Art in the World of Architecture* (New York: Chelsea House Publishers with R. R. Bowker Company, 1980), pp. 164–67.

12. Serra's *Verb List* is reproduced in *Richard Serra: Interviews, Etc. 1970–1980* (Yonkers, New York: The Hudson River Museum, 1980), pp. 9-11. It was first published in 1972.

13. See Beardsley, *Earthworks*, p. 112.

14. See John Beardsley, *Art in Public Places* (Washington, D.C.: Partners for Livable Places, 1981), p. 79.

15. Quoted in Beardsley, *Earthworks*, p. 111.

16. John Russell, "Art People," *The New York Times*, September 2, 1979, p. C16.

17. Lucy Lippard, *Overlay*, p. 21.

18. Lewis Mumford, *The City in History* (New York: Harcourt Brace Jovanovich, 1961), p. 236, mentions the presence of at least 500 fountains in ancient Rome. See H. V. Morton, *The Waters of Rome* (London: The Connoisseur and Michael Joseph, 1966),

for a detailed history of the famous (and not so famous) fountains of Rome. For some interesting Florentine precursors, see Bertha Harries Wiles, *The Fountains of the Florentine Sculptors* (Cambridge, Mass.: Harvard University Press, 1933).

19. Peter F. Smith, "Symbolic Meaning in Contemporary Cities," *Ekistics,* March 1975, pp. 159–64.

20. In late sixteenth- and seventeenth-century Rome, fountains and obelisks were also used in overall planning schemes as focal points for long vistas. This use was first noted under the reign of Pope Sixtus V (1585–90). Increasingly elaborate sculptural designs also took on iconographic significance. For a general discussion of the use of fountains in later western European history see Paul Zucker, *Town and Square* (Cambridge, Mass.: MIT Press, 1970).

21. Quoted in Beardsley, *Earth Art,* p. 103.

22. Quoted in "Design for Detroit Civic Center Plaza Focuses on Fountain of Jetting Water," *AIA Journal,* August 1973, p. 8.

23. These comments were made by Oldenburg and van Bruggen at a lecture at City College, New York, on March 20, 1986.

24. Bruce Weber, "Pitted Against the Sky," *New York Times Magazine,* April 17, 1988, p. 106.

25. The evolution of the *Spoonbridge and Cherry* fountain design is described by Martin Friedman in *Design Quarterly,* n. 141, pp. 24–29. All subsequent quotations, unless otherwise noted, are from this account.

26. Oldenburg's and van Bruggen's statement was included in the press kit distributed by the Metro-Dade Art in Public Places program at the time of the dedication of the piece in 1990.

27. This association was articulated by a number of municipal employees during a visit in January 1990.

28. This quotation is from a conversation with the author in November 1985. It is reproduced in *Sculpture for Public Spaces* (New York: Marisa del Re Gallery, 1985, n.p.), as is some of the subsequent discussion of this piece.

29. This observation was made by Benjamin Forgey, "Pipe Dreams," *The Washington Post,* November 25, 1984, p. G11.

30. Conversation with the author in November 1985.

31. This and subsequent quotes, unless otherwise noted, are taken from Harriet Senie, *Landscape/Sculpture* (New York: SUNY, Old Westbury, 1981).

32. For a good general introduction to Christo's work, see David Bourdon, *Christo* (New York: Harry N. Abrams, 1972).

33. David Bourdon, "Christo Stakes His Claim Out West," *Village Voice,* July 26, 1976, p. 92, observed, "*Running Fence* is more than a visual phenomenon; it is also a sociopolitical event, affecting the lives of hundreds of people in the two California counties."

34. Lucy R. Lippard, "Gardens: Some Metaphors for Public Art," *Art in America,* November 1981, p. 137.

35. A brief general introduction to the history of landscape design is provided by Elizabeth B. Kessler, *Modern Gardens and the Landscape* (New York: Museum of Modern Art, 1984 revised edition). Kessler discusses the classical tradition, eighteenth-century England, the influence of China and Japan, and the Moslem contribution.

36. Isamu Noguchi, "Towards a Reintegration of the Arts," *College Art Journal,* Autumn 1949, p. 59.

37. Isamu Noguchi, *A Sculptor's World* (New York: Harper & Row, 1968), p. 171. For a good general introduction to Japanese gardens see T. Ito, *The Japanese Garden* (New Haven: Yale University Press, 1972).

38. Noguchi, *A Sculptor's World*, p. 167.

39. A pamphlet on the project was published by Arlington County in 1984 including comments by Holt, Benjamin Forgey, and John Beardsley, among others.

40. The unusual degree of autonomy that Holt had for this commission is discussed by Joan Marter, "Collaboration: Artists and Architects on Public Sites," *Art Journal*, Winter 1989, pp. 315–20.

41. *Dark Star Park* (Arlington County Administration, 1984), n.p.

42. Adam Gopnik in a review of the sculpture in *Arts Magazine*, October 1984, p. 79, cites the reference to Forster's image of "endless walls of smooth stone; a visitor lights a match and, as the reflection of a single point of light bounces from mirrored wall to mirrored wall, sees an endless forest of light points."

43. The discussion of *Keystone Island* is excerpted from Senie, *Sculpture for Public Spaces*. Quotations, unless otherwise noted, were made in conversation with the author.

44. That was the title of an exhibition of his work at the Neuberger Museum at Purchase, N.Y.

45. Quoted in Michael Auping, "Earth Art: A Study in Ecological Politics," in Alan Sonfist, ed., *Art in the Land* (New York: E. P. Dutton, Inc., 1983), p. 101.

46. Mark Rosenthal, "Some Attitudes of Earth Art: From Competition to Adoration," in Alan Sonfist, ed., *Art in the Land* (New York: E. P. Dutton, Inc., 1983), p. 70.

47. See Athena Tacha, "Rhythm as Form," *Landscape Architecture*, May 1978, pp. 196–205. The discussion of *Streams* and *Tide Park* is adapted from the author's *Landscape/Sculpture*.

48. For a complete documentation of Tacha's public commissions, see Catherine M. Howett and John Howett, *Athena Tacha: Public Works, 1970–1988* (Atlanta: High Museum of Art, 1989).

49. Lippard, *Overlay*, p. 32.

50. Robert Hobbs, *Robert Smithson: Sculpture* (Ithaca, N.Y.: Cornell University Press, 1981), p. 215.

51. Holt, *The Writings of Robert Smithson*, p. 221. Smithson's activities in land reclamation are detailed by Hobbs, *Smithson*, pp. 215–27.

52. The project is documented and discussed in *Robert Morris/Grand Rapids Project* (Grand Rapids, Michigan: Grand Rapids Art Museum, 1975). It is also discussed by Beardsley, *Art in Public Places*, pp. 18ff.

53. Morris's statement is reproduced in the catalogue *Earthworks: Land Reclamation as Sculpture* (Seattle: Seattle Art Museum, 1979). The exhibition also included works by Herbert Bayer, Iain Baxter, Richard Fleischner, Lawrence Hanson, Mary Miss, Dennis Oppenheim, and Beverly Pepper.

54. Morris, "Land Reclamation as Sculpture," *Earthworks*.

55. For a discussion of this controversy and an interpretation of the piece as an example of entropic formalism, see Kenneth S. Friedman, "Notes on the Environment: Robert Morris," in Peter Frank, ed., *Re-Dact* (New York: Willis, Locker & Owens Publishing, 1984), pp. 70–72.

56. The best overview of Bayer's work is found in Jan van der Marck, *Herbert Bayer: From Type to Landscape. Designs, Projects and Proposals, 1923–73* (Hanover, N.H.: Dartmouth College Museum and Galleries, 1977). See also Gwen Finkel Chanzit, *Herbert Bayer and Modernist Design in America* (Ann Arbor: UMI Research Press, 1987).

57. The discussion of Fair Park Lagoon is adapted from the author's *Sculpture for Public Places*. See also Lucy Lippard, *Patricia Johanson: Drawings and Models for Environmental Projects, 1969–1985* (Pittsfield, Mass.: The Berkshire Museum, 1987).

58. Patricia Johanson, *Gallerie,* 1989 Annual, pp. 24–25.

59. Johanson's comments are from an unpublished statement entitled "Endangered Garden," Sunnydale Facilities, San Francisco, California, 1988.

60. For an excellent discussion of Heizer's *Effigy Tumuli Sculpture,* see Klaus Kertess, "Earth Angles," *Artforum,* February 1986, pp. 76–79.

Chapter 5

1. For numerous expressions of the modernist canon and how it has influenced our attitudes toward art, see Valerie Jaudon and Joyce Kozloff, "Art Hysterical Notions of Progress and Culture," *Heresies,* Winter 1978, pp. 38–42.

2. For a discussion of the changing status of craft vis-à-vis art, see Calvin Tomkins, "Erasing the Line," *The New Yorker,* July 28, 1980, pp. 83–87. A two-day symposium at the Museum of Contemporary Craft in New York in January 1990, entitled "A Neglected History: Twentieth Century American Craft," also addressed this issue.

3. See the exhibition pamphlet, *The Artist as Social Designer: Aspects of Public Urban Art Today* (Los Angeles: Los Angeles County Museum, 1985). See also Nancy Princenthal, "Art with Designs on the Public Domain," *Industrial Design,* March/April 1984, pp. 44–49.

4. Arthur C. Danto, "Perspective: On Public Art and the Public Interest," *Artnews,* October 1987, p. 28.

5. `Matisse managed to breach the canonical separation of high and decorative art without sanction, but he was a rare exception. For a brief history of the decorative art movement of the mid-1970s, see Corinne Robins, *The Pluralist Era in American Art, 1968–1981* (New York: Harper & Row, 1984), pp. 131–54. For a theoretical defense of decorative art, see Valerie Jaudon and Joyce Kozloff, "Art Hysterical Notions of Progress and Culture," *Heresies,* Winter 1978, pp. 38–43. The relationship of decorative art and useful art is addressed by Carrie Rickey, "Decoration, Ornament, Pattern and Utility: Four Tendencies in Search of a Movement," *Flash Art,* June/July 1979, pp. 19–23. The revival of ornament in public art is discussed and documented in Robert Jensen and Patricia Conway, *Ornamentalism* (New York: C. N. Potter, 1982).

6. For a discussion of Sugarman's work as a public artist, see Elizabeth Frank, "Multiple Disjunctions: George Sugarman," *Art in America,* September 1983, pp. 144–49. This article is a review of the traveling retrospective curated by Holliday Day, *Shape of Space: The Sculpture of George Sugarman* (Omaha, Nebraska: Joslyn Art Museum, 1983). See also John Gruen, "George Sugarman's Maximal, Musical Sculpture," *Artnews,* January 1987, pp. 138–43.

7. For Sugarman's philosophy of public art, see "From the Other Side: Public Artists on Public Art," *Art Journal,* Winter 1989, pp. 340–42.

8. Sugarman, *Art Journal,* p. 342.

9. Some of the following material on Scott Burton first appeared in slightly different form in an exhibition catalogue by the author, *Sculpture for Public Spaces* (New York: Marisa del Re Gallery, 1985).

10. Peter Schjeldahl, "Scott Burton Chairs the Discussion," *Village Voice,* June 1, 1982, p. 86.

11. Schjeldahl, p. 86.

12. For a complete description of the NOAA project, see Patricia Fuller, *Five Artists at NOAA: A Casebook on Art in Public Places* (Seattle: Real Comet Press, 1983). The project is also discussed in some detail by Bill Berkson, "Seattle Sites," *Art in America,* July 1986, pp. 68–83, 133, and more critically, by Matthew Kangas, "Art in Public

Places: Seattle," in Arlene Raven, ed., *Art the in Public Interest* (Ann Arbor, Michigan: UMI Research Press, 1989), pp. 303–24.

13. As David C. Streatfield, "The Emerald City: A Landscape of Paradox," *Landscape Architecture,* September/October 1988, pp. 56–63, observed, "What could have been a wonderful public garden, in which the reciprocal relationship between works of art and the landscape created powerful resonances, is nothing more than a string of fine art projects by individual artists along a path at the edge of Lake Washington."

14. See Barbara Swift and Robert Wilkinson, "The NOAA Artwork Program: Exploring Cultural History on a Shoreline Site," *Landscape Architecture,* Fall 1988. See also Kangas, cited above.

15. At a symposium on public sculpture held at the Neuberger Museum, SUNY, Purchase, in October 1988, Burton stated that he "wanted to theatricalize the experience of public life."

16. This project was analyzed from firsthand experience by William Tucker, "Brancusi at Turgu Jiu," *Studio International,* October 1972, pp. 117–21. Tucker liked the table and seating elements least, labeling the stools as good in design terms but not art. He compares the ensemble to studio furniture and observes that "its ambivalent status between art and taste cannot be redeemed by the portentous title (*The Table of Silence*) or the dressing of symbolism."

17. Brancusi's pioneering influence on contemporary artists was explored in essays by Suzanne Delehanty and Robert Pincus-Witten in *Improbable Furniture* (Philadelphia: Institute of Contemporary Art, 1977), pp. 8–16.

18. For a discussion of Artschwager's artistic concerns, see *Richard Artschwager's Theme(s)* (Buffalo: Albright-Knox Art Gallery, 1979), with insightful essays by Suzanne Delehanty and Linda Cathcart. More recent exhibitions include a 1988 retrospective at the Whitney Museum of American Art and "Artschwager: His Peers and Persuasion, 1963–1988" at the Daniel Weinberg Gallery in Los Angeles, also in 1988. The latter, focusing on the artist's influence, is reviewed by Colin Gardner in *Artforum,* September 1988, p. 150. An interesting profile of the artist is Stephen Henry Madoff, "Richard Artschwager's Sleight of Mind," *Artnews,* January 1988, pp. 114–21.

19. Suzanne Delehanty, *Soundings* (Purchase, New York: Neuberger Museum, 1981), p. 7. The catalogue also includes essays by Dore Ashton, Germano Celant, and Lucy Fischer.

20. See Jeff Kelley, "Conversation with Douglas Hollis," *Places,* vol. 2, no. 3 (1985), pp. 50–51.

21. Henry Korn, Executive Director of the Santa Monica Arts Commission, was quoted as saying, "New York has the Statue of Liberty, and St. Louis has the arch. And now Los Angeles has the singing beach chairs." See Margo Kaufman, "Serenading Sculptures," *The New York Times,* September 1, 1988, p. C10. For a nice appreciation of the piece, including some local responses, see Paul Bob, "Musical Chairs," *Stroll,* October 1987, pp. 53–54.

22. Brian Hatton, "Artists and Architecture at the ICA, London," *Architectural Review,* March 1983, p. 5, observed that "the particular references of her pieces seem to be to stories and dreams, and are often suggestive of journeys."

23. *Projects and Proposals: New York City's Percent for Art Program* (New York: New York City Department of Cultural Affairs, 1988), p. 26.

24. *Steps to Enjoying Seattle's Public Art* is a pamphlet published by the Seattle Arts Commission in 1988 indicating exact locations and funding sources for public art in the city.

25. For a discussion of the public art in MacArthur Park, see Steven Bingler, "The MacArthur Park Experiment 1983–87," *On View*, Spring/Summer 1990, pp. 16–27.

26. For perceptive discussions of Fischer's work see Dan Cameron, "The Case for R. M. Fischer," *Arts*, September 1984, pp. 70–73; David Craven, "Science Fiction and the Future of Art," *Arts*, May 1984, pp. 125–9; Gerrit Henry, "R. M. Fischer at Baskerville & Watson," *Artnews*, December 1983, p. 150. Cameron's article focuses primarily on Fischer's lamps, comparing his position to Burton's in expanding the definition of art to incorporate use and at the same time maintaining "full credibility as a fine artist."

27. See Wade Saunders, "Talking Objects: Interviews with Ten Younger Sculptors," *Art in America*, November 1985, p. 115.

28. For a full description of the project, see Penny Balkin Bach, "To Light Up Philadelphia: Lighting, Public Art, and Public Space," *Art Journal*, Winter 1989, pp. 324–30.

29. Metro-Dade Art in Public Places program press release, 105.01–81.

30. Jane Adams Allen, "Rockne Krebs," *The Washington Times Magazine*, December 23, 1983, p. 4D.

31. Sandra Dibble, "Artist Wants to Shed Light on Miami River," *The Miami Herald*, March 22, 1984, p. 3.

32. The catchall category of postmodern architecture (as well as art) encompasses such a variety of work as to make it nearly useless except as a demarcation of time in the sense of after, as in Post-Impressionism. It is used here in this broad temporal context, rather than to indicate a specific style.

33. Martin Friedman, *Scale and Environment: 10 Sculptors* (Minneapolis: Walker Art Center, 1977), p. 5. The artists in the exhibition were Siah Armajani, Michael Hall, Robert Stackhouse, George Trakas, Donna Dennis, Aldo Maroni, Thomas Rose, Harry Roseman, Joel Shapiro, and Charles Simonds. In addition to Friedman's provocative introduction, the catalogue includes individual essays on all the sculptors represented in the exhibition. For an interesting review of the exhibition, see Christopher Knight, "Some Recent Art and an Architectural Analogue," *LAICA Journal*, January/February 1978, pp. 50–54.

34. The exhibition included work by Alice Adams, Siah Armajani, Alice Aycock, Tony Berlant, Donna Dennis, Harriet Feigenbaum, Rafael Ferrer, Will Insley, Gordon Matta-Clark, Jody Pinto, Alan Saret, Wade Saunders, Joel Shapiro, Charles Simonds, and Katherine Sokolnikoff.

35. *Dwellings* (Philadelphia: Institute of Contemporary Art, University of Pennsylvania, 1978), p. 5. Lippard's essay is entitled "Body, House, City, Civilization, Journey."

36. For a summary of the debate, see Kate Linker, "An Anti-Architectural Analogue," *Flash Art*, January 1980, pp. 20–25.

37. Vito Acconci, "Projections of Home," *Artforum*, March 1988, p. 128.

38. Acconci's *Seedbed* of 1972 at the Sonnabend Gallery will undoubtedly remain the most famous. This exhibition consisted of the artist masturbating underneath a ramp in the gallery while his fantasies about gallery visitors were broadcast through a loudspeaker.

39. Linda Shearer, *Vito Acconci: Public Places* (New York: Museum of Modern Art, 1988), p. 5.

40. For example, Jennifer Bartlett's *At Sands Point #50* was installed in the lobby of the company's southside headquarters in 1986.

41. A variety of local responses are reported by Catherine Fox, "Fun House," *The Atlanta Journal*, August 7, 1988, pp. 1K–2K.

42. Vito Acconci, "Projections of Home," *Artforum*, March 1988, p. 128. For further explication of Acconci's idea about the house form as it relates to public art, see *Vito Acconci: Domestic Trappings* (La Jolla, Calif.: La Jolla Museum of Contemporary Art, 1987), pp. 61–69.

43. Shearer, *Vito Acconci: Public Places*, p. 27.

44. For a perceptive and chilling study of the privatization of public space, see Herbert Schiller, *Culture, Inc.* (New York: Oxford University Press, 1989).

45. See Siah Armajani, "The Exuvial of Time: Architecture as Subject for Art," *Perspecta*, no. 18, 1982, p. 69.

46. See Janet Kardon, *Siah Armajani: Bridges, Houses, Communal Spaces, Dictionary for Building* (Philadelphia: Institute of Contemporary Art, 1985), p. 77.

47. For a discussion of Armajani's bridge and the entire project, see "Minneapolis Sculpture Garden," *Design Quarterly*, no. 141, 1988.

48. An interesting discussion of this aspect of his work is found in Robert Berlind, "Armajani's Open-End Structures," *Art in America*, October 1979, pp. 82–85.

49. See *Loop Sculpture Guide* (Chicago: Tourism Council, 1986), p. 16. Funded by the Chicago Sculpture International 1985 Purchase Prize from Arthur Anderson and Company, it was first exhibited in its present site in 1983.

50. For a discussion of Nauman's use of neon, see Brenda Richardson, *Bruce Nauman: Neons* (Baltimore: Baltimore Museum of Art, 1983).

51. For contemporary reviews see Joshua Dector, "Dennis Adams," *Arts*, December 1986, p. 146; Fleming Meeks, "Dennis Adams at Broadway and 66th Street," *Art in America*, September 1984, p. 207; Patricia C. Phillips, "Dennis Adams," *Artforum*, January 1987, p. 116.

52. Public Art Fund news release, February 7, 1991.

53. For a discussion of *Grand River Sculpture* in terms of funding and public art in Grand Rapids, see John Beardsley *Art in Public Places* (Washington, D.C.: Partners for Livable Places, 1981), pp. 18–20.

54. For interesting reviews of Ferrara's work see Ronny H. Cohen, "Jackie Ferrara," *Artforum*, April 1983, pp. 72–73 and Eleanor Heartney, "Jackie Ferrara," *Arts*, March 1983, p. 9.

55. See Martin Friedman, "Minneapolis Sculpture Garden," *Design Quarterly*, no. 141, p. 22.

56. Friedman, "Minneapolis Sculpture Garden," p. 23.

57. Amy Goldin, "The 'New' Whitney Biennial: Pattern Emerging," *Art in America*, May/June 1975, pp. 72–73, noticed an "oddly persistent interest in pattern." She praised this development toward the decorative because it allowed the artist to communicate with a broader audience. Goldin herself was instrumental in the development of a new decorative sensibility as the teacher of Robert Kushner and Kim McConnell. In 1977 Goldin curated "Patterning and Decoration" at the Museum of the American Foundation of the Arts in Miami. The same year John Perreault curated "Pattern Painting" at P.S. 1 in Long Island City, N.Y., and in 1979 he curated "Patterning Painting" at the Palais des Beaux-Arts in Brussels. Other significant exhibitions focusing on this development were "Arabesque," curated by Ruth K. Meyer at the Contemporary Arts Center in Cincinnati in 1978, and "The Decorative Impulse," curated by Janet Kardon at the Institute of Contemporary Art at the University of Pennsylvania in 1979.

58. Donald Thalacker, *The Place of Art in the World of Architecture* (New York: Chelsea House Publishers and R. R. Bowker Company, 1980), p. 152.

59. Smyth's reuse of images from his earlier work is discussed in Brit Brinkly, "Smyth Spirit," *Stroll*, October 1987, pp. 62–64.

60. For a more positive evaluation of *Upper Room,* see Robert Mahoney, "Theory-Praxis in Public Sculpture," *Arts Magazine,* November 1988, pp. 114–17. Mahoney calls it "a perfect endgame filter between the Hudson and the town."

61. See Daralice C. Boles, "Profile: Peter Walker and Martha Schwartz," *Progressive Architecture,* July 1989, pp. 56–65.

62. Lyn Smallwood, "Seattle: Paradise Lost," *Artnews,* October 1987, p. 57.

63. Robert Irwin, *Being and Circumstance: Notes Toward a Conditional Art* (Larkspur Landing, California: The Lapis Press in conjunction with The Pace Gallery and the San Francisco Museum of Art, 1985), p. 67.

64. Irwin, *Being and Circumstance,* p. 25.

65. Irwin, *Being and Circumstance,* p. 27.

66. Claudia Hart, "Environment of Light: Ornament in Search of Architecture," *Industrial Design,* March/April 1984, pp. 22–24.

67. Thomas McEvilley, "Seattle/Washington, D.C., Robert Irwin, Public Safety Building Plaza, Old Post Office," *Artforum,* Summer 1984, p. 96.

68. For a discussion of Noguchi's innovations and influence as a playground designer, as well as some of his ill-fated projects, see "Prophet Without Honor," *Art in America,* November/December 1967, pp. 44–47.

Chapter 6

1. Albert Elsen, *Rodin's Thinker and the Dilemmas of Modern Public Sculpture* (New Haven: Yale University Press, 1985).

2. Curated by Gerald Nordland, the exhibition was held at the Milwaukee Art Museum from October 21, 1983, to January 15, 1984. It did not travel.

3. The GSA's *Factsheet: Art-in-Architecture for Federal Buildings* includes a brief history of the program as well as a summary of the current commissioning process.

4. For a history of the GSA's commissioning practices, see Donald W. Thalacker, *The Place of Art in the World of Architecture* (New York: Chelsea House Publishers and R. R. Bowker Company, 1980); Lois Craig and the Staff of the Federal Architecture Project, *The Federal Presence: Architecture, Politics, and Symbols in United States Government Building* (Cambridge, Mass.: The MIT Press, 1977); JoAnn Lewis, "A Modern Medici for Public Art," *Artnews,* April 1977, pp. 37–40; Kate Linker, "Public Sculpture II: Provisions for the Paradise," *Artforum,* Summer 1981, pp. 37–42.

5. For an analysis of the different commissioning practices of the GSA and the NEA, see Judith H. Balfe and Margaret J. Wyszomirski, "Public Art and Public Policy," *The Journal of Arts Management and Law,* Winter, 1986.

6. For a fuller discussion of the fate of Serra's *Tilted Arc,* see the author's "Richard Serra's *Tilted Arc:* Art and Non-Art Issues," *Art Journal,* Winter 1989, pp. 298–302, and the forthcoming *Dangerous Precedent: Richard Serras' Tilted Arc in Context* (Berkeley, Calif.: University of California Press, 1993).

7. The December 1988 issue of *Art in America* included articles on both projects. Sue Taylor's "Garden City," pp. 28–37, on the Minneapolis Sculpture Garden at the Walker Art Center was followed by Nancy Princenthal's "Corporate Pleasures," pp. 38–41, on the new outdoor art at General Mills.

8. See Rosanne Martorella, *Corporate Art* (New Brunswick and London: Rutgers University Press, 1990), p. xi.

9. Personal interview with Gordon Bunshaft in 1978.

10. Princenthal, "Corporate Pleasures," p. 39.

11. Brian O'Doherty, "Public Art and the Government: A Progress Report," *Art in America,* May/June 1974, p. 45.

12. Other significant studies in the area of art education are *Coming to Our Senses: The Significance of the Arts for American Education* (New York: McGraw-Hill Book Company, 1977) and *Toward Civilization: A Report on Arts Education* (Washington, D.C.: National Endowment for the Arts, 1988).

13. The fate of this commission was related to the author in a private interview with a person closely involved with the project. The Noguchi–pet rock comparison is mentioned by Thalacker, *The Place of Art in the World of Architecture*, p. viii.

14. Ronald G. Shafer, "A Touch of Class? Washington Planners Beset by Critical Public over Their Efforts to Put Art into Architecture," *The Wall Street Journal*, September 21, 1976, p. 48.

15. This and other testimony is available in the unpublished proceedings on the GSA hearing on *Tilted Arc*, which took place on March 6–8, 1985.

16. Thalacker, p. vii.

17. For a summary of the controversy see JoAnn Lewis, "People Sculpture: Objections Overruled," *Artnews*, December 1976, pp. 83–85. A more detailed narrative is provided in Thalacker, pp. 8–13.

18. One judge complained that "It invites vandals to place graffiti upon it [and] transients have actually been seen urinating on it." Another judge objected, "Graffiti is written all over it, most of which is obscene and unmentionable. . . . Some animals use it as a waste deposit."

19. Information on these programs may be obtained from Pat Marx, Education Coordinator, Metro-Dade Art in Public Places Trust, 111 N.W. First Street, Suite 610, Miami, Fla. 33128. Although the education programs as well as the art commissioned by the trust have been much praised by the public art community, the fate of the overall program remains somewhat in question at the time of this writing. See David Joselit, "Public Art & Public Purse," *Art in America*, July 1990, pp. 142ff.

20. See Pilar Viladas, "Art for Whose Sake?" *Progressive Architecture*, April 1985, p. 29; and "Neon Sculpture Controversy in Tacoma," *Interior Design*, May 1985, p. 70.

21. For example, Thalacker, *The Place of Art in the World of Architecture*, p. xi, attributes the suspension of the GSA's Art-in-Architecture program in 1966 to specious reporting in the *Boston Herald* about a mural by Robert Rauschenberg installed in the John F. Kennedy Federal Building in Boston.

22. Various interesting ways of considering the meaning of site are discussed in *Design Quarterly*, vol. 122 (1983), entitled *Site: The Meaning of Place in Art and Architecture*.

23. Sugarman made this remark at a panel discussion at the annual meeting of the College Art Association in 1986.

24. A cogent argument for maintaining the primacy of the artistic vision is made by Douglas Davis, "Public Art: Taming of the Vision," *Art in America*, May/June 1974, pp. 84–85.

Epilogue

1. I am indebted to Michael Faubian for this and other information about recent changes in NEA programs affecting public art. It is too early to ascertain the reasons and implications for the decline in applications, but it is possible that with the increase in local funding agencies at state and city levels, these projects are taking a more local focus in every respect, including funding.

2. The NEA was under constant attack in 1988 as the result of controversy centering on two exhibitions partially funded by the agency: one by Robert Mapplethorpe and

the other by Andreas Serrano. Debate on the Senate floor was heated and the threat of an anti-obscenity oath attached to NEA grants was in fact a brief reality. The attack was headed by Senator Jesse Helms, who was joined by other conservative politicians and organizations. Details of the controversy were reported regularly in the media.

3. A variety of these projects are discussed in Arlene Raven, ed., *Art in the Public Interest* (Ann Arbor: UMI Press, 1989). See also Patricia C. Phillips, "Temporality and Public Art," *Art Journal,* Winter 1989, pp. 331–335, and Michael Brenson, "Visual Arts Join Spoleto Festival U.S.A.," *The New York Times,* May 27, 1991, pp. 11, 14.

Index